PAINTERS AND PUBLIC LIFE
in Eighteenth-Century Paris

THOMAS E. CROW

PAINTERS AND PUBLIC LIFE

in Eighteenth-Century Paris

YALE UNIVERSITY PRESS
NEW HAVEN & LONDON · 1985

Copyright © 1985 by Yale University
Second printing 1986
Third printing 1988
Fourth printing 1991

Designed by Gillian Malpass
Colour originated in Hong Kong by
Hongkong Graphic Arts Ltd.
Set in Monophoto Ehrhardt and printed in Great Britain by
BAS Printers Limited, Over Wallop, Hampshire.

Library of Congress Cataloging in Publication Data
Crow, Thomas, 1948—
 Painters and public life in 18th century Paris.
 Includes bibliographies and index.
 1. Salon (Exhibition) 2. Painting, Modern—17th–18th
centuries—France—Paris. 3. Art exhibition audiences—
France—Paris. 4. Art and state—France—Paris.
I. Title.
ND550.C75 1985 750'.1 85-5375
ISBN 0-300-03354-0 (cloth)
ISBN 0-300-03764-3 (paper)

CONTENTS

ACKNOWLEDGEMENTS

THE work on this book has consumed a number of years and many people have helped its passage. The text as it stands owes much to the careful reading and comments of Thomas DaC. Kaufmann, John Shearman, Svetlana Alpers, Carol Armstrong, and Patricia Brown. Earlier versions of material in chapters IV, VI and VII benefited greatly from Francis Haskell's interest and close criticism. Serge Guilbaut likewise gave that manuscript a patient and incisive reading. Joseph Baillio, Jerrine Mitchell, Edgar Munhall, Julie Ann Plax, and Richard Wrigley have generously made available findings from their unpublished research.

Many thanks must go to those at Princeton University who provided crucial practical assistance. Mary Schmidt and the staff of Marquand Library made every effort to secure needed sources. Without Shari Taylor's energy and efficiency, the task of gathering photographs would have been infinitely more difficult. The Spears Fund of the Department of Art and Archaeology has generously sustained my research here and abroad during the last four years. Further support was provided by the Humanities Research Council of the university. The germ of this book was my dissertation, written at the University of California, Los Angeles. I completed its research and writing while holding an Edward A. Dickson History of Art Fellowship. The University of Chicago also provided needed assistance for travel. At Yale University Press, John Nicoll and Gillian Malpass have given a first book the best kind of editorial attention.

From beginning to end, this project has drawn most from the advice and friendship of Timothy Clark. Other friends, particularly Deborah and Steven Weiner, have helped more than they know. From Catherine Phillips I continually learn how to see the work of art.

INTRODUCTION

The Salon Exhibition in the Eighteenth Century and the Problem of its Public

–i–

AMBITIOUS painting most conspicuously entered the lives of eighteenth-century Parisians in the Salon exhibitions mounted by the Academy of Painting and Sculpture. These had begun as regular events in 1737; held in odd-numbered years, except for a brief early spell of annual exhibitions, they opened on the feast-day of St. Louis (25 August) and lasted from three to six weeks. During its run, the Salon was the dominant public entertainment in the city.[1] As visual spectacle, it was dazzling: the *Salon carré* of the Louvre—the vast box of a room which gave the exhibition its name—packed with pictures from eye-level to the distant ceiling, the overflow of still-life and genre pictures spilling down the stairwells that led to the gallery (Plate 1); an acre of color, gleaming varnish, and teeming imagery in the midst of the tumble-down capital (the dilapidation of the Louvre itself was the subject of much contemporary complaint). "Ceaseless waves" of spectators filled the room, so the contemporary accounts tell us,[2] the crush at times blocking the door and making movement inside impossible. The Salon brought together a broad mix of classes and social types, many of whom were unused to sharing the same leisure-time diversions. Their awkward, jostling encounters provided constant material for satirical commentary.

The success of the Salon as a central Parisian institution, however, had been many decades in the making. Its actual origins lay in the later seventeenth century, but these had not been particularly auspicious. The Academy's initial efforts at public exhibition had been limited to a few cramped and irregular displays of pictures, first in its own meeting rooms and later in the open arcades of the adjoining Palais Royal. The disadvantage of the latter practice, according to an early account, was that the artists "had the constant worry of damage to the paintings by the weather, which pressed them often to withdraw the pictures before the curiosity of the public had been satisfied."[3] By 1699 the Salon was more comfortably installed inside the Louvre, and Parisians were spared the sight of academicians hustling their canvases out of the rain. By all accounts, that exhibition was a popular success, but it was almost forty years before the Salon became a permanent fixture of French cultural life.

After 1737, however, its status was never in question, and its effects on the artistic life of Paris were immediate and dramatic. Painters found themselves being exhorted in the press and in art-critical tracts to address the needs and desires of the exhibition "public"; the journalists and critics who voiced this demand claimed to speak with the backing of this public; state officials responsible for the arts hastened to assert that their

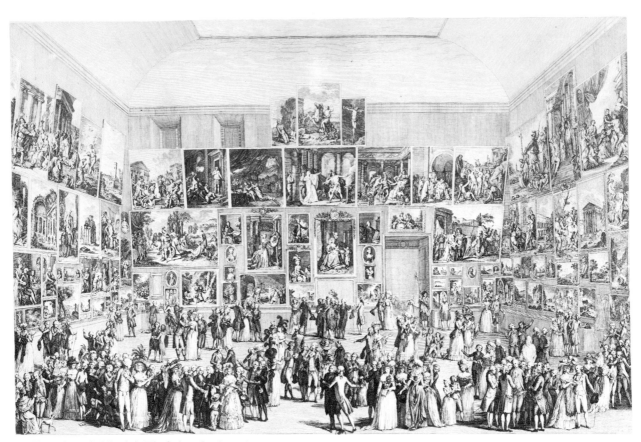

1. Pietro Antonio Martini, *The Salon of 1787*. 1787. Engraving

decisions had been taken in the public's interest; and collectors began to ask, rather ominously for the artists, which pictures had received the stamp of the public's approval. All those with a vested interest in the Salon exhibitions were thus faced with the task of defining what sort of public it had brought into being.

This proved to be no easy matter, for any of those involved. The Salon exhibition presented them with a collective space that was markedly different from those in which painting and sculpture had served a public function in the past. Visual art had of course always figured in the public life of the community that produced it: civic processions up the Athenian Acropolis, the massing of Easter penitents before the portal of Chartres cathedral, the assembly of Florentine patriots around Michelangelo's *David*—these would just begin the list of occasions in which art of the highest quality entered the life of the ordinary European citizen and did so in a vivid and compelling way. But prior to the eighteenth century, the popular experience of high art, however important and moving it may have been to the mass of people viewing it, was openly determined and administered from above. Artists operating at the highest levels of aesthetic ambition did not address their wider audience directly; they had first to satisfy, or at least resolve, the more immediate demands of elite individuals and groups. Whatever factors we might name which bear on the character of the art object, these were always refracted through the direct relationship between artists and patrons, that is, between artists and a circumscribed, privileged minority.

The broad public for painting and sculpture would thus have been defined in terms

other than those of interest in the arts for their own sake. In the pre-eighteenth-century examples cited above, it was more or less identical with the ritualized assembly of the political and/or religious community as a whole—and it could be identified as such. The eighteenth-century Salon, however, marked a removal of art from the ritual hierarchies of earlier communal life. There the ordinary man or woman was encouraged to rehearse before works of art the kinds of pleasure and discrimination that once had been the exclusive prerogative of the patron and his intimates. There had been precedents for this kind of exhibition, of course, in France and elsewhere in Europe: displays of paintings often accompanied the festival of Corpus Christi, for example, and there were moves underway in many places to make royal and noble collections available to a wider audience.[4] But the Salon was the first regularly repeated, open, and free display of contemporary art in Europe to be offered in a completely secular setting and for the purpose of encouraging a primarily aesthetic response in large numbers of people.

There was in this arrangement, however, an inherent tension between the part and the whole: the institution was collective in character, yet the experience it was meant to foster was an intimate and private one. In the modern public exhibition, starting with the Salon, the audience is assumed to share in some community of interest, but what significant commonality may actually exist has been a far more elusive question. What was an aesthetic response when divorced from the small community of erudition, connoisseurship, and aristocratic culture that had heretofore given it meaning? To call the Salon audience a "public" implies some meaningful degree of coherence in attitudes and expectations: could the crowd in the Louvre be described as anything more than a temporary collection of hopelessly heterogeneous individuals? This was the question facing the members of the art world of eighteenth-century Paris. Many thought so, but the actual

2. Gabriel-Jacques de Saint-Aubin, *Staircase of the Salon.* 1753. Etching

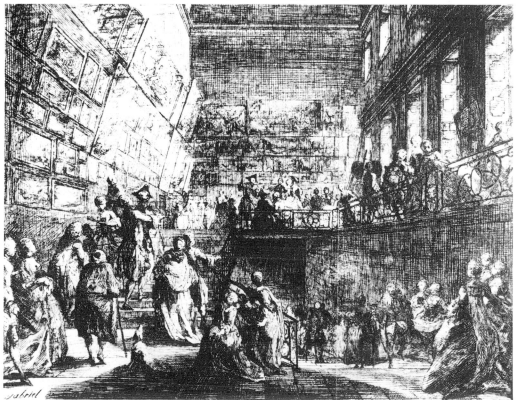

attempt caused them endless difficulty. Here is one representative effort, written in 1777 by a veteran social commentator and art critic, Pidansat de Mairobert. He begins with his physical entry into the space of the exhibition (Plate 2):

> You emerge through a stairwell like a trapdoor, which is always choked despite its considerable width. Having escaped that painful gauntlet, you cannot catch your breath before being plunged into an abyss of heat and a whirlpool of dust. Air so pestilential and impregnated with the exhalations of so many unhealthy persons should in the end produce either lightning or plague. Finally you are deafened by a continuous noise like that of the crashing waves in an angry sea. But here nevertheless is a thing to delight the eye of an Englishman: the mixing, men and women together, of all the orders and all the ranks of the state. . . . This is perhaps the only public place in France where he could find that precious liberty visible everywhere in London. This enchanting spectacle pleases me even more than the works displayed in this temple of the arts. Here the Savoyard odd-job man rubs shoulders with the great noble in his *cordon bleu*; the fishwife trades her perfumes with those of a lady of quality, making the latter resort to holding her nose to combat the strong odor of cheap brandy drifting her way; the rough artisan, guided only by natural feeling, comes out with a just observation, at which an inept wit nearby bursts out laughing only because of the comical accent in which it was expressed; while an artist hiding in the crowd unravels the meaning of it all and turns it to his profit.[5]

The source of this passage is Mairobert's clandestine news-sheet, the "English Spy," hence the conspicuous English references. It appears as part of a lengthy and sober history of official art in France and of the public exhibitions of the Academy (as good as any the eighteenth century produced). His half-comic observations of the Salon crowd are meant to carry serious meaning and can serve to introduce the principal themes of this book.

First of all, the rhetoric of the passage points up the degree to which the "public" in the Salon defied efforts at concrete description. In its choices of metaphor it is positively at war with concreteness. Merely to enter the Salon requires a passage through a blinding vortex in which all the boundaries and distinctions which demarcate a ranked society are broken down. The result is a new social body which is seductive and enchanting in its liberated vitality, but at the same time mined with insidious hazards. Once barriers have been dissolved, social contact multiplies and expands uncontrollably like the invisible circulation of disease. The flux of the Salon crowd, likened to the commingling of heady and noxious gases, contains equal measures of vitality and peril. At the same time, this apparent chaos does in the end yield useful knowledge to the artist, knowledge free, as Mairobert states further on, from "prejudices, passions, jealousy, and servile conformity." Wisdom emerges from the most unexpected sources, and is easily misread by the complacent and shallow. But the artist, via saturation in the fluid mass of his public, does sort it all out, does come away with new information useful, indeed essential, to his art.

The connection between the two, however, between artist and public, remains occult, the product of secret and private intelligence. Likewise, the sage response of the artisan is incomprehensible to his immediate neighbor. As we shall see repeatedly, Mairobert's text is typical in its contradictory insistence on an undifferentiated whole while attending in detail exclusively to heterogeneity, to the particular and private. These are the con-

traditions of the term itself; the "public" is both everywhere and nowhere in particular. If we limit ourselves to a positivist historical approach, to an empirical reconstruction of the emerging Parisian art public as recorded in the surviving documents, we shall continually be left with the same split perception present in this brief account. We can and shall arrive at empirical knowledge concerning the Salon *audience*, because an audience is by definition an additive phenomenon: we identify, and count if possible, the individuals and groups recorded as making it up; no one who was present can be disqualified from membership. But what transforms that audience into a public, that is, a commonality with a legitimate role to play in justifying artistic practice and setting value on the products of that practice? The audience is the concrete manifestation of the public but never identical with it. In empirical terms, we are confronted only with the gross totality of the audience and its positively identifiable constituent parts: individuals and group categories defined by sex, age, occupation, wealth, residence, etc. The public, on the other hand, is the entity which mediates between the two, a representation of the *significant* totality by and for someone. A public appears, with a shape and a will, via the various claims made to represent it; and when sufficient numbers of an audience come to believe in one or another of these representations, the public can become an important art-historical actor.

It follows from this that the role of the new public space in the history of eighteenth-century French painting will be bound up with a struggle over representation, over language and symbols and who had the right to use them. The issue was never whether that problematic entity, the public, should be consulted in artistic matters, but who could be legitimately included in it, who spoke for its interests, and which or how many of the contending directions in artistic practice could claim its support. If the Salon as a social location seemed mystifyingly fluid and undefined, what other public spaces of assembly and shared discourse might it be like? In what ways did one's experience there overlap with those of the festival, fair, royal entry, marketplace, theater, salesroom, court of law, church, or political demonstration? A combination of historical factors made the conflict over such questions intense, and what might otherwise have been rather esoteric questions of artistic style and subject matter were often caught up in that struggle. One way therefore to begin an account of the place of painting in the social fabric of the city will be to trace the history of this argument, and in so doing, we will begin to understand something of the intensity with which it was fought out. This chapter then will primarily be concerned with the perceptions of eighteenth-century witnesses and their disputes over perception. Subsequent chapters will try to recover as much as possible of the historical actuality underlying this war of words and to assess in detail what that meant for the practice of painting.

−ii−

Considering the casual hierarchy of the eighteenth-century debate over the Salon public, the most appropriate place to begin would be with the view of the state at the time of the revival of the Salon in 1737. The official responsible for its permanent re-establishment was the finance minister Philibert Orry. Newly appointed head of the arts administration (as *Directeur-général des bâtiments*), Orry seems to have carried a tendency to fiscal thinking over into his new responsibilities. The Salon, in his conception, would

be like an annual public audit of artistic productivity. The official journal, the *Mercure de France*, endorsed Orry's proposal in just these terms:

> . . . the Academy does well to render a sort of accounting to the public of its work and to make known the progress achieved in the arts it nurtures by bringing to light the work of its most distinguished members in the diverse genres it embraces, so that each thereby submits himself to the judgement of informed persons gathered in the greatest possible number and receives the praise or blame due him. This will both encourage genuine talents and unmask the false fame of those who have progressed too little in their art, but, full of pride in their illustrious company, think themselves automatically as able as their fellows and neglect their calling.[6]

This passage announces what will be an incessant theme in eighteenth-century discussions of art: that quality in art depends on public scrutiny, and that this quality is threatened or declines to the extent that artists restrict their audience, whether to a noble or moneyed elite or to a coterie of their fellow academicians. So declared that writer often cited as the first modern art critic, one La Font de Saint-Yenne. "It is only in the mouths of those firm and equitable men who compose the Public, who have no links whatever with the artists, . . . that we can find the language of truth," he wrote in defense of his critical pamphlet of 1747.[7] That pamphlet, entitled *Reflections on Some Causes of the Current State of Painting in France*,[8] contained a comprehensive discussion of the previous year's Salon and proposed for the first time that a museum be established in the Louvre to provide artists and public alike with a continuing education in art history.

Following La Font's critical sally, the volume of published comment on the exhibitions and the public functions of art expanded rapidly. Substantial numbers of critiques appeared during and after subsequent Salons, as well as more far-ranging treatises on painting intended for a general literate public.[9] Well-established literary men and *amateurs*—Laugier, Sainte-Palaye, Caylus, Bachaumont—offered the Salon audience enlightened instruction and advocacy. The current *Directeur-général*, Lenormand de Tournehem, answered the call for a museum by putting part of the royal collection on public display two days per week in the Luxembourg Palace. This same official, whose responsibility included state patronage and the administration of the Academy, recognized the increasing importance of the Salon as an artistic forum by establishing the first Salon jury in 1748, and in general regularizing selection procedures and toughening standards. To complete the picture, the abbé Laugier (author of the widely-read and influential *Essay on Architecture*[10]) confidently proposed to Tournehem that a regular arts periodical, the first of its kind, be established under his direction.[11] He had in mind a monthly review, to be called *The State of the Arts in France*, composed very much like an art journal today: it was to offer feature articles on individual artists and architects, reports on the meetings of the two academies, biographies of past artists, and reviews of books. A waiting readership seemed to exist; each year the Academy had to print increasing numbers of its Salon guide and catalogue (the *livret*), and soon was selling them in the thousands.[12] The official handbook was supplemented by more and more critical pamphlets, many of them illegal and anonymous, sold in the streets, cafés, and printshops of the city during the run of each exhibition. To judge from their numbers and variety, these constituted a small industry in themselves.

We could draw from all this an optimistic and affirmative picture of the new public sphere, one in which the audience (via the critics who spoke in its name) joined the

public audit of artistic productivity

public scrutiny

Academy and the state in fundamental agreement on principles and the direction of needed reform. Certainly since the 1912 publication of Jean Locquin's classic *History Painting in France from 1747 to 1785*,[13] scholars have taken for granted that a rough audience/official consensus propelled painting away from privatized, sensual values of the Rococo style toward the revival of an elevated and moralizing classicism. Locquin's opening and closing dates indicate the argument: 1747 saw La Font's unprecedented public appeal that painters forsake the trivial and erotic for the principles of Poussin and Le Brun—high-minded themes, sober clarity of style, the example of the antique. He launched this appeal, so he claimed, only in response to a growing clamor of audience complaint.[14] The preceding year had marked the advent of Tournehem's reformist arts administration, which had the same end in view. The Salon as a public event had restored the mandate once provided by the aggressive cultural policies of Louis XIV and Colbert. In the process, direct subservience to the throne was muted and a more general notion of public service came to the fore. The engraver Cochin, then first officer of the Academy, made the connection plainly in 1757: after the death of Louis XIV, he declared:

> . . . the art of painting languished without support or protection. . . . The custom of exhibitions at the Salon was not yet in force, and we can say confidently that this fortunate institution has saved painting by a prompt display of the most deserving talents and by inspiring with a love of the arts a good number of people who, without the exhibition, would never have given them a thought.[15]

1785 stands for the final success of this policy, the popular embrace of classicizing and didactic historical painting effected by Jacques-Louis David's *Oath of the Horatii* (Color Plate 2). The roots of David's overwhelming Salon successes of the 1780s are present in the convergence some forty years before between public awakening and enlightenment from above.

—iii—

The account sketched above is venerable and, I think, roughly right. But it is easily misread. The dramatic and rapid appearance of the modern art public was a much more difficult process than the standard history would indicate. The institution of a regular public audience may well have revived the old authority and priorities of state patronage, but those in charge did not want that dependence overstressed. One of the reasons we know so little about La Font is the angry, even violent reaction of the academic artists, who succeeded in hounding him back into the obscurity from which he had briefly emerged. Pamphlets and prints ridiculed and caricatured him as blind and feeble-minded, ignorant and opportunistic by turns.[16] A writer close to the the academic leadership, the abbé Leblanc, produced a booklet countering La Font's *Reflections* later in the same year.[17] It featured a frontispiece designed by Boucher depicting a personified art of painting in despair, besieged by a hooting crowd of harpies and asses (Plate 3). The rumor current at the time was that Leblanc had attacked La Font at the express direction of the portraitist Latour and had received in return a portrait of himself. (It was displayed in the Salon of 1747 and garnered this accolade from Leblanc himself in his published review: "The public has found the likeness of Monsieur the abbé Leblanc one of the strongest efforts ever made in any genre.")[18] La Font was personally the target of a number of satirical prints produced by other artists. A student of *Premier peintre*

Charles Coypel designed one which provided the critic with a blind man's cane and dog, and Watelet, *amateur honoraire* in the Academy, engraved it (Plate 5). Another, accompanied by the caption "LA FONTaine de St. Innocent," shows him mindlessly examining the Paris landmark under a magnifying glass. The pun on his name tags him as a village idiot, an *innocent*, while the image depicts him as one (Plate 6). The artists reacted with more than propaganda: in 1749, as an open protest against the new critical climate, they refused even to hold an exhibition.[19] Two years later, the cream of the Academy—Boucher, Coypel, Natoire, Bouchardon—still refused to submit work.

The reaction at the state level was hardly more encouraging. Tournehem, far from endorsing La Font's public campaign, declared himself "outraged indeed that illegal pamphlets should afflict our artists with the stupidities they can peddle. The best response would be simple contempt, and this should shut up their impertinent authors."[20] The *Directeur-général* also moved in more concrete ways. His establishment of the Salon jury was largely a preemptive move to protect artists from further insult by screening out the works most likely to provoke it.[21] Cochin, despite having consistently praised the salutary influence of public opinion on the arts, branded La Font as "that ignoramus who sounded the charge in the war being waged on the arts and on the most distinguished

3. After François Boucher, *Painting mocked by Envy, Stupidity, and Drunkenness*. Frontispiece to the abbé Leblanc, *Lettre sur l'exposition*, 1747. Etching

4. Charles-Nicolas Cochin (?), *A Critic at the Salon of 1753*. Frontispiece to Jacques Lacombe, *Le Salon*, 1753. Etching

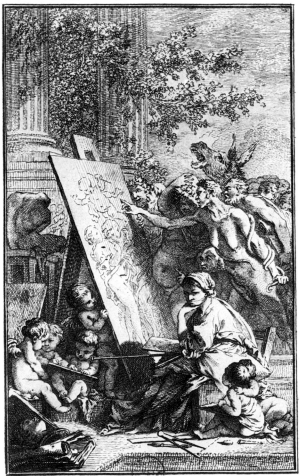

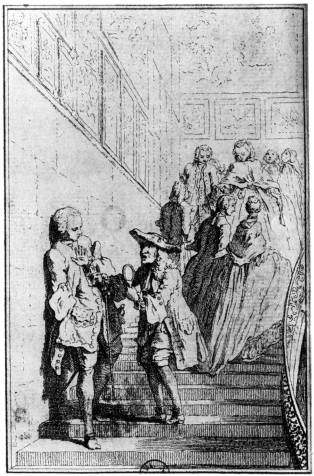

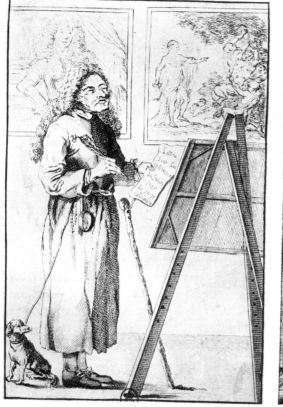 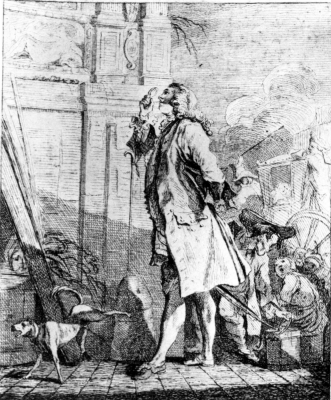

5. Claude-Henri Watelet, *La Font de Saint-Yenne*. Etching after design by Portien

6. *La Font de Saint-Yenne*. Anonymous etching

artists."[22] And as for Laugier's proposed journal of art and architecture, Cochin, in his capacity as secretary to the Academy, rendered this opinion:

> This sort of publication can degenerate in no time to criticisms, mockery, and baseless judgements. Any writer will soon persuade himself that negativity amuses the public and can sell his work. Self-interest runs the show, and it will become no more than a periodical series of insults which would aggrieve our artists, close the studios, and ruin public exhibitions, which are more useful to the arts than are the arguments of literary men who know next to nothing.[23]

The new *Directeur-général*, the marquis de Marigny, refused Laugier his necessary permission.

As fast as the components of the artistic public sphere had appeared, they were variously denounced, ridiculed, suppressed, or ignored by the Academy and the responsible state officials. Public access to the Luxembourg Palace collection was allowed to lapse; the proposal for a museum in the Louvre languished for decades while similar museums were opening all over Europe. The following decade, the 1760s, stands out in the history of modern art criticism because of Diderot's monumental commentaries on the Salon; but it needs to be recalled that he was writing only for a small, international circle of titled subscribers to Melchior Grimm's *Correspondence littéraire*. At home almost no Salon criticism of substance was available. Cochin had by this time taken steps to force the unofficial critics to submit their work to the state censor and was attempting,

with some success, to ban critical anonymity. Clandestine critiques remained in circulation (Diderot's texts received some limited domestic distribution in manuscript), but the pressure was kept on: in 1769 the Academy had a relatively inoffensive piece of light satire by Daudet de Jossan seized by the police.[24] Nothing like lively public debate on the Salon would be seen until the 1770s and '80s, and it would be strongly resisted even then. In pre-Revolutionary Paris, public discourse on art would never achieve uncontested legitimacy.[25]

If there was a marriage between the interests of the Academy, the state, and the public in these years, it was a troubled one. The two statements by Cochin quoted above indicate the difficulty: the Salon and its audience were the salvation of serious painting, yet that audience was in the market chiefly for negativity and slander; for the public to have a voice of its own would be the ruin of established artistic careers and of the Salon itself. It is a peculiar proposition, that there be a public arena yet at the same time no public speech, no regular medium for the expression of unofficial opinion. Cochin is utterly forthright on this. In direct response to La Font's contrary claim, he wrote in the *Mercure*: "I hold the principle that a painting, a statue, *do not* [my emphasis] belong to the public in the same way that a book does."[26] And La Font's asserted modesty of purpose, that he wrote only to voice "the complaints of the public as much concerning the sterility and lack of inspiration in the choices of subject as the stiffness and mediocrity of the execution,"[27] elicited from Coypel—the artist at the top of the academic hierarchy—this impassioned denial that the Salon audience constituted a public at all:

> Myself, I maintain that in the Salon where the paintings are displayed, the public changes twenty times a day. What the public admires at ten o'clock in the morning, is publicly condemned at noon. Yes, I tell you, this place can offer twenty publics of different tone and character in the course of a single day: a simple public at certain times, a prejudiced public, a flighty public, an envious public, a public slavish to fashion, which in order to judge wants to see everything and examine nothing. I can assure you that a final accounting of these publics would lead to infinity. I must allow that the Salon can always be filled with these same kinds of people, but believe me, after having heard them all, you will have heard not a true public, but only the mob, and not at all that public on which we should rely. Let us not confuse the one with the other; the mob at first rushes forward passionately, speaks with vehemence, fears to waste in reflection those few moments it devotes to its oracular pronouncements. But time in the end moderates its passions: it is then that one is able to hear the knowing public that the mob hides in its midst and whose voice it smothers.[28]

To conjure up the spectre of a coherent, engaged, and demanding public, this was a sufficient sin in the eyes of Cochin, Coypel, Tournehem, and company to consign La Font to outer darkness. Certainly there was nothing in the actual substance of his criticism to justify their implacable hostility, little that differed from the stated principles of his opponents (thus the false impression, as noted above, of a broad anti-Rococo consensus). What is striking about La Font's *Reflections*, given the violent reaction to it, is its moderate, even tentative character. Though he presents himself as one compelled to speak out by the serious decline of French painting from its unchallenged preeminence in the later seventeenth century, his comments on the pictures he chooses to discuss are largely positive and admiring. He is quick to say, despite his reformist stance, that he is "very far from believing that French genius is extinguished or its vigor entirely depleted."[29] And

his praise, even flattery at times, for the best-known painters of the day—Carle Van Loo, Restout, Parrocel, Coypel—outweigh any fault-finding. He praises not only the religious and historical works exhibited by these artists, but also the lower-ranking landscapes of Joseph Vernet and the genre scenes of Oudry. Boucher's sumptuous images are the only works that come off at all badly in his commentary. (What is more, his fellow unofficial critics so outdid him in general inoffensiveness that in 1754 an exasperated La Font attacked the lot of them for their unrelieved blandness; but it was not until this date that La Font himself produced anything like a severe critique—and it was also his last.[30]) The problem then is to account for the vehement opposition of the artists, their official patrons, and their supporters in the press to even this extremely circumscribed public discussion. Why did La Font's safe and undisputed program become a threat when argued in public?

—iv—

Whatever their complaints, artists today live on critical attention—and can die professionally from the lack of it. But it is really no surprise that in 1747 artists should have resented a public criticism that promised them no material advantage and seemed indeed to threaten the opposite. What they saw was propaganda coming from an influential quarter which singled out for disapproval all of the most lucrative forms of painting. Paris in the 1740s was in the midst of a building boom, one largely fuelled by the construction of luxurious *hôtels* for the court and financial elite. Since the decline and death of Louis XIV, the life of that elite had made its way back from Versailles to the city. The owners of these new town mansions required quantities of small-scale decorative pictures, tapestry designs, and family portraits. This was the period when Parisian aristocratic life had evolved into an intensely personal theater of social and erotic intrigue, one played out in interiors appropriately intimate in scale, luxuriant and ornate in their décor, and bright with reflective surfaces of mirror and gilt. The qualities that distinguish the Rococo style—its playful and erotic subject matter, yielding and pliant surface patterns, combined delicacy and exuberance of touch, texture, and color—represent both a projection of and euphemism for the forms of life it adorned.

The way was open for skilled producers of decorative Rococo painting to become quite wealthy: Boucher was earning 50,000 livres per year for his steady output of loves of the gods, amorous shepherds, and fantasy landscapes. (By comparison, an average comfortable *bourgeois*, living on revenues from bonds or real estate, earned 3,000–4,000 livres; the salary of a professor at the Sorbonne was about 1,900.) Latour asked and got 48,000 livres for a portrait of Mme. de Pompadour, the King's favorite and the leading patron of the period. Joseph Vernet's picturesque landscapes, harbor scenes, and stormy coasts were also much in demand; he earned close to a million livres over his career, and his pictures were generally spoken for before they left the studio.[31]

Had Vernet heeded his admirers among the unofficial critics and turned his talents to large-scale narrative painting, there would have been no more buyers lining up. For history painting in the grand manner, too large in size and ponderous in character for the intimate aristocratic interiors of the day, the state was the only support in sight. And state patronage was erratic at best and often absent altogether. The official program for the support of serious painters just did not amount to much in material terms. If an artist received a commission, it could be years before he was fully paid for his work.

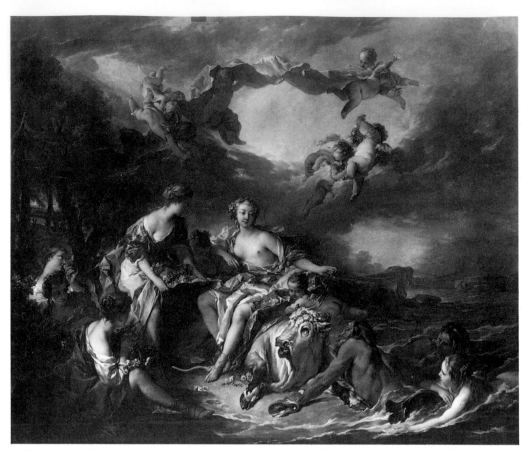

7. François Boucher, *The Rape of Europa*. 1747. Oil on canvas, 160.5 × 193.5 cm. Louvre, Paris

Even then, the price of a major painting, which required a large workshop and months of labor, was set at between four and six thousand livres.[32] For the sake of tradition and institutional prestige, history painting went on, but neither the state nor the established artists could have afforded a much greater devotion to the genre. Tournehem's first effort to re-establish the priority of history painting—eleven commissions to be displayed in the Galerie d'Apollon in the Louvre—was notably unconvincing. These had been passed among the top academicians, and the choice of subject, provided it was in the historical genre, had been left to each of the chosen artists. The results, when they were first displayed in public, succeeded only in drawing the first sustained attack on the Academy in harshly specific terms. An anonymous pamphlet of 1749 savaged the artists for their selection of tired and irrelevant themes and the implicit contempt thereby shown for the interests of the Salon public:

> The "Rape of Europa" [by Boucher (Plate 7)], isn't that a bit worn out? "Pyrrhus at the Court of Glaucius" [by Collin de Vermont] is a subject which is little known and even less interesting. And what a lovely gift to offer a king in need of a *tableau d'histoire*, this "Diogenes Drinking from his Hand after Breaking his Cup" [by Etienne Jeurat]. As far as their execution is concerned, it was of such a quality that they were all relegated to the storerooms. I say then that when the Academy has performed so poorly in terms of both content and form, there can be no doubt that it has collapsed.[33]

It was not until 1765, almost two decades later, that another major initiative in state support for classical painting was undertaken: four pictures depicting good deeds of the Roman emperors destined for the royal residence at Choisy. The public, by all accounts, greeted them with indifference, and the King refused them.[34] The program went back on the shelf for another decade.

So long, therefore, as the voice of the public was linked to an unappealing, indeed impossible, shift in the economic underpinnings of the art world, it was bound to be rejected by those inside that world. There was no confident, open-handed state agency to bring it off and thus no possible return to the days when Colbert had put the Academy at the centre of a flourishing official culture. The monarchy was retreating more and more into the pleasures of sport and domestic life, and the purposes of the Academy no longer coincided with the needs of its principal patron. On one side then were private patrons whose demands were familiar and remunerative; on the other was the mob in the Salon: shifting, heterogeneous, largely anonymous, unstable in its demands if it had any, and for the most part not in the market for pictures. The sheer spectacle of the thing was bound to make artists and authorities uneasy: jammed, noisy, sweaty, as much urban festival as occasion for considered aesthetic experience. They must have asked themselves what in the world they were to make of that crowd. What if, God forbid, artists' reputations should come to depend on what it thought—or on what its opinion was said to be? How could they know in advance what was appropriate, what would appeal?

For the established painters of the period, as we have seen, the question was not even worth answering. Faced with an opaque Salon audience and carping critics who claimed their unpalatable program was the demand of that audience, Cochin and Coypel declared that claim a lie. Yes, there was an enlightened public for painting, but it was not that crowd, which concealed rather than embodied it. The critics were no more than self-seeking literary upstarts, trying to make cheap reputations by causing sensation at the artist's expense. Public criticism, in fact, constituted for them an illegitimate annexation of painting to the alien practices of literary men. In Leblanc's words,

> The desire to make a name is the only motive behind such work; the public interest is no more than a pretext. They want to be read, and they choose this genre over another because they have seen these critiques succeed. The author's profession is most often a mere trade. . . . A man who arrives in Paris with neither means nor talent has only to advertise himself in a brochure as a man of taste and he will instantly be somebody; his words are taken to heart; the doors of the rich are open to him; he will pay his court to these haughty patrons, and in turn will see artists pay their court to him out of fear that he will damn their works; finally he will pass for a "connoisseur" according to those who take nonsense for the language of the arts. . . . This character, who is one of the absurdities of our time, would be an excellent subject for a comedy, but it would appeal only to those initiated into the mysteries of the arts.[35]

The critics were being read, that much is clear, and read in influential circles. Leblanc concedes their impact and personal success. And there were more pamphlets to be read than the handful that have survived. We hear continually in the anti-critical literature of a "horde of *libelles*" unleashed at the opening of every Salon—the term *libelle* referring to a brand of insulting and personal scandal sheet which was the staple product of an

irrepressible clandestine press.[36] La Font, by 1752, felt it necessary publicly to disassociate himself from a number of such indecorous and cutting critiques which were being laid at his door.[37] His opponents nevertheless held him responsible for opening the gates to the Salon *libelles* if not actually producing them.[38]

The note of panic evident in all these official reactions—critics could close the studios, ruin the arts—is real. It was precisely the dependence of artists on a private and increasingly privatized market that created fear of even an image of articulate public opinion. That market, though familiar, was not necessarily secure. Artists were beholden to a narrow clientele, obsessed with shifting, elusive nuances of style and motif. Successfully negotiating such a market was difficult enough; a further variable affecting an artist's value, that is, perceived Salon success as a separate quantity, was decidedly unwelcome. Beyond Paris, there were provincial and foreign markets closely attentive to shifts of taste in the French capital. The anonymous author of that sarcastic dismissal of Tournehem's Galerie d'Apollon commissions went on to explain the cancellation of the 1749 Salon in these terms.[39] He takes issue with the notion that the artists had withdrawn simply to avoid gratuitous and self-seeking criticism; they were afraid, he claims, that the unofficial pamphlets, when distributed in the provinces, would be taken to represent Parisian opinion. The critics, further, were creating a new kind of patron at home, so Cochin complained in 1757: alongside the genial followers of fashion had emerged a group of patrons who had taken the exacting jargon of Salon criticism for their own, a "swarm of would-be connoisseurs whose entire perception is limited to discovering faults in the most beautiful works."[40] More than the larger audience, it was this group which "afflicted the artists and put them off displaying their work in public."

When La Font asserted that a picture on exhibition was like a book in print or a play on the stage, it was probably the latter analogy that more alarmed the likes of Leblanc, Cochin, and Coypel. In this period, the success and failure of plays and playwrights were already being determined by a vocal audience of mixed class and station. The most important part of the audience at the *Comédie française*, as far as the fate of a production was concerned, was called the *parterre* after the open space in front of the stage where about half of the spectators stood during the performance. Admission to this section was reasonably inexpensive, and the majority of the standees made no secret of their opinions. Plays often began with some difficulty because of disorder in the *parterre* and then were commonly interrupted by its interventions; the repetition of popular lines might be demanded, and unpopular ones occasionally caused performances to be halted altogether. The success of a new play depended so much on the reaction of the *parterre* that authors as renowned as Voltaire felt it necessary to organize claques which would create the impression of loudly favorable responses to their work. Diderot led such claques on behalf of his friends.[41]

Almost all successful writers in the eighteenth century relied for their living on personal aristocratic patronage, and the *Comédie*, as a privileged corporation holding a monopoly on the production of serious plays, was free to make its own determinations. But the tumult of the *parterre*, its creation of a public verdict known immediately in every café, had a direct effect on attendance and a long-term effect on a writer's continued enjoyment of patronage and privilege. The efforts of Voltaire and Diderot surreptitiously to sway opinion speak not only of the audience's importance but also of its unpredictability. Political disputes and scandals brought in from outside the theater were often a factor in its responses, and these changed from week to week. Its social composition was hard to

read. Aristocrats abandoned the *petites loges* for the standing crowd; the author's friends, protectors, and rivals were to be found there as well, in the midst of the meanest scribblers from the Palace of Justice. The core of that crowd seems to have been drawn from the legal profession, the most socially mobile and socially ambiguous segment of the eighteenth-century bourgeoisie. In the heat of the performance, they became one body, or so it seemed: in the words of one sympathetic observer writing at the end of the century, they were "that illustrious *parterre* which reigned in so much glory for almost ninety years."[42]

This was a precise picture of the Academy's nightmare: a loud, demonstrative *parterre* transferred to the Salon, the critics leading the claques, the painters' clientele mixed in with it and swayed by its volatile responses. The popular critics made this fear explicit: advised one in 1773, "Distinguish well between the public that repeats and the public that sees. It is the latter that makes its judgements from the *parterre* and in the Salon; the former judges only by what it hears." The same author then offers a chilling—for the artist—example of how the verdict of fashion might be reversed in the public exhibition: "The charming Taraval [Hughes Taraval (1729–1795). He first exhibited in the Salon of 1765] who so comfortably enjoys his facile renown in the hall of some town mansion, having imprudently risked sending two sketches for ceilings to the Salon, was publicly brought to justice. God have mercy on the poor condemned man."[43] It was not the existence of the public audience in itself that promised a *parterre* in the Salon; for better or worse, the institutional purpose of the Academy was now bound up with the exhibition. But a public sphere of discussion, debate, and free exchange of opinion was something else again. No longer, it seemed, would non-initiates be awed at a distance by the splendor of a culture in which they had no share; a vocal portion of the Salon audience, egged on by self-interested critics, would actively be disputing existing hierarchical arrangements. And in the volatile social atmosphere of the exhibition, dissident opinion could spread like contagion to the artist's normal patrons. This was the threat that La Font and the rest represented to those in authority. An anonymous letter on the Salon of 1748 confirms what has been stated above concerning official anxiety of the stability of the markets. The imposition of an exhibition jury in that year is interpreted as a conscious effort to deprive the critics of material for discussion (vain hope) and so limit their impact on taste, while at the same time effecting a complementary internal discipline inside the Academy:

> The judges will admit only those that they deem worthy to be endorsed by the Academy, whose purpose is not to be informed by the judgement of the public—the Academy considers itself entirely informed already—but to receive the public's applause and praise and to stimulate it to take advantage of the talents so brilliantly in evidence. . . . First of all, the critics will have little to attack. Subsequently, the public will know those artists who can be confidently trusted with commissions, and finally, they [the academicians] will be able to cast off without fuss those stubborn spirits who disturb the deliberations of the company by taking an academy for a republic.[44]

This is of course a hostile account, but seen in any light, Tournehem and company were plainly working to limit the permitted space of public opinion to the narrowest possible confines, if not to suppress its existence altogether.

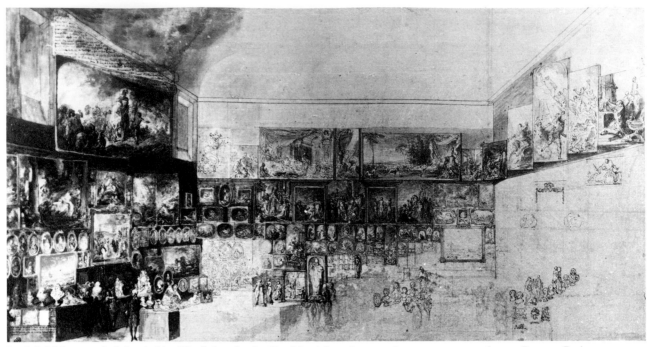

8. Gabriel-Jacques de Saint-Aubin, *The Salon of 1765*. Graphite, ink, and watercolor on paper, 24 × 46.7 cm. Louvre, Paris

—V—

That determination may now appear poignant or comic in its doomed refusal of the inevitable. But we need to entertain the possibility that Coypel, Cochin, Leblanc, Boucher, and their colleagues were right, that the Salon audience of eighteenth-century Paris was so fragmented, distracted, and incoherent that it did not deserve the title of "public". This is to say that it could present no useful demands or criteria to which an artist could respond. It certainly enjoyed no "natural" affinity with much of the work on display. Through the first several decades of Salons, there were almost no pictures produced primarily to be shown there; they were works of art meant for other places and other onlookers. There were pieces of Rococo confection looking naked in the cavernous space, rows of interchangeable portraits, and high above, the large history paintings, their life-size figures reduced by the distance to the scale of miniatures (Plate 8). Though ostensibly the most "public" in their purpose, these last were not only physically remote from the Salon visitor, but difficult to decipher once seen. A literate Parisian would have had a certain degree of familiarity with the motifs and narratives of classical literature, more than is usually recognized today, but academic artists tended to choose subjects few viewers would have understood adequately. Tournehem's Galerie d'Apollon commissions demonstrated this in 1747. Later in the century, a trend towards esoteric episodes from Homer drew much complaint from the popular critics.[45] The recondite character of this sort of literary subject matter, its meaning often carried in details and stylistic nuances nearly invisible from the gallery floor, plainly communicated the ambivalence of the Academy toward the business of public exhibition. There was an inevitable gap in comprehension which distinguished the secondary from the primary consumers of art.

The placement of pictures on the walls of the Salon was, of course, partly the result of practical necessity: the lower sections were packed with small pictures so they could be seen. The elevated placement of history painting in the Salon did not represent a willful withdrawal of access, but it did unavoidably express the contradictory character of the public exhibition under the Old Regime. What, after all, would ambitious painting be like if it were not learned and difficult, artificial and self-referential in style, aspiring to the sophistication of literary classicism and the audience that all this implied? It would have been difficult to find some available point of reference by which a care-worn merchant or apprentice clerk could genuinely participate in that culture. Everyday life, its physical imprint on the body, its costume, texture, and grit: include more than a hint of that and you have fatally compromised the desired nobility of the form. This is a period, we need to remind ourselves, when individuals and spheres of human life were rigorously distinguished and ranked on a scale of intrinsic value. The hierarchy of genres was, for the eighteenth century, a translation into cultural terms of the division of persons between *noblesse* and *roture*. Here, for example, is one eighteenth-century art critic defending that hierarchy and then moving on to maintain that even the physical constitutions of noble persons (the overriding figural concern of history painting) were different from those of the non-noble:

> The sublimity of a simple tale is not that of an epic. The good family father, the return of the nurse, the village bride, all make charming scenes. But should you transform these humble actors into Consuls or Roman matrons, or in place of the invalid grandfather suppose a dying Emperor, you will see that the malady of a hero and that of a man of the people are in no way the same, anymore than are their healthy constitutions. The majesty of a Caesar demands a character which should make itself felt in every form and movement of the body and soul.[46]

This is, to be sure, a distinction present in poetics since antiquity and in art theory since the Renaissance at least. It is telling, however, that the source of this passage is an anonymous pamphlet by a popular critic. This writer's position in cultural politics was one of liberal opposition to what he and others of his type regarded as the mendacity and sterile despotism of the academic hierarchy. Yet such critics found it difficult or impossible to imagine a democratic painting, that is, an art which did not make implicit distinctions among spectators in terms of social class. As it stood, history painting would speak through a repertoire of signs over which the typical Salon-goer would have little command.

The date of this text is 1773, and by this time popular criticism has re-emerged, following much the same line as La Font had done two decades before—though with more irony and seasoned bitterness—and still meeting the same kind of resistance. Its claims on behalf of the Salon audience put even more stress on the liberating and egalitarian implications of its assembly within the public exhibition. And at the same time, the difficulty in reconciling theory and practice became correspondingly sharper. In 1777, for example, the reviewer in a dissenting newsheet called the *Mémoires secrets* pronounced himself unable to follow normal critical custom and treat the pictures in the order of their relative public success: the Salon, he states, had become a hollow, self-justifying spectacle, and the interest of its audience went no further than a routinized and conformist enthusiasm for its habitual entertainments:

The Salon, sir, attracts this year the same swelling crowd as is customary; but this is less for the sake of the masterpieces on display than as a result of routine inertia, and that excitement which the crowd senses in its own movements. The moment one enters the gallery, one finds cold and distracted spectators regarding one another rather than the works that enrich the Salon and that produce no sensation in their collective soul. It is rare when, out of this multitude of pictures, it is not one of the least that lifts the boredom of a frivolous people, fond only of novelty, whose restless curiosity has well earned the epithets *burlesque* and *badaud*.[47]

In that last sentence, this observer evokes the marginal diversions of street fairs and the haphazard "events" that punctuate any large gathering ("badaud" signifies the idle gawker, unemployed, wandering the streets hungry for any distraction, uselessly underfoot when it occurs.) The milieu is irredeemably common, and it is a vain hope that art might elevate the crowd to some adequately concentrated and ennobled state of mind.

—vi—

This split allegiance to hierarchical culture and democratic reception appears dramatically in the most prominent body of radical criticism produced in the decade before the Revolution: a series of anonymous pamphlets written, according to contemporary testimony, by Louis de Carmontelle, comic playwright, high-society portraitist, engineer, landscape architect, fabled wit, and protected intimate of the court of the ducs d'Orléans.[48] The first of these tracts on the Salon appeared in 1779, the last in 1789, and together they provide the most sustained attention to the role of art in society to be found in eighteenth-century criticism (as well as some of its best literary moments). In the 1785 critique, the description of the audience presents a picture of group opinion formation right out of classic democratic theory: the exhibition, he states, is

> a vast theater where neither rank, favor, nor wealth can reserve a place for bad taste. . . . Paris comes alive, all classes of citizens come to pack the Salon. The public, natural judge of the fine arts, already renders its verdict on the merits of pictures which two years of labor have brought forth. Its opinions, at first unsteady and tentative, quickly gain stability. The experience of some, the enlightenment of others, the extreme *sensibilité* of one segment, and above all the good faith of the majority, arrive finally to produced a judgement all the more equitable in that the greatest liberty has presided there.[49]

Like all liberal theories of democratic pluralism, this picture is meant to recognize the inevitably fractured and conflicted character of its object, but at the same time to transform that very heterogeneity into the means by which ultimate coherence and harmony are achieved. Indeed, well before this liberalism could be tried out in the larger arena of political life, the exhibition space provided a kind of temporary model in microcosm, one which fascinated opponents of absolutism (the pre-Revolutionary Marat for one[50]). It was even possible for a writer like Carmontelle to imagine that a public unified in its engagement with art might be the foundation of a new, liberal social order; as he declared in 1779 in his very first Salon critique:

> Let us preserve ourselves from the belief that servitude is the natural condition of man; let us be fully persuaded that he must freely exercise all his faculties. Between

the treacherous sociability of civilized men, who are slaves, and the fierce hostility of the savage who fears to become so, I conceive a sentiment worthy of unifying the human species; this is the passionate love for the fine arts.[51]

Carmontelle's actual experience in the Salon, however, made it impossible to maintain this aesthetic utopianism without wavering. We discover this in one of the rare instances—rare for Carmontelle and for any eighteenth-century writer—when the audience is described in some detail. From the following passage, it is difficult to imagine much if any commonality of expectation and purpose, any collective accord:

> The Salon opens and the crowd presses through the entrance; how its diversity and turbulence disturbs the spectator! This person here, moved by vanity, wants only to be the first to give his opinion; that one there, moved by boredom, searches only for a new spectacle. Here is one who treats pictures as simple items of commerce and concerns himself only to estimate the prices they will fetch; another hopes only that they will provide material for his idle chat. The *amateur* examines them with a passionate but troubled eye; the painter's eye is penetrating but jealous; the vulgarian's is comical but stupid. The inferior class of people, accustomed to adjusting its tastes to those of its masters, waits to hear a titled person before rendering its opinion. And wherever one looks, countless young clerks, merchants, and shop assistants in whom unchanging, tedious daily labor has inevitably extinguished all feeling for beauty: here nevertheless are the men whom every artist has endeavoured to please.[52]

Reading this account, we are reminded of Coypel's imperious dismissal of the public some four decades earlier. Carmontelle has no use whatever (as we shall see presently) for painters like Coypel, as Coypel has none for unofficial critics. But their perceptions are fundamentally in agreement. There is closer observation from Carmontelle: the intrusion of calculating dealers, the manifest lack of connection between the works on offer and the "unchanging, tedious daily labor" which formed the sensibility of the majority of the spectators, the passivity and finally the boredom of the artisan-class members of the audience, the imperious if ignorant assurance of the rich and titled. But both painter and critic see in the Salon a raw, unassimilated, hopelessly heterogeneous congregation of classes and interests. Artists, both agree, look in vain for useful direction or guidance from the crowd.

Nowhere in the extensive eighteenth-century literature on the Salon do we find this gap bridged; the disparity between a public evoked in abstract terms and an actual audience whose behavior can only be characterized as a collection of vagrant individual responses. Carmontelle believes—believes with passion and anger—in the new public role for art, yet is unable actually to describe it in operation. His long, pejorative description of the Salon scene, with its mean streak of snobbery, is an exceptional moment of failure in his effort to reiterate an image of purposeful and coherent public opinion. As noted above, it is exceptional not only in the writing of this critic, but in the contemporary literature as a whole. For the most part, the concrete character of the crowd is never attended to at all.

One of the few additional accounts we have is, however, particularly interesting in this regard, in that it reproduces the split perception of Carmontelle, but does so within a single narrative sequence and without apparent sense of contradiction. It comes from

that encyclopedic portrait of Paris in the later eighteenth century, Louis-Sébastien Mercier's *Tableau de Paris*.[53] Mercier first describes the Salon as the very image of incoherence, conjuring up a mob of low-lifers confronting the classics with only the common coin of superstition and popular culture in hand:

> The sacred, the profane, the pathetic, the grotesque; the pictures offer every subject of history and myth all in a jumble; the sight is confusion itself, and the spectators form no less motley a crowd than the objects they contemplate. A typical idler takes the characters of myth to be heavenly saints, Typhoeus to be Gargantua, Charon to be St. Peter, a satyr to be a demon, and Noah's Ark to be the Auxerre coach.

Then, without a pause, he seems to shift his ground completely:

> All the same, this populace, which has no sophisticated understanding of painting, moves unerringly and by instinct to the most striking pictures, the most true. That is to say, it is the judge of the truth of natural appearances, and all pictures, in the final analysis, are made to be judged by the eyes of the people.

In assessing Mercier, we need to allow for irony and humorous exaggeration; the *Tableau* is a work of satire as much as one of observation. But certainly his stated populism here is genuine. Frustrated in his own more elevated literary ambitions, Mercier was no friend of established cultural hierarchies. This is evident further down in the text when he makes it plain that it is history painting, not the domestic and landscape genres, which has been displaced from the top rung of the social ladder; when he speaks of the public's instinctive attraction to the truth of nature, he does not mean a truth to be found within the comfortable range of its everyday experience. No longer guided by "monkish fanaticism" or base adulation, the noblest genre has become common property: "Painting in the last century," he states, "seemed to belong only to the church and to kings; it toiled only for temples and palaces: for this reason, the history painters waxed proud and wanted to hold the first rank. And they retain that rank so long as they join noble and engaging subjects to fine execution. . . ." Thus, while he does not in the end contest the preeminence of history painting, he does dispute its previous legitimation and proposes a new rationale: its status is now contingent on the maintenance of certain standards which are essentially public in nature, that is, on a collective ratification of its claims which could be withdrawn.

Mercier's is a casual and wandering text, but perhaps for that reason puts together recognitions that others do not, ones that we have found scattered and isolated through the documents discussed above. We might list them in the following way:

1. His perspective on the Salon is historical and political. Painting of the first rank once served the needs of domination; the eighteenth century had witnessed an irrevocable shift in priority: ". . . all pictures, in the final analysis, are made to be judged by the eyes of the people."

2. The history painters were not, even in the 1780s, entirely reconciled to this change. They saw their rank as fixed for all time, assured by art's necessary orders. But Mercier situates that rank (accurately) in the seventeenth-century alliance between art and power. To the extent that the arrangements of power were disputable, as they were proving to be, the standing of history painting was disputable. Because the artists had come to choose more suitable subjects "belonging to morality . . . and patriotism," the public still conceded it first place, but retained the right not to do so.

3. The public puts the Salon in its own order, makes its just determinations, with little or no help from above. The physical arrangement of the exhibition, as well as the distribution of types and subjects of paintings, were "pêle-mêle arrangés," and presented little coherent order to the spectator (this despite the very deliberate order by genre and academic rank which actually went into the hanging). Sophistication in the existing rules and practices of art is in itself suspect and, in any event, irrelevant to perceiving the truth or falsehood of the work of art.

4. Consistent with this stance, Mercier represents the Salon as fundamentally a "popular" event, in several senses of the word. First, it is attractive and interesting to large numbers of people; it provides a sense of occasion and public focus like no other cultural venue: "Neither literature nor music obtains so great a number of enthusiasts," he states at the outset; "the crowds flock there; the waves of people do not subside from morning until night during six whole weeks; there are times when one is choked." Second, the Salon provides an occasion for the manifestation of a popular identity and assertiveness opposed to the elite and propertied. This is implicit, I think, in the passages quoted above, and it surfaces explicitly in Mercier's denunciation of the large numbers of portraits on display:

> What is wearying and at times revolting is to find a crowd of busts and painted
> portraits of nameless people, and more often those engaged in anti-popular pursuits.
> What are we to make of these financiers, these middle-men, these unknown
> countesses, these indolent marquises . . . as long as the brush sells itself to idle
> opulence, to mincing *coquetterie*, to snobbish fatuousness, the portrait should remain
> in the boudoir; but it should never affront the vision of the public in the place where
> the nation hastens to visit!

This was a venerable critical complaint, but Mercier revives it with an extra polemical edge. There is again the implication that the Salon, as officially organized, was at variance with its proper function, that it inappropriately mixed privatized and oppressive modes of art with genuinely public ones. The Academy was in league with the powerful in unacceptable ways, and popular consciousness was the corrective to that tendency. Third, and this must be advanced far more speculatively, the crowd draws on a reservoir of "popular" materials distinct from the elite culture on display—Gargantua, demons, Christian legend. Again, Mercier may be reaching for humorous contrast, but the reference is made with some specificity and even affection. Might these Salon visitors be able to deflate the pretensions of patrons and painters because they have an alternative culture at their disposal? And shall we therefore, as we attempt to describe the beginnings of the artistic public sphere, have to take that other, abiding level of culture into account?

This last point is at best no more than a hint, and we should not want to build a case on any of the elements of Mercier's account. Certainly, as much as any of the others we have considered, it evades any direct, dispassionate description of the audience and the specifics of its engagement with high art; as much as ever, invisibility and exclusion from language characterize contemporary apprehension of our subject. Having assembled representative examples of most of the surviving commentaries on the Salon audience, we find ourselves at the apparent limits of empirical documentation and still frustratingly far from a satisfactory picture of the Salon public, its internal dynamics, and its impact on eighteenth-century painting. If that picture fails to cohere, however, it remains an open question whether more evidence of the same kind, should it exist, would make

a difference. The language, the assumptions, the tools of perception at work in these documents make them as much an obstacle as a means to historical knowledge. So first of all we shall need an account of these very mediating factors, a history which includes language, ideas, and governing institutions. The story of painting's public space properly begins at that point where the dependence of the artist on the dictates of any individual or circumscribed elite begins to be contested. There need be nothing overtly levelling or democratic in that challenge; it need not seek to dispossess the traditional patron nor take issue with his appropriation of the finest works of art. It is sufficient merely that a third party join the transaction, some disinterested community with a degree of stability and staying power whose authority can be invoked by either the buyer or seller of a painterly service. This represents something different from the prince's humanist advisers or the artist's self-protective guild. It signifies the arrival of a collectivity possessing both a legislative and judicial function, the ultimate repository of a body of rules governing artistic seriousness, decorum, and moral value, whose continual vigilance is required for their maintenance.

The eighteenth-century dispute documented in this chapter was over whether the actual audience in the Salon could be said to represent this community. But from the inception of their corporation in 1648, the French academicians never disputed that such a public existed and exercised these functions with perfect legitimacy. Indeed, in the very founding of the company, they had staked their legitimacy on just this contention. Resistance to the idea came from those artists who wanted no academy and no direct dependence on the Crown. Any claim on art made for or by the Salon public had its origins in those months of political turmoil which preceded the Day of the Barricades in 1648 and the onset of the Fronde, the final, violent rebellion of the old nobility against the new absolutist order. The Academy's original charter, drawn in February of that year, did not proceed from the direct will of the absolute monarch—the King was only ten years old and Mazarin, for all his love of fine objects, had a thousand more pressing concerns. As the eventual iron absolutism of Louis XIV was a direct response to the atavism and late-feudal willfulness of the aristocratic *frondeurs*, so the new artistic order emerged as a defensive response to an aggressive resurgence of the old, the campaign by the medieval guild to reestablish its bygone monopolistic control. Weak and harassed, the newly-created academicians had continually to invoke a new kind of authority, and it is there that the story of the modern public has to begin.

I

A Public Space in the Making

-i-

THE most obvious point of reference for an understanding of the young Academy of Painting would be to look at its literary and linguistic counterpart, Richelieu's forty immortals in the *Académie française*. But the comparison would in many ways be a misleading one. The latter body drew its mandate to refine and preserve the national language from the ancient connection, lodged in the discipline of classical rhetoric, between verbal skill and the exercise of power. Oratorical and literary competence was traditionally part of the expected equipment of the influential man, vital instruments of persuasion and inseparable from literacy itself. The ambitions of a new academy devoted to the visual arts enjoyed no such secure footing in the social hierarchy. Even after its split from the old Parisian guild, the Academy was still fundamentally an association of craft specialists whose skills were inaccessible to outsiders and by definition alien to "noble" pursuits.

For the guild artists, such a state of affairs was entirely expected and congenial. Its authority was founded on a common identity between its practices and those of other urban craftsmen. And that identity was still being enforced in the middle of the seventeenth century. It was in fact a renewed insistence by the *Maîtrise* on its ancient boundaries and prerogatives that provoked the counter-effort to identify art with the high-minded and disinterested liberal arts. The background of what we might call the artists' Fronde of 1648 was this. Shortly after the formation of the *Maîtrise* in 1391, provision had been made for artists working directly under royal command to work unencumbered by guild dues, restrictions, and supervision. Charles VI, in 1399, was the first king to grant his artists the *lettres de brevet* that served as their legal defense against the jealous guildsmen. The practice was renewed by each succeeding Valois monarch, and the other princely families subsequently acquired the right to create their own *brevetaires*. The number of artists operating free of the guild increased rapidly when Henri IV undertook the concerted architectural embellishment of Paris as one expression of his reestablishment of monarchial power. Along with their exceptional legal status, these artists had the lucrative advantage of free studios and lodging in the Louvre and other royal buildings. Under Richelieu and Mazarin, the corps of *brevetaires* continued to grow, despite the understandably unremitting opposition of the *Maîtrise*. (The irritant was compounded by the presence of a large colony of resident Flemish artists whose members worked under the independent protection of the abbey of St. Germain.)[1]

By mid-century, the supply of official commissions to artists outside the charmed circle of *brevetaires* was being seriously threatened. At the same time, in the years since Richelieu's death, political resistance to the monarchy on a broad front had brought the

French state to a point of crisis. The costs of concluding the Thirty Years' War had been ruinous. The resultingly drastic and coercive policies of royal taxation (which served, in the eyes of nobles and commoners alike, only to fatten the *traitants*, an endemically corrupt corps of tax farmers and financial middlemen) had provoked open revolt in the countryside. The insurrectionary atmosphere emboldened those aristocratic groups which had been marginalized during Richelieu's consolidation of royal hegemony—that is, the great feudal families and the ennobled officers of Parlements—to reassert old claims to shared power with the crown. The Paris Parlement, which held itself to be the supreme court of appeal in the state, took the lead in that offensive. By virtue of its authority to register royal decrees and thus make them into law, its members regarded themselves as the permanent representatives of the nation as constituted in the Estates General and therefore the ultimate check on royal power. Mazarin and the Regent, Anne of Austria, made the mistake of trying blackmail to coerce the registration of a whole package of offensive new tax measures, threatening to interfere with the *paulette*, that system which guaranteed the inheritability of the judges' venal offices and titles. The new decrees were forced on the Parlement on 15 January, 1648 in the requisite pompous ceremony, the *lit de justice*, presided over by the boy Louis XIV. But that naked imposition of royal will only provoked the *parlementaires* to more determined resistance, and, by the following August, to open rebellion, the Day of the Barricades, and the onset of four years of civil war.[2]

The growing intransigence of the Parlement and the isolation of the Regent presented the *Maîtrise*, backed by the former, with what seemed the opportunity for a bold stroke. Already in 1646 it had successfully won a judicial order eliminating all but a handful of *brevetaires* and severely restricting the activities of those that would remain. The guildsmen would hold a monopoly over all church and private commissions, as well as every aspect of the art trade. This potentially devastating attack on the independent artistic community was the first stimulus to leadership of a young *brevetaire* to the Queen, Charles Le Brun. His counterattack on behalf of his fellow privileged artists found a fortunate ally on the royal council itself, one Martin de Charmois. The latter, after serving in the French diplomatic delegation in Rome, had brought back an *amateur*'s enthusiasm for art in the great tradition, an interest that was still rare among the Parisian elite. He shared with Le Brun a fascination with the collective and public nature of artistic training in Rome, as it was overseen by the Academy of St. Luke. In an audacious reply to the legal offensive mounted by the *Maîtrise*, Le Brun's small inner circle, with the backing of Charmois, drew up a set of statutes which would establish an equivalent body for Paris, a whole new corporation to break the monopoly of the guild.

Charmois brought the proposal to the Council of State just five days after the inflammatory *lit de justice* of 15 January. It was a chance, however marginal, to slap down the pretensions of the Parlement, and Anne ordered instant approval of the new academy exactly as proposed. Her anger was such that she wanted to abolish the guild in the bargain. A more moderate policy of coexistence prevailed, however, and the *Maîtrise* was simply forbidden to interfere in the activities of its new rival. Le Brun's faction was organized enough to hold its inaugural public session as the Royal Academy of Painting and Sculpture only ten days later. It was, in the words of the Academy's contemporary chronicler (probably founding member Henri Testelin), "an extraordinary gathering of persons of various classes . . .: there were amateurs of the fine arts, and among the latter many of distinguished rank; there were the painters and sculptors of the highest order

. . . ; there were the *brevetaires* of the King . . . and finally the young students."[3] Its letters patent were issued and published by the middle of March.

So at a stroke, a still-medieval organization of artistic practice, craft-oriented and mercantile, was officially subordinated to one in which the most conspicuous features and concerns of guild life were not only absent but specifically forbidden. Academicians could not by law keep a shop or even allow works to be visible in the windows of their studios. Also banished was the whole dimension of organized pleasure in the artistic community, the banquets and rituals which made the *Maîtrise*, like the guilds of other trades, a festive and religious confraternity as well as the overseer of a craft. In their place, the Academy offered a regime of gentlemanly deportment, "love of art, learning, dutifulness, and cordiality."[4] Where the guild devoted the bulk of its collective funds to its unseemly and vulgar pleasures (or so they seemed to the high-minded *brevetaires*), the Academy would substitute the shared study of the living model. The establishment of a regular school of figure drawing, something too expensive for any one master to maintain, was and remained the Academy's principal reason for being. The past superiority of Italian painting was ascribed to greater opportunity there for drawing from life, and that sentiment was seemingly shared by the apprentice artists of Paris; during its first months of existence, the influx of students forced the Academy into progressively larger quarters. The transmission of artistic skill—and of the great tradition itself—would now be the collective work of the twelve *anciens*, as the founding officers were called, supervising together and in public the training of young artists. The predilections of any one teacher would thus be continually tested and balanced by the presence of others. Rules would be laid down in a setting perpetually open to outside scrutiny. Further, instead of artists working under direct obligation to a royal or princely protector, there was now an intermediate body sponsored by the state and charged with maintaining a set of standards which superseded any desire on the part of the patron to dictate every aspect of the work.

All of the subsequent expansion of the public sphere under the Old Regime rests on this moment of ideological substitution—and so did the Academy's survival. For if the new company was to prevail over its resilient guild rivals in the long run, it had to make good its claim to be the superior body, and do so by demonstrating that in its hands painting and sculpture had come to rest among the liberal arts. Those aspirations could never be ratified through any individual agreement between artist and patron, even if the latter were a Mazarin, a Séguier, or the King himself. Application to the visual arts of what were originally literary values of erudition and decorum would remain contingent and *ad hoc* unless consented to in a public forum, some permanent community of shared values and common discourse.

The issue was crucial in that the Academy had little else to offer at this point to distinguish itself from the *Maîtrise*. Its membership was by no means limited to high-minded specialists in historical subjects; the Le Nain brothers, for example, figured among the original recruits; established practitioners of the elevated genres, notably Vouet and Mignard, remained outside and antagonistic. And its self-image as the unique guardian of disinterested propriety and correctness of practice was all that sustained the beleaguered group when its royal support evaporated. This took place as quickly as the Queen-Regent's original endorsement had been secured. By the end of the Academy's first year of existence, Anne, Mazarin, and the young King had been forced to flee their capital; the Parlement was forming a wartime government and raising an army to defend itself

against the forces of the monarchy. The position of the Academy resembled that of their exiled protectors, and the *Maîtrise* found itself in an almost impregnable position of political dominance. It could call on its old allies in the Parlement, hostile to any creature of arbitrary royal power, to delay endlessly the registration of the Academy's founding statutes, while the academicians had no funds to pursue a defense. The stipend they had expected from Mazarin had never actually appeared and by this point was only a dream. The continuation of public exercises now depended on sporadic contributions from the pockets of the members themselves. Increased fees only drove the once-eager students away, as did the less and less frequent appearance of the *brevetaires*, for whom the Fronde had produced a disastrous interruption of commissions and a consequent need to look to their own affairs.

The power of the Academy's example was, however, endorsed in a backhanded way by its enemy. Having seen the enthusiastic response to the public program of instruction in drawing, the *Maîtrise* attempted to take advantage of the situation by founding its own "Academy of St. Luke." As a conspicuous demonstration of its superior material resources, there were no student fees, and a series of elaborate prizes, including a "Sword of Honor" was instituted. To provide essential credibility at the top, the aged Vouet was recruited to direct the school. He seems to have had little success as a teacher, limiting his instruction to garrulous and repetitive monologues, and tired of the whole business after little more than a week. With Vouet gone, the other guildsmen were in over their heads; the students regarded the free tuition and glittering prizes as poor compensation for incompetent teaching, and Le Brun's Academy, with the return of its chastened aspirants, was again growing by the end of 1650.

Despite the failure of its counterfeit academy, the *Maîtrise* still had the backing of the Parlement, and the majority of academicians saw no hope in continued resistance. It would in fact be years before the royal family could again enter the city, and at this point accommodation with the guild seemed to these artists the only way out of their legal and financial difficulties. Consequently, in 1651, the two bodies agreed to merge, the guild perceiving that it would thereby gain for itself the privileges granted the Academy in 1648, while dominating the union through superior numbers, funds, and political allies. (Le Brun violently opposed this course, and made the first of his several strategic withdrawals to fight another day.) But it was during this lowest ebb of academic fortunes that one of the definitive features of the institution was adumbrated: the *conférences*, regular lectures by senior academicians on various theoretical aspects of painting, with discussion open to interested lay spectators as well as to artists. Learned instruction in art history and critical doctrine had of course been a feature of earlier academies in Italy, but in this instance, such talks had a more immediately pragmatic purpose: that of discouraging the more hostile and obstructionist guildsmen—generally illiterate and inarticulate men—from attending the meetings. It was a kind of combat through tedium, and it may have had a degree of success. In a way parallel to that of the origins of the Academy as an institution, this signature feature of academic life began as a defensive maneuver against the stubborn power of late-medieval practices. There is no evidence that the *conférences* were intended at the start to regulate the aesthetic choices of member artists. But eventually they would become central to the crucial task of building a public community of discourse, giving it a regular social setting, a mode of speech, and a developing body of law.

In 1654, with the *frondeurs* defeated and Mazarin back in control, Le Brun prepared

a secret and decisive return to leadership. With the aid of the chancellor Séguier, he won a definitive order from the Cardinal returning the combined body of artists to the Academy's statutes of 1648, and those statutes alone. Thus all but the twelve *anciens* were stripped of power. The *coup d'état* was announced to an astonished assembly on 3 July, 1655, a date which marks the beginning of the end of guild influence in the sphere of high art. At the same time and by the same order, the reborn Academy was accorded the same privileges as the *Académie française*, as well as an annual pension, free lodging for its members, and the exclusive right to pose the model. The original titles for officers were revised and took their permanent form: the *chef* was now the *directeur*, the *anciens* became *professeurs*, and the rotating election of four *recteurs* to oversee the school was established.

This coincidence between the return of absolutism and the achievement of institutional stability for the Academy can, however, make the latter appear too much a creature of the former. Only in the most qualified sense can the practices of the Academy at this stage be considered an emanation of the throne; nor can Anne's and Mazarin's original endorsement of the concept be read as official sponsorship for a coherent artistic program. It was a short-term political decision, an unpremeditated defense of one among many threatened royal interests. The *conférences* were one response of the desperate early academicians to the evaporation of state support, when they had only their wits to keep them afloat in a sea of artist-*frondeurs*. Even in 1655, the coup against the *Maîtrise* was the result of some ingenious maneuvering by a small faction around Le Brun and Séguier to win the approval of the distracted Mazarin. There had certainly been no independent demand from on high for the reform of art. Even the financial commitment was strictly limited: 1,000 livres per year and a few dilapidated royal buildings. The period from 1651 to 1654 was one of continuing rural insurrections, economic depression, food shortages, and military emergencies only one step away from the conditions of the Fronde itself. There was no money or time for a still-precarious monarchy to set about organizing visual culture in its image.

Yet it was in this period, not in the palmy years after 1663, that the public rationale for the conduct of painting was established. The public implied in the "public exercises" with which the Academy inaugurated its existence in 1648 was doubtless one, following normal seventeenth-century usage, limited to cultivated and largely well-born cultural sophisticates. But as we have seen in the introductory chapter, the boundaries of the significant public could be pushed back by determined advocates of previously excluded groups. The concept is inherently inclusive rather than exclusive; every subsequent collective claim on art rests on the legitimacy of disinterested outside intervention fashioned and clung to by the fledgling Academy in these first years. The public sphere is precipitated into a vacuum between two existing forms of institutional power: the medieval corporatism of the guild and the ascendant absolutism of Richelieu and Mazarin. The vacuum was there because both sides were fighting from weakened, defensive positions, the guild's as well as the crown's. The temporary convergence in the Fronde of popular revolt, the atavistic sedition of the princely families, and the constitutionalist aims of the Parlement was riven with contradictions and productive in the end only of chaos, dearth, and suffering. The "tragedy" of the Fronde was that its successes produced, as a reaction, a degree of absolutism unthought-of in 1648, permanent marginalization of the high nobility, and a half-century of utter subjugation of the sovereign courts. And the weaknesses which debilitated the monarchy in the first place—addiction to ruinous

military expansionism, aversion to existing constitutional mechanisms for securing consent to its policies—would reappear well before the death of Louis XIV, revive the resistance of the *parlementaires*, and make the eighteenth century one long financial and political crisis for the French state. Had the monarchy not been in such desperate shape during Anne's regency, the *ad hoc* system of *brevets* and dispersed client status for the most gifted artists would no doubt have continued, and the subsequent course of art in all of Europe would have been very different. But a third quantity had irrevocably been introduced between longstanding, craft-orientated practices of visual representation on the one hand and the symbolic requirements of the state and its governing elites on the other: something as yet inarticulate and inchoate, but even then designated by the word public.

−ii−

On the death of Mazarin in 1661, it was Le Brun's shrewd gamble on Colbert's ascendance that at last put the Academy on permanent solid footing. That alliance won him the final and crucial prize—monopoly. Only after this point were all *brevetaires* required to join. Le Brun was named to the newly created office of First Painter to the King (*Premier peintre*) and got a noble title along with it. Behind this statutory and titular supremacy was material responsibility for an ambitious program of royal manufactures in the arts, as well as the decorative requirements of the King's mammoth building program. The annual pension from the state was quadrupled. Colbert accepted appointment as the Academy's "Vice-Protector" (formally subordinate to its venerable official ally, Séguier) and became its effective supervisor. He took the still-fragile institution and made it a central instrument in his planned consolidation of state control over high culture.

From this point forward, the official status of Le Brun's ideal was never in doubt. Not only was all state patronage of consequence to be routed through the Academy, Colbert acted to ensure its efficient production of legitimating discourse. He appointed the first of the renowned *amateurs honoraires*, André Félibien, as a lay member of the company with the duty of setting down in precise terms the theoretical results of the *conférences*. (Two officials from Colbert's building administration, Gédéon Barbier du Metz and Charles Perrault, were accorded the same title and oversaw commissions and expenditures.) Beginning in 1666, Colbert and the lay members he had installed were especially concerned that the formal monthly *conférences* remain at the center of the company's responsibilities, that there be full and free participation by interested *amateurs*, and that no time limitations be imposed on discussion. The establishment of the *grand prix* for students in 1661 and the custom of sending the winners to Rome for extended study was consistent with the aim of these sessions. This ensured that the future academic leadership would be formed within an international artistic community conversant with theory and removed from the parochial pressures of the home market. In ideological terms, Rome stood for a unified and universal body of tradition by which French art would continually check its bearings.

At every point in our account, however, we need to be wary of substituting bureaucratic intentions for actual outcomes, and the official imposition of an ideological position cannot instantly create a genuine community imbued with those principles. Though almost all of the important Parisian artists had been gathered under the Academy's direction (only a few renegades like Mignard had opted for the *Maîtrise*), the ideal of a codified, intellectu-

ally articulate, and publicly scrutinized collective practice remained no less a minority position. To begin with, there was virtually no tradition of elevated artistic discourse on which to build. Evidence exists for only the most marginal discussion of painting in Paris before 1648.[5] Prior to that time, the mere fact that its exercise required manual work was enough to exclude it from serious intellectual consideration. The efforts of earlier Italian theorists to prove otherwise had made little impression in France. Fréart de Chambray's *Idea of the Perfection of Painting*, probably the first published French work devoted to pictorial aesthetics, did not appear until 1662, and the legal distinction between academicians and ordinary artisans like furniture makers and goldsmiths—a crucial matter in a corporate society—was established in court only in 1668, two decades after the Academy's incorporation.[6]

What we know of the larger lay audience for the visual arts indicates a similar lack of development. For a start, the example of the state was far from encouraging: the royal collection had not been much augmented since the time of François I in the early sixteenth century; the aims of princely patronage had since been conceived largely in terms of treasure and display. As in the private collections of the time, interest in painting and sculpture was rarely differentiated from the acquisition of other rare or precious objects. Gaston d'Orléans, brother of Louis XIII, did share with their mother, Marie de Médicis, a taste for Italianate splendor in the visual arts. He collected old masters from an early age, but his zeal in amassing, for example, exotic botanical specimens was an inseparable part of the same impulse.[7] The integration of works of art into a micro-cosmic, material encyclopedia of the universe, the *Kunstkammer*, had been a norm in northern Europe at least since the days of the first Habsburg imperial collections.[8] This remained the pattern in France where paintings, when valued as more than simple items of wealth, were regarded as another kind of *curiosité*—the English cognate captures the essence of the term—stand-ins for experience and people distant in place or time. A prominent collector of the period, the physician and *érudit* Pierre Borel compiled a list of his treasures in a published work of 1649.[9] This is the order of object-categories as Borel catalogues them:

Human rarities (including the bones of a giant and a two-headed monster)
Four-legged beasts
Fish and creatures of the sea
Other marine objects
Insects and snakes
Plants, firstly stems and roots
Leaves
Flowers
Gums and saps
Seeds and grains
Rare fruits
Other fruits and seeds
Fossils
Other minerals
Antiquities
Artificial things

The next-to-last category is the first to include works of art: urns, vases, coins, medals,

as well as "450 rare miniatures after the greatest masters, such as Michelangelo, Raphael, Lucas, and Albert mounted in an extremely large album." The final category of "artificial" things included, alongside mirrors, porcelains, and lenses, fifty "portraits in oil from Rome, Flanders, and Paris." The activity of a *curieux* like Borel was most frequently designated by verbs meaning "to amass" or "to make a pile of."[10] The terms *amateur* and *connaisseur*, with their specific connotations of high-minded aesthetic discrimination, had not yet supplanted *curieux* even to designate those whose primary interest lay in the visual arts. The *curieux* themselves tended to be doctors and apothecaries, middle-level professional men, some in the capital, but a majority in provincial ports where there was a steady traffic in exotic materials. One scholar has recently estimated their numbers at no more than one or two hundred throughout the whole of France.[11]

In aristocratic interiors, concerns of taste prevailed over dusty erudition, but just as often at the expense of the autonomy of the work of art. Paintings and sculpture were invariably subordinated to an overall decorative plan, no more in the foreground of a visitor's attention than the mirrors, rugs, tapestries, moldings, furniture, clocks, and cabinets that made up the ensemble. There was little hesitation, for example, in cutting down pictures or, more commonly, enlarging them to fit the demands of the surrounding décor. Important collections of works of art for their own sake—those of Loménie de Brienne, the duc de Richelieu, Evrard Jabach (the last a German banker)—do not emerge in France until after the middle of the century. Mazarin's zealous activity as a collector was an expression less of any leading edge of taste in France than it was of his continued identification with and nostalgia for Italy. Poussin's small circle of French patrons was remarkable mainly for the marginality of their taste and position. By virtue of both, they perpetuated the outlook of the *nobles hommes* of the previous century, that is, traditional *officiers* and propertied men who had carefully distinguished their civic virtue and classical learning from (in their eyes) the ignorant and parasitical *gentilshommes* or *nobles de race*. Their descendants now found themselves largely bypassed and ignored in favor of the host of "new men" brought into state service by Richelieu and Mazarin.[12]

This was the unpromising environment in which the Academy's public meetings and *conférences* were introduced, and it was one they had to change. This new artistic experiment needed a constituency, one composed not so much of *curieux* as of *connaisseurs* and enlightened *amateurs*. Constituencies need a shared language, ceremonial occasions, a continuing elaboration of focal concerns, a sense of inclusion and exclusion. In a tentative way, the early Academy meant to provide this necessary social and discursive field. By the early 1660s, two documents at least indicate that it had made some headway, first in cultivating a group of *curieux* sensitive to its special claims, and second in the vital task of investing the idea of a public with normative meaning.

—iii—

The first takes the peculiar and negative form of a cutting satire by Samuel de Sorbière. This philosophical enemy of Descartes and partisan of Gassendi's epicurean skepticism had just achieved the most important official success of his life: a post as historiographer to the King and a pension of 2,000 livres per year. From that intellectual platform, he held the Academy's most central pretensions up to a barrage of ridicule:

> There is truly something of metaphysics and pedantry in this *curiosité*, in the way
> it is practiced in our country and the way it has taken us over along with all those

other fine habits we borrow from Italy. All this has led to a certain style of speaking which could easily fill a fat dictionary on its own. . . . Those who speak this jargon are judged the most knowledgeable, and their great aptitude consists in knowing how to identify the artist after glancing at a picture, then being able to pronounce on his manner of painting: if the artisan made vertical strokes or horizontal, how many pictures he painted, which are the most highly regarded, through whose hands they have passed, and so on and on. In all this I see nothing of more than mediocre intelligence, and I am not sure but that there is some degree of servility in this enthusiasm. Dare I say what I think of this debauchery and corrupt *curiosité?* One must somehow enjoy a swindle to apply one's mind to studying pictures. . . .[13]

Sorbière allows that painters and sculptors have produced objects worthy of admiration, but so, he says, have other craftsmen—puppet-masters and opticians, for example—and no one has so exaggerated the invention of these artisans, nor have any been singled out as "personages of importance in the land of the muses." To back up their presumptions, the academicians "have engaged or encouraged several *curieux* to write a number of volumes on the lives of their fellow artists, and you will never hear them speak of an Andrea Sacchi, of a Pietro da Cortona, of a Rubens, without piously removing their hats" So much for the new art-historical consciousness. And as for the vaunted ideal of the learned painter practicing a liberal art, he finds that this academic doctrine sounds no less fitting in the mouth of his barber, who declares that "his art is the most beautiful and difficult of all, that it demands knowledge of nearly all subjects and a fortunate birth, refined by long study, in order to cut hair properly."[14]

Sorbière was nowhere near the first rank of seventeenth-century *savants*, but he was known for his practiced pursuit of the patronage and favor of the powerful. He would have thus expected his satire of academic aspirations to receive a sympathetic hearing. In his eyes, the Academy's success in forming an intellectual aura around the visual arts was no more than a confidence trick, a racket hatched by collectors and artists to drive up the value of works of art. His text represents a stubborn refusal to see painting and sculpture in any but the old way: they are members of a larger class of diverting and refined objects, and nothing more. And if the academicians are no more than artisans, then they must be behaving like artisans. Thus he sees the growing influence of specialized connoisseurship and visual aesthetics as an unacceptable rationalization of a market through the artificial stimulation and management of demand. But the vehemence of the text is a sign of success for the new artistic consciousness, while at the same time revealing a strong residual resistance which the Academy would still have to break down.

Fréart de Chambray, writing two years later in his *Idea of the Perfection of Painting*, is likewise disturbed by the nature of the contemporary audience for art.[15] Like Sorbière, he sees false and calculating interests behind the growing cult of the *amateur*. But Chambray, a passionate advocate of the Poussiniste conception of erudite painting, sees the solution in the cultivation of an ever greater number of enthusiasts for art. And in his argument, we find the modern, essentially discursive notion of an art public more or less fully formed. In discussions of French art before 1747, the term *public* does not normally designate the community of Parisians or Frenchmen, but carries the more restricted sense of a habitual audience for some particular attraction or entertainment. This text, however, already proposes the most general definition of art's significant audience. Today, he observes, with some faint sense of wonderment, "not only men of letters and those of noble condition, whom we always presume to be the most reflective

of people, take an eager interest in painting; even the common man joins in to deliver his opinion and does it so well that painting seems to have become the *métier* of everyone." Far from disapproving of this "presumption," Chambray goes on to observe that such broadly shared interest is as old as art itself and that it was particularly evident among the Greeks. To illustrate his point, he takes us back to the antique origins of the self-effacing artist, hidden in the Salon crowd, that Mairobert evoked in his description of the exhibition quoted in the Introduction. Apelles himself, he states, citing Pliny, would place his recently finished pictures on the street, exposed to the scrutiny of any passer-by. Hiding behind one of the panels, he would wait to overhear the "censure" of his neighbors and so profit from their candid judgments: "from this," says Chambray, "comes the proverb: *Apelles post tabulam.*"

Unfortunately however, he goes on to say, the days of Apelles are long past, days when artists "were humble enough to submit their works to the criticism, not only of learned men and philosophers, but of the common people and artisans of all crafts, who sometimes would suggest quite judicious corrections to the works put before them." The absence of such interchange, he suggests, has condemned modern painting to its current condition of corruption and decadence. Instead of striving like the ancients for "glorious renown and the immortality of their names as their reward," French artists look only to "immediate utility"; their goals are ones which "they have uniquely determined for themselves. To this end, they have introduced, by means of their cabal, I don't know what kind of libertine painting, an art entirely detached from all the strictures which once made painting so admirable and so difficult."

That last sentence transforms the more usual, restrictive sense of the art public into the *opposite* term to its inclusive, normative sense. The true public may in fact never coincide with any of the actual audiences for painting. These may well be nothing but falsely representative "cabals," which allow selfish, egoistic interests to prevail over those of the community as a whole. The true public for Chambray is not so much an empirical construct, as it is one of law and discourse. It comes into existence via the application within a society of certain rules.

These rules can be divided into two categories. The first are those which guarantee open access to works of art and maximize freedom of discussion and judgement on their merits. The artist and his patrons must be prevented from setting themselves apart and determining unilaterally the character and purposes of art; the community as a whole must have its say. The second group of rules is quite different in nature, and seemingly in tension or even contradiction with the first: we know a true public exists when a certain set of fixed artistic principles are in force. These principles are those presumably laid down by the ancients, but known to us most immediately in the art of Raphael and Poussin. While maximum freedom of thought and expression must reign, the results are known beforehand, preordained in established aesthetic precedent.

Objections to this formula arising from our own post-romantic assumptions about art and artists would have made little impression on Chambray. They would for him represent that selfish and corrupting license which makes painting too changeable and disorganized to express the lasting values that sustain the true polity. The logic of Chambray's argument is that of absolutism itself, which consolidated its centralized authority by de-legitimizing the existing, dispersed centers of power within the state. The absence of representative institutions prevents any organized counter-claim to represent the interests of the nation as a whole. And so it was with the presumed connection

between academic doctrine and the public interest. Thus while there had been little or no programmatic alignment between the original Academy and its state sponsors, by the 1660s there had been an important convergence of interest between the Colbert administration and the more theoretically committed wing of the Parisian artistic community.

—iv—

In the following years, Colbert would find it necessary pointedly to intervene in the Academy's affairs in order to ensure its efficient production of theory. The background of the confrontation was a growing indifference on the part of the majority of artists to public discourse in general and to the participation of lay supporters. With their legal hegemony now beyond challenge, they found these occasions something of a burden and less than relevant to their immediate needs. Félibien's first volume of *conférences* had apparently stirred more interest among outside readers than the artists were prepared to deal with. As a result, the *amateur honoraire* was effectively prevented from publishing any more.[16] In 1669 Le Brun apparently tried letting the sessions lapse and received in response a stiff message from the minister: "Monsieur Colbert is finding it strange that the company is failing to continue its public discussions . . . if these exercises are abandoned, the Academy would risk being deprived of the presence of its most affectionate *amateurs*."[17] There being no doubt that the *amateurs* in question included Colbert's own surrogates, the Academy beat a quick retreat, protesting that it only wanted to reduce the frequency (then twice a year) at which its officers were obliged to deliver lectures. Informed that the minister "felt that the Academy should continue public discussions as usual," it relented, but did manage to impose new limits on actual lay participation in the sessions.

Colbert knew better than the artists that ambitious cultural policies, even in an absolutist state, require influential constituencies of their own. The frequent public sessions, in that they forced the Academy continually to expose and justify its practices, were at the same time a means of supervision and control. The business of public exhibition also begins in this initial period of academic hegemony, but in the rather desultory form noted in the Introduction above. From its first years, the company had required an acceptance piece (the *morceau de réception*) from each member in order to weed out those who could not compete technically with the guild artists. These were hung permanently in the meeting rooms and soon amounted to a sizeable permanent exhibition.[18] The first "Salons" (the term is at this point an anachronism) were fairly modest efforts to augment this display with examples of current work. Provisions for regular public exposure had in fact been included in the definitive academic statutes of 1663.[19] Article XXV directs that "each year there will be a general assembly in the Academy on the first Saturday in July, at which each officer will bring some piece of his work in order to decorate the premises of the Academy for a few days." But difficulties with this requirement for an annual *fête* appeared almost immediately. On 5 July of the following year, the minutes of the Academy record that "a number of members of the company have reported significant reasons to justify their inability to complete their pictures for today's session."[20] The exhibition was postponed until the festival of St. Louis in late August, but still the artists dragged their feet: only pictures entered in the current competitions for prizes were shown alongside the permanent collection. In 1665, there seems to have been an

effort to compensate for their poor showing the first time out. On 27 June, the hall was ordered to be hung with tapestries to provide a fitting background for the submissions, and each member was warned that their work was required for the following week. Nevertheless, the same excuses had to be made on 4 July, and it was not until sometime after the end of August that the first group exhibition took place. The results must have been disappointing in that the provisions of article XXV were revised over the winter, lengthening the interval between these displays from one to two years. The date was also shifted from summer to Holy Week.[21]

By 1667 at least, the event seems to have come off without a hitch, and that exhibition has left us with probably the first example of Salon reportage. Its author was Jean Rou, a Protestant intellectual close to Henri Testelin, the Academy's first secretary and chronicler. Both were forced to flee France following the end of toleration of Protestantism, and Rou appears around 1690 to have used his friend's material to begin a history of the Academy. The project seems to have been just as quickly abandoned, fragments surviving only in Rou's manuscript memoirs.[22] What he preserved, however, begins with a description of the exhibition of 1667:

> . . . while crossing the Palais-Royal, where some errands had drawn me, I found myself unexpectedly in the midst of a confusion of traffic involving a number of carriages blocking the entire entrance to the vast rue de Richelieu. I was, it seemed, the only one present who knew nothing of a famous gathering of men and women of every age and rank, who had brought themselves to the grand courtyard of the Hôtel Brion in order to admire the rich pictures and the superb statues which the Royal Academy of Painting and Sculpture had laid out on that day by the express order of his Majesty. Words could not express what an agreeable spectacle this was for me to see all at one time a prodigious quantity of every kind of work in all the diverse aspects of painting; I mean *history*, *portrait*, *landscape*, *seascape*, *flowers*, *fruits*; nor could they convey by what sort of magic, as if I had been transported to strange climes and to the remotest centuries, I found myself a spectator at those famous events the extraordinary written accounts of which had so often stirred my imagination. I could barely comprehend how I could find myself able to converse with the celebrated dead whom I had known before now only by the aura of their fame, or how, by some change of scenery, I could find myself instantly in the solitude of the fiercest deserts, or just as quickly, in the fertility of the happiest countryside or the horror of storms and shipwrecks, all the while remaining in the midst of the streets of the most populous city on earth, which is forty leagues from the nearest sea. Finally I could not without the greatest pleasure see art, by its innocent fictions, claim from nature the truth of its models and agreeably fool my eyes by spreading before them the latest fruits among the earliest buds, as if autumn had been transplanted into spring.[23]

This text probably qualifies as the earliest surviving "Salon." Its usefulness as a document is limited, however, by its narrative function in Rou's projected history: in what follows he describes his passage from naïve passerby to knowledgeable academic insider. The magnetism of the assembled imagery, with the attendant chaos of traffic and visitors, is a figure in the discourse and part of the author's self-insertion into his text (it will in fact be a recurrent textual strategy in Salon writing and may well have been established in Rou's time.[24]) Still, there is more evidence for significant public access and enthusiastic response to the fêtes of the Academy. During Holy Week in 1671, the number of submit-

ted works of art overflowed the interior of the Hôtel Brion into the inner courtyard of the Palais Royal complex. Colbert, impressed by the initiative of the artists and the number of spectators, ordered the exhibition to be prolonged for an additional week. One further sign of the crowds attracted by the event turns up in deliberations over the coming *fête* in 1673: it was decided that all ordinary academic activities would be suspended during the exhibition because "unfortunate accidents were wont to occur as a result of the *confusion populaire* . . . and to allow the public freely to move about and satisfy its curiosity."[25] In that year, the extensive outdoor hanging was repeated, and there is good reason to assume a particular state interest in a more impressive showcase: it included Le Brun's four gargantuan Battles of Alexander, explicit allegories of Louis XIV's victories and the most spectacular result to date of Colbert's program for the visual arts. And with this exhibition came the first *livret*, a handlist offered for public sale. The minister again ordered a prolongation, and the works remained on view from 25 August until 3 September.[26]

The date of the opening, however, is a sign of continuing difficulties and resistance beneath the spectacle. On 26 February, the proceedings of the Academy declare that "the Company, having determined there was not a sufficient number of works ready for Easter week, has decided to delay the ceremony of the *fête* until Pentecost when the weather is ordinarily more favorable."[27] In light of the new outdoor venue, that last point has a reasonable sound. But a few days before the postponed date, another delay was announced, this time until June. And this apparent lack of enthusiasm and preparedness caused a further unexplained postponement until 25 August. (The later immovable custom of opening the Salon on the name-day of the King seems to have begun inadvertently as a result of this procrastination in 1673.) Even then, forty-five of the members submitted nothing. And though tentative efforts to continue the Palais Royal exhibitions are recorded in 1675 and 1680, there is no evidence for any repetition of the events of 1673 until the end of the century. These last decades of the seventeenth century saw the often-described erosion of the Academy's authority and ability to impose a coherent vision on its clients and its membership. The drift away from Le Brun's programmatic leadership is typically understood as a decline in the power and effectiveness of the Academy as an institution, one brought on by successful efforts of the partisans of Rubens, that is, of color over line, to undermine classical dogma. In most accounts, their success is presented as a "good thing," a salutary break from the rigid subordination of painting to narrow doctrine and conformity.[28]

But from the point of view of painting's engagement with the interests of a larger public, this was a period of retreat. The waxing and waning "debate" over color and line need not detain us here, however much the "color" party might be thought to represent the more democratic bias toward immediate experience over an imposed and elitist body of rules. The actual effectiveness of the Academy's vaunted system was always tenuous; with Colbert's ministerial successor Louvois and Le Brun's old enemy Mignard in ascendance, the issue was by this time largely moot in practical terms. The insurgents did nothing to make the Academy less monopolistic and self-protective in its control of the artistic economy. The result of the Poussiniste-Rubéniste debates was an even more relaxed and expedient eclecticism in matters of style, one which, in the absence of a solid theoretical counter-position, could not be challenged. It became correspondingly more difficult for a public claim on painting to be registered.

The later campaign by La Font demonstrates the way in which the revival of fidelity

to Poussin's example (or Le Brun's or Le Sueur's) could serve as a vehicle for the cultural demands of outsiders. The doctrinal (as opposed to practical) monopoly of the Academy always contained the potential for such a claim in that it stood for a universal ideal which transcended the authority of privileged individuals. That ideal, formerly identified with a rarefied and exclusive aesthetic tradition, was now, thanks to Colbert, identified with the body of the nation, and by extension with the interests of any individual citizen whatever. Reversing the usual account, we could describe the rear-guard Poussiniste faction as, in the long run, the more progressive. When aesthetic authority was fragmented and dispersed, it was much more difficult to identify the "national" component in the Academy's work and thus to apply leverage in the name of the public interest.

Despite this drift, there would be a revival of the public exhibition at the end of the century. The nature and fate of that initiative, however, will reveal the difficulties which confronted the state in recovering a persuasive public rationale for the Academy and for the work of its members.

— v —

In 1699, an accomplished artist, intent on restoring the old academic élan, took over as *Surintendant* of royal buildings. This was the architect J. H. Mansart, who then installed Charles de la Fosse as First Painter and Roger de Piles as *amateur honoraire* and chief theoretician. It was a reform slate and one that had to overcome some initial resistance. Noël Coypel, the Academy's Director, was apparently content with the slack regime of the outgoing *Surintendant* Villacerf. He fought hard to keep Villacerf on as "Protector" and managed to prevent Mansart from assuming that additional title for several weeks.

Mansart inaugurated his direction of the Academy with an aggressive message which may go some way to explaining the elder Coypel's hostility. One of the new *Surintendant*'s first acts was to revive the *conférences*, these having degenerated in the interim into stale recitations of artists' biographies and old theoretical discourses. In a session of July 1699, Mansart personally introduced de Piles' first lecture, listened with conspicuous attention, and stood up afterwards to endorse its message. The title of the lecture was "On the necessity of establishing principles and the means of doing so."[29] "We fail to see," de Piles told the assembled company, "that the Academy has, since its establishment, yet formed many individuals who have equalled the past restorers of its two arts, let alone surpassed them." Technical proficiency, social support, good intentions, all these it possessed; what it lacked was theory. It was the historic task of the Academy to sum up the lessons of the best painting of the past, "to reduce them to infallible rules and transmit them gloriously to the centuries to come." With the help of his new colleagues, de Piles announced, he would take on the job of formulating these "infallible principles."

Given their later response to La Font's considerably more modest critical ambitions, we can imagine the reactions of the artists. But as the assault came from inside and from above, they suffered in apparent silence. In truth, the administration's scope for reform was limited. It was not in a position to restore anything like the levels of material support available during the early, splendid decades of Louis XIV's personal rule. To renew the Academy's mandate, it had of necessity to stress the less tangible forms of public discourse and display. One of these was theory—another was the public exhibition. The month following de Piles' *conférence* saw a new "Salon" conceived on a far grander scale

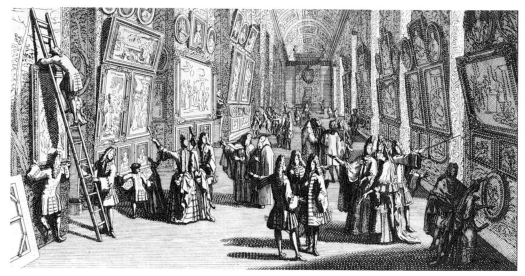

9. A Hadamart, *The Salon of 1699*. 1699. Engraving

than its predecessors (Plate 9). The Academy was now housed in larger quarters in the
Louvre, and the exhibition took place there. It was mounted in a spacious setting, the
grande galerie facing the river. Though partitions closed off half the available space, what
remained was still an impressive 660 feet in length. The revived exhibition in fact so
eclipsed its predecessors that, throughout the eighteenth century, it would be remembered
as the very first of its kind.[30]

For the first time, the display was accompanied by an explicit statement of its educa-
tional and discursive intentions. The aim of the academicians, stated the small guidebook
(the *livret*) that was on sale to visitors, was "to renew the former custom of exhibiting
their works to the public in order to receive its judgment and to foster that worthy com-
petition so necessary to the progress of the fine arts."[31] In the following exhibition, held
in 1704 and again at Mansart's direction, the *livret*'s preface expanded on this theme,
and cautiously observed that the attractions of the private market were again undermining
the Academy's image of effective public performance:

> The Academy has always been convinced that it could better make known its efforts
> and zeal for the perfection of the fine arts only by displaying from time to time works
> of painting and sculpture produced by its membership. Although the greater part of
> its productions are made to augment the majesty of temples and the magnificence
> of palaces, it realizes that there remain a large number of others that are immediately
> placed in the private *cabinets* for which they are destined, so that they are often
> concealed from the eyes of the public. Thus the progress that the Academy is making
> in these arts could go unnoticed if it did not take some measure to re-awaken the
> public's attention.[32]

In the 1699 installation, however, that re-awakened attention was not directed to
the works of painting and sculpture alone. The warehouse of the Gobelins factory had
supplied "all the tapestries required" to cover the walls completely, and the paintings
were hung against them.[33] The focus of the installation was the partition immediately

to the left on entering. There, above a carpeted platform and overhung by an ornate velvet canopy, were portraits of the King and Dauphin. Flanking this ensemble was the entire suite of tapestries after Raphael depicting the acts of the apostles. At the further end of the gallery was another tapestry group, these after Giulio Romano's history of Scipio. Small groupings of sculpture punctuated the Raphael series, and beyond were the paintings. A description of the exhibition exists in Florent Le Comte's general survey of Parisian architecture and collections of 1700.[34] Consistent with the elaborate setting, Le Comte's description gives first priority not to the pictures, but to their frames. Extraordinary effort had gone into them, he is at pains to say, and the effect of the intricate moldings had been enhanced by a remarkably subtle play of gold and silver leaf varied in delicate degrees of luster. He also makes much, early in his account, of the unchallenged curiosity of the exhibition: relief portraits in polychrome waxwork by Benoist, two of foreign diplomats and one of the King himself, whose likeness was surrounded by a crystalline bubble.

Le Comte then proceeds to describe the exhibition as a visitor would make his or her way around the gallery from window to window on the river side, from alcove to alcove on the other. On the relatively narrow walls betweens window and alcoves were arranged a succession of compact groups of pictures, disposed with an eye to compatibility of size and shape. We can get a good idea of the general pattern of the hanging from a quite detailed contemporary print depicting the last stages of the work of installation: narrative paintings of moderate size hung just above eye level, small cabinet pictures below, and symmetrical trios of portraits above, many in oval format. One such group is being hoisted into place against a pastoral tapestry; a collection of fashionable onlookers is already in attendance (Plate 9).

This represented a different sort of viewing experience than the jammed, towering, almost brutal accumulation of images offered in later Salons (these took place in the square, high-ceilinged *Salon carré*, hence the generic name Salon). The scale of the hanging in 1699 and the effort expended on the composite sensory experience of the space look to modes of display and habits of attention characteristic of the private collections of the day. Le Comte's description, which leads the reader from point to point as if one were physically traversing the room is exactly the way he elsewhere describes the works of art in palaces and private dwellings. The official *livret* too follows the same program. Its text begins by carefully laying out the architectural setting and supporting décor; the works of art are initially located and identified for the visitor as part of that décor, and the name of the artist is only supplied after the location and subject matter of each work have been firmly established. In this the *livret* of 1699 is not an isolated instance; if anything, that of 1704 is even more emphatic in its topographic emphasis, and that format will be revived along with the Salon itself in 1737.

The striking part of this mode of presentation is what is not given stress: the identity and academic rank of the individual artist, the didactic significance of the hierarchy of genres, some relative order of importance among the works submitted by each artist. These considerations would determine the arrangement of later *livrets*—they stand after all for the Academy's own distinct orders—but at this stage are presented as secondary points of reference. The priority given the topography of the physical space over and above information specific to the art itself, the pains taken to situate and guide the visitor, imply an audience that, by the Academy's reckoning, had to be brought along slowly.

In any event, to the extent that the constituency existed which benefited from and

felt a proprietary interest in the exhibition, it was unable to ensure its continued existence. As noted above, it would be five years before a second one took place, and as that was staged to celebrate the birth of a royal heir, it looked to a tradition of provided official festivity—pageants, processions, and entries—as much as it did to newer notions of the public interest. The artists themselves continued to be indifferent or hostile. After 1704, there was one, virtually forgotten exhibition in 1725. It lasted just ten days, and none of the senior members of the Academy took part. The *Mercure* made the best of it in its review by suggesting that they had not wanted to overshadow their young colleagues.[35] That would be the last for another dozen years.

<h2 style="text-align:center">—vi—</h2>

The death of Mansart in 1708 seems to have removed the primary impetus behind the exhibitions. His plans for an active theoretical community around the arts likewise failed to survive him. De Piles, true to his word, labored for a decade on his *summa* of academic theory, but in effective isolation from the Academy itself: there are no recorded contributions by the other members, despite de Piles' validation of a more tolerant Rubéniste aesthetic. He had to find support and interested debate among the collectors and *amateurs* who had always been his real constituency, a world increasingly focused on the circle of Pierre Crozat, the fabulously wealthy financier and collector.[36] From at least 1708 on, de Piles was receiving a generous annual pension from Crozat of 1,500 livres per year. This support was just one of a whole *ad hoc* program in artistic erudition organized by this *amateur*. Crozat's example indicates that there now existed a substantial base for an informed, intellectual artistic community in Paris, despite the inability of the state to exploit that base for its own ends. Erudition in this case was joined to considerable power. To mention the name of Crozat in this period would have been to invoke the greatest concentration of wealth in France next to that of the royal family. The family had originated in Toulouse, where Pierre's father had risen to the ennobling municipal office of *capitoul*. The head of the clan in the early eighteenth century was Pierre's older brother Antoine, its dominant public personality and reputedly the richest man in France. Having shifted family operations to Paris, Antoine began reaping vast sums in various speculative ventures: principally military supplies and overseas trade; he was a prime mover in the Indies Company and in 1712 was granted a personal monopoly over trade with the Louisiana colony. In 1715, in return for a loan to the state treasury of three million livres, he was made "treasurer" of the Order of the Holy Spirit, which put him instantly in the most noble honorary company in the kingdom.

The far more retiring Pierre became the family's specialist in culture. Born in 1665, almost nothing is known of his life until 1699, though his activity as a collector has been traced back to 1683 when he was still in Toulouse.[37] His holdings would eventually be surpassed only by those of the Crown and the Regent. He bought shrewdly and tended to purchase existing collections in bulk, aided by his numerous diplomatic and ecclesiastical contacts in Italy. His collection of paintings was supplemented by an even more impressive accumulation of old-master drawings, one which numbered in the thousands. The latter especially provided an extraordinary and unprecedented technical resource for the artists who frequented his house.

As will be discussed below, Pierre Crozat came to serve as a trusted operative and artistic adviser for the duc d'Orléans during his reign as Regent. If his older brother had gained access to influence at the highest level through sheer financial muscle, Pierre would do so through expertise in the visual arts. Part of that expertise was acquired through the artists he boarded in his home, notably the senior academician Charles de la Fosse. Antoine Coypel, First Painter to the duc d'Orléans, was a regular guest, and his son Charles, destined for equal success, also joined the famous weekly *réunions* for artists and *amateurs* held at the Crozat residence. The influential eighteenth-century connoisseur P. J. Mariette would write of these sessions: "I owe what little knowledge I have acquired to the works of the great masters that we examined there and equally to the conversation of the noble persons who made up the company."[38] Not only artists— Nicolas Vleughels, future Director of the Rome Academy, and Watteau were also initiates—but an entire generation of critics and historians of art was also nurtured there. Along with Mariette, Jean de Jullienne, the entrepreneurial patron and promoter of Watteau, was a regular visitor. The abbé Du Bos, whose *Critical Reflections on Poetry and Painting* was a dominant aesthetic text of the first half of the century, figured in the Crozat entourage. The comte de Caylus and Louis Petit de Bachaumont, among the commanding personalities in the revival of serious artistic discourse around mid-century, cut their teeth as connoisseurs among Crozat's pictures and protégés.[39]

What all this added up to was a kind of shadow Academy, sustained by private initiative and enthusiasm, but carrying on many of the actual Academy's public responsibilities on quite a significant scale. The high artistic theory of the late seventeenth century, in the person of de Piles, comes to rest in the Crozat circle, while much of the most influential eighteenth-century theory and connoisseurship have their origins there. In these confines, learned discourse occupied the honored position it had never quite achieved in the official structure. He regularly entertained prominent Italian artists and *amateurs*, primarily from Venice.[40] Crozat's *hôtel* indeed served as a kind of international clearing house for advanced artistic knowledge and ideas. In 1721, he began to put this expertise to work in a public forum: with the help of Mariette, he undertook the production of bound volumes of prints after paintings and drawings in the collections of the Crown, the Regent, and a number of private individuals (including of course a healthy representation of his own). This set the pattern for similar, widely distributed *recueils* of reproductive engravings later in the century.

The kind of *amateur* who was attracted to the Crozat circle may well have turned away from the contemporary Academy with a sense of both despair and relief. After decades of effort, they and their predecessors had not succeeded in maintaining the academic *conférences* and the proto-Salons as anything more than grudging exercises on the part of the artists. That is to say, they had been unable to exert sufficient pressure to preserve the principal official institutions which represented their interests. As far as the majority of academicians were concerned, the public sphere in all its aspects— speech, the printed word, the open exhibition—remained at best an abstract, ideological convenience. It fitted their purposes best during the relatively brief period of confident and open-handed state patronage under Colbert; at other times, it was peripheral to their more immediate concerns and consequently ignored as much as possible. But it is important to recognize that this period around 1700 was one of dispersion of power within the state. The increasing weakness and financial instability of the Crown allowed concentrations of power to emerge, like the Crozat empire, with virtually governmental

authority. A court requires a culture, and Pierre Crozat provided a leaner, more alert informal academy to serve that function.

The existence and far-reaching influence of the Crozat circle thus mitigates what would otherwise have been a fairly bleak outcome of a half-century's worth of effort to establish the public sphere for art. After the death of Louis XIV, when the Orléans regency moved the court from Versailles back to Paris, it was the artists of the Crozat inner circle, not the Academy at large, who provided the new ruler with the visual imagery he required. In the expansion and embellishment of the Palais Royal (the seat of the collateral line since Louis XIV bestowed it on his brother "Monsieur", and now the seat of government), the major decorative commission went to Antoine Coypel. And Pierre Crozat himself would play a central role in assembling its collection of paintings. In 1714 he was dispatched to Italy personally to carry out the protracted negotiations which secured the core of the Orléans holdings: the pictures formerly in the possession of the late queen of Sweden, a collection built on booty taken from the court of Prague.[41]

This effort prepared the way for the most conspicuous new opportunity, before the resumption of the Salon, for public access to major works of art. By 1727, the magnificent collection of the late Regent had been put on display in the Palais Royal. A guidebook for tourists to the city was published that year by a German, Joachim Nemeitz, who enthusiastically recommended the exhibition to his readers: "The new gallery, with various rooms embellished by rare paintings, is the most remarkable part of the palace."[42] In contrast, Nemeitz describes the royal collection in the Louvre as being all but inaccessible, even for the best connected foreign traveller, the pictures being "today in very poor condition."

Also in 1727, Dubois de St. Gelais, historiographer of the Academy, produced a detailed catalogue of the Palais Royal collection, and unlike the other handlists examined above, it was organized according to fairly modern critical principles.[43] The entries are not ordered by the arrangement of the pictures on the walls, but alphabetically by artist's name. Dubois then attempts to describe for each "his character as a painter in order that he might be easier to recognize."[44] The nature of the collection too was determined by the studied connoisseurship and even technical proficiency of its owner. Dubois claims that the Regent had, under Antoine Coypel's tutelage, learned to draw and paint like a master, and by means of his eye and erudition, had been able to assemble a major princely collection in a mere twenty years.[45] Whatever the actual artistic attainments of the Regent, the claim itself, applied to a head of state, is a novel one. The catalogue preface concedes, proudly even, that connoisseurship must be systematically acquired, even by its most noble practitioners, and that its basis is analytic and technical.

There is in this period then a clear passage outward from the private cultivation of enlightened aesthetics to a strong public manifestation of those aesthetics by the late 1720s. Dubois assures his reader that, as a guide to the collection, he "has abstained from any critical judgement . . . in order to leave each viewer the liberty to make judgements according to the impression made on him by each picture."[46] However the distribution of emphasis in his biographical sketches and individual entries conforms to an unmistakable hierarchy. One of the most prominent artists in the collection, measured by numbers of pictures, was David Teniers, the Flemish artist most renowned in France for low-life genre, and here the Regent was only conforming to a widespread contemporary enthusiasm for that painter in France. Nevertheless Dubois gives Teniers only a perfunctory paragraph. By contrast, the nine pictures by Poussin receive twenty-eight

pages of description and praise. The Seven Sacraments in particular are presented as a national treasure and the jewel of the collection.

This was a view which, according to the available evidence, was ratified by an interested bourgeois audience. A survey of works of art included in the inventoried possessions of 1,247 merchants and artisans who died in Paris between 1726 and 1759 has recently been published by Jean Chatelus.[47] His results indicate a "considerable vogue" for prints after the Poussin Sacraments, many in complete editions and specified as belonging to "the cabinet of the duc d'Orléans."[48] The two other series of reproductions which followed the Sacraments in popularity bespeak a similarly elevated and national taste. One was the Life and Death of St. Bruno as painted by Le Sueur in grave and austere episodes for the cloister of the Chartreux. An apothecary is recorded as owning a painted copy of these, as did a merchant's widow and a furrier who had served as a *consul*, (that is, a judge in a court of commercial affairs); a hosiery merchant possessed an engraved set bound in vellum. The third series was Le Brun's Battles of Alexander. Engravings after these pictures by Jean Audran turn up in the collections of one former *échevin* (city magistrate) and a "merchant-*bourgeois* of Paris, a councilor to the king in the *Hôtel* of that city." A former official of the drapers guild owned five painted copies valued at the considerable sum of 400 livres (a year's income for a Parisian journeyman).[49]

That trio of names—Poussin, Le Sueur, Le Brun—constituted the collective summit of artistic authority in French painting. No names are mentioned more often in the eighteenth century as models for emulation and reproaches to errant tendencies. The less familiar name of Le Sueur perhaps seems a surprising inclusion to us now, but in this period he was firmly part of the holy trinity. One influential connoisseur and critic of La Font's generation, La Curne de Sainte-Palaye, vaunted the St. Bruno series as the supreme achievement of French art, one which placed Le Sueur next to Raphael and the Carracci in the universal artistic pantheon (Plate 10). For Sainte-Palaye, it was an exemplary sobriety, reticence, "la plus grande simplicité," which made Le Sueur the most stirring representative of the *grand siècle*:

> I observe two or three figures in a monk's cell or in a landscape as simple as the cell itself; these make up the entire subject. There are absolutely none of these contrived attitudes which the painter provides only to show that he enjoys the play of line; none of these bizarre expressions which are always wide of the mark, and these draperies whose richness consists in an over-abundance of folds and superfluous ornament; none of these fairy palaces which pierce a stormy and fiery sky; none of these contrasts in the disposition of groups and in the distribution of light which add to the din of what is called the "Machine."[50]

To contemporary eyes, Poussin's Sacraments stood as a similarly persuasive model of gravity, compositional strength, and narrative clarity. The statistics suggest a significant public among the well-off mercantile classes of Paris which was responsive to these qualities and correspondingly less interested, like Sainte-Palaye, in the more mannered and theatrical end of the Baroque stylistic spectrum. The nostalgic patriotism embodied in Le Brun's Battles also appears significant—many more portraits of Louis XIV appear in the inventories than images of the reigning monarch.[51]

A striking result of the survey is the almost complete absence of *fêtes galantes* and subjects we think of as peculiarly Rococo: only one picture after Watteau, another described as in his style, and a scattering of scenes from the Italian comedy. Mythological

10. Eustache Le Sueur, *Saint Bruno at Prayer*. 1645–48. Oil on canvas, 193 × 130 cm. Louvre, Paris

subjects comprise only 3·7% of the total sample. On this evidence, it would appear that a copyist or printmaker wishing to appeal to the Parisian market would have done well to choose paintings appealing to an upright and reformist taste. One of the best-placed observers of the trade in prints, P. J. Mariette, nevertheless gave precisely the opposite advice to young engravers in 1731: however much you admire the great Poussin, he wrote, you will go broke reproducing his pictures.[52] That opinion is seconded in a later text by J. B. d'Argens:

> In effect, the pictures of Poussin, Le Brun, and Le Sueur are not particularly sought after today; and the artists who work in the character of these great men, who try to give their work the nobility and the harmony which constitute the soul of design, have a much smaller following than those who paint pictures one would once have hung only in a waiting room. Watteau was the Fontenelle and Lancret the La Motte of painting.[53]

But we need to note that Mariette and d'Argens moved in high circles (in the case of d'Argens, the court of Frederick the Great, who was a renowned enthusiast for all varieties of the French *fête galante*). Among the cosmopolitan elite, demand was for scenes of stylized dalliance and intrigue between social actors in idyllic parks, for comic-opera

shepherds and shepherdesses, for the lighter episodes of the loves of the gods. De Troy, Lancret, and Pater were their painters; Boucher was at the start of his long, well-compensated career. It is this taste that has given the early eighteenth century its reputation for elitism, privatism, and lack of seriousness in artistic matters. But it coexisted, as we are seeing, with a developed preference in the social stratum just below the top for the verities of seventeenth-century classicism.[54]

The artistic life of the Regency thus represents an important point of juncture in our account, pointing simultaneously in two directions at once and emanating from the same center in the circle around Crozat. Not quite private, not quite official in character, this group served as a mediator between the agenda of the theoreticians within the Academy and the needs of an expansive urban aristocracy, now liberated by the decline of Louis XIV's personal hegemony and infused with the energy and intellectual alertness of new nobles like Crozat himself. The artistic education of the Regent, culminating in the posthumous display of his collection, helped enlarge the number of visually literate Parisians receptive to the publicly-oriented values of the enlightened *amateur*. Thanks to Crozat's sophisticated internationalism and keen sense of curatorial responsibility for the accumulated artistic wisdom embodied in drawings, ambitious French artists were exposed to an unprecedented range of technical possibilities. And he provided a haven for high theory. The initiatives of Le Brun, Mansart, and de Piles had been beaten back but not defeated. Their values by this time possessed sufficient strength to survive the effective collapse of the Academy as a vehicle for them.

But the preponderance of Venetians among the Italian artists who were guests in the Crozat household, and the implicit favor thus given to coloristic and gestural facility, remind us that this was also the forcing-house of the Rococo style in painting. Watteau resided there and honed his skills as an artificer of *fêtes galantes* in its receptive surroundings. His example encouraged a re-orientation of painting toward the provision of sensual pleasure at the expense of moral and intellectual edification. Mariette's expressed regret over the triumph of Rococo taste over the classic rings slightly false when we realize that the vogue for Watteau, which largely antedated his death, was consciously managed and promoted from inside the same coterie of which he was so proud to have been a member. (Jean de Jullienne, the publisher of the great *recueil* of prints after Watteau, at one time owned at least forty pictures by the artist, but at the time of his death, possessed only eight; prices had risen enormously in the interim.)[55] But is this contradiction more apparent than real? Did this last great episode of courtly art in Europe in fact depend on the very expansion of the public sphere that Watteau's art seems to negate? The purpose of the following chapter will be to show that these questions can be answered affirmatively. For it was here that the new visual literacy and art-historical intelligence finally took root outside the Academy, thus coming into productive contact with more vital and unpredictable uses for painting. The milieu of the Regency aristocracy was open to other components of urban culture, open indeed to some of those "popular" forms of collective pleasure and expression touched on briefly in the Introduction. For there were spaces in Paris distinct from those controlled by the state in which "low" audiences were finding ways to use the materials of high culture for their own ends. At the same time, individuals fully in command of elevated artistic culture were finding, in the old communal spaces of festival and fair, something they had been missing. Via that permeable, public-private milieu symbolized for us by the Crozat circle, painting would find ways to respond.

II

Fêtes Galantes and Fêtes Publiques

−i−

IN the notarial records of eighteenth-century Paris, by far the most common category of picture in the inventories of all classes is that of devotional images, the larger part of these being simple depictions of Christ, the Virgin, and various saints. Their proportion is highest among artisans, and most would have been anonymous, almost industrially produced objects like those on which Watteau labored when he first arrived in Paris. His friend and patron, the dealer Gersaint, has left a memorable account of such an operation direct from the painter himself:

> In those days, many small portraits and subjects of devotion were wholesaled to merchants in the provinces, who bought them by the dozen or even the gross. The painter for whom he [Watteau] had just begun to work was the one most in demand for this kind of painting, in which he maintained a considerable turnover. He had at times as many as a dozen miserable pupils whom he used like manual laborers. The only talent that he required of his apprentices was one for quick execution. Each one had his job: some did skies; others did heads; this one painted draperies; that one dabbed in the highlights. Finally the picture found itself finished after it had passed through the hands of the last one.[1]

(Watteau, however, distinguished himself by being able to handle whole pictures at speed, especially the popular figure of St. Nicholas: as he told Gersaint, "I knew my St. Nicholas by heart and had no need of the original to copy.")

By no means all such pictures left the capital for the provinces, and one did not have to look far to find them. Many of the painters of the *Maîtrise* maintained shops on the quais and bridges of the Seine, which were open to passers-by and in which they retailed objects from a variety of sources. In addition, some of the richest displays of images were to be found in the fairs. There were two of these in the period under discussion, the Foire St. Laurent and the Foire St. Germain, urban variants of the annual commercial events staged at pilgrimage churches and abbeys since the middle ages[2]. Comparatively recent in origin, the Paris fairs lasted for several months each year and allowed the city's economy a certain amount of freedom from guild-imposed restrictions on trade. The St. Germain fairground, active between 3 February and Palm Sunday, was the older and richer of the two (Plate 11). Timbered roofing constructed by the abbey in the sixteenth century marked out nine interior streets lined with boutiques. Its separateness from the surrounding city was reinforced physically by its being below ground level, in places six to eight feet lower than the adjacent land. One of the interior passages was designated

11. *The Foire Saint-Germain.* Anonymous engraving

the "street of painters and ironmongers," and, according to one early account, was the most impressive in the fair. Charles Sorel's unfinished novel of bourgeois life, *Polyandre*, the first part of which was published in 1648, includes a long scene set in the fairgrounds, and mainly among the boutiques of the picture sellers.[3] There he observes crude pictures made with cheap and impermanent materials, but also art objects of considerable value: ". . . peasants and other persons of base origins take as much pleasure in grotesque paintings of distemper as enlightened people do in seeing the most beautiful pictures." The scene as described by Sorel, and what we know of the character of the fairs in general, are a caution against any strict stratification of taste or levels of culture in the eighteenth-century city. These should not be confused with country fairs, he informs his reader, where livestock and useful implements are the main stock in trade. The St. Germain boutiques contained "everything that the merchants could gather to tempt the curiosity of men and to excite them to extravagance and prodigality."[4] The fair, like the Salons, attracted the broadest range of classes and types. Dancourt's play of 1696 entitled *La Foire St. Germain*, to cite another literary example, included as characters a marquise, a provincial noble, an officer of the Parlement, a financier, an abbé, and a customs officer, along with raffish actors, lackeys, and thieves.[5] Nemeitz's 1727 tourist guide observes "masters with valets and lackeys, thieves with honest people, the most refined courtesans,

the prettiest young ladies, the subtlest thieves, are as if intertwined together."[6] The more fashionable boutiques were closed structures used by elite visitors as much as gathering places as for trade. These were illuminated until ten in the evening for the benefit of people leaving the theater, and that was the most popular time to arrive. Most of them specialized in luxury goods, "manufactures de Paris" in the parlance of contemporary Europe, and at prices higher than elsewhere; their custom derived in large part from the practice of ceremonial exchange of gifts among those gathered on the premises.[7]

The artists and picture-sellers of the St. Germain fair were primarily Flemish and constituted a third quantity in the art world of Paris distinct from either the Academy or the *Maîtrise*. An independent and international community of artisans had been drawn to the quarter early in the seventeenth century by the construction of the Luxembourg Palace. Separate guilds, among them one for painters, had been established for St. Germain des Près alone.[8] In 1626, Archduchess Isabella, Stadtholder of the Spanish Netherlands, established a Catholic confraternity for expatriate Flemings which was moved to that parish in 1630. Its rolls show a large influx of artists in the 1640s and '50s, a phenomenon which has been linked to the dispersal of Rubens' studio assistants after his death in 1640.[9] The St. Germain fair provided these artists with a place to sell free from the restrictions of the Paris *Maîtrise*, as long as they did not try to operate outside its boundaries. (The principal hazard they faced was in getting the pictures into the grounds from their studios in the surrounding quarter: while on the streets their work was subject to confiscation and fines by the guild.) There is nothing to indicate that paintings of some quality in the manner of Brouwer, Wouvermans, and Teniers were not thus on continuous view for several months of each year. The vogue among wealthy collectors for the artists just named is a well-known eighteenth-century phenomenon.[10] And via the fair, this kind of painting reached a wider circle of buyers and a broad public beyond. The notaries' inventories discussed above confirm the special status of these Flemish pictures during this period by assigning them to a category apart from genre subjects taken generally. Most of these are listed as anonymous, and as a category, are overwhelmingly the preference of merchants rather than master artisans (107 "tableaux flamands" were found in 750 households of the former versus only 19 in 497 households of the latter). A handful of original seventeenth-century works turn up (three "Returns from the Hunt" by Wouvermans, for example, valued at 150 livres), and Teniers is mentioned over and over, his name serving as a kind of portable designation for the style as a whole. Flemish subjects account for about 30% of the total number of genre images.[11] In Wildenstein's parallel survey, the most common single category is that of works labelled "flamands," "œuvres de Flandre," "cuisinières de flamands," and so on.[12]

There was certainly a fit between these images and the social space where they were commonly seen and sold. Drinkers, smokers, revelers, similar in all but costume to the typical characters of seventeenth-century northern genre, could be observed on every hand. The fairs were places of pleasure, of excess and license. Nemeitz warns his readers away from a long list of alcoholic poisons on offer in its cafés. Above all to be avoided were the drinking establishments that ringed the grounds just outside its boundaries; these, he states, were no more than common brothels. Gambling was pervasive, and the crowds overflowing the gaming establishments could pose a threat to purse and person.[13] Sorel earlier described the street of the painters as ringing with the clatter of cups and dice.[14] Nemeitz found it more attractive to the "well-born voyager" than he would have

12. Bernard Picart, *Le Théâtre de la foire.*
1730. Etching

13. After Antoine Watteau, *The Departure of the Italian Comedians.* Etching and engraving

liked: he councils his readers that it is really not necessary to frequent the fair *every* night.[15] Given the interests and expectations of fair patrons, it is easy to picture the Flemish artists thriving in this milieu.

There was, as might be imagined, little that was innovative in the work on offer. The fair artists concentrated their energies on the replication of popular seventeenth-century prototypes. Another of Watteau's early specialties (for he identified himself as a Fleming and was at the start a journeyman on the fringes of this colony) was Dou's *The Reader.*[16] But after 1697, outside forces could intervene in such a way that expatriate Flemish genre painting would come vividly to engage the life of contemporary Paris. To understand this development, we need to follow the attention of the fair visitors themselves, away from the passage of painters and ironmongers, to the preeminent attraction on the grounds: the four or five ramshackle theaters set up in the open inner court. Troupes of *danseurs de cordes* or tightrope acrobats were the principal attraction in these establishments (Plate 12). But, Nemeitz explains, that designation is a misleadingly restrictive one:

> The dancing on the rope is not as highly regarded as the *comedy* which comes afterward. Be aware that some of these troupes include the rump of the so-called Italian theater. . . . Many things are permitted in the time of the fair that would not be permitted at other times, and this has allowed these "gentlemen" to reinstate their former theater on the pretext of being tightrope performers: but it is said that the present production is only a shadow of the former one.[17]

The "Italian Theater," that is the *Comédie italienne,* had become "former" in 1697 when it saw its royal privilege summarily revoked and its company banished from France. The comic intrigues of Harlequin, Colombine, Mezzetin, and their colleagues had for

some time been at odds with the increasingly pious and austere tone of life in the King's inner circle. Their satire had raised official tempers further afield as well. In 1695, an officer of the Châtelet law courts found himself depicted as a "forger and thief" in a play called the *Return from the Fair at Bezons*. His complaint drew the august minister Pontchartrain into warning the Italians against similar conduct in the future. In 1697, however, the target of their impertinence in Fatouville's *La Fausse belle-mère* was taken to be Mme. de Maintenon herself, and Pontchartrain sent the players packing. (An early painting by Watteau depicts their ban and departure (Plate 13).) A good number of them, however, found refuge with the mixed acrobatic and theatrical troupes of the fairs, to which they brought an extraordinary influx of talent and sophistication honed in their long years at court; their recent vicissitudes added a tinge of forbidden glamor as well. A large, unfinished drawing by Claude Gillot now in Stockholm illustrates precisely the newly mixed theatrical genre that resulted (Plate 14): while an acrobat leaps several feet above the tightrope, various actors from the Italian comedy gather below; Harlequin climbs the standard that supports the rope; one pretends to be able to catch a falling performer in his hat. In the years that followed, the popularity of these theaters among all classes of the city markedly increased.[18]

The repertoire of the Italian players, however, underwent some drastic transformations in the process. Legally there was to be no drama with spoken dialogue in the fairs at all. The exclusive right to present plays in French was jealously held by the *Comédie française*. The exiled Italians were at first licensed only as acrobats and therefore were forced to present their stock playlets in pantomime form. As the characters were familiar—Harlequin, whom the French company had modified from a crude and greedy servant to an ingenious intriguer prone to being undone by his own intrigues; Pierrot/ Gilles, the melancholy dupe and crowd favorite; Colombine, the coquette; Pantalone, the despotic father or cuckolded husband; and the rest—there was no real problem of communication. But comedic effects now depended of necessity on broad physical antics. Our German guide notes with disapproval: "The sets, the men who appear in the guise of wild beasts, the low slapstick, the obscenities, the indecent postures of the dancing girls . . . shock reason and morality."[19]

All this was of course the traditional comic entertainment of the fairs and festivals. The roots of the *commedia dell'arte*, to use the familiar Italian term, lay in that popular tradition. In seventeenth-century France, it had been made over into a far more stylized and verbal elite diversion, but proscription returned the form to its roots, re-inserting it into a contemporary form of popular festive life. The terms "popular" and "festive", however, should not be allowed here to carry too much of a timeless, folkloric ring. The most extraordinary innovations and effects of the fair players, or *forains* as they were known, emerged directly from their current circumstances and struggles. Though the official *Comédie* kept up an unrelenting pressure to maintain the restrictions on the scope of their performances (violations could and did bring on the police), the *forains* were endlessly inventive in evading those restrictions, the evasions themselves becoming an essential element in the performance and in their public appeal.

A few examples will give some idea of what the *Comédie* was up against. To avoid the strictures against dialogue on stage, plays were presented *en monologues*, that is, an actor would appear alone on stage, speak his line, then disappear into the wings while another performer appeared and replied. Well known material from the repertoire of the *Comédie* must have been hilarious when subjected to this treatment. Even more deflat-

MEZZETIN. ARLEQUIN. PIERROT.

14 (facing page). Claude Gillot, *Comedians and Acrobats*. Ink and wash over graphite on paper, 82.5 × 56.4 cm. Nationalmuseum, Stockholm

On the placard:

ARLEQUIN

C'est lui/plaignez ses malheurs/
C'est lui qui le sort balote.
Reconnoissez·le à ses pleurs,
Encor plus à sa culote.

15. *Ecriteaux at a fair theater.* Anonymous etching

ing was classical tragedy presented *en jargon*: the players would appear in the costume of the best-known legitimate actors in their signature roles and speak their parts in perfect alexandrines; their lines, however, would be composed entirely of ridiculous-sounding nonsense syllables. Nor was the audience left out of the game. Verse would be written to well-known melodies and mounted on *écriteaux*, or placards, hung above the stage (this device had its origin in another evasive tactic: written lines of dialogue carried by the actor supposed to be speaking them) (Plate 15). While the actors pantomimed, the audience would sing their songs for them. These plays *en écriteaux* became enormously popular.[20]

In 1715, two of the fair companies succeeded in purchasing from the financially-pressed Opera the right to sing, dance, and change sets; with that, a full-blown alternative theater, the *Opéra-comique*, was in place. Typically a performance would be composed of three distinct plays: one *pièce à intrigue*, one *pièce à caractères*, that is, a satire of contemporary persons, and a prologue which introduced and joined them. This last would be a reflection on the current affairs of the company, often an attack on a rival production, especially

those of the "Romans" at the *Comédie*. Send-ups *en jargon* or in song (*vaudevilles*) gave way after 1715 to true parodies of the classics.

All this proved to have great appeal for those the *Comédie* and the Opera considered to be their rightful audience. Nemeitz writes,

> I have viewed with astonishment that even ladies of quality were able to hear and see the obscenities without blushing in shame; but what can I say, seeing that they have no need to hide the contentment they feel and laugh from the heart? This is Parisian high society. The more a drôlerie is earthy and grotesque, the more one is entertained. All is permitted to Harlequin and Colombine, these two happy children.[21]

The popularity among the affluent of a theater where "all was permitted" was sufficient to threaten the solvency, even the survival, of the legitimate theaters. "From the day of the opening of the St. Laurent fair," wrote the *Mercure* in July of 1715, "the *Comédie* and the Opera are rightly deserted. . . . Thousands and thousands of persons of every age, sex, quality, and condition indeed will go, linger with every satisfaction, and leave charmed by the novelties they came to see."[22] By early 1718, the *Comédie* was 30,000 livres in debt, had no new plays, and was regularly cancelling performances for lack of spectators. Over the regular Easter closure of that year, its best actors, including Dancourt who doubled as its most popular author, jumped ship. This led to a desperate effort to close the fair theaters for good. The latter, however, responded with their most brilliant season to date. Subsequently, the *Comédie* was reduced to commissioning its own imitations of the fair repertoire (most notably Legrand's *Le Roi de Cocagne*).[23]

One spokesman for official culture we have already encountered, Dubois de St. Gelais, took time from his duties at the Academy to denounce the *forains*: he wrote in 1717,

> . . . the name *danseur de corde* no longer defines these kinds of people; it marks only their origin. Their performances consist entirely of farces and slapstick, to which they improperly give the name Italian comedies because they feature Harlequins and Scaramouches . . . fashion is now all for them, to the point that they are preferred to the most beautiful plays and operas. People seem indeed to be greatly amused, though they would be much embarrassed to recount what so diverted them.[24]

On a deeper level, what the little theaters threatened was the fit which had existed between a clear, articulated cultural hierarchy and a corresponding social one: an elevated, improving culture for the nobility (and its numerous bourgeois aspirants), a marginalized low culture for the common majority.[25] It is true of course that elites have traditionally indulged in the seasonal diversions of feast-day and fair. In late medieval and early modern Europe, confraternities of younger notables took a leading part in the organized folly of carnival. Paris had its "Kingdom of the Basoche," drawn from young clerks and lawyers of the Parlement, which staged mocking morality plays and elected its "prince of fools."[26] And there were no doubt many ill-educated nobles who took their greatest cultural pleasure in these events. But the great codification of symbol and status which was effected from above under Louis XIV blocked that interchange, or at any rate de-legitimized it. One has only to chart the changing assessments of Rabelais from the mid-seventeenth century on, the gradual incomprehension of—and disgust at—his scatological and licentious imagery, his improbable mixture of modes, which overtakes the literary commentators.[27] The wearying and deracinated permanent *fête* of Versailles transformed the

studied idleness of the high nobility into a form of control, while the imposing edifice of *grand-siècle* classicism was erected above. As Norbert Elias, in his monumental study *The Civilizing Process*, has written of its literary expression:

> The importance of good form, the specific mark of every genuine "society"; the control of individual feelings by reason, a vital necessity for every courtier; the reserved behavior and elimination of every plebeian expression, . . . all this finds its purest expression in classical tragedy. What must be hidden in court life, all vulgar feelings and attitudes, everything of which "one" does not speak, does not appear in tragedy either. People of low rank, which for this class also means of base character, have no place in it. Its form is clear, transparent, precisely regulated, like etiquette and court life in general. It shows the courtly people as they would like to be and, at the same time, as the absolute prince wants to see them.[28]

That, at least, was the intention, but the edifice of classicism was always more fragile than it looked. After the turn of the century, the elite to some degree returns to the shared experience of festive life—a life made dramatic and contemporary by the active conflict between the *forains* and the guardians of approved culture. Those guardians tried to limit the appeal of the upstarts by degrading their product, prohibiting any evident dramatic unity or literary quality, keeping the price of tickets to the fair performances low in hopes of discouraging a status-conscious audience. This, however, proved to be precisely the wrong strategy. For it was the very imperfection of their performances, the outlandish and seemingly artless mix of genres and effects that attracted fashionable spectators. When the Regent restored the Italian Comedy to its old privileged status in 1716, and it could again present its old repertoire unaltered, public interest was slight.[29] The fair theaters, on the other hand, continued to flourish.

The one element of the fair comedy which the Parisian elite appropriated for its own was, in fact, that which anyone could see for free. These were the *parades*, the brief and bawdy come-ons played on balconies above the doors of the enclosed theater structures (Plate 12). A theatrical dictionary of 1763 defined the genre as "farces or little comedies with no rules whatsoever, of an affected and ridiculous style, full of gross turns and tricks, very free and very satirical, that the buffoons stage on scaffolding above the entrance to their plays in order to attract the public."[30] These were the crudest and most broadly physical entertainments available, played for the broadest possible audience; for the lowest social tier of the fair public, those who could not even afford the modest admission charges, these were all they would ever see. Around 1710, amateur versions of Italian-style comedy became a favourite, not to say obsessive, pastime among the Parisian aristocracy, both in the city and more importantly in country pleasure parks outside it. And it was not the plays once staged by the Italians at court or even the principal productions of the fair that fascinated elite enthusiasts; it was the knockabout farce of the *parades* that provided the model and texts for these private performances.

The primary instigator of the fashion was a young noble from a *parlementaire* family called Thomas-Simon Gueullette. In 1707, the twenty-year-old Gueullette and some like-minded companions began staging their amateur version of the *parade* first in Paris and then in an opulent hostelry in Auteil called "La Grande". As he relates in his memoirs, the stage effects in their performances and the complexity of the scripts were deliberately kept to a minimum: a few make-shift props, a bit of flour for white-face, a simple story line which could be memorized quickly and without serious effort; all the actual lines

were improvised. These rough performances, however, were incorporated into elaborate, high-style balls and masquerades. As Gueullette tells it:

> Our diversions, always new and varied, drew to us, apart from our invited friends, an astonishing turn-out of spectators of the highest rank. As we did not raise our curtain until eleven o'clock in the evening, many gentlemen and ladies left Versailles *en poste* after the King's supper in order to take part in our amusements. Following the example of what goes on in Venice, we admitted masks to our entertainments. We held a ball afterwards. All this made for white nights in which everyone seemed well pleased . . .[31]

Subsequently Gueullette began holding these events on his own country properties, first near Charenton, then after 1718, at Choisy. There a number of his fellow players were of particularly high rank: the princesse de Conti, daughter of Louis XIV, was a frequent guest and participant in the *parades*; the duc de la Vallière carried the fashion to the court itself and the Pompadour circle; the marquis de Paulmy, son of the duc d'Argenson, was long an associate of Gueullette's. The list of aristocratic houses where *parades* were performed is a long one. A special type of kept literary man emerged—Charles Collé was one and Carmontelle another—whose functions included supplying new texts for this kind of play. And aristocrats like the comte de Caylus tried their hands at the form as well.[32]

As one historian of theater has written, "It was thus under the auspices of the *Basoche* that the farce passed shamelessly from the inner court of the fair to the most aristocratic salons."[33] Via Gueullette and company, the ritualized slapstick and mockery of traditional carnival, brought forward by the aggressive clowning of the *forains*, became an important medium of elite diversion and even self-definition. A new and flexible kind of fantastic, erotic theater had been born. Where it stood in the hierarchy of genres was never at issue because, as a genre "with no rules," it simply fell outside that hierarchy—indeed outside of literature altogether. Because of its incompleteness, the heterogeneous mix of texts and kinds of performance that went into its making, it was as far removed from the here and now as high tragedy, without for all that forsaking the most direct contact with immediate sensual life: flirtation, lust, scatology, pratfalls, the dizzying defiance of gravity by the tightrope acrobats. The sophistication of the exiled Italians guaranteed that their product would never be so crude and haphazard as to fail to repay serious attention. Yet at the same time, the apparent artlessness of the playing made it imitable by an elite clientele: it could play the parts with relish but without any odious professionalism.

We speak often of the erosion in eighteenth-century France of the stable cultural orders established in the century before: the rise of the novel, the cult of sentiment, the *drame bourgeois*, the greater vitality and aesthetic superiority to be found in the lower genres of painting. But we speak comparatively little of the concrete practices by which those orders were made unstable, by which persuasive substitutes were discovered and applied. In the active conflict between official and unofficial forms of theater, an important new mode of elite conduct was generated. The limited clientele of the amateur *parade* may tempt us to see it as an essentially private kind of cultural practice, but it was in fact the result of certain legitimate but outmoded literary forms being transformed in the crucible of an improvised, illegitimate public arena. This public space paralleled the one developing in the realm of the visual arts to the extent that it emerged from a conflict

16. Antoine Watteau, *La Perspective*. About 1715. Oil on canvas, 46.9 × 56.7 cm. Museum of Fine Arts, Boston

over legitimacy. It is not to be identified with either the official cultural institutions of the modernizing state or with the older, festive forms of "popular" collective life embodied in the fairs: it was rather the very process by which the former was resisted and modified by the latter. As it proceeded, that resistance, though perhaps atavistic in origin, took on a good measure of the intellectual resources and self-consciousness of its official antagonist. Something new had been born: the fair players made the very break-down of cultural certainties into a portable spectacle which could be appropriated and put to use by that idle and sophisticated elite to whom high culture mattered most.

—ii—

The preceding introduction to the cultural skirmishes of the early eighteenth-century fairs will have a direct bearing on practices of unofficial art exhibition to be discussed in the following chapter. More immediately, it brings us to a consideration of the first major artist to be substantially, even decisively, influenced by the public arena in the sense defined above. He is not one of the ostensibly "public" history painters of the Academy, not a Coypel, de La Fosse, or Boullogne: it would be difficult to identify an important element in the work of these preeminent artists of the day which had been seriously modified by exposure to general public scrutiny or by the privilege accorded such scrutiny in advanced theory and official statements of purpose. The painter whose project came to be defined in the give and take of public cultural life was one far less visible to any truly public audience. This was Antoine Watteau. My account of the elite theatrical play promoted by Gueullette will have brought images from Watteau into the mind of every reader, and appropriately so. The artist's protector Crozat maintained an elaborate *maison de plaisance* and pleasure park north of Paris at Montmorency. A glimpse of its architecture appears in one of Watteau's early *fêtes galantes* (Plate 16). In the costumed promenaders, music makers, dancers, and flirtatious lovers that inhabit the genre, we are looking at a social phenomenon as actual as their setting. The famous ambiguity of costume and status in Watteau's pictures was one deliberately sought by many of the people he painted and painted for. How deep the play could go is indicated in this reminiscence by Gueullette of the habitual behavior of Pierre Pasquereau, one of his faithful companions in farce:

17. Antoine Watteau, *The Shepherds*. About 1716. Oil on canvas, 56 × 81 cm. About 1716. Schloss Charlottenburg, Berlin

Using the name "Bertrand" and in the dress of a true peasant, he imitated people
of this sort with such naturalness and accuracy in speech, song, and dance that when,
after changing his make-up and costume, he came to sup with people meeting him
for the first time, they never recognized him. And when we "unmasked" him, they
would never believe that this was the same man they had seen that afternoon.[34]

Once we take account of this kind of behavior and its penetration into elite sociability,
it becomes difficult to see Watteau's *fête galante* as a purely personal theater, a fantastic
transformation of prosaic experience. That this has been the guiding assumption in even
the best literature on the artist hardly needs underlining. A juxtaposition like that of
the bagpipe-playing rustic in the *Shepherds* (Plate 17) with a group of elegantly dressed
aristocrats is thought to have had no counterpart in the realities of eighteenth-century
life.[35] That conviction is in part what has sustained our belief in the artist's extraordinary
powers of invention. But without denying them in the least, we can ground those powers
more securely in his attention to observable details of aristocratic leisure, his eye directed
precisely to stylized and theatrical ambiguity of appearance. If, as Caylus relates, Watteau
kept a supply of *galants* and *comiques* costumes in which to pose his friends, he was only
following a common practice inaugurated by Gueullette in his amateur *parades*. The
costume of peasant or comedian which appears so often in these scenes is, as René Démoris
has pointed out in an unjustly neglected essay, "less the sign of a profession than of
a noble diversion, than of a being capable of giving his life the dimension of fiction . . ."[36]

But if there is nothing imaginary about the subject matter of the *fête galante*, if the
activities and costumes which Watteau depicts were present in his daily experience as
a protégé of the Crozat circle, it would nevertheless be far too simple to see these pictures
as a literal rendering of the life around him, however much accuracy of description they

might contain. The genre is a frankly artificial one: it had to be if it was to add another, necessary layer of fiction over the life-as-fiction it portrays, that is, if it was to be in any way distinguishable as a mode of representation from the already existing lower genres. Its emergence can be traced via Watteau's own passage through the milieu of fair entertainment and a series of marginal, often highly unrealistic—or anti-realistic— forms of artistic practice. Rather than some kind of "realist" grounding of the genre, we are dealing here with two related and artificial systems of representation being maneuvered into productive contact.

We need to begin soon after the artist's arrival in Paris. Thanks to his continuing contacts within the Flemish colony, he was not allowed to languish with the taskmaster of the Pont Nôtre-Dame. Sometime in 1704 or 1705 he went to work for Claude Gillot and found his first real teacher. Gillot had begun his career as an apprentice to the academic painter J. B. Corneille and had his sights on that status for himself (he would finally gain membership in 1715, shortly before his famous pupil, with a *Passion of Christ* as his reception piece). In the meantime, he maintained a varied and eclectic practice. Designs for popular engravers and small cabinet pictures were his principal line. The subjects for a major part of his work were drawn from the Italian comedy, and more particularly, the companies of the fairs. Some of these were vignettes of indi- vidual players of the kind produced by Callot and others before him. He also painted groups of characters in scenes from well known plays (Plate 18). These Gillot would normally assemble out of his stock of single figures rather than composing his groupings from scratch. Neither master nor pupil was at this stage disposed to create more integrated

18. Claude Gillot. *The Scene of the Carriages.* About 1707. Oil on canvas, 127 × 160 cm. Louvre, Paris

20 (facing page left). Claude III Audran, design for an arabesque. Nationalmuseum, Stockholm

21 (facing page right). Claude III Audran, design for an arabesque. Nationalmuseum, Stockholm

19. Claude Gillot, *The Trojan Horse*. About 1707. Oil on canvas, 53 × 45 cm. Musée du Breuil de Saint-Germain, Langres

figural compositions. The curiously additive and disconnected quality which resulted can be seen in one of Watteau's exercises in the same mode: the lost *Departure of the Italian Comedians* (Plate 13) which survives in print form. The picture was probably a true apprentice piece, executed after Gillot's drawings of each figure in isolation.[37]

To work with Gillot was then a two-sided experience, one split between high and low. The older artist's training and aspirations were for the Academy, yet his day-to-day practice had little to do with high ideals. And all the evidence points to Gillot's involvement with the outlaw comedy of the fairs going beyond representation to participation. He cultivated contacts with the players, painted sets and signs, and, in 1708, may have operated a marionette theater (the *Hôtel des comédiens de bois*) on his own account.[38] These were enjoying a vogue similar to that for the *danseurs de corde*. Actors used puppets as another way to evade the prohibitions on stage dialogue and played to equally fashionable crowds. Nemeitz speaks of one puppeteer in the St. Germain fair besieged night after night by overflow audiences.[39] The ubiquitous Gueullette and his friends took up marionettes as one medium for their *parades*. Gillot, further, may have been himself the author of at least two scenarios for Italian comedy, one for a ballet pantomime, and one for marionettes.[40]

Watteau broke with Gillot after two or three years. The reasons for the split have never been discovered, but his next move, to the studio of Claude III Audran, took him closer to the centers of power and patronage. First of all, he now enjoyed the protection of his employer's uncle, Gérard Audran, a print-maker and academician, and thus was able to begin training as a formal student of the Academy. His new master, moreover, was just coming into his own as the dominant designer of decorative interiors in Paris.[41] In 1708 and 1709, he worked on the residence of the Dauphin at Meudon as well as the château of La Muette in the Bois de Boulogne for Fleuriau d'Armenonville, the new

minister of finance. His popularity was built on his revival of the *arabesque* as a decorative mode (or, in earlier usage, the *grotesque*, the antique form involving the fanciful interweaving of human and animal forms with foliage and scrollwork, which had already undergone one revival during the Renaissance). As a form of architectural embellishment, it was particularly suited to the country *maison de plaisance*, or to evoking that ambience in a city interior. The large collection of Audran's drawings preserved today in Stockholm demonstrate a consistent stress on the more playful, outlandish and hybrid possibilities of the form. Though the vocabulary is for the most part classical, it is with all the weight of seriousness removed. One of Audran's vignettes might be a warrior in cuirass and plumed helmet, but instead of assuming a heroic stance, the legs of the figure will turn into a pretty pirouette (Plate 20). In this kind of work, Watteau's command of the imagery of the fairs stood him in good stead. Travesty of the classics was the *forains*' stock-in-trade. One of Gillot's rare surviving paintings had a classical subject, the *Trojan Horse* (Plate 19), but the scene depicted derives not from Homer but from a play for marionettes by Fuzelier entitled, *Harlequin-Aeneas, or the Fall of Troy*, first performed in 1711 at the St. Laurent fair.[42] In this version, the horse takes the form of an ass, and Scaramouche uses an enema syringe to make it defecate the Greeks (Gillot gives this role to Harlequin in the picture). While Audran certainly abjures this particular brand of humor, the motifs in his *arabesques* come most often from the lower, bodily-oriented segment of the classical repertoire: heads of Bacchus, sileni, dolphins as messengers of love (Plate 21). There are mythical beasts of mixed, transformative character such as tritons, chimeras, and sphinxes. Among earthly animals, the most common are monkeys, which will often occupy a lower register parallel to human figures above, imitating and mocking their serious activities (Plate 22). There are precedents for the *singerie* in Flemish painting and more generally in the ape lore of antiquity and the Renaissance[43]; monkeys are traditional symbols of both sexual license and mocking imitation, and in the latter sense serve as deflating alter egos of the artist. But a more direct contemporary reference takes us again back to the fairs, where trained apes and monkeys were among the most popular of its attractions. One trainer was said to have made the phenomenal sum of 5,000 livres in one season at the St. Germain fair, and the animal's tricks correspond at many points to the busy monkeys of Audran's invention:

The ape dressed first as a musketeer, then as a young girl, and afterwards as a harlequin. This animal saluted the gathering, doffed his little hat and put it on again; it took its little rifle and performed all the exercises of an infantryman, drew its pistol, danced a minuet, made several turns of the ring mounted on a dog and holding a flag in its hand, and performed several other tricks.[44]

And finally, Audran includes direct reference to contemporary human entertainment: scenes of *danseurs de corde* and other acrobats (Plate 23) combined with bizarre imaginary personages. These are very like some of Gillot's drawings or the theatrical sign visible in an engraving of a fair theater by Picart (Plate 12), the sort of sign Gillot might well have supplied.

So in a way parallel to the elite appropriation of the *parade*, leaders of fashion favored in their interior décor the same playful mix of levels of seriousness and otherwise exclusive symbolic vocabularies. Like their dramatic equivalents, these decorative forms were not so much an inferior mode of art as they were outside the hierarchy of genres altogether, a mode which permitted unprecedented combination and interplay of genres. In a draft version of his biography of Watteau, Caylus notes that Audran allowed clients directly to join in the game, that he "would reserve places in these sorts of compositions for different subjects to be determined by the wishes of the individuals decorating their ceilings and panelling in this genre."[45]

LE SCARPOLETE

26. After Antoine Watteau, *The Swing*. Etching and engraving

22 (facing page top left). Claude III Audran, decorative motifs. Nationalmuseum, Stockholm

23 (facing page top right). Claude III Audran, decorative design. Nationalmuseum, Stockholm

24 (facing page bottom left). After Antoine Watteau, *The Apes of Mars*. Etching

25 (facing page bottom right). After Antoine Watteau, *The Children of Momus*. Etching

Among Watteau's own designs, there are some which stick close to Audran's example in their organization and choice of elements. The *Apes of Mars* uses the martial monkeys of the fair as a mocking lower register to a central image of the seated god of war (Plate 24). A frivolous disillusion with the defeats and costs of recent campaigns is surely present in this particular classical travesty. Like one of Audran's designs, it is relatively spare with a good deal of blank space, the separate elements balanced and small in scale. The majority of the younger artist's preserved works, however, depart from this established pattern. The central motif tends to expand and draw the surrounding elements into a tighter and more responsive frame around it. The relatively early *Children of Momus* (*c.* 1708) (Plate 25) creates a sort of frame within a frame, a miniature theater in a pastoral setting. Like the actual juvenile performers sometimes used in the fair comedy as yet another way to evade the monopoly of the *Comédie*, children occupy the center stage dressed as *putti* and characters from the Italian stage. Above a fountain in the form of paired dolphins, the face of Colombine shines from a circle of roses. His later designs deploy these mixed classical/popular materials in increasingly pictorial compositions. In an *arabesque* like *The Swing* (Plate 26) (which virtually introduced the subject into the iconography of Western art),[46] there is a greater confusion still between the abstract

27. After Antoine Watteau, *L'Amour mal accompagné*. Etching and engraving

28. After Antoine Watteau, *La Cascade*. Etching and engraving

border surrounding the central vignette and the props—trees, vegetation, architecture—which belong to the illusionism of the scene. The confusion is deliberate, and the effect is one of suspension between pictorial unity and free decorative fantasy. The various emblematic elements of the frame hover just beyond the reach of the illusionistic space but close enough so that their mixed symbolic load spills into our reading of the enclosed drama. Below the richly dressed lovers, posed in the costumes of the stage, rest inflated bagpipes, a sign of rustic pleasure, but more pointedly in folk symbolism, of the male genitals; a woman's cast-off hat, shawl, and tipping basket of flowers rest against them. That bawdy subtext from the popular tradition is itself framed above and below by symbols from the classical lexicon of pleasure: the horned male goat as another symbol of aggressive lust bears down from the top center while a world-weary head of Bacchus closes the design at the bottom. The silenus terms seem implanted within the world of the lovers—is it a stage set? a pleasure park? a pastoral never-never land?—and support an airy canopy that shifts at its outer edge into a flat decorative border, part of the cartouche that encloses the goat. A path emerging below the swing artfully suggests, but does not define, a spatial link to the rocky bridge on which the bagpipe still-life is poised.[47]

At its most subtle, the *arabesque* format allowed playful and intriguingly layered allegories of desire which could make reference to contemporary experience without being merely imitative of it. It was Watteau's great and original move, in 1712 or 1713, to project the disjunctive strategies of the *arabesque* into an apparently unified moment in space and time. Certain very early pictures anticipate the procedure and document a contemporary taste for the most implausible allegories of pleasure. The rather maligned *Amour mal accompagné* (Plate 27), perhaps done during his stay with Gillot, could be an *arabesque* come to life on an improbable single stage: there is a monkey dancer mounted on a bust of a female pan, a monkey musician below with (naturally) bagpipes, and, removed from the action, a monkey Gilles in the exact pose of Watteau's famous painting of the following decade. A classical emblem comes to life in the foreground as *putti* try ineffectually to tame and ride a stubborn billy goat.

The same *putti* and goat, now spouting water into an overflowing fountain, turn up in the *Cascade*, probably painted in 1715 (Plate 28). And the same message of hurrying physical desire, pointed straight at the back of the hesitating young woman, is more than clear; the twisting, lubricated energy of its rise is irrepressible and charges with anticipation the suspended human action on the other half of the stage. This picture, and the *fête galante* form in general, preserve the emblematic interplay and metamorphoses of the later *arabesques*. The organic, rectangular frame, which had stood metaphorically for the borders of the "garden of love", now appears as a garden setting in space, but whether actual, theatrical, or fictional is a moot question: some pictures will favor one interpretation more than others, but no reading can be conclusive. The players in the central vignette now stand in that space and multiply in numbers, while the various allegorical symbols insert themselves into the scene as accessories, instruments, and props. The *Shepherds* (Plate 17) joins another swinging couple with an actual player of bagpipes in rustic dress, the discrete frame of trees around the swing still preserving the effect of a vignette. The inscrutably titled *Fêtes vénitiennes* (Color Plate 1), painted about the same time, retains even more of the symbolic economy established in the *Swing*. The swing itself is gone, now completely displaced by dance as the central love play, but the bagpipes remain, played by a more fancifully dressed stage peasant traditionally taken to be the painter himself. Directly above the upright torso of the doll-like female dancer, the baleful male goat, sculpted onto a mammoth urn, gazes down. The black-caped figure, the detached *lorgneur* of so many of Watteau's *fêtes galantes*, reproduces the jaded, knowing presence of Bacchus. The artist's friend and fellow painter Vleughels is the model for the figure in oriental drag at the left. His portly figure, courting and strutting before his contained partner, appears comic at first, but there are signs of a sexual conquest in the offing: the goat's presence above and the man in black, already departing with a woman, who looks back at Vleughels while suggestively gesturing toward the nude female statue. These statues work as another kind of emblem, present in almost every picture. Reclining voluptuously as here or stirring into rude, carnal wakefulness, they serve as living figures of the desire hidden beneath stylized costume and restrained gesture. Via the "innocence" of the work of art, Watteau can allude to the erotic obsessiveness which was an inescapable part of his subject. Those six elements—Vleughels, his partner, the *lorgneur*, Watteau as piper, and the two tell-tale sculptures—are the strong points of meaning in the composition, which signal to each other across the supporting matrix of landscape and linked subsidiary figures.

This dispersed constellation of signs functions to a significant degree independently of the "scene" before us. Its allegories guarantee its status as fiction, as a work of and for the imagination; it cannot be read as a faithful (and inevitably inferior) reproduction of a pre-existing reality. Watteau's treatment of the human actors reinforces that refusal. The blockage of narrative or emotional unity, which has become a commonplace in discussion of the artist, produces more than enigmas: one of its effects is to prevent the non-human elements of the symbolic play from becoming mere accessories, that is, forming a clearly secondary register of commentary behind a self-sufficient human drama. As his friend Caylus later put it, ". . . his compositions have no focus, they do not express any passion, and therefore lack one of the most exciting elements in painting, namely action."[48] Merely dressing the pleasure-seekers in theatrical costume contributes significantly to this end, since Watteau never shows an actual amateur performance. Divorced from any obvious scenario, the stereotyped roles become anti-dramatic, interfering with

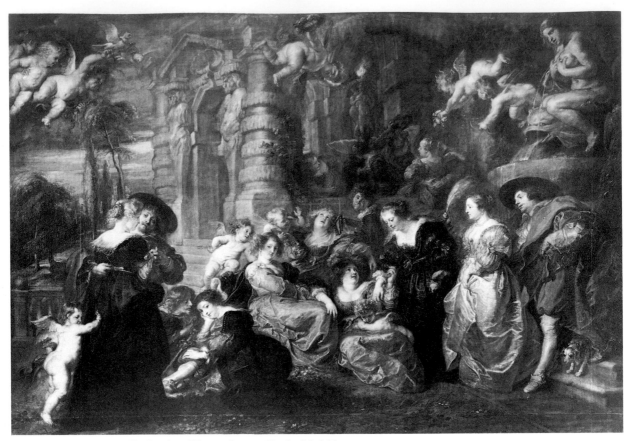

29. Peter Paul Rubens, *The Garden of Love*. 1632–34. Prado, Madrid

the readability of the picture in dramatic terms. These might be moments before or after a play, but it would be truer to their fundamental removal from the here-and-now to say that they posit theatrical disguise as a condition of leisure and therefore of nobility.

To note the allegorical character of Watteau's mature art is, of course, no new observation. Numerous antecedents for both the surface subject matter and the play of coded symbol can be cited in earlier art, particularly in the merry companies and outdoor concerts of seventeenth-century lowland painting.[49] Watteau's northern origins and his acquaintances in Paris argue for a thorough familiarity with this kind of imagery. But the central question remains how that kind of allegory was made available as an image of elite pleasure in early eighteenth-century Paris. Clearly, the moralizing and Christian character of the Dutch and Flemish examples was of little use to Watteau's clientele. Mordant reflections on the hollowness of ritual play, perhaps, but implied censure, no. The evidence is, in fact, that, despite the vogue for northern genre, much of its original content was opaque or uninteresting to its French enthusiasts. Once in France, for example, a brothel scene by Terborch was retitled *Paternal Admonition*; Teniers' *Seven Acts of Mercy* was secularized and sentimentalized in an eighteenth-century catalogue into *A Good Old Man Giving Bread to the Poor*.[50] Watteau, however, by finding his subject and his means much closer to home—and outside the traditional boundaries of high art—was able to re-engage an older allegorical tradition for his own ends. One of the strongest examples of that tradition and his most obvious point of departure, Ruben's

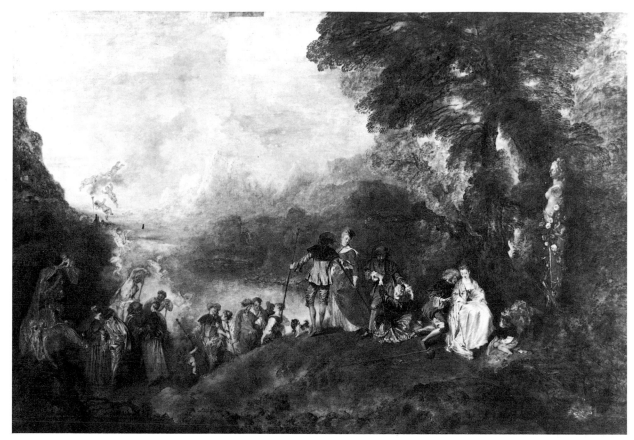

30. Antoine Watteau, *Pilgrimage to the Island of Cythera*. 1717. Oil on canvas, 127 × 192 cm. Louvre, Paris

Garden of Love (Plate 29), was immediately available to him. A copy of the picture belonged to one of his patrons, the comtesse de Verrue, who, as the *Dame de Volupté* of later legend, played a highly visible part in the libertine subculture of the Regency.[51] He probably knew the picture well from 1710 on, and its narrative chain of love's varied stages has left a visible mark on a number of his compositions, including the *Fêtes vénitiennes* and the *Pilgrimage to the Island of Cythera* (Plate 30). But that narrative is projected into a vastly different pictorial economy. The mood is all irony; the attenuated and self-effacing figures give no purchase to the "robust" allegory of Rubens or to the complex of conventional and reassuring meanings it embodies: that is, eroticism as resolved and contained in the institution of marriage.[52] Watteau's disjunctive syntax permits allusive reference to an eroticism that tests the limits of the permitted rather than confirming them.

–iii–

We are looking at the origins of the Rococo in painting, a thematic and stylistic mode whose original ironies and perversity would be largely lost in Boucher and recovered, to a degree, by Fragonard. But we are also uncovering the stamp of public life on art precisely where we would least expect it: in an art that seems to stand for a privileged and privatized withdrawal from the world of ordinary men and women. This reading

runs against the grain of, for example, Mikhail Bakhtin's commanding account of the estrangement between high and low culture after Rabelais.[53] For Bakhtin, the Rococo spirit emerges from a thoroughly unproductive split in eighteenth-century artistic production: the fantastic and scandalous loses its public means of expression and retreats into individualized and monotonously sexual forms, while the public sphere assumes a relentlessly sober and improving character. The time was long over, he claims, when high art could renew itself by joining its historical consciousness and technical proficiency to the disruptive and regenerating energy of popular, festive laughter. But while the efforts of a Gueullette or a Caylus in the popular mode may have done relatively little for literature, the example of painting reveals that the cross-fertilization between high and low could still have the most productive results. The public space of the Paris fairs remained an active zone in which apparently fixed cultural categories were subjected to continuous pressure, transgression, and re-combination. And out of that was generated a new, potent kind of painterly practice: the first coherent response in art to an important feature of elite status and behavior.

The Academy of course recognized Watteau's invention as a new approved category of painting on his reception in 1718. The point of the preceding discussion has been that a mode of art adequate to the double task of both representing and fictionalizing a novel, complex form of elite behavior came into being in a way parallel to the origins of its subject. Both subject and artistic response required a passage through a low or marginal form of artistic practice. And in neither case did this mean a simple connoisseurship of the popular or a detached, aestheticized borrowing from it. Both demanded a concrete, practical penetration into the culture of an active, mixed public. Watteau's deep personal attachment to the *forains* has been well documented, first by Dora Panofsky[54] and later, with greater precision, by A. P. de Mirimonde.[55] These writers concentrate on those pictures which depict professional actors, and Mirimonde particularly has shown that Watteau's growing concentration on the peculiarly French (that is, non-Italian) figure of Pierrot/Gilles represents an allegiance to the fair comedy over the restored official Italian troupe. But such pictures make up a relatively small part of the artist's mature output; no art historian has extended discussion to the amateur *parade*, that is, to the elite appropriation of the popular form independent of Watteau's personal iconographic choices.[56] The *arabesque* provided a vehicle for an analogous appropriation in graphic form, which Watteau was able to transform into a new allegorical mode. No allegory can decode itself: it requires some relatively fixed and stable set of referents outside the work of art. That is what the *forains* supplied, first for the frankly "non-serious" decorative schemes of Audran and his assistants, and later for the *fête galante*.[57]

In the process, Watteau found a means to represent, for the first time in visual terms, that set of contemporary aristocratic values and modes of behavior which together fell under the category of *honnêteté*. In this sense, the *fête galante* was less a cyclical reaction to the pomp of Le Brun's classicism than it was a tardy visual realization of an ideal form of life which had always existed apart from and even in opposition to the demands of the court. Those familiar with the cult of *honnêteté*, from the marquise de Rambouillet's *chambre bleue* to the chevalier de Méré's late seventeenth-century codification of the *honnête homme* as an ideal type, will find nothing surprising in Watteau's cultivation of indirection and ambiguity to the point of enigma. Over the course of the previous century, these qualities had been enshrined as the essence of true aristocratic deportment.[58]

The work of defining who and what embodied this elusive concept of *honnêteté* has its own history (and to grasp its seventeenth-century uses we must forget the English cognate entirely). At first, as articulated in treatises such as Nicolas Faret's *L'Honneste homme, ou l'art de plaire à la cour* of 1630,[59] the term designated a more or less stoic ideal of selfless service to the state. The chaos of the Wars of Religion had shown the French *gentilshommes* or *noblesse de race* in all their late-feudal violence, irrationality, and ignorant self-indulgence. In the first decades of the seventeenth century, the seigneurial class desperately required an image and ideology of self-discipline and responsibility if it was to hold its own in the face of an encroaching absolutism. Increasingly (partly to forestall bourgeois opportunism), the old nobility began to move into the ranks of venal state *officiers*; the illiterate marauder of 1600 was now to be a polished and effective man of the court. For models, early guides like Faret's reached back to the classical texts on civic virtue. But the relevance of that ideal was short-lived. The swelling ranks of low-born royal *commissaires* pushed aside both the *noblesse de race* and the heirs of the ennobled *officiers* who had established their prerogatives in the previous century. (This was a prime underlying grievance behind the spasm of the Fronde.) As the opportunities for actual state service decreased, it became imperative for the genuine nobleman to distinguish himself from the actual service class—the upstart creatures of Richelieu, Mazarin, and Colbert. The traditional *officier* class (the *nobles hommes* as opposed to the *gentilshommes*) displaced its thwarted ambitions variously into scholarly retirement, Jansenism, and somewhat restive country life (Montaigne being the operative model).[60] The ancient nobility, on the other hand, predictably abjured such earnest concerns. Increasingly, another ideal of courtly life began to dominate the instructional treatises, like those of Méré, which were published during the reign of Louis XIV.[61] The *honnête homme* now embodied a fastidious withdrawal from any mundane interest, despising all that was practical and common, crafting a superior identity out of an ever more refined *politesse*, in a life of studied leisure broken only by warfare. Now the highest nobility was to be expressed through a conspicuous independence from any need to cultivate royal favor.

In Faret's treatise, instructions to those who wish to "please at court" is quite close to Le Brun's later, very civic-minded sensibility. The outward gesture and expressions of the courtier are transparent and immediately legible signs of his inner qualities. But that classically-derived model survived among the old nobility only as long as its members still counted on recovering their old liberties and regaining hegemony over the state. As early as the 1630s, the great families were establishing their own (and, in their eyes, superior) centers of courtly ceremony and style. The memoirs of Pierre Lenet describe the mode of life at Chantilly in 1650 among the family and clients of the imprisoned arch-*frondeur* Condé:

> It was the greatest pleasure to see all the young ladies who made up the court there sad or gay, depending on the rare or frequent visits or the nature of the letters they received; and as one who knew a bit about their affairs, it was easy to enter into the game and gain amusement in doing so. There were some who were attached to the same gallant, others who believed themselves to own the hearts of several and in truth owned none, and others who yearned after someone other than the one who paid them court. Still others held the hope of being the only one to receive the devotion of all; and in truth, they all deserved this honor. Out of all this were born attachments of

friendship between some, frost between others, according to whether their gallants were allies or enemies on the field; and as the greater part were absent in the service of the princes [Condé and Conti], we constantly witnessed the arrival of messengers, which aroused great jealousy in those who had received none; and all of this drew from us couplets of songs, sonnets, and elegies, which diverted the onlookers as much as the participants. We fashioned games of end-rhymes and poetic enigmas which filled the time in those lost hours. We would watch some of our number wander along the banks of the ponds, in the alleys of the garden or the park, on the terrace or across the lawn; alone or in groups, following the impulse of the moment; while others of us sang an air and recited verse, or read novels on a balcony, while strolling or while seated on the grass. Never has one seen such a beautiful place, in such a beautiful season, filled with better or more agreeable company. . . .[62]

As the text itself intimates, this scene is the reverse side of the bloody confusion on the battlefield (intrigues such as the ones Lenet describes would have much to do with Turenne's decisive switch in sides). This is an image of the grand nobility in retreat, carrying on its last desperate resistance to the consolidation of the absolutist state; it was here where its greatest warriors would rest from the campaigns. It is also a nearly perfect verbal match to any number of paintings by Watteau. Then, as later, the social form that retreat assumed was a perfection of style, *politesse*, and nuances of emotional intrigue. In small coteries (the Hôtel de Rambouillet providing the original model), withdrawn from the direct, often crude speech and deportment which characterized the court in the first half of the century, an ideal of *honnêteté* had emerged which opposed, in its mode of signification, the classical model of Faret. The body was no longer thought of as the mirror of the soul, but became rather a malleable surface which, when employed properly, worked to block the transmission of direct or transparent meaning. The essence of *honnêteté* lay in the maintenance of artifice and secret penetration of the artifice of others; the decoding of hidden messages and undeclared desires. Its ideal was an infinite responsiveness, one keyed by the words *complaisance*, *souplesse*, and *insinuation*. As Méré advised one of his pupils, "Those who have found nothing more appealing than virtue have not felt these so very piquant graces which appear in your person and in your smallest movements. In them is a secret magic that would baffle the highest wisdom."[63] Within the Rambouillet circle, the forthright passions displayed by the heroes of the courtly *roman* had already been thoroughly subverted by its dominant male figure, the poet Vincent Voiture. In his love poetry and in the studied behavior of the group in general, the stuff of romance—desire, longing, jealousy, loss—was deliberately hidden or misdirected. The masking of desire and the play of disguise was the source of endless games and literary conceits. Voiture, typically, titled one of his poems, "Verse written with the left hand on a page facing a mirror placed inside the cover of a notebook."[64] His patroness could orchestrate a physical environment imbued with the same sensibility, one which mixed the theatrical, the mythological, and the actual in seemingly artless, impromptu tableaux. Voiture relates in a letter of 1630 one such surprise prepared for the habitués of the Hôtel Rambouillet on a country outing:

At the end of a grand *allée*, hidden from sight, we found a fountain which by itself spouted more water than those of Tivoli. Around it were arranged twenty-four violinists who could barely make themselves heard above the noise of the falling water.

When we had approached more closely, we discovered inside a niche in the enclosure an eleven- or twelve-year-old Diana, and one more beautiful than the forests of Greece or Thessaly had ever seen. She carried her bows and arrows in her eyes and shone with all the brilliance of her brother. In another niche nearby was one of her nymphs, beautiful and charming enough to belong among her attendants. Those present who did not believe in myths believed that these were Mlle. de Bourbon [sister of the *grand* Condé and the future duchesse de Longueville, herself a leading *frondeur*] and the virginal Priande [Mlle. Aubry, the future duchesse de Noirmoutier]. And in truth there was a great resemblance. Everyone was speechless in admiration of so many things that stunned the eyes and ears, when suddenly the goddess leaped from her niche, and with a grace no one could possibly represent, began the dancing which went on for hours around the fountain.[65]

Not only the preadolescent Mlle. de Bourbon, but most of that later company at Chantilly described by Lenet were present at this earlier *fête galante* (the festivities were all in honor of Condé's mother). I have quoted these accounts at length not only for their sheer appeal but to demonstrate the modes of leisure cultivated by the grandest princely families in France. The flight from the court was not a phenomenon unique to the early eighteenth century, but a longstanding and tenacious resistance to the assimilation of noble *oisiveté* to *raison d'état*. And that symbolic resistance was occasionally accompanied by the more active kind, up to and including armed conflict. No text of Watteau's time could come closer to the tone of his *fêtes* than Voiture's letter, complete with impudent animated statuary, written nearly a century before. And no painter before Watteau was sensitive to that abiding sensibility. For most of the high nobility, the sort of Italianate codification of the visual arts enforced by Colbert would have been no more congenial than any other form of systematic learning (hence the isolation of the young Academy of Painting discussed in the previous chapter). There is much evidence to document the hostility of the *gentilshommes* to literature which adhered too rigorously to classical models or paraded heavy antique metaphors: that smacked of bourgeois pedantry and was thought appropriate only for an audience of dreary scholars and schoolteachers.[66] Comparative ignorance of and lack of interest in classical learning seems to have prevailed among this class until at least the 1660s. The principal effect of more widespread learning may have been to broaden the readership of classical travesties like Scarron's *Virgile travesti*. While Boileau attacked the genre as a vile contagion passed upward from the bourgeoisie to the elite, Charles Perrault found nothing undignified in the practice and asserted that the hunchbacked Scarron, whose *Roman comique* celebrated a ragged troupe of itinerant actors, "always appeared the gallant and always had the air of the court and of the highest society."[67]

All this provides Watteau with a long and fairly direct pedigree. And there can be no doubt that the artist's circle was acutely aware of these precedents. Honoré d'Urfé's pastoral romance *L'Astrée*, which had played such an important part in the early articulation of *honnêteté*, was undergoing a revival in the early eighteenth century in both straight and parodied versions. *L'Astrée* and subsequent seventeenth-century romances like *Le Grand Cyrus*, Madame Scudéry's *roman-à-clef* homage to the young Condé and his sister, provided a frequent and explicit foil for the Italian comedians. In one play, *Arlequin Misanthrope* by Louis Biancolelli and Brugière de Barante, first performed in 1696, Harlequin invokes these heroes while reproaching Colombine for resisting his advances:

Do you want to practice the methods of romances?
Do you believe you can oblige me to moon after you in the woods?
Are you trying to direct me like a modern-day Céladon [d'Urfé's perpetually yearning shepherd-hero]
A hero of Cyrus without fear of weakness . . .?[68]

A scene from this play may have been, as Julie Anne Plax has plausibly argued, the direct inspiration for one of Watteau's finest pictures, *Voulez-vous triompher des belles . . .* in the Wallace Collection (Plate 31).[69] The space of the picture is divided into two distinct compartments. The foreground is dominated by Colombine and the awkwardly importunate Harlequin. The background is occupied by an oblivious quintet of refined, costumed figures—a lady with two suitors and their valets—arranged in a traditional pastoral concert. As in many of Watteau's pictures, the fretted instrument, with its multiple tunings yet effortless chording, is the metaphor for the achievement of love's harmonies. That association of the guitar or lute with the ideal courtier's insouciant production of harmonizing strains goes back to Castiglione. In step with the character of Harlequin, the painter here exposes the referential poles of his practice, juxtaposing the bumptious loveplay of the *parades* with the ideal image of refined courtship.

This picture is less one of reaction against seventeenth-century prototypes of the love game, or a mocking deflation of them, than it is an image of their survival and transformation. The whole cult of *honnêteté* demonstrates the longstanding contradiction between the cultural demands of the absolutist state and the needs of the high nobility. Too often we conflate the two and miss the resistance of the latter, resistance increasingly displaced into style, leisure, and intimate forms of art. The definitions of high art offered by the Academy of Painting were essentially inclusive, intellectually universal, and national in purpose, while the essence of any aristocratic art lies in its exclusivity, its enforcement of boundaries, and opacity to outsiders. When Elias states that the hierarchical forms like classical tragedy show "courtly people as they would like to be and, at the same time, as the absolute prince wants to see them," he suggests an automatic coincidence of interests which rarely applied in practice. Seventeenth-century classicism required an unreal and unrealizable removal from sensual life; for a class which required metaphors for a privileged existence displaced into leisure and elaborate sensual gratification, the unrelieved seriousness of tragic drama and its equivalent in painting were of marginal usefulness. In both literature and art, the existing hierarchy of genres proposed only two unusable alternatives. Heroes consumed by passions unknown to ordinary mortals could not attend to the contingent details of worldly experience. Concern for physical reality was reserved in literature for non-noble characters—bourgeois, servants, peasants—and in painting for the inferior genres. And one of the reasons those types and genres were marked as inferior was their total identification with material life, the fact, so it was believed, that they made no demands on the higher imaginative faculties.

The actual practices of high noble culture were, as we have seen, inhospitable to relentless high-mindedness and far less rigorous in their strictures. A studied effect of artlessness rather than grandeur was the goal. It is not then wholly surprising that the Regency elite should embrace another kind of resistance against state pretensions to monopoly over cultural expression, that of the outlaw *forains*. Yet the success of Watteau in fashioning a coherent visual image of this resistant mode of aristocratic life points, in a paradoxical way, to important inroads made by the Academy and its partisans. Watteau's art is essen-

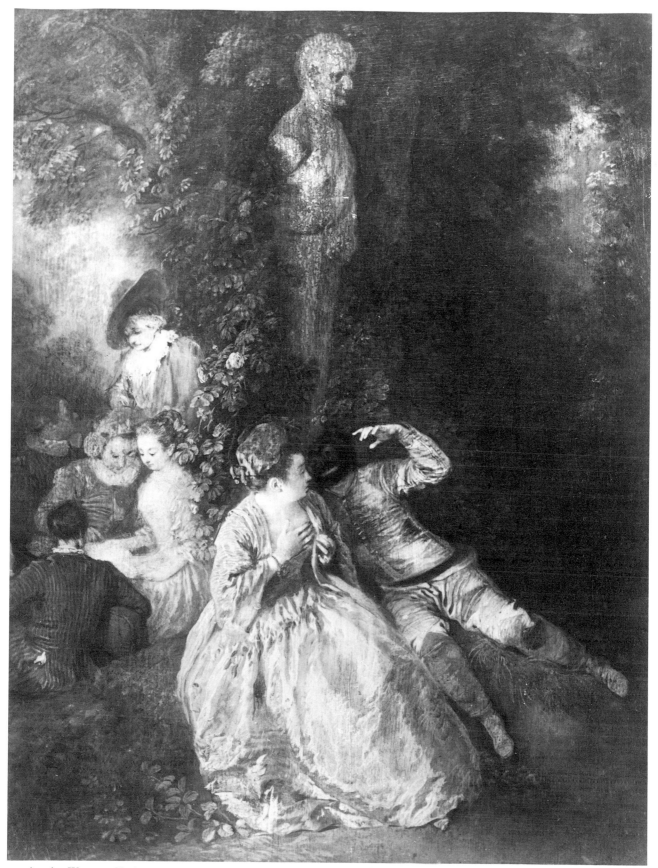

31. Antoine Watteau, *Voulez-vous triompher des belles* . . . About 1718. Oil on canvas, 37 × 28 cm. Wallace Collection, London

tially a *belated* phenomenon: why did it take so long, we need to ask, for the withdrawal of the high nobility to find its representation in paint? It is this question most of all that joins the art of Watteau with the main direction of our inquiry. In order for painting to be available as a symbolic resource to the Parisian aristocracy, the status of both art and the artist had had to change.

To start with the simplest reason, a painter could not have had access to the Hôtel Rambouillet or to the Condé's Chantilly. A commoner like Voiture could use literary talent to gain a social footing among the elite, but a French painter in 1630 or 1650 was still a mechanical tradesman without the remotest hope of acceptance in such circles. There would consequently have been no avenue for the artist to penetrate the intricate and subtle codes at work among these elites.[70] Nor was there, before 1670 or so, any appreciable sophistication among the high nobility in visual aesthetics or the history of art. The impetus for change came largely from outside these elites, that is, from the Academy and the interested amateurs linked to it. Later it would be taken up by a minority of noble and quasi-noble collectors, led by the first Prince of the Blood and future Regent.

By 1720, a permanent change had been effected: the temporary ruler of France was at the same time the preeminent private collector in France, with a formidable group of advisers on call in the Crozat circle. After the decline of Versailles, as the return of courtiers to Paris stimulated a boom in the construction of luxury housing, the demands of patrons reflected a new sophistication in architecture, painting, and the decorative arts. There was knowledge now, on the side of both patron and artist, out of which adequate visual equivalents to noble leisure might be fashioned. Thus the success of a figure like Audran III. One could argue too that with the dispersal of the court, as well as the aggressive imitation of courtly styles by the new class of wealthy financiers, withdrawal into cultivated private leisure became the norm among the elite rather than an admired exception limited to those who could afford to be absent from the King's sight and favor. In the proliferation of suburban *maisons de plaisance* and intimate, luxurious urban interiors, there emerged an almost inevitable demand that metaphors for the life of the *honnêtes gens* of the previous century be reproduced as images to embellish them. In fact, parvenu enthusiasts for art history and academic theory such as Crozat possessed the superior command over images and could negotiate with their social betters on that basis.

The career of Watteau—his Flemish origins, early aspirations for academic legitimacy, immersion in the milieu of the fairs, apprenticeship in the most lavish and fashionable decorative painting, and acceptance in a circle of both unsurpassed private luxury and advanced art-historical awareness—put him, in an almost uncanny way, at the intersection of all the major components of artistic culture after 1700. The special relevance of his art for the present inquiry is that it arrives at a point of extraordinary stress on the mode of life it memorializes. The detached coteries of hyper-refined nobles had always operated in relation to the necessarily more practical and heterogeneous life of a strong court, as its conscience and ideal emanation. As the court declined, the retreat to a semi-private and improvised form of ritual leisure lost its earlier rationale and its discipline. Thus the libertine cynicism for which the Regency period is noted. The court life of the Regent himself set the tone; having introduced him solely as a patron of high art, we should recall his better known historical identity as Philippe the Debauched, a ruler who favored the company of actresses, courtesans, and rakes. This intense theater of organized sexual intrigue would wait for Choderlos de Laclos to provide its image in

high literature, but in the meantime it required scripts other than the elevated and euphemistic texts of *L'Astrée* and its progeny. These the fair-players possessed. At the same time, the old ideal of *honnêteté* remained an inescapable point of reference in legitimizing elite leisure as something essentially noble, even if that ideal had become a largely alienated form of nostalgia. To make it over into an image of satisfying complexity, depth, and sensual allure required an extraordinarily inventive exploitation of the high art tradition, even if that tradition was alien in many respects to the practices of *honnêteté* in its original form.

It might indeed be said that the escapades of the *forains* were more easily incorporated into the symbolic life of the Parisian aristocracy than was the painted theater of Watteau. That is to say, that the necessary visual literacy was, during the artist's lifetime, still limited to a relatively circumscribed, advanced elite network. What we know of Watteau's patronage and the posthumous market for his works would seem to confirm this hypothesis.[71] His original buyers did not in the main come from high aristocratic and financial circles. A few insiders in the Crozat household, some men who did business there, and dealers predominate. One modest early patron, the abbé Harenger, was a canon in the church of Paris' Flemish colony. A good number of pictures belonged to collectors of no great ambition or sophistication, nor is it likely that they either paid much for their acquisitions or valued them highly. The evidence suggests that they were easily bought out by the textile heir and *amateur* Jean de Jullienne and his cousin Claude Glucq, who, around 1720 and after, assembled by far the largest existing cache of Watteaus. Glucq's subsequent financial reverses left Jullienne holding more than forty of them. But, as noted in the previous chapter, there were only eight in his collection at the time of his death, the rest having gone to wealthy collectors across Europe now eager for *fêtes galantes*. A network of active dealers had much to do with this. And this market was sufficiently strong to absorb the considerable output of Pater and Lancret, Watteau's more formulaic imitators, not to mention even lesser progeny. Watteau proved to be the instrument by which contemporary French art achieved a stature among European collectors at least comparable to that of earlier Italian and Flemish art: no small breakthrough.

The response of elite collectors, for all its eventual enthusiasm, was thus an even more belated phenomenon in relation to the moment of Watteau's actual practice than was that practice in relation to its seventeenth-century antecedents. It required a quite extraordinary mobilization of critical expertise and entrepreneurial energy from within the Crozat inner circle to organize and stimulate the wide, increasing demand for the *fête galante*, and to link that genre inextricably to the name of a single artist. Jullienne of course was the overseer and publisher of the remarkable *recueil* of prints after Watteau's paintings and decorative designs, the *Œuvre gravé*, completed in 1739.[72] This was a pathbreaking effort to record, preserve, and sum up the career of one contemporary artist. In addition to publicizing the extent and quality of Jullienne's own holdings, it provided a complete compendium of the vocabulary of the *fête galante* to an international audience of collectors, *amateurs*, imitators, and forgers. Prices for Watteau's paintings are difficult to establish until they begin to emerge from the private market into public sales in the latter part of the century; but by the 1770s, the major *fêtes galantes* were fetching around 6,000 livres in Paris[73] (an amount, we can remind ourselves, that would be nearly double the average annual income of a comfortable *rentier* and equal to the maximum price for a state commission). Sir Joshua Reynolds would write that Watteau's works "being extremely dear on the continent, the brokers and dealers bring over copies or those of

his imitators Lancret and Pater, which they impose on us as originals."[74]

The proliferation of pastiches after Watteau (turned out in Britain, for example, by the French artist Philippe Mercier)[75] and stereotyped imitations reminds us that with its success as *art*, his genre was further and further removed from any active engagement with the theatrical play, both aristocratic and popular, in which it had been nurtured. The constant exchange of meaning between image and social practice was eliminated, and the *fête galante*'s principal point of reference was shifted from a particular urban culture into a cosmopolitan *lingua franca* of visual aesthetics and connoisseurship. François Boucher, who stands as Watteau's effective successor as the painter of pleasure, would largely transfer his iconography into the far less ambiguous territory of classical mythology and simple pastoral make-believe. Here is where Bakhtin's thesis again takes hold; for these changes did indeed cut sophisticated painting off from the world of "popular, festive laughter," that had so permeated Watteau's practice as an artist. But was that energy therefore excluded from the world of high art? The following chapter will argue that it was not. The revival of the Salon would see to that. And indeed, having been excluded from the elaboration of Rococo painting, the energy of the street would be ranged vengefully against the trappings of an exclusivist, privatized, elite culture.

Color Plate 1. Antoine Watteau, *Les Fêtes vénitiennes*. About 1718. Oil on canvas, 55.9 × 45.7 cm. National Gallery of Scotland, Edinburgh

Color Plate 2 (following pages). Jacques-Louis David, *The Oath of the Horatii* (detail)

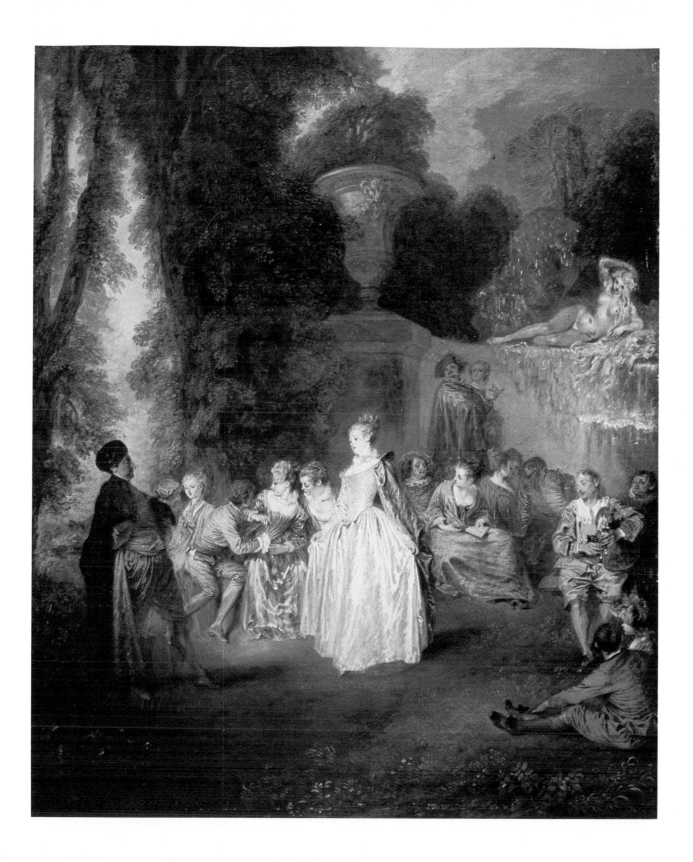

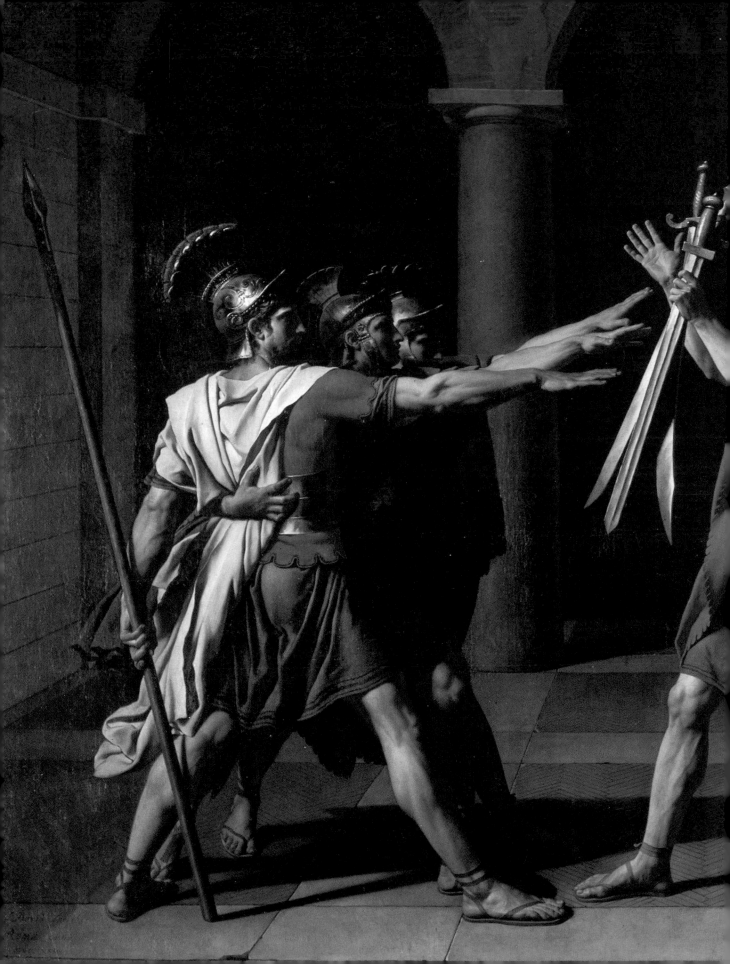

III

The Salon and the Street

−i−

THE intent of the preceding two chapters has been to contrast two sectors of culture in early eighteenth-century Paris that could reasonably be described as public. The first, in its ideological form, directly anticipates the relationship that obtains between art and its modern audience. The practice of ambitious painting is tied to a mediating community of disinterested and informed viewers, among whom a freedom of access to art and an open exchange of information and opinion is assumed. But that access and exchange is to go on within strictly defined limits—boundaries originally derived from existing definitions of the liberal arts and perpetuated by the institutional needs of the French state. From the formation of the Academy down to the present, the notion of art as a fundamentally serious, immaterial, and therefore ennobled mode of cognition has survived every challenge to it. But we have seen in the early history of the Academy and the Salon how difficult it was to make this use of art more than marginal and short-winded, to make it as attractive and richly particularized as either the older, casual consumption of works of art by the nobility or the anarchic, unself-conscious play of imagery that occurred in the second of these public spaces, the Paris fairs. In the latter, inherited high-cultural forms were subjected to an often ruthless negation and re-ordering.

But if the public space of the fair was vital and productive in comparison with that of the Academy and the official exhibition, the former was not a location to encourage the historical and aesthetic self-consciousness central to modern assumptions about the public role in artistic practice. The sharp cultural conflict centered around the "Italian" comedy after 1697 can be interpreted as resistance to the cultural dictates of a modernizing, mercantilist regime in the name of entrenched, parochial, and pre-modern practices. That resistance was appropriated by Watteau to renew an essentially elite form: what was potentially conscious in the daily transgressions of the fair players became manifestly so only in an art largely inaccessible to a general audience. The art of Watteau, it could be said, embodies in the end as much a refusal of modernity as an anticipation of it.

It is still to the public exhibition in the conventional sense of the term that we need to direct our attention, even in this period before 1737. On the official level, there was one event during the long interregnum between Mansart's Salons and Orry's revival of the exhibition that points to an awakening ability on the part of outsiders to play a role in academic affairs. In 1727, the *Directeur-général des bâtiments*, the duc d'Antin, announced a competitive exhibition of work by the twelve premier artists among the active painters of history.[1] The pictures were all to be of identical size (about six feet

Color Plate 3. Jean-Baptiste Oudry, *Bizarre Antlers of a Stag taken by the King on 3 July 1741*. 1741. Oil on canvas, 114 × 67 cm (11 cm added at top, 4 cm at bottom). Musée National du Château, Fontainebleau

by four feet), but the choice of subject was left to each individual entrant. The results were hung in the Galerie d'Apollon in the Louvre at the beginning of May and remained on display through the latter part of June. During that time, the exhibition was continuously open to public view. The motive behind this unprecedented experiment appears to have been an anticipated struggle for precedence following the passing of the old guard: de la Fosse, Jouvenet, and Antoine Coypel had died; the current *Premier peintre*, Louis de Boullogne, was ill and no longer working. And a major royal commission was in the offing, the Salon d'Hercule at Versailles, the recipient of which would stand in a natural line for the top position.

There were a number of contenders: among others, de Troy the younger (Plate 32), Noël-Nicolas Coypel (Plate 33), Cazes, and Lemoyne (Plate 34). Partisans of the last artist had d'Antin's ear, and were behind the proposal for a contest they were sure their man would win. D'Antin was backing Lemoyne as well, and one would think that would have been enough. But the holding of a contest, even one with preordained results, indicates that he felt a need for public ratification of his choice. He probably did not reckon on the risk involved—which proved to be considerable. De Troy was able early on to mount a competing claim to precedence and d'Antin reacted by offering two prizes instead of one. Even this accommodation was insufficient in the end as entries by Cazes and Coypel were judged by an interested public to be superior to those of the predetermined victors. This is plain even in the dry reporting of the *Mercure* and the guarded statements of amateurs like Caylus. The unfortunate Lemoyne (he would die by his own hand in 1737) went on to the Salon d'Hercule and the rank of *Premier peintre*, and de Troy received the compensating post as Director of the French Academy in Rome. But the episode was clearly damaging to the credibility of d'Antin's administration. He had promised further *concours*, including one in sculpture, but none ever took place.

Once again, the numbers of interested and disputatious onlookers in the Galerie d'Apollon are impossible to estimate. But 1727 was also the date of Dubois de St. Gelais' catalogue for the Orléans collection in the Palais Royal, a publishing venture that implies some significant readership with the curiosity to seek out high art. The Orléans family clearly found it useful to recall the artistic certainties of the past century, to insist in a grand public display on the natural preeminence of history painting. We have seen, via the notaries' inventories discussed above, that one sector of the Parisian upper bourgeoisie, proud of its civic honors, seems to have adopted this patriotic aesthetic as its own. Might this interest have extended to a vocal involvement in contemporary history painting (despite the *galant* themes chosen by Lemoyne's main rivals)? If so, the public side of the work carried on within the Crozat circle would now be bearing fruit. The 1727 competition does reveal that the state did not feel itself able to make a major decision without establishing the legitimacy of that decision in a larger public forum than the one provided by the Academy itself. Further, in its first real opportunity for expression in two decades, public opinion proved resistant to dictates from above, and therefore demanding of consultation. When Philibert Orry took over the *Bâtiments* in 1737, he moved immediately to ground his authority in annual Salons. (His title was now *Directeur-général* rather than *Surintendant*; the change had been made in 1726 and signified less independent control of finances—though in Orry's case, since he was finance minister as well, the issue was moot.)[2]

The official literature accompanying the revived exhibitions assumes greater sophistication on the part of the visitor. If we continue attending to the style and format of

32. Jean-François de Troy, *The Rest of Diana*. 1726. Oil on canvas, 130 × 196 cm. Musée des Beaux-Arts, Nancy

33. Noël-Nicolas Coypel, *The Rape of Europa*. 1727. Oil on canvas, 129.5 × 194.5 cm. Philadelphia Museum of Art (Gift of John Cadwalader)

34. François Lemoyne, *The Continence of Scipio*. 1727. Oil on canvas, 147 × 207 cm. Musée des Beaux-Arts, Nancy

the *livrets*, we find that the emphasis on the physical arrangement of the pictures diminishes year by year until 1740 when it assumes the form it will retain permanently: the pictures and works of sculpture are now grouped and numbered by artist in order of academic rank; the viewer is assumed able to sort out the actual hanging without help. The preface of the 1741 *livret* specifies the contribution of the assembled public and the utility of exhibitions in more egalitarian terms than any previous document:

> As the votes of the enlightened public bestow on each kind of work its true value,
> it is out of these assembled opinions that reputations are made. What more equitable
> means could one find to place the public in a position to decide with justice than
> the exhibition of various objects which are the outcome of the Academy's work.[3]

While there is again no reason yet to think that the word public refers to the audience as a whole, this is still, in comparison to earlier *livrets*, a ringing vote of confidence in the enlightened *amateur*. These changes suggest that the heretofore empty notion of an active, challenging public audience had taken on some substance. And it would be only a few years until the dramatic emergence of art criticism and debate from the *conférence* into the streets.

But the apparent contrast between the period before and after 1737 is surely a deceptive one. The first question we need to ask is, given the presumed indifference to the public exhibition on the part of the academicians themselves, why was the Salon re-instituted at all, and, even more remarkably, with an unprecedented and aggressive frequency? Given too that Parisians had had virtually no experience with official exhibitions for a generation, from where did the pressure come for resumption, and why does the evidence suggest a confident and knowledgeable response? And can we go on assuming that La Font appeared more or less out of thin air? The supposition behind these questions is quite obviously that these events must have been prepared for. We shall need, for a start, to consider the long-term effects of the early, sporadic exhibitions, effects which the meager official documents do not reveal. The principle of regular public access to the whole range of works of art had been established, and the rapid developments after 1737 would not have been possible had not access been in some way maintained.

There was in fact one kind of open display of pictures which persisted and even expanded during these decades; one which included works of indisputably high quality by both contemporary academicians and past artists, one in which spectators were encouraged to make comparative judgements on works of art "as art," yet which still remained close to the festive context of celebration and pleasure. These exhibitions were held most years on the *fête-Dieu*, Corpus Christi day, which falls in late spring. The traditional ceremony on that day is a procession bearing the host through the streets of the city, with the mass being performed at various temporary outdoor altars called *reposoirs*. It is the feast during which the church is, in effect, turned inside-out. It was the common practice throughout Europe that the streets through which the host was carried be adorned with rugs, tapestries, and even pictures suspended from windows along its route; the surfaces of the city were transformed to provide as splendid a setting as possible for the passage of the procession. In Paris, the size and elaborateness of the *reposoirs* were a matter of pride and competition among the guilds, confraternities, office-holders, and wealthy private individuals who sponsored their construction. By the seventeenth century at least, the custom was established of embellishing these altars with works

35. Stefano della Bella, *Corpus Christi procession and reposoir*. 1645. Etching

of art—and considerable ones. There is a print by Stefano della Bella showing one *reposoir* sponsored by Tubeuf, *intendant* of finances during Louis XIV's minority (Plate 35): clearly delineated are the Raphael tapestries of the Acts of the Apostles (probably the same set displayed in the "Salon" of 1699) forming wings on either side.[4]

In one parish, that of St. Bartholomew on the Ile de la Cité, the role of art in the ceremonies was uniquely central and organized. This was a parish of some ancient renown, having served the King when he resided in the adjacent palace. Long before the eighteenth century, it had become the church of a less august group of functionaries from the law courts now housed there and did not enjoy any particular prominence. On Corpus Christi, however, it was the focus of much attention and drew people from all over the city. The attraction was an exhibition of paintings hung on walls around the Place Dauphine, that triangular open space at the western tip of the island that intersects with the Pont-Neuf (and was then capped, at its extreme end facing the bridge, by the great equestrian statue of Henri IV). The local procession of the host would file by the display, and the assembled pictures would remain on view during the whole day and sometimes for the one after as well.

It is hard to say just when the custom began and how it developed. It survives through the better part of the eighteenth century, known, after the establishment of the Salon, as the "Exhibition of Youth," the place where untried apprentice painters could—

prematurely, it was often said—show their work (Plate 36). But in the years we are considering here, the Place Dauphine exhibition was much more than this. It was clearly regarded by this time as an event in its own right, distinct from the other embellishments of the feast day. For many artists, including a number of prominent academicians, it was the place where they first achieved public recognition. Some members of the Academy continued to exhibit on Corpus Christi even after their *agrégation* and reception, taking the opportunity to offer their work for sale. François Lemoyne, for one, began his illustrious academic career in 1718, and that same year, sold a *Perseus Delivering Andromeda* to a private collector in the Place Dauphine.[5] The *Mercure* reported in June 1722 that the work of the "outstanding masters" of the Academy had been on view that Corpus Christi day and on the octave, or *petite fête-Dieu*, following it.[6] Its account mentions as particularly noteworthy a *Descent from the Cross* by Restout, a number of *sujets galants* by Watteau's follower Lancret, and several landscape, flower, and animal subjects by Oudry. In subsequent years, works by Charles Coypel, Bonnart, Allegrain, and finally Chardin are singled out in these reports; Rigaud is known to have shown a portrait of Cardinal Dubois.[7] Many of these pictures were supplied, not by the artists, but by the collectors who had purchased them, and such *amateurs* regularly provided older, seventeenth-century works by Italian and Flemish as well as French artists. In 1732, the lenders of a number of Chardin's pictures are mentioned in the *Mercure* by name:[8] one was the comte de Rothenbourg, French ambassador to Spain, who lent several still-life and animal subjects (Plate 37); another was J. B. Van Loo, history painter, academ-

36. Gaspard Duché de Vancy, *L'Exposition de la jeunesse*. 1783. Graphite on paper, 21.3 × 27.5 cm. Musée Carnavalet, Paris

37. Jean-Baptiste-Siméon Chardin, *Musical Instruments and Parrot*. Before 1732. Oil on canvas, 117.5 × 143.5 cm. Private collection, Paris

38. Jean-Baptiste-Siméon Chardin, *Eight Children playing with a Goat*. Before 1732. Oil on canvas, 23.5 × 40 cm. Private collection, Paris

ician, and patriarch of the clan (Plate 38). Dealers too found supplying pictures from their stock a convenient gesture.

Probably because the Place Dauphine affair was not an imposing official event, the *Mercure*, predictable and perfunctory when it comes to Salons, is more revealing about public attitudes and responses. The exhibition, it is clear, was strongly valued and keenly anticipated for itself and not simply as an incidental element of the larger celebration. This shows up in the comments of 1724 when for some reason no exhibition took place on the appointed day: "There were no pictures shown this year on the day of the *fête-Dieu* in the Place Dauphine nor at that part of the Pont-Neuf where the procession of St. Bartholomew passes. The public was surprised and mortified at this."[9] Following some hasty efforts to satisfy popular demand, an exhibition was arranged for the *petite fête-Dieu*, "which gave the spectators much pleasure." The enthusiasts for the event were not only capable of ensuring its regular recurrence, they were conscious of it as an alternative to the official exhibition in the Louvre. In its account of the 1725 showing at the Place Dauphine, the *Mercure* likens it to similar festive displays in Rome, and then pointedly remarks on the contrastingly poor performance of the Academy:

> It is an ancient custom in Rome to display pictures on certain feast-days in order both to attract a greater gathering of people and to satisfy the taste of connoisseurs, while stimulating the young students of the Academy of St. Luke to work and compete by exposing them to the work of the great painters. Those in charge of the arrangements for these festivals borrow large numbers of pictures by the greatest masters. One thus owes the pleasure of these events to a few generous individuals. But one must say that the public makes its contribution as well by inducing these collectors to part with the rarest objects to be found in their cabinets.
>
> It has been almost twenty-five years since there were two successive exhibitions of paintings and sculpture by the living painters and sculptors of the Academy in the *grande galerie* of the Louvre, which then attracted a prodigious gathering of spectators.[10]

Even this lament over the small number of official exhibitions over-estimates their earlier frequency (there was none in 1700). This kind of comment, which is made ritually concerning almost every Place Dauphine display, indicates that the proto-Salons of 1699

and 1704 had a stronger effect on public expectations than the bland official documents reveal, that they had stimulated a demand that would not go away. This one- or two-day affair, improvised by collectors, artists, dealers, churchmen, and a large interested audience as part of a surviving medieval ceremony, grew in the first decades of the century partly as a conscious reaction to the absence of a Salon. And, as the remarks of the *Mercure* make plain, it was seen as a mutual communication between collectors and those whose access to art depended on the exhibition; the choices of the patron found their ratification in the collective assent of the public. This is, obviously, the characteristic pattern of the fully-developed modern life of art as we know it today. The influential patron still exists, and it is possible for a single collector to have a measurable impact on taste; but the stature of such individuals is marked not by any personal stamp they impose on the art of their time, but rather by their successful anticipation of a subsequent collective judgement of value, one registered by the art press, museums, the determinations of the market, and eventually, historical scholarship. Consequently private owners of works of art eagerly put their possessions forward for museum exhibitions, cultivate curators, critics, and art historians, and generally try to attract as much public attention and approval of their choices as possible. Their actions as individuals are continually mediated by very public processes.

Catalyzed by Mansart's initiative of 1699, the Place Dauphine exhibitions provided an early, limited instance of this modern form of artistic communication and value-formation. (As we shall see presently, the *Mercure* makes a point of reporting the expressed preferences of the crowd.) It could be argued that this development was retarded by the intervention of the state in 1737. It may not be coincidental that the re-establishment of the Salon followed a particularly healthy run of exhibitions at Corpus Christi, events which never failed to produce invidious comparisons to the dereliction of the Academy. Orry, the new Protector, appears to have been relatively insensitive, if not indifferent, to artistic practicalities and consequently was more attentive to the letter of the company's mandate and the needs of the state. The lifeblood of the evolved cultural structure of the Old Regime was monopoly. In that intermeshed system of exclusive corporate bodies, there were not supposed to be spaces for alternative and rival cultural practices. The theatrical wars discussed in the last chapter provide ample evidence of the official determination to contain if not to eliminate such practices. The exhibition in the Place Dauphine, vastly weaker and more ephemeral than the fair comedy, was easily appropriated and marginalized by the superior weight and splendor of the Salon. The *Mercure*, in its report on the first of the revived exhibitions in the Louvre, simply applies to it the language it had already developed to describe its rival, remarking further that "the crowd was such that, despite the orderly provisions made for its movement, one could hardly get inside."[11] By 1759, the affair at Corpus Christi had been reduced to a simple "exhibition of youth" and a comparatively insignificant one at that: the *Feuille nécessaire* complained that the young artists, "for the most part too impatient to expose their budding talents to the public, often present what are no more than half-formed attempts."[12]

There are other similarities worth noting between the unofficial exhibition and the unofficial theater of the same period. In the Place Dauphine as well, the prescribed hierarchy was undone by popular preference. During the 1720s, the overwhelming choice of spectators was the still-life and hunting scenes of Oudry, "works which appeared to excite a great crowd and to deserve the most applause."[13] In 1725, half of the commentary in the *Mercure* is devoted to Oudry (Plate 39), who is reported to have captivated "a

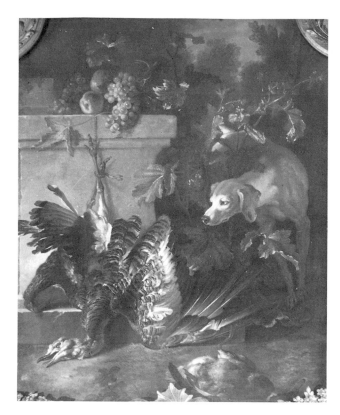

39. Jean-Baptiste Oudry, *White Dog, Game, and Fruit*. 1724. Oil on canvas, 145 × 118 cm. (Shown in the *Expositions de la Jeunesse* of 1724 and 1725). Nationalmuseum, Stockholm

countless number of spectators."[14] More elevated offerings received no detailed comment whatever. By 1732, the young Chardin had replaced Oudry as crowd favorite, and only a few other artists rate even a mention. The appeal of both artists was earthbound and immediate, prompted, so we are told, by their effectiveness in producing a kind of magic realism. Thus on Chardin: "One is seduced to the point that one must absolutely place a hand on the canvas and touch the picture in order to comprehend the painter's artifice."[15]

Several of Chardin's fairly conventional still-life studies on display that year might have elicited such response, but it is interesting to note that this comment was directed to an example of the artist's most artificial and "classical" painting: a *camaïeu, trompe-l'oeil* bas-relief depicting a group of *putti* restraining a headstrong goat (Plate 38). The specific source of the image is a bronze copy of an early seventeenth-century sculpture by François Duquesnoy, a work which had become a recurrent allegorical symbol in northern genre painting; Dou reproduced it as a pictorial accessory no less than ten times. The usefulness of the image as a classicized emblem of straining lust was, as we have seen, attractive in the eighteenth century to Watteau, as well as to artists like Desportes and Boucher.[16] The fact that this picure was singled out as a particular popular success reminds us that Corpus Christi was not only, nor even primarily, a solemn religious event. Typically in France and Spain, the procession of the host was preceded and followed by grotesque and carnivalesque figures. Ahead of the holy representation of the sacred body were monstrous distortions of the human form: giants (which were particularly popular in northern France) or the "Babylonian Harlot" astride a composite creature with divine, human, and animal attributes.[17] The procession would often be closed by carriages bearing actors in theatrical costume, performers in the mystery plays tradition-

40. Gabriel-Jacques de Saint-Aubin, *A Charlatan on the Pont-Neuf*. Etching

ally included in the celebration. These performances too could contain satirical elements which effectively reversed the serious intended meanings of the central ceremony. Rabelais provides a number of grotesque images of the Corpus Christi events derived from the parodistic folk traditions associated with it: in one, Panurge chooses that day to avenge himself on a noble-woman who had rejected his advances; sprinkling her dress with the diced genitals of a bitch in heat, he causes a parade of "600,014" dogs to follow her through the streets assaulting her dress.[18]

Once again then, we find a public display of art in a context of festive drama. As it happens moreover, the Place Dauphine and the Pont-Neuf were together a permanent scene of popular entertainment, a year-round mini-fair offering many of the pleasures and temptations described above in connection with the temporary venues of St. Germain and St. Laurent (Plate 40): acrobats, *farceurs*, mountebanks, charlatans, story-tellers, peddlers, quacks (none of these roles being mutually exclusive). On Corpus Christi, this was all heightened and focused, while, at the same time, a quite conscious exercise in public connoisseurship of painting was also taking place, one which took the official exhibition in the Louvre as its model and point of comparison.

–ii–

Having proposed the Place Dauphine exhibition as an impetus behind the resumption of the Salon, it follows that this experience of art in public provided the Salon audience with some of its habits of attention and expectations as to what interest and pleasure it would derive from the works on show. The question then is whether the particular festive circumstances described above can be shown to have marked those habits and expectations. The response to Chardin in 1732 is suggestive, and what it suggests is supported by the earliest sustained commentary on the Salon that we possess. Its date, surprising in view of the unanimous election of La Font de Saint-Yenne as the first Salon critic, is 1741. Anonymously published (the name of the author is still unknown), it takes the form of a letter to a provincial official from his agent in the capital.[19] This is a common form in the ephemeral literature of the period, one which duplicates the private reports of a professional *chasseur de nouvelles*. Though this particular text is known in the modern art-historical literature for other reasons,[20] it somehow has never entered the history of Salon criticism and thus of public responses to art in the eighteenth century. As will be evident, this omission cannot be due to any lack of compelling content; but it will

be equally plain that this author does not fit the mold of the eighteenth-century critic if La Font or Diderot is the model; he is not moralizing, improving, or "enlightened"; he has nothing to say about the antique or the hierarchy of genres. But he does produce, almost precisely, the mix of elements at work in the Place Dauphine and holds that constellation of the serious and the comic together as an attitude of remarkable coherence.

The narrator of the text begins in a chatty vein, apologizing for the lateness of his report, explaining that on his first visit, "my timing was badly chosen, . . . the tumultuous waves of every sort of onlooker made me fear to block its progress by any prolonged examination of the pictures. It is best to give them a wide berth."[21] So he resolves to arrive the following day well before opening time, hoping to persuade the guard to allow him in ahead of the crowds. But the next morning he finds that hope thoroughly frustrated: "The guardian of the door, without taking the least precaution to see if he offended titles of nobility, if deference was or was not due me, without considering me, without seeing me, without perceiving me, greeting me only with the words 'No entry!' and offending all propriety, turned his back and slammed the door." This show of official inflexibility sets the stage for an extraordinary, fantastic narrative which takes up fully a quarter of the fairly lengthy pamphlet. The narrator, having thus been turned away, finds that he is not alone in his plight, that fifty or so other individuals, similarly refused, are milling around the forecourt. And before this gathering, the drama unfolds (this will require quoting at length):

> . . . a grand carriage, flying more than rolling thanks to the dashing speed of the chargers that drew it, pulled up to the desolate portal. The luxury of the vehicle and its lackeys told me what I was about to see emerge from the compartment.
>
> The first to appear was a young man made more out of costume than he was out of flesh. It would have been more accurate to call him a richly dressed phantom. The color of his diaphanous visage was almost the same shade as the powder that weighed down his hair. His arms and legs had the appearance of belonging more to a skeleton than to a living body. . . . I believe he only lived by an artifice of vanity.
>
> There then appeared a lady about forty years in age. Her bearing was haughty, her speech sour-sweet, and although already obese, she seemed to gorge herself further on the glory she extracted from the carriage and retinue. The sight of this crowd of people waiting on the good humor of the Swiss guard inflated still more the volume of her self-regard, which triumphed completely when, realizing that entry had been forbidden these onlookers, she imagined that she would thus be exercising an *Exclusive Privilege* on entering, one that would command the deference of all eyes kept to a strict ration.
>
> A younger woman, of pleasing proportions but whose looks were more flashy than refined, was barely twenty. Her glance might have seemed modest but was really only guilty. She only half opened her eyes, but did not for that see any less: she turned them on you only in secret, but it was easy to recognize in this suspicious reserve that she was the willing pupil of her fat companion, whose jaded glances said no more than hers. . . . She attracted all eyes to her by the vivacity, not to say the dizziness, of her speech and manners, managing it so well that whatever happened she could count on shooting sparks into the heart of any man around her.
>
> I do not speak to you of their complexions. You know wonderfully well that the women of Paris pride themselves on never having any. Lotions, ointments, white lead,

rouge: these are everything. Each one manipulates these drugs to her own fantasy; how then can one discern the skin underneath?

The face of the older one carried a violent hue, and one could not have accused her of trying to deceive anyone by the art with which she deployed her rouge. Her cheeks were two placards, more painted than any mask, and I was astonished to see anyone so made-up so early in the morning.

The younger one had not received the same treatment, and when taken on her own, seemed to be in excellent health. But when one contemplated her at the same time as her companion, one perceived in her a languished quality, a kind of listlessness, and on final examination, she could be seen to have just been patched up with white plaster.

They were both, moreover, in a state of undress as indecent as if they had never left home, but rich enough to rival the finery of much more illustrious ladies.

There you have them well described. It must seem to you that they stand right before you and you are no doubt convinced that the Swiss guard, who had turned me away as the ordinary individual I am, a man without ostentation or display, would never hold out against this assault. You would easily have been on the side of the older woman's presumptuous hopes, and I must admit that I too had the same idea at first. I was already considering approaching them and imploring their protection—looking forward to that of the young lady in particular. Would she miss the opportunity to acquire a courtier, a momentary one to be sure, but one who could be engaged to pay homage for an hour or two? It is always thus: Greed, Gluttony, and Vanity never miss a trick; they squeeze the last penny, collect everything, and for want of better, content themselves with small profits. I was therefore counting on her.

Their escort knocked at the door, with the assurance of a man to whom no door is closed. But he did not find there even the pleasure of a response. Vainly, after a long monologue worthy of the character I have painted for you, he humiliated himself to the point of pleading, of begging. All was deaf and dumb to his entreaties. He found there an incorruptible integrity.

The ladies were not silent during all this: they complained bitterly of the lack of consideration being shown them. The gaiety they had brought at the gallop suddenly deserted them and let collapse the graces it had sustained. My God, but mortified pride cuts a sorry figure.

There are other vices that adversity chastens. This one is just the most ridiculous and the most unjust. He who had wanted to bestow this gift ended up swallowing it, and taking the blame as well. The fat women quarreled nastily with him as he re-entered the carriage, whose horses, less intelligent than those of Hippolytus.

Instead of having "a mournful eye and downcast head"

Better "to conform to" their "sad sentiment,"*

left as smartly as they had arrived, taking this humiliated trio off to parts unknown.[22]

*Tragedy of *Phèdre*, V:6.

Here is the Rococo come to the Salon in the flesh—or lack of it: a hallucinatory dance of grotesques laid on just to introduce a piece of (as we shall see) plain-spoken and straightforward commentary on the pictures. What it amounts to is, in effect, a *parade*—a piece of both enticing and dilatory farce, played literally at the door in front of a milling crowd,

in order to lead the reader/visitor into the performance. In the pattern of the earlier fair theaters, the *parade* threatens to become the principal object of attention, moving in and taking over the text. The characters are not the stock figures of the Italian comedy (we are now twenty years after the peak of its popularity), but they do offer a play of elemental, almost mythical oppositions: death (the clothes and make-up of the male figure moved to a ghostly semblance of life) set against the furthest extremes of fleshly appetite embodied in the older woman, sunk into gluttony and pride. The young woman shares traits with both: she is the student of her fat, painted companion, but her pride is weak, needing the attention even of humble types like the narrator; her lust is devious and ashamed; though she is seemingly robust, caked-on cosmetics disguise a wilting and insubstantial body.

But if the structural symmetries of the narrative strike a timeless, synchronic note, its venomous social antagonism is thoroughly of its time. In this morality play before the standing crowd, the deadly sins are given a firm class identity. The sole prop sustaining this lewd, eroded *ménage à trois* is "Exclusive Privilege" (that phrase appears in bold-face capitals), and within the outwardly modest bourgeois lies a vivid fantasy of debasement and revenge. We encounter here a use of this kind of material opposed to the elite forms discussed in the previous chapter. That is, rather than being drawn into a reformulation of the signs of exclusivity, it is joined to a defense of the official public sphere of culture. These characters, out of some scabrous parody of Watteau or Boucher, find themselves defeated by the incorruptible and egalitarian portal of the Louvre. That barrier exposes and levels a bankrupt structure of privilege. The desiccated male knocks as one "to whom no door is closed"—no door in France except this one, which, if not open to all, is open to none.

In this particular anti-Rococo reaction, six years before that phenomenon is generally supposed to have emerged, humor, politics, and style are bound up together. The description of the aristocratic grotesques is intensely visual; they are laid out as they would appear in two dimensions, all paint, powder, and plaster. The codes of class difference contained in this *parade* can in fact be tied quite closely to stylistic features of Rococo painting: the imagery of make-up especially conjures up fat surfaces of paint, disguise, and even drugged fantasy. The insubstantial, melting body becomes not a promise of pleasure but a sign of the decayed and moribund; rich surfaces of cloth are vain covering for decrepitude; the sensual and abundant is equated with the bloated and corrupt. Sexuality itself—in this text, the mediating term between death and life—is sated and promiscuous. This whole array of artifice is unmasked and deflated at the Salon door: ". . . the gaiety they had brought at the gallop suddenly deserted them and let collapse the graces it had sustained."

The vivid and incongruous nature of this early art-critical preamble tempts one to elaborate interpretation (perhaps there is a reference here to the increasingly exacting exploitation of rights and dues by the contemporary nobility). But before going any further, and before examining the actual Salon commentary in light of its preface, we need to answer some obvious questions about the status of the text. What sort of writer would have produced it and for what audience? Were there others like it, and if so, what relation do they have with the kind of serious Salon criticism familiar to art historians?

—iii—

Apart from our 1741 pamphlet, there is one other piece of indirect evidence concerning the critical reaction which greeted the earliest Salons. On the occasion of the restoration of the exhibition in 1737, the well-established poet J. B. L. Gresset published a long, barbed ode to the Academy. In place of the platitudes usual in this kind of effort, the poem immediately strikes a negative, worried note:

> If one believes aggrieved complaints
> By dissidents of ill repute,
> And the clandestine satires,
> Of a few forgotten authors,
> Everything in France crumbles to dust,
> Taste, the most brilliant arts,
> All dies under indolent gods;
> And, worshiping opulence,
> Our times heap ignorance
> On the ruin of talents.[23]

The date of these lines is significant to our account for two reasons. First and most obviously, they establish that the history of unofficial public art criticism in Paris has to be pushed back to the late 1730s: a decade before La Font's pamphlets on the Salon were being written and circulated. What is more, these critiques contained a good deal of harsh complaint concerning the existing condition of French art. Secondly, if we take 1737 as the effective beginning of the Salon as a stable institution, there is no lag whatever before a popular form of discourse springs up in answer to it; that discourse appears simultaneously with its object.

In later years, as we have already noted, academic spokesmen would dismiss any unofficial Salon commentary as a contemptible *libelle*. In so doing, they assigned the critical brochure to a much larger category of illicit literary production. Gresset's choice of words points us in the same direction. It is time to specify in more detail what the epithet *libelle* meant, for the term itself joins Salon criticism to an underground and genuinely popular literary form.

The literate public in eighteenth-century Paris was larger than is often assumed. It was not limited to an elite, or even to the professional and *rentier* middle classes. Many independent artisans were proud of their literacy—more than a few had patched together some knowledge of the classics. There was a large market for the printed word whose demands could not be satisfied by the meager flow of books and pamphlets which came stamped "with the approbation and privilege of the King." A chaotic sort of industry thrived in the city grinding out gossip sheets, throwaway boulevard satires, sentimental tales, and more or less explicit pornography. Any turn of political events, sensational court case, revelation of scandal in high places, stockmarket fluctuation, successful play, or other cause for public talk elicited its quota of pamphlets; each interested person or party could marshal an offensive or a retaliation in the streets and cafés. Printers speculated on public interest in some affair by turning out commentaries for profit. Pamphlets could be produced practically overnight, replies formulated, advantages pressed, retreats covered. Those who could not read or lay hands on some brochure could easily hear them read aloud; there were those who did this newsmongering for a living. Snippets from the most popular would be compiled in semi-clandestine *nouvelles à la*

main that supplied their elite subscribers with inside political news and gossip (these were a development from the older *chasseurs de nouvelles*, men employed by wealthy individuals to keep them up to date with the news, a practice with its origins in the seventeenth century.)[24]

All this did not produce a literature which appealed to the higher sensibilities of its audience; then as now, sentiment, sex, and sensationalism were the stock in trade of popular journalism. As far as the authorities were concerned, most of it, involving as it did some degree of slanderous abuse of titled personalities, belonged in the illegal category of *libelle* and its practitioners in the Bastille. In 1745, whipping and banishment were decreed as punishment for even the distribution of dissenting political manuscripts. But Old Regime France, though a police state, was a relatively inefficient one, and the pamphlet trade flourished in spite of restrictions and prohibitions.

For its labor, the popular press drew on a growing writers' subculture, a reserve army of the literary unemployed which the Enlightenment itself had called into being. The newly proud and independent *République des lettres* announced by Voltaire appeared to offer an avenue for social advancement to educated young provincials whose low birth and lack of fortune closed off any other. But for every Voltaire, Diderot, or Rousseau who rose from obscure origins to public renown, there were scores who did not. Talent and intellect, if they had them, were rarely enough. The really successful man of letters in this period lived not from the sale of books (even the best-selling authors, such as Rousseau and Choderlos de Laclos, received virtually nothing from this source[25]) but on aristocratic or state patronage. Most would-be writers, lacking either extraordinary brilliance, or, failing that, skill in social climbing and bureaucratic opportunism, found themselves excluded from the recognition and rewards of established intellectual life. They had to make it on their work and their wits alone. Some found editorial hackwork for legitimate publishers; many of those who hung on in Paris were denied even this ill-paid and insecure employment, and turned to one form or other of underground journalism. It was often a desperate and difficult life. When they had work, they were writing for hire, anonymously or under a name of convenience; they found themselves risking flogging, exile, or prison, pandering to the most common tastes, consorting with out-and-out criminals.

This is the milieu, nonetheless, which produced a great deal of the literature which interests us here. It was, first of all, a principal channel of transmission between high and low culture during the eighteenth century. Most of the *libellistes* were educated men, acquainted with advanced speculative thought, political theory, and literary innovation. They brought classical training from their provincial *collèges* and commonly had come to the capital for the ostensible purpose of studying law. In their hands, much of what we think of as Enlightenment thought found its way into popular discourse. A lampoon of government malfeasance might wrap Montesquieu in a salacious personal attack on a ruling clique; a piece of anti-Jesuit agitation might draw on Voltaire, a tear-jerking tale on Rousseau. In the process, elevated social criticism was made a vivid, intelligible, and everyday presence for an audience vastly larger than the one directly addressed by the great figures.

Nor did this transmission proceed in one direction only. Turning back to the pamphlet we have been considering can give us some clues in this regard. Its full title is *Letter to Monsieur de Poiresson-Chamarande, Lieutenant-General in the Bailiwick and Presidential Bench at Chaumont in Bassigny on the Subject of the Pictures Shown in the Louvre*. The putative addressee was most probably Adrien-François Poiresson, a descendant of a long

line of *procureurs du roi* in the region of the upper Marne.[26] Born in 1686, he gained
the office of *lieutenant-général* in 1732 and would become mayor of Chaumont in 1742.
His family had purchased the château and property of Chamarande by 1620 and had
added its name to theirs. Though the seat was raised to a marquisate in 1745, Poiresson
was no *gentilhomme*, but thoroughly a man of the magistrature; his wife's father was
a *président à mortier* in the Parlement of Metz, and his son would succeed to his judicial
office in 1742. In the sixteenth century, the Poiressons would have been known as *nobles
hommes*, superior to the merchant-bourgeoisie, but just as canny in their purchase and
manipulation of farms, *rentes* (perpetual annuities), timber rights, tax receiverships, and
the like—handsome properties like Chamarande did not come on a magistrate's income
alone. As a *noblesse*, they held themselves apart from the mercenary preoccupations of
trade, but rejected just as much the values and way of life of the feudal *gentilshommes*:
the thoughtless arrogance of the "sword-draggers," their obsession with sexuality, gam-
bling, drink, and violence, and their indifference to civic virtue and classical learning.[27]
After a century of eclipse, this brand of high bourgeois self-consciousness had re-emerged
as a significant factor in French politics. Its principal adversary was no longer the thuggish
rural *hobereaux*, but a corrupt urban elite of courtiers and financiers. There will be much
more to say on this topic in the chapter to follow, but for the moment, we can read
the present text as a clever deployment of an ancient hatred in order to situate the Salon
outside the realm of illegitimate "privilege." The skill and relative sophistication of the
typical *libelliste* was as appealing to an educated, upper-class audience as to any other.
Low culture had its fascination and usefulness for disaffected elite groups, as we have
already had occasion to observe. This unofficial cultural channel made available to self-
conscious social criticism certain modes of parody, burlesque, and grotesque humor which
properly belonged to the carnivalesque oral tradition.

As soon as it came into being, the Salon became fair game for the pamphlet trade.
Both on the walls and in the crowd, there were plenty of subjects for sensational, sentimen-
tal, humorous, or polemical treatment. A number of surviving critiques document the
extent to which the exhibition had, as Mercier observed, been made over into a "popular"
event. We find in them the time-honored parade of buffoons, pedants, coquettes, and
clever tricksters engaged in dialogue over the pictures, singing *vaudevilles* about them
to popular tunes, suffering comic misadventures on their excursions to the Louvre. A
Salon review written in the *genre poissard*, the mock-popular literary form named after
the argot of fishwives and market women, appeared in 1769.[28] In 1781, a hastily written
"Response to the Critiques of the Salon" was published which complained of the continu-
ing popularity of the form: "Already seven critiques without counting those yet to menace
the exhibition! What furor! What relentlessness . . .! The marketplace and the boulevards
have come together to inspire the majority of authors, who write with the delicacy and
taste customary in these locations."[29] In the following Salon, surely one of the most
"menacing" would have been *Marlborough au Sallon*, published anonymously by an
author of practiced satirical skill.[30] To a familiar form of abusive, mock-popular dialogue
on the pictures, *Marlborough* adds a unique feature: engraved caricatures sending up
the grandest and most solemn history paintings on show. A vast (eight feet by twelve
feet) *Resurrection* by Suvée (Plate 41), for example, is crudely rendered with a Montgolfier
balloon emerging from the tomb in place of the risen Christ (Plate 42); Lagrenée's *Two
Widows of an Indian Officer* (Plate 44) features stick figures with false heads (this one
gets the old *vaudeville* tag, "*changez-moi ces têtes*") (Plate 43); David's *Andromache*

41 (top left). Joseph-Benoît Suvée, *The Resurrection*. 1783. Church of Sainte Walburge, Bruges

42 (top right). *La Machine aréostatique*, caricature of J. B. Suvée, *The Resurrection*. Anonymous etching from *Marlborough au Sallon*, Paris, 1783

43 (bottom right). *Changez-moi ces têtes*, caricature of L. J. F. Lagrenée, *Two Widows of an Indian Officer*. Anonymous etching from *Marlborough au Sallon*, Paris, 1783

44. Louis-Jean-François Lagrenée, *Two Widows of an Indian Officer*. 1783. Musée des Beaux-Arts, Dijon

45. *Le Tombeau de Marlborough*, caricature of J.-L. David, *Andromache mourning Hector*. Anonymous etching from *Marlborough au Salon*, Paris, 1783

Mourning Hector (Plate 104) takes place before an outsized *tombeau de Marlborough* (Plate 45), thus evoking that stock image of Epinal prints; each has a piece of satirically apposite verse attached. A similarly comic voice was adopted by one of the most active radical propagandists of the 1780s, A. J. Gorsas, when he turned his hand to art criticism.[31] Gorsas used it to introduce serious judgements on works of art: he provides us with some of the most revealing commentary on David in 1785 (see chapter VII). And he was popular; at least one imitator, Joly de St. Just, produced a pamphlet in 1787 that conspicuously mimicked the tone and style Gorsas had introduced in 1785.[32]

To return to the 1741 text introduced in the previous section, we can state that it stands near the beginning of a persistent and consistently appealing strain of Salon commentary, and also that it had a good deal of company: unofficial pamphlets like it, which took an independent and critical line on the event, were available in numbers to the exhibition audience right from the start. The next question to be addressed then is what, in this early instance, did an independent and critical line consist of? To what end were its popular comic imagery and anti-Rococo anger directed?

−iv−

Unlike the "dissidents" (*frondeurs*) cited by Gresset, the writer of the 1741 pamphlet does not explicitly denounce the state of French painting as administered by the Academy or declare that all its efforts came to nothing ("s'anéantit"). But he does conspicuously ignore most of the Academy's claims and priorities. He begins by assuring his reader that he will "follow the precise order of the exhibition, so that you will lose nothing from my recitation, even its arrangement. I leave it to you to judge, sir, if my attention on your behalf does not extend to the furthest limits."[33] True to his word, he immediately seizes on three small pictures hanging in the stairwell by which visitors ascend to the gallery proper, that is to say, on the very first objects he sees. Throughout the text, the actual sequence in which he physically encounters the pictures, the immediate physi-

cal presence of their subject matter, are always more important than who painted them or what their categorical importance might be. Tackling these still-life subjects hung from the cornice above the steps, his description moves methodically and intensely through each one, attending lovingly to each depicted object. "On this one," he says of the first picture,

> is painted one of those small *Tables* that ladies keep near them to hold their handiwork. It is half-covered by a *piece of Tapestry* thrown over it in a highly elegant way. A *game board* filled with some cards and *Dice Cups* is placed at the base of this *Table*, and these seem to be pushed slightly under it. On the other side appears a bowl half-filled with *Water*. Without downgrading the rest of the work, which is entirely excellent, this *Porcelain* is the most perfect piece of it. Art could never produce anything more deceiving. One feels the wetness and transparency of the water, as well as the ray of light which slips into the interior of the bowl, producing a certain brilliant warp, which is perhaps easy to render passably, but which would be impossible to imitate more truly than it is imitated here.[34]

He continues in this vein for several pages until he has completely enumerated the objects in the three pictures before him, continuing to introduce each item with a drumbeat of italics. The third picture he finds even more remarkable:

> . . . the representation of *Bizarre Antlers of a Stag Taken by the King on Last July Fifth* [Color Plate 3]. I believe that there has never been anything better in the genre. You could take the *Horns of the Stag* in your hand. They seem to stand against *Planks* which are so deceiving that one can scarcely keep from believing that the artist did not work directly on these very boards, and though we know that we are in a Salon of painting, we must apply our powers of reasoning to convince ourselves that this is only a work of art.[35]

Finally, and not before the end of all this, he mentions that the painter of the pictures is Oudry.

He then makes his way into the Salon proper; the still-life pictures of Desportes, as we might expect, get the same treatment, though without the extravagant superlatives, and so does a pastel portrait of a certain *parlementaire* by Latour, which comes in for the longest prose description in the pamphlet, every accessory and article of clothing being obsessively delineated.[36] His concentration remains on the most immediate objects, the pictures low on the walls. Only when he is half-way through the pamphlet (18 out of 36 pages) and one third through the Salon commentary proper does he bother to look up and take note of a large-scale historical canvas, in this case, *The Grape Harvest of Daphnis and Chloe* by Jeurat.[37]

How then are we to interpret what surely is to us a peculiar voice, and what importance should we assign to it? We might conclude that it is merely an atavistic survival of the kinds of attention and habits of viewing which the Salon *livret* of 1699 seemed to address: taking in the exhibition as it is physically laid before the visitor, seeing it all as visual spectacle. But where that earlier view (evident in Florent Le Comte as well) attempted to be comprehensive, this text is strongly selective; it is making choices, finding its particular path through the Salon, and registering that in fascinated, sequential order. An even simpler hypothesis would be that this writer is just a *naïf*, in no way initiated into the proper codes of artistic value and therefore captivated by the simple magic of illusion-

46. Charles-Antoine Coypel, *The Sleep of Rinaldo*. 1741. Oil on canvas, 328 × 630 cm. Musée des Beaux-Arts, Nantes

ism. This interpretation, however, would not accord with the general quality of the text, which is clearly the work of an inventive professional journalist. He can quote Racine, as we have seen, to ironic effect and expect his readers to get the joke. (That sort of play on the classics is another reminder of popular theater.) When he does turn his attention in earnest to a major historical picture, the mammoth (20 feet by 11 feet) *Sleep of Rinaldo* by Charles Coypel (Plate 46), he can shift without strain into a credible and "normal" critical discourse. He adds up the successes and failures of Coypel's handling of the narrative, directing his negative comments chiefly to the figure of Armida: she is about to attack the sleeping hero and our critic suggests that the mixed anger and passion described by Tasso ought to make her appearance less placidly beautiful than that of the unconscious Rinaldo and that the stiff gesture of her arms conveys little of the character's state of mind. The fact that the main dramatic grouping is dwarfed by the setting and its mythological accessory figures (that is, that Coypel has failed properly to handle the vast scale of the thing) he also finds unfortunate. Giving points for the figure of Rinaldo and that of Cupid who shields him, as well as for the variety and active quality of the setting, he pronounces the picture at best a mixed success.[38]

 To modern eyes, these are accurate judgements, and without claiming too much for them, they are certainly up to the standard of most eighteenth-century criticism of whatever origin. The dominant voice and quality of attention in the text then is again a matter of choice rather than limitation. The commentary here is in fact directly reminiscent of the audience responses reported by the *Mercure* in its accounts of the Place Dauphine exhibitions. Oudry had been the popular choice there for a number of years running. And what had brought our narrator to Coypel was actually a small picture hanging directly below it by Oudry's successor as the favorite of the Corpus Christi crowd, namely Chardin. It is the narrative picture *The Morning Toilette* (Plate 47), one of the artist's series of meditations on the theme of mothers and children. It brings out, I think, the

47. Jean-Baptiste-Siméon Chardin, *The Morning Toilette*. 1741. Oil on canvas, 49 × 39 cm. Nationalmuseum, Stockholm

best in this critic. His emphasis remains on the immediate and the directly observable, but in this case, it is the facts of social class which come to the fore:

> It is always the *Bourgeoisie* that he puts into play. . . . Does a woman of the Third Estate ever pass by without believing that here is an idea of her character, who does not see her domestic surroundings, her countenance, her frank manners, her daily occupations, her morality, the emotions of her children, her furniture, her wardrobe . . . ?
>
> As to this particular subject, we observe here a deep understanding of nature, first in his figures and the easy, accurate movements of their bodies, and secondly in the workings of their inner lives. While her *Mother* adjusts her hair, this *little Girl* turns to look back at the *Mirror*. In this displacement of her head we read awakening vanity. Her little heart is in the eyes which interrogate the mirror, lying in wait for those small graces she is afraid may elude her. Place this figure squarely before her mother and you would lose all of this; it would no longer say a word to us.[39]

These comments too will have a familiar ring to the reader conversant with the critical literature of the period. Within the commonplace moralizing about feminine vanity is the sort of empathetic internal reading of pictorial narrative we associate with Diderot, attention to how a picture speaks without words. And that displacement of the young girl behind her mother is indeed the key to the way the picture works. What distinguishes this from later criticism, however, is its utter directness about the facts of social class. The critic feels in no doubt about Chardin's intentions and appeal in this regard, as he carefully enumerates the emblems of class in the *Morning Toilette*. (This is the only instance I have encountered in which the political term Third Estate is linked directly to painting.) He intimates further that the artist has been harshly treated for his exclusive concentration on bourgeois mores: "I have been hearing *raisonneurs* carp on this and reproach him for falling into a mannerism."[40] But he defends both the validity of the genre and Chardin's success in it.

These measured observations about class coming at the end of the text recall the extreme, fantastic polemic which introduced it. Both draw a positive awareness of bourgeois status out of the institution of the Salon: "Does a women of the Third Estate ever pass by . . . ?"—it is in the public exhibition that contact with an accomplished image of one's own middle-class life is possible. And the universal access to art provided by the Salon bans the distinctions of "Exclusive Privilege" operative in every other sector of social life. That was obviously not the intention of its organizers, but it could be *read* that way, the comic parable at the beginning transforms that reading into an imaginative reconstruction of the visit itself.

The use of low comedy here is quite different from those examined earlier. In the hands of the exiled Italians, popular theater had been a means of resisting and subverting the monopolistic claims of official culture. The amateur *parade* and the *fête galante* had drawn that resistance into a restatement of elite cultural prerogatives. But the official public sphere as embodied in the Salon, despite its apparent marginality, had nevertheless been established as an example and a principle. The state's insistence on monopolies in culture may seem absurdly repressive today (one theater in the whole of Paris allowed to stage dramas in French!), but monopoly was a two-edged weapon. It enforced existing privileges, but at the same time worked against the principle behind privilege, namely cultural division. Because it is by definition universal, it stands, potentially at any rate,

for open and democratic access. During the Choiseul administration of the 1760s, the official theatrical monopolies were relaxed and the fair troupes allowed a good measure of freedom; but the rationale for this policy was anti-democratic in intent. The lower orders were to be placated by the plentiful provision of cheap amusements on the condition that a clear distinction between the high and low companies—and their respective audiences—be maintained.[41]

The kind of public consciousness stimulated by the Place Dauphine exhibitions, however, remained fixed on the vision of a unified artistic culture. By virtue of its setting, that consciousness could draw on active, traditional forms of collective life—pleasure, celebration, ritual. A rudimentary aesthetic language was developed which was nonetheless distinctive to the place and the interests of its audience (important as much for what it refused as for what it embraced). Artists like Oudry and Chardin knew how to respond to those interests, and to the extent that their reputations were thereby enhanced, they were learning the modern game of playing patron and public off against one another. The aesthetic consciousness of that audience was joined in the process to a more sophisticated notion of what it wanted politically: it wanted the Salon, which meant it wanted to be accommodated fully within the artistic machinery of the state. By 1741, that had been achieved, though in reading our anonymous critic, the officers of the Academy could only have been confirmed in their indifference to a broad audience, seeing their most vaunted efforts blithely passed over or ignored, while the artists who had made their way most successfully into informal public channels garnered the lion's share of attention and praise. They also cannot have been much pleased to see their principal patron class held up to bitter mockery as a way of explaining what the Salon was all about.

— V —

The introductory chapter concluded with a consideration of Sébastien Mercier's reaction to the Salon audience in the 1780s. Having worked our way through the various early forms of public exhibition prior to the beginning of the regular Salon, it will be useful to match his description with our developing picture of the early Salon public. The major point of Mercier's observations was that the Salon in a fundamental way belonged to its public. It was not a spectacle for passive onlookers, but an opportunity for active audience participation and judgement. In its determinations, a broad public would bypass the imposed orders of the event as staged and put that array into an order of its own. The Salon further provided an occasion for manifestations of antagonism against the pretensions of the titled and propertied: "... as long as the brush sells itself to idle opulence, to mincing *coquetterie*, to snobbish fatuousness . . . it should never affront the vision of the public in the place where the nation hastens to visit!"[42]

Those words could sum up the message of the 1741 critic as well, and his text inscribes a set of attitudes toward art much like those enunciated by Mercier some forty years later. Further, Mercier's intimation of a readiness on the part of the audience to shift from the pictures on display to a mental store of images drawn from the popular tradition appears to be born out by the interpenetration of high and low culture earlier in the century. More concretely, the earlier text demonstrates the potential of that heritage for bolstering a critical response to imposed culture. Mercier had conjured up a crowd of idlers mistakenly reading figures from classical history and myth as more familiar characters from folklore or Christian legend. Our narrator of course does nothing so naïve,

but the *forain*-style comedy at the start, as well as his subsequent patterns of attention, have a comparably deflating effect—one that is put to pointed use. And there lies the principal difference between the two accounts: for Mercier, some half-century later, the "popular" presence has become marginal and rather comically rustic. Like every serious Salon writer after La Font, he is preoccupied with the hierarchy of genres; his public ratifies, if only provisionally, the preeminence of moralizing historical pictures. With him we are back on familiar ground: approved anti-Rococo reform enjoys spontaneous public approbation. But it is not likely that a Tournehem on one side or a La Font on the other would have enjoyed any such support in the 1740s: for an attack on Rococo artifice and its parasitic patrons, yes, but not for any jump from that to a revival of Le Brun-style history painting. What our author displays, quite knowingly, is that attitude denigrated by Jean Rou around 1690, one which is at once "popular" and at the same time a form of skeptical resistance to the claims of academic theory. He updates the figure of the naive Rou stumbling into the proto-Salon for the first time, gazing in wonder at the shifting spectacle of pictorial illusion:

> I could barely comprehend, [he had declared] . . . how by some change of scenery
> I could find myself in the solitude of the fiercest deserts, or just as quickly in the
> fertility of the happiest countryside or the horror of storms and shipwrecks, while
> remaining all the while in the midst of the streets of the most populous city on earth,
> . . . I could not without the greatest pleasure see art, by its innocent fictions, claim
> from nature the truth of its models and agreeably fool my eyes by spreading before
> them the latest fruits among the earliest buds, as if autumn had been transplanted
> into spring.

But Rou had gone on to condemn this attitude of unforced wonderment as

> an error which, as gross as it may be, has nevertheless all too much popularity in
> the world, where the greater number of people, even learned men and the cleverest
> types, lapse into the error of raising themselves on their own authority to the status
> of judges competent in the mysteries of a profession the true knowledge of which
> is reserved only for initiates. Fooled by this assumption, they imagine that this art,
> since it often takes as its objects the commonest natural things, is as open to their
> judgement as the originals which are before their eyes everyday.[43]

That forbidden opinion is precisely the one retained by our commentator, steadfastly and with high humor. He repeats also the same elaborate attention to the narrator's arrival at the Salon door—typically there is some obstacle in the way around which the initial action then turns—which in this and later critiques comes to stand for the naive or uniniti-ated voice.

It is not that those who use this voice present themselves as untutored or socially inferior (despite the Uriah-Heepish mannerisms of the speaker in this instance) but rather that they assume this sensibility to be the appropriate one for discussing pictures. The germinal completeness of the form in Rou's manuscript reveals not any direct antecedence but rather the early establishment of a much-repeated topos; the connection provides yet another clue to that largely lost substratum of non-certified discourse on art under the Old Regime. The voice, it should be stressed, is a representation of popular percep-tion, not that elusive thing itself. But the "public," in the end, is nothing more nor less than a series of representations; the issue for us is its consistency, efficacy, and demon-

strable fit with actual social practice. In 1741, we see that what had begun as a mock-popular form of philistine skepticism (as in, say, Sorbière) could be joined to a genre of aggressive, embittered social satire. The attitude is of course far older than Sorbière and Rou, who deploy to contrary ends the now archaic values of the *Kunstkammer* or *cabinet de curiosités*, in which pictures were used as semi-miraculous simulations of distant marvels. It is an example of how a bypassed, once-dominant ideological system can survive as a potentially resistant, even oppositional one. It was "popular" in the first instance because, to judge by its recurrence from Salon to Salon, it had an audience: the pamphlets in question sold. It further inaugurates the first appearance of the art public as a solid figure in discourse. If we think back to the dismissal of the Salon audience by Cochin and Coypel, what they perceived in the behavior of the crowd was not the incoherence and inattention they ostensibly decry, but a practiced and persistent attention to the wrong things.

We need, however, to be cautious when using terms like resistance and opposition. To speak of resistance is to speak of some active contention over resources or space, however marginal. The fair players and their public in the early eighteenth century certainly were carrying on a fight against entrenched opposition in order to win a place for themselves. Does our 1741 text represent a comparable struggle? The answer, I think, would have to be no, or better, that the struggle to which it refers is safely over. The exclusionary Rococo aristocrats have long since been routed by official order; they put in an appearance here simply to make that plain.[44] The ordinary visitor is entirely free to indulge an appetite for illusion, unselective attention to the physical presence of things, and a straightforward delight in representations of his or her own everyday life. And there will be no shortage of art, happily supplied by academic artists, to satisfy these impulses. Such refusal to internalize the Academy's hierarchies would by itself cause no difficulty for those in authority; it would only assure the approved specialists in the lower genres of an admiring popular audience and could easily coexist with the sophisticated responses of a *public instruit*.

But while we find little sense of active struggle for a cultural franchise in the Salon of 1741, there will certainly be all the signs of one after 1747. The peaceful coexistence between an enlightened public thoughtfully attending to the Academy's more ambitious productions and a mass audience easily satisfied with the rest will be upset when *neither* group appears to accept the offical program for painting. Beginning with La Font, the most articulate *amateurs* will launch a campaign of criticism against the Academy's efforts in the elevated genres. At that point, the demonstrable indifference to history painting on the part of the majority of Salon-goers becomes a serious issue. For then the programmatic opposition of a small group of critics could plausibly be presented as the reasoned will of the audience at large: the mass is thus magically transformed into a public; undeniable indifference becomes tacit critique. The dissenting Salon writers of the 1750s will make just such an argument. More than that, they will begin equating the crowd in the Salon with the voice of the French "nation," the true and abiding body politic traduced by a corrupt and despotic government. As we shall see, such was the force of this idea in the political life of the period that the discourse of the art world was permanently altered. A possible stake that the broad audience might have in history painting could now be articulated. A terrain of struggle for control of the "noblest" genre was being mapped out in which the failure of the history painters to address the majority could be seen to matter.

Whose Salon?

–i–

THE presence of the new Salon audience presented such an abiding problem for those in authority over French art because of a fundamental contradiction at the heart of academic doctrine: a universalizing conception of artistic value had to be mapped onto a divisive social hierarchy. This is why discussion of the public in the exhibition continually intersected with reflection on the hierarchy of genres and its meaning. It was not that this doctrine represented in itself an enforcement of privilege and exclusion: the supremacy assigned to history painting was theoretically justified by the fact that it *included* all the others and the visual interests they separately satisfied. But the French Academy, in order to achieve and maintain its special status, had to claim further that the highest genre was perforce the *noble* genre, and that equation inserted aesthetic issues into an increasingly unstable structure of social ideology. Nobility was the achievement of an aesthetic and intellectual standard in art and, at the same time, a disputed symbolic marker of actual social superiority. For the first, some plausible public was required before which that achievement could be demonstrated, while the second could be made to exclude most if not all of the available audiences with a genuine stake in the public exhibition as an institution.

Clearly this is not an issue that troubled our writer of 1741, but it would be a constant worry for many of the unofficial critics who followed, writers with a determined commitment both to the public realm and to the academic ideal. For them, the ambiguous issue of *noblesse* in painting—to what and to whom did it refer?—was an issue that had to be addressed if not resolved. Their efforts to do so can roughly be divided into two categories. In the first, there was the assertion that with some added effort, the academicians could instruct the ordinary citizens in the crowd in the skills necessary to apprehend history painting's elevated and expansive vision. The public, they concede, is fascinated by the verisimilitude of the lower genres, but there is nothing essentially wrong with its preference. It is the responsibility of the history painters rather to include direct experience within the realm of higher ideas. That, once accomplished, would elevate the viewing habits of the crowd. So goes the argument of one moderate critic writing on the Salon of 1757:

> Observe the large numbers of people who, after having given M. Van Loo an initial glance [Plate 48] are seized by a victorious instinct which leads them to truth, searching out and planting themselves before the most truthful pictures of the Salon. You will reply and object to this, that I assert more than I can prove, that too often

48. Carle Van Loo, *The Sacrifice of Iphigenia*. 1757. Oil on canvas, 426 × 613 cm. Sanssouci New Palace, Potsdam

the public is amused to look at familiar everyday objects, rather than those which rise to the noble style of history. I agree: but the reason is that in the genre of history, they have not sought after truth as they should. I dare to believe that a history painting where one encountered truth at every step would give this public a taste for the genre. It would find pleasure, settle itself there, and commune with a type of painting which customarily has displayed too much of mere application of method, above all in terms of color. History is not a genre above nature, but a genre where one must make a choice of true nature, and once having chosen, follow it blindly and without reserve.[1]

Echoed here is the sentiment we have observed earlier: that the history painters of the Academy were wilfully pursuing a desiccated and artificial manner answerable only to a set of contrived, in-group criteria. The implication of this critic's reproach is that history painting had to take its lead from the lower genres if it was not only to enjoy any broad public appeal but also fulfill its own mandate to be the superior genre. This perception seems to lie behind the inordinate praise heaped on the (admittedly superb) landscape painter Joseph Vernet (Plate 49). This artist's authority was such that his commission of 1753 to produce a comprehensive cycle on the "Ports of France" represented the only substantial initiative in patronage undertaken during the first decade of Marigny's "reform" administration. The extravagant rhetoric which surrounded his Salon entries (of which Diderot's is a conspicuous example) found in his stormy coasts and moonlit bays the virtual equivalent of nature's own variety and plenitude—and as such, an object

49. Claude-Joseph Vernet, *Storm on the Coast*. 1754. Oil on canvas, 85.7 × 136 cm. Wallace Collection, London

lesson and reproach to the painters of historical subjects. States this same commentator of 1757, "Our century must count itself lucky to possess him: happy that century will be that will possess a history painter of his power! *But that blessed Phoenix has yet to arise.*"[2]

In this basically generous conception of nobility in painting, it is a divisible quality, available at least partially to those otherwise excluded from that realm. It also depends on neither of the two meanings of nobility, neither the intellectually universal nor the socially exclusive, being invoked with any particular rigor. When they were, the assessment was likely to be far more negative. More commonly, when the issue was addressed, the conclusion was that any ambition or hope for resolution between the demands of the genre and the character of contemporary society was doomed from the start. The image of the "blessed phoenix" recurs as a trope in later criticism, but with the clear implication that the looked-for savior of the Academy could only emerge from an ashen wreckage and was in fact no more likely to appear in Paris than the bird of myth. We find it used again—same wording, same italics—in a text written almost two decades later. There its object had shifted from painter to painting, and it states plainly that the ideological status of history painting had become so elevated as to exceed all the possibilities of actual practice:

History, or the heroic style in painting, embraces all the genres and is their common mother—landscape, architecture, animals, human figures—everything is its domain. It paints the whole universe, but the universe enhanced. This is to say that its style

must be noble; it must paint nature, but only in the moments when nature presents itself in its most majestic aspect. But the life of man seems to be too limited for the acquisition (to the highest degree) of this exquisite sentiment which causes us to distinguish in a single glance what must be adopted or rejected. . . . a painting executed in all its parts according to these conditions would be one of the rarest wonders of the world. *But this blessed phoenix has yet to arise.*[3]

"The life of man seems too limited," irredeemably estranged from a notion of art that hovers like a dream over the visual aesthetics of the latter half of the century: that is the regretful premise of this text and many others like it. We find, on one side, a progressively more inflated and abstract notion of nobility projected onto painting, and on the other, a social awareness that no significant segment of its audience could locate this nobility in its own experience.

These discussions of history painting and *noblesse* tend to oscillate in an unstable way between the aesthetic/theoretical and the social dimensions of the term, reflecting the powerful fascination the latter still possessed for even the most politically liberal writers. The anxiety on the part of such critics somehow to make the two aspects of nobility commensurate with one another led to such close examination of the credentials of producers and consumers alike that all in the end were somehow disqualified. No theorist of the seventeenth century, for example, had paid much mind to the actual social origins of the artists themselves, the men entrusted to find form for the noble ideal. In the eighteenth century, it became a significant source of troubled reflection. The obvious facts were that the class background and the education of most artists during this period were at best indifferent; they were men for whom art was still, in practice, very much a craft and whose outlook extended little further than their studio training and the wishes of their patrons. When Bachaumont wished to flatter the painter Pierre in a letter of 1752, he distinguished him from his colleagues on the basis of his learning and cultivation:

You are an able man, and you have a fine mind. You have had a good education; you are well versed in literature; you love to read, and you enjoy the fruits of an *honnête* fortune. These are the marked advantages you possess over those who follow the same career as yours.[4]

Marmontel, the *philosophe* closest to the affairs of the Academy, describes the artists who made appearances in fashionable society—Van Loo, Boucher, J. B. Lemoyne, Latour—as a dull and hopelessly vulgar group, much patronized and condescended to: ". . . they lack, almost all of them, any learning or culture."[5] The contradiction was profound and drove some critics to despair: in such hands, was painting in the only "public" sense available, that is, elevated *peinture d'histoire*, even conceivable?

The verdict of at least one significant text written in the 1780s is bleakly negative on this point. This is a long (82-page) pamphlet entitled *Sur la peinture*, which was published by an anonymous artist in 1782.[6] It is manifestly Rousseauian in its "sincerity," emotional tone, and egalitarian politics; yet it is unable to see its way out of the existing hierarchies of art. The author claims to be a young painter committed to an historical painting of heroic and moral stature, but is unable to imagine that commitment being realized. He and his colleagues suffer

the built-in disadvantage of coming for the most part from the lower classes of society, where the lack of education and of a certain noble manner of seeing makes us judge things with a coarseness which the greatest effort cannot correct. It is in vain that we look to our more experienced masters for examples of conduct which might improve our own, which might indicate to us the true path toward one day attaining the moral perfection of Art. They are no more perfected than we: as they behave in the studios with only the manner of their families, rather than purifying their conduct through the application of just principles worthy of others, we find ourselves far below the level of distinguished art; they remain *Peuple*, disposed to this mean facility, this calculating cunning, which, if it does not reveal a black and evil character, marks at the least a futile and superficial spirit.[7]

Turning from the producers to the consumers, we find similarly crippling doubts in evidence concerning not just the common majority in the exhibition (as was noted in the introduction) but even those members of the audience with a claim to noble status. Diderot produced some vivid thoughts on this subject in his Salon review of 1767.[8] He begins with musings on a possible natural history of morality:

> . . . I was thinking that there was one moral order appropriate for one animal species and another moral order appropriate for a different species; perhaps within a single species there was a different morality for different individuals or at least for different classes or collections of similar persons, and further, not to scandalize you with too serious an example, a morality special to artists, or rather to art, and that this morality could well go against the grain of everyday morality.

He then contrasts those subjects which he and other critics were urging painters to take as their worthiest challenge—the heroes of classical literature and the histories of Greece and Rome—with the down-to-earth ambitions of "M. Baliveu", a fictional bourgeois notable from Alexis Piron's popular comedy *La Métromanie*:

> . . . heroes, lovers out of romances, grand patriots, incorruptible judges, philosophers steadfast unto death, all these rare and divine madmen make poetry of their lives, to their grief. It is these, after their deaths, who provide us with great pictures; they are excellent for painting. . . . What a difference, I shout out loud, between genius and common sense, between the tranquil man and the impassioned man! Happy, one hundred times happy, I shout out loud again, is M. Baliveu, *capitoul* of Toulouse. It is M. Baliveu who drinks well, eats well, digests well, sleeps well; it is he who takes his coffee each morning, keeps order in the marketplace, spouts off in his little family circle, rounds off his fortune, preaches prosperity to his children, sells his oats and wheat at the right moment, keeps his wines in his cellar until frost on the vines has made them dear; who knows how to lay secure foundations, prides himself on never having gone bankrupt, lives an obscure life, and for whom was made that happiness which was the futile envy of Horace, the happiness to die unknown. M. Baliveu is a man made for his own happiness and for the unhappiness of others.

To be a *capitoul* of Toulouse was to be a bourgeois-made-good in the southwest of France. The title was that of a municipal office which, like most under the Old Regime, was acquired by purchase, and this one was of sufficient stature to confer a kind of nobility on its holder. In Piron's play, Baliveu is a malicious philistine, arrived in Paris to punish

a nephew with extravagant poetic ambitions; he carries a *lettre de cachet* that could send the poor *métromane* to prison.[9]

This sociological vignette points once again to the troubling lack of fit in the eighteenth century between nobility as a social value—that is, the still unchallenged equation between "virtue" and noble status—and the shifting composition of the actual titled elite. Diderot is careful to designate his representative spectator not just as any bourgeois, but as one with legal claims to noble status. This is a *noble homme*, in the strict sense, of the later eighteenth century. The text, however, alerts us to the fact that when a family crossed the line into a state of "living nobly," its divorce from the debasing concerns of commerce was far more apparent than real. To pursue this one instance in detail, the low rate of return on investments in land and *rentes* (around 2% per year) has led some recent commentators[10] to describe the traditional bourgeois elites of the eighteenth century as sacrificing their old entrepreneurial instincts on the altar of social ambition. But this analysis has obscured the other ways that wealth could be accumulated in a still largely agricultural economy. *Rentes*, for example, were loans made in return for a regular repayment *in perpetuity*; the borrower could never reduce the principal without raising the entire amount of the obligation. Time after time, the records reveal debtors to *nobles hommes* inexorably falling behind in their payments, eventually ceding choice parcels of land to the likes of the fictional Baliveu or the real Poiresson. These debtors were just as likely to be impecunious gentlefolk as hard-up peasant small-holders. Consequently, a family of bourgeois notables could accumulate the manorial properties essential to noble pretensions, and go on acquiring larger and grander ones. The practices of capitalist life were not so much left behind as redirected to a more exclusive category of property. Small advantages in liquidity, managerial skills, and financial acumen could, over time, produce very large differences in wealth. The low rate of return on investment in offices can be deceptive as well, in that an important local post frequently gave its holder access to more lucrative opportunities. If a financial matter ended up in court, the average *noble homme*, usually trained in the law, was at an advantage there as well.[11]

In the Salon, one thus discovers both producers and consumers of images whose claims to an ennobled sensibility could be challenged on the basis of their actual conditions of life. The artists were mere tradesmen; the heirs of Montaigne were more likely to be Baliveus. This would not have been so great a problem had there been some other, securely noble constituency that wanted a classicizing history painting badly enough to define its character, to dictate the terms for success and failure. But none existed. The "noble genre" was a largely artificial transplant sustained by a narrow state bureaucracy, an organ of a central government intent on expanding its power at the expense of both the descendants of the feudal nobility and the traditional bourgeois elite of *nobles hommes*. Emerging to challenge both was a new, court-dependent aristocracy of financial speculators and aggressive venture capitalists in the prosperous provincial ports. Sugar refiners and slave traders in Bordeaux, textile manufacturers in Lyons, bankers in Rouen, the tax farmers and financiers of Paris, such men were able to purchase directly those offices which conferred immediate nobility; they could readily buy the hereditary seigneuries and privileges so dear (in both senses of the word) to the more traditional bourgeois elites; and they could provide their daughters with the outsized dowries sufficient to attract suitors from the high nobility. As noted in the previous chapter, the Parisian *gens de finance* adopted the opulent style of life of the court nobility and came to surpass their models in matters of luxury and display.[12]

History painting, having been effectively abandoned by its nominal state sponsors, was potentially available to any of these "noble" groups as a vehicle for advancing, in the sphere of culture, their particular claims to precedence, but it was the "natural" possession of none. Around mid-century, one of them, the elite of finance, made a move on this free-floating symbol of all that was elevated and morally commanding, attempting both to stimulate and to assume control of a renewed state investment in the visual arts. This set off a protracted conflict with its social and political rivals for this suddenly glittering prize, a struggle which generated in passing the reflections on class and the hierarchy of genres just discussed. However, because of its potent yet problematic and contested character, that move could just as easily raise uncomfortable questions about any group's claims to "true" nobility. Weightier players with more complex aims and higher stakes are beginning to move on this symbolic stage. And each will put forward a "public" to back its claims. The purpose of the present chapter is to describe the initial phase in this development.

—ii—

In 1746, the Academy's affairs had been administered for almost a decade by the finance minister Orry, for whom the post, and artistic matters generally, were a secondary priority. Before his tenure, from 1708 until 1736, that position had been held by a man, the duc d'Antin, who habitually addressed artists using the familiar "tu" form as one would a servant or a child.[13] Immediately after 1746, however, the Academy and the whole realm of visual art began to enjoy a good deal of high-level consideration. This rather sudden shift is tied directly to an historical event of some notoriety, namely the accession in 1745 of Jeanne-Antoinette Lenormand d'Etiolles, née Poisson, as official royal favorite. Her new title was marquise de Pompadour, and that name is one of the most familiar in the cultural history of the period, standing itself for Rococo elaboration and excess ("Van Loo, Pompadour, Rococo!" would be the denunciatory cry of the rigorous classicists among David's pupils).[14] That equation, however, has always been a facile one, and the immediate effect of her sudden prominence and power was in fact to introduce a new seriousness and sobriety into the administration of the arts.

One of the first and most lasting signs of the favorite's new power at court was the movement of her relatives into positions of responsibility over the Academy and state patronage. Orry's tenure in both of his posts came to an abrupt end, and the new *Directeur-général des bâtiments*, Lenormand de Tournehem, was the man who had arguably played the most important part in the young life of Mme. d'Etiolles. Her father, a minor operator in the financial empire of the Pâris brothers, had taken the blame for some illegal maneuvering higher up and been forced to flee the country. Tournehem, a much grander financier and Pâris ally (he was a Farmer-General, director of the Indies Company, and former ambassador to Sweden), stepped in as the lover of Mme. Poisson and protector of her family. The liaison, so it was strongly rumored, had been established much earlier, and Tournehem may have been the favorite's natural father. The Poisson marriage, in any event, had originally been one of convenience, an arrangement to protect the reputation of Pompadour's mother, who had been since adolescence the mistress of one of the Pâris clan, Pâris-Montmartel.[15] When Jeanne-Antoinette came of age, Tournehem arranged her marriage to his own reluctant nephew and heir, Charles-Guillaume Lenormand, providing the couple with house and income. Neither uncle nor nephew put any

50. François Boucher, *Madame de Pompadour*. 1756. Oil on canvas, 201 × 157 cm. Alte Pinakothek, Munich

obstacle in the way of her higher ambitions, because those ambitions were as much those of the Lenormand family as her own and represented the culmination of Tournehem's tireless grooming of his daughter in all but name.

The departure of Orry, a past adversary of Pâris interests, had been an inevitable consequence of the Lenormand ascendance. The resulting vacancy in the *Bâtiments* was a perhaps unanticipated opportunity, but the appointment of Tournehem, the powerful head of the family, indicates that Pompadour and her partisans intended to make maximum use of that relatively moribund position. Indeed it was to be the primary instrument of their dynastic ambitions. At the time of Tournehem's accession it was agreed that the post would pass at his death to Abel Poisson, the favorite's well-loved twenty-year-old brother and the future marquis de Marigny.[16] The directorship was made in effect a hereditary title for the lives of the two men, and the grooming of the heir began immediately, with Charles-Nicolas Cochin, as adept then in his role of court graphic artist as he would later be in administering the Academy, serving as principal mentor (Cochin's rapid rise in the academic hierarchy dates from the moment of this alliance).[17] In keeping with the scope of their ambitions, both Tournehem and Marigny wanted the *Bâtiments* again to play an active, interventionist role in artistic practice. This they conceived in terms of the precedent set in the seventeenth century by Colbert and Le Brun; their stated policy for painting, therefore, was one of rebuilding the Academy's capacity to generate publicly-oriented narrative pictures that were stylistically and morally disciplined by the classicism of the past century.

There is a marked divergence, however, between this aesthetic program and what we know of the private artistic tastes of the family. Its well-known patronage of Boucher (Plate 50), for example, is entirely consistent with its social origins in the Parisian financial

elite. It was the ascendance in matters of taste of precisely this group that La Font and other like-minded advocates of vigorous reform held responsible for the decline in French painting. This apparent inconsistency has bolstered the arguments of those who see no connection between the new tendencies and any particular class interest or identity—and certainly no tie to the consciousness of some adversary bourgeoisie.[18] "Neo-Classicism" was nurtured in the heart of the court by a luxury-loving elite closely identified with the interests and tastes of the King.

Yet the family of Pompadour was bourgeois, for all its eventual titles and prominence, and that fact itself suggests a logic for its conduct in power. Certainly lavish support for the arts as a means of legitimizing *arriviste* pretensions to aristocratic status is practically as old as Western culture. But the newly rationalized and detailed deployment of the visual arts as a privileged language of absolute authority had significantly altered the rules of the game. At stake now were the makings of a modern bureaucratic institution, a semi-autonomous center of power and patronage within the state (Tournehem and Pompadour would independently push the financial outlay of the *Bâtiments* to something like 2.5% of total government expenditures).[19] Simultaneously, the incomplete shift of aesthetic criteria from the personal dictates of the prince to public, universalistic criteria made the whole system fragile—and vulnerable to adventurous appropriation from below. It depended, ostensibly at any rate, on a system of values in which the older nobility displayed little interest and over which they exercised even less control. The wealthy financiers of Paris had as a guide the example of Crozat, whose enterprise supplanted, to a significant degree, the imposing but short-winded apparatus put in place by Colbert. In the process, as we have observed, the very real accommodations between the seigneurial and financial elites were not only articulated in paint, but were the stimulus for a new courtly style that evoked both nostalgia and modernity with equal power. And the role of Crozat went well beyond the incubation of a Watteau to an assumed responsibility for preservation and transmission of the great tradition. He sheltered de Piles, and his profound collector's expertise was one means by which he reinforced an alliance of interests with the Regent (recall his key role in assembling the Palais Royal collection). The strategy of the Lenormand clan would be consistent with the increasing role of culture, and the visual arts in particular, as a common ground and mediator between old and aspiring elite groups. It would seem but one step from the *ad hoc* authority exercised by the grand financier Crozat to a ceding of legal responsibility for the conduct of the fine arts to members of the same social group; the fortuitous rise of Pompadour provided the means by which informal authority was transformed into established hegemony. Given that either Tournehem or Marigny might easily have gained another kind of post and responsibilities of greater traditional weight, administration of the arts emerges as their chosen path to permanent dynastic power.

From our account thus far, a general principle has begun to emerge concerning the gradual increase in opportunities for public opinion to make itself felt in the Salon. This initiative is rarely if ever one-sided, that is, organized and pushed from below. The public role can be seen to expand when the needs of one or another faction in power causes them to "go public" in an effort to enhance their position. As there came to be more at stake in the cultural apparatus of the state, the potential for conflict over its resources increased, as did the likelihood that these conflicts would spill over into public discourse. This pattern emerges with absolute clarity in the assumption of official authority over the visual arts by the Lenormand clan. More so than it would have been for a *Directeur*

of assured social standing or a solid power base elsewhere, it was incumbent on Tourne-hem first to restore the damaged legitimacy and seriousness of the institution. And the Lenormands had no choice but to do this in terms of the Academy's established legal mandate; precisely *because* they were parvenu bourgeois, they had to make it their policy to revive the standards and practices of Colbert's half-remembered golden age.

There are two senses in which that policy required a conspicuous commitment to the public dimension of artistic practice. First, their stewardship would have to be ratified in a highly visible forum. The popularity of the revived Salon left no doubt as to what that forum would be. And we have already noted in the introductory chapter some of Tournehem's efforts—the institution of a jury, the Galerie d'Apollon competition, for example—designed to make the exhibition into a more effective showcase for his regime's accomplishments. There will be much more to say on this subject below. The second sense of public commitment, the reinforcement of enlightened and dispassionate forms of knowledge and discourse within the Academy, was in many ways a precondition of the first. To accomplish this, the Lenormands had to go beyond their own taste and experience to call on expertise which they did not personally command.

We here pick up a strand in our account which we left at the end of the discussion on Watteau: the partial privatization, at the beginning of the eighteenth century, of con-trol over art-historical and critical knowledge. It was in fact to the hold-overs from the old Crozat circle that Tournehem turned for direction in the early stages of his director-ship. Charles Coypel was now *Premier peintre*, and the aging *amateurs* Bachaumont and Caylus became suddenly far more active in the activities of the Academy. The latter pair we have encountered already. A close examination of the careers of each will illustrate the process by which an earlier investment in connoisseurship and art-historical acumen was re-converted at mid-century into power within the state.

−iii−

Bachaumont embodied much of the indeterminacy of social role and station that charac-terized the new aristocracy. In the manuscript memoirs he began writing in 1731, he embraced this condition: "I have lived for a long time without knowing if I came from noble or common stock, and, what is more, without bothering myself about it."[20] His ancestry seems actually to have been of extremely modest nobility in the Chartrais, and there was no important property in the family, at least not before the time of his paternal grandfather. The latter's route to enhanced standing and fortune was a professional career in medicine, very much a middle-class option. It was one, however, which took him to court, first as *médecin ordinaire du roi*, then, in a real coup, as personal physician to the Dauphin. On that base, and with a good admixture of thrift, he was able to provide himself and his wastrel son, Charles-Antoine Petit, seigneur de Bachaumont, with a pur-chased sinecure in the Paris judiciary. Charles-Antoine died not long after the birth of his son in 1690, and the child was deposited with his grandfather at Versailles. By this time the Dauphin himself and the princesse de Conti, another child of Louis XIV, had stood as his godparents. He appears to have spent considerable time in the presence of both, at Versailles and at various country retreats. The princesse has already appeared in the present account as a member of the troupe of Gueullette, and the young Bachaumont was, by his own account, thoroughly initiated into the court high-life of

the period. Another doting elder, he tells us, was the great landscape architect Le Nôtre, who indulged him in drawing lessons. Bachaumont's understandable pride in that early tutelage should be qualified by the fact that it took place well before his tenth birthday and that he was, by his own admission, no prodigy.

The details of his early adult life are sketchy (his manuscript memoirs end in early adolescence), but he was apparently left with a sufficient fortune to live "nobly"; as he wrote to Pierre many years later, "I was born with a *bien fort honnête*, the use of which was mine from my first years; I wanted neither duties nor responsibilities."[21] The paintings and décor of the palace of Versailles were a repeated point of reference throughout his later writings, a sign of a lasting identification with his upbringing in the court periphery and its displacement into connoisseurship of fine and precious objects. In 1743, he was offered the quite lofty post of *premier président* in the Parlement of Paris, but, unlike his father, would not accept even the minimal application required in a lucrative judicial sinecure. He had by that time already fashioned a secure niche for himself as an amateur of the arts.

That role had begun, whatever apposite skills his life at court had provided, through an indirect personal and property relationship which tied him to the Parisian connoisseurs in the Crozat orbit. Title to his "ancestral" seigneurie at Breuilpont had shifted (why, we don't know) to a financier with a high position in the Orléanist bureaucracy called Louis Doublet, though Bachaumont retained it as his residence until after 1730. Doublet's wife, the former Marie-Anne Legendre, was the daughter of a tax farmer and sister-in-law to Antoine Crozat. The famous relationship between Madame Doublet and the young amateur would last until her death. Both attended Coypel's suppers—where Caylus could be found—and the Sunday gatherings at Pierre Crozat's. Bachaumont had taken up amateur engraving in the manner of Caylus, though instead of copying Watteau, he concentrated on the draughtsmanship, as non-professional as his own, of his friend Marie-Anne Doublet. (This fact seems to belie his later explanation to Pierre that poor eyesight prevented his taking up painting;[22] with his stated pretentions to *honnêteté*, such an ambition is not really credible and was no doubt meant to flatter the artist.) The château at Breuilpont was the scene of erudite and libertine rituals very much in the Regency style.

The liaison between the young connoisseur and Madame Doublet, thirteen years his senior, became, then or later, one of some degree of intimacy. Some years after the death of Louis Doublet in 1722, by 1730 at any rate, Bachaumont moved permanently to Paris and into an *hôtel* adjoining and connected to the Doublet residence. And together they launched a regular salon, ironically named the "Parish" after their location—not an unusual residential arrangement at the time—within the walls of the convent of the Filles St. Thomas. Their parish would last for some four decades. As an intellectual and social nexus, it will figure in our account from several angles and encompass a number of protagonists in the art-critical wars of the late 1740s and early '50s.

To concentrate for a moment on Bachaumont's personal career: his principal activities from an early date appear to have been as a busy, free-lance arbiter of taste in the visual arts, providing prospective patrons with firm direction in the choice of domestic architects, decorators, artists, framers, even picture cleaners (Singas on the Pont Notre-Dame is favored; "Colins is too expensive"[23]). Complete memoranda survive for several such inclusive projects.[24] They emphasize the practical: Boucher, for example, is recommended repeatedly for his speed of execution and (relatively) cheap prices. Follow-up

documents indicate Bachaumont was willing to take on an active supervisory role in the building and decorating process, no doubt for substantial remuneration. He kept a sharp eye on the market for pictures, keeping dealers' price lists, charting auctioneers' estimates against actual prices, and evaluating private collections himself. From 1737 on, he composed categorical lists of the members of the Academy for a group of paid subscribers in Paris and further afield (as part of a clandestine news service operated by the "Parish" to be discussed below). Though much of the information on these lists is basic, the coincidence of date between the first of them and Orry's advent as *Directeur* and Protector is suggestive. Given what we know of his relative indifference to artistic matters, Orry probably required some elementary familiarization with his new charges. Consistent with this interpretation of its purpose, there are suggestions in the list of appropriate choices for *amateurs honoraires*, which could only have been an official concern. In 1746, he addresses a similar memorandum directly to Tournehem, along with pages of recommendations on the whole range of the new Director's responsibilities.[25] Among his prime concerns was the deteriorating condition of the royal collection; pictures of the order of Poussin's *Sabines* and *Triumph of Flora* were languishing without frames on rotting canvas and spavined stretchers.

Bachaumont appears to have seen the accession of Tournehem as an opportunity to exert substantially greater influence on official decisions concerning the arts. In a 1748 memorandum on the subject of the architectural setting for the equestrian statue of Louis XV (commissioned by the city of Paris and executed by Bouchardon), he does not hesitate to overwhelm the *Directeur-général* with the weight of his connections and influence.[26] The abbé Bernis (the future prime minister and cardinal), says Bachaumont, had shown his plans to Tournehem and tried to arrange a meeting between the three of them. Then the names of the powerful come thick and fast: he had already "taken the liberty" of showing the project to the duc de Gesvres, governor of Paris, "my relation and old friend," and to the Prévôt de Marchands, the official directly responsible for the commission; the foreign minister, the marquis de Puysieulx, had seen it, as had the Comptroller-General "who had much appreciated this project as had all the others whom I have just named. . . . Madame de Pompadour," he goes on, "has judged it similarly, as have the duc de Gesvres and Monsieur the marquis de Puysieulx who have spoken of it to the King in this same spirit." A good deal of conventional flattery follows with a remembrance to "my good and old friend Coypel."

This is probably the most revealing document we possess concerning the internal workings of the "reforms" of 1746–9. Tournehem himself seems to have remained somewhat distant from events, infrequently in Paris and easily bored by detail. "Your *petits séjours* in Paris and your various excursions," says Bachaumont, had prevented their meeting with Bernis; consequently, he is forwarding the complete plans. But Tournehem is not to be intimidated by the bulk of the package, Bachaumont quickly reassures him: the paper is unusually thick, the writing large, and the margins wide. None of this suggests a commanding official authority; Tournehem appears to have become more a conduit through which an entrenched group of *amateurs*, sustained by sympathetic "enlightened courtiers," could influence policy. In the Bachaumont papers, there is evidence for one instance of this influence. His 1746 *mémoire* puts particular emphasis on the Galerie d'Apollon in the Louvre; he points out that the seventeenth-century decoration was never completed and that the new program of historical commissions could be usefully directed to finishing off the job, the space being superior, in his estimation, even to the Galerie

51. The *Galerie d'Apollon* today

des Glâces at Versailles. Tournehem's competition of 1747 was, as we have seen, displayed inside this gallery (Plate 51).

Bachaumont's influence also moved outward into the public sphere. Among his lists of pictures and artists are manuscript catalogues of recommended books on art and architecture—Félibien, Du Bos, etc.—with prices. He was an entrepreneur of aesthetic discourse as much as of objects and artistic labor. The parallel activities of the comte de Caylus during this period were directed, in contrast to those of Bachaumont, to the renewed production of that discourse. The pursuits of the two men, friends since the 1710s, were linked and complementary: where Bachaumont was a sedentary and amiable broker and middle-man, Caylus was original, adventurous, and controversial. The latter's personal confidence and independence of mind may have owed much to his origins in the old nobility. His youth was spent in the requisite military career, and it was a warrior's taste for adventure that produced his first contact with the classical art to which he was to remain so devoted. He made a long circuit of the Middle East in the first years of the eighteenth century when such travel was dangerous and rare for Europeans: his excursion to Ephesus required treating with the local bandit chieftain. Later, when he invoked, relentlessly, the Greek ideal, he would speak as one of the few Frenchmen to have seen the surviving monuments first hand, long before the published works by Le Roy and Stewart and Revett made that knowledge widely available in the 1750s. Returning to France and to retirement from active service, he emerged as one of the more visible figures in Regency culture and established his close links to Gueullette. Thanks to his acquaintance with Crozat and the Coypels he put himself through a both historical and practical education in drawing and painting: yet another aristocratic amateur engraver, he copied from Crozat's hoard of old master drawings and from those of his friend Watteau.[27]

Depending on which specialist study of eighteenth-century culture one reads, a different Caylus appears. Art historians recall exclusively the one marked by a rigorous devotion to the antique and a reformist zeal in pressing his archaeological purism on the arts. This came, however, after a period of almost legendary dissipation in the 1730s, regarded as exceptional even in a society inured to such things.[28] His formal affiliation with the Academy as *amateur honoraire* began in 1731, at the peak of his period of swaggering libertinism. That he took no active part in academic affairs over the next fifteen years no doubt has a number of explanations: one was his distracted mode of life, another the indifference of d'Antin and inexperience of Orry. One lesson of the history of the Academy seems to be that no concerted push of aesthetic/ideological reform could take

place without the strong support of the *Surintendant* or *Directeur*, so under the circumstances Caylus would have had to bide his time anyway. But after Tournehem's accession, he was galvanized into purposeful public action. Among a whole series of formal and informal initiatives, Caylus was responsible for reviving the *conférences*, which once again, in the years since Mansart's death, had been effectively abandoned by the artists. He himself delivered the first of the new lectures (entitled "On the Necessity of Conferences"), a reprise of de Pile's scolding performance of 1699, in which he upbraided the academicians for their idleness and lethargy.[29]

If Bachaumont represented a development of the more private and informal cultivation of expertise characteristic of the Crozat circle, Caylus, in contrast, tended to apply his knowledge and enthusiasm directly through public institutions. He took a special interest in education, establishing a prize for drawing, and it was no doubt with his approval that, in 1748, Coypel, the *Premier peintre* and an old ally, directed that students begin attending the *conférences*. This move was part of the same policy that established the School of Protected Pupils (*Ecole des Elèves Protégés*), one of the most ambitious innovations of the Tournehem regime. Beginning in 1749, winners of the Rome prize would no longer leave directly for Italy, but would first spend three years in concentrated study of history, literature, geography, and historical costume along with their art. If the mediocrity of history painting was due to a shortage of learned painters on the Renaissance model, there was now an institution designed to attack the problem at its root. Another Caylus ally, Carle Van Loo, took over the governorship of the school soon after its opening and kept the position until 1765.[30]

The received image of Caylus as a rigid and pedantic *anticomane* has always been an exaggerated one that simply reflects the predictable resistance of the majority of artists to any attempt at programmatic leadership. His later running disputes with Cochin and Diderot, which led to a rapid decline in his influence during the 1750s, have also contributed to this reputation.[31] But in these first years of the Lenormand regime, his seriousness and experience as a connoisseur were difficult to challenge. Cochin, who was later to be so antagonistic to Caylus's critical principles, wrote him an extremely deferential letter in 1749 confessing timidity about expressing in public his own untested opinions on painting.[32] Caylus's nobility was of an antiquity rare among those who took an active interest in the arts, and, initially, this was a powerful advantage. Overall, his authority was instrumental in re-establishing debate in and around the Academy over its principles and attainments.

The intervention of these veteran connoisseurs was essential if the visual arts were to prove a malleable instrument of public policy and an attractive magnet for state money and power. Beyond personalities and individual capabilities, the alliance of these three men was an instance and model for the larger merging of elites in eighteenth-century Paris: Tournehem belonging to the high bourgeoisie of banking and state finance, Bachaumont to the intellectual and scholarly wing of the *robe* nobility, Caylus to the aristocracy of blood. Each one, as an exceptionally imaginative representative of his group, had already fashioned a unique identity and influence. And they had done so by borrowing skills, interests, and attitudes from outside the equipment of their respective social stations. The artistic policies and demands that resulted thus cannot be traced to any one class position: by necessity, they would represent efforts to find and articulate common ground. Social class remains crucially important in any analysis of the revival of the *Bâtiments* and Academy at mid-century, but it would be naïve even to try to ascribe

any encouragement of particular styles or themes in painting to a single, univocal class voice or political interest—the bourgeoisie, the nobility, the state, or any fractions thereof. Nor need there be any automatic coincidence between private preferences and public decisions; a unity of "taste" can be posited neither on the collective nor the individual level.

But if we grant that it is the relationship between classes that matters, that is, negotiated accommodation between groups with well-defined interests, some opposed and some in common, how far does this accommodation have to proceed before class issues are suspended, pushed into a background of secondary significance? Here this does not become an issue, because this alliance of interests proved quickly to be provisional and temporary, disrupted almost as soon as it began to operate. Conflicting interests combined to produce the despair documented at the beginning of the present chapter, the polemics by spokesmen for almost every interested party: Coypel and Cochin for the Academy; Tournehem for the bureaucracy: Leblanc for the kept intellectuals; La Font for the independent *amateurs*; the writer of *Sur la peinture* for disaffected apprentices and *agréés*; Carmontelle for the pre-Revolutionary Left; Diderot for the Encyclopédistes. Each blamed some other group for the decline of serious painting and the intractable difficulties in reviving it; the cause was the financiers, the public, the critics, the petty bourgeoisie, monarchism, academicism, capitalism, depending on which of the many social diagnoses one reads. These disputes had their origin, as we have seen earlier, in the eruption of public critical debate over the Salon starting in 1747, a debate that revolved around the one uncontrolled and undefined collectivity in play: the audience in the exhibition. That issue emerged from the very midst of the promising coalition of 1746 and split it irrevocably. The merger of elites on the larger political stage had disintegrated, and that break intruded on the fragile revolution being attempted in the artistic sphere.

−iv−

In this chapter we have tried directly to address an issue which has been implicitly present in our inquiry since the beginning. That is the relationship between, on one hand, certain forms of collective discourse and behavior that we designate as public, and on the other, actual social classes and subclasses each with its own characteristic complex of discourses and practices. Our attention thus far has been on long-term processes of accommodation and partial assimilation that characterize the elites of eighteenth-century Paris, processes which found expression in the ambitions of the Lenormand family and its conduct in power over the visual arts. Their effect was to force a greater exposure of painting to public scrutiny and to publicly debated criteria by which an artist's success or failure might be assessed.

These patterns of elite social interaction were evolving only gradually; thus the historical scope of our discussion has been rather wide, stressing continuities that extend from the early Academy, through the hey-day of the Crozat circle, to the middle of the eighteenth century. But the transformation of the Salon audience from a passive, unexamined presence into a subject of impassioned debate introduces an abrupt discontinuity into our account. The most dramatic sign of this break is the appearance of unofficial, dissenting art criticism, which the Academy and the state cannot afford to ignore. If we believe Gresset's verse comments of 1737 (and there is no reason not to), the academ-

icians had been harshly criticized in print before. But the offending pamphlets apparently had so little impact that no great effort was made to preserve them or the names of their authors, nor was there any recorded outcry from the official hierarchy. What made the period after 1747 different?

That question will require a complex answer, but one part of an explanation lies in the onset of political crisis in these years, one which invested key terms like "public," "virtue," and "nobility" with charged, partisan meanings. Where one stood in the most important controversies of the time could be determined by the construction one put on words like these. And as such language was as central to the discussion of painting as it was to political debate, the potential for impassioned disagreement over arts policy and performance increased proportionately. The tentative consensus forged between Tournehem, Bachaumont, Caylus, and others as to what would constitute the public sphere for painting was ended in large part by social and political conflicts outside the art world.

The most illuminating way to demonstrate this will be to work outward from the critical texts themselves; to sort out what political codings may be present in them. To return to La Font, the following is his extended explanation of the special appropriateness of subjects from Roman history to the revival of the French school of painting:

> . . . what period do we find more fertile in the marvelous, more rich in great examples of all the human virtues than the beautiful centuries of the formidable empire of the Romans? Where can one find in any other people a statecraft so profound and until then unknown, one so faithful to its great principles? Willingly and honorably indifferent to riches, untiring in their labors, sober to an extreme, detesting opulence, contemptuous of sloth and idleness [oisiveté]. Men for whom public pomp and magnificence were outrageous and incredible, who maintained simplicity and economy in private life, inexorable severity in their discipline, and impenetrable discretion in their councils; conquerors without cruelty, generous and beneficent toward the defeated, their noble and elevated ambition could be commanded only by the laws. Finally, theirs was a love for the glory of country stronger than blood or nature; it is true that each individual, by taking part in government, made the sound constitution of the state into his own property and his own personal interest [son bien propre, et son intérêt personnel].[33]

From an art-historical standpoint, this text immediately points forward to the stoic, self-sacrificing heroes who dominate French painting in the d'Angiviller generation of the 1770s and '80s—that of Brenet, Suvée, Peyron, Berthélemy, and David. But it contains more than a lonely and prescient advocacy of a development in painting still decades in the future. La Font was a member of the Lyons Academy and an educated man; he would know that as description of the centuries of Roman "empire," this was an untenable idealization, which took the legends of the early republic for general fact. Where it gains its obvious cogency is in the unmistakeable moral contrast drawn between Roman virtue on the one hand and the practices of the French crown and the Parisian aristocracy on the other. As instruction to artists, it was not calculated to please an Academy and a *Bâtiments* for whom "pomp and magnificence in public" were not outrageous and incredible but a solemn mandate. Likewise "*oisiveté*" was not for the Old-Regime nobility a negative term opposed to honorable industry, but a condition to be lovingly crafted and savored, an essential mark of exclusivity. These are pointed, purposeful rebukes,

and La Font's focus becomes still sharper in the last sentence: the indirect equation of a "*constitution*" with collective investment and property directly evokes the patriotic rhetoric of the *parlementaires*, whose fundamental franchise consisted of venal (i.e. purchased) judicial office.

The character and patriotism of the judges of the Parlements was a matter of the most charged political controversy at the time that La Font was writing (1754). The government and the Paris Parlement were locked in their most serious confrontation since the days of the Fronde a century before. The reader's suspicion that La Font has more than an antiquarian interest in exemplary Roman patriotism is amply confirmed in a later passage in the same text in which the identical virtues are ascribed to the "heroic" *parlementaires*. It follows a restatement of his longstanding grievance over the large numbers of portraits in the Salon (Mercier's excoriation in the 1780s of aristocratic portrait-images as offensive expressions of privilege was just a repetition of the theme first voiced long before by La Font). Eminent and exemplary persons would, obviously, be an exception to this stricture, as would one class of persons: the officers of the Parlements. "A highly interesting spectacle for the public," he states,

are portraits of these upright and irreproachable magistrates, of these Ministers of Justice who hold the balance in a resolute equilibrium between the blandishments of official favor and those still more dangerous temptations of enrichment. What images could be more dear to all good subjects than those of these men made invincible by their fidelity to the laws and to their oaths? Generous to the point of sacrificing, to no personal profit, the sweet leisure of a tranquil and materially abundant life to duties which are burdensome and almost always thankless! who expose their property, their liberty, often their very lives in order to be a wall of impenetrable iron before the unexpected blows directed at religion and the beneficence of the Prince! of these vigorous defenders of the well-being of his subjects and of public tranquility by the maintenance of order and the laws of the state, of which they are the sacred repository! of these untiring citizens whose one arm wields always the sword of justice to exterminate the malefactor and scoundrel and whose other holds a sheltering shield to repulse the arrows with which the inhumanity of opulence and the omnipotence of credit are always ready to overwhelm the friendless and indigent victim! What duties bring man closer to divinity? And is it not in this sense that the Prophet-King calls judges gods?[34]

The high religious rhetoric and reference to extreme personal sacrifice in defense of King and true religion possessed precise political significance in 1754, when the long exile of the Paris Parlement was coming to an end. The sovereign court of the capital was the most powerful of the regional bodies, claiming not only its territorial jurisdiction, but the right to speak on national matters on behalf of the courts as a united body. By position and ideological make-up it was the most intransigent in confronting royal authority. The underlying source of conflict was primarily fiscal, but the issue which forced a show-down and rallied the Paris population to the side of the *parlementaires* was a religious one: the effort by the Crown and the high clergy to suppress Jansenism once and for all. In 1713, Pope Clement XI had issued the bull *Unigenitus*, specifically condemning the Jansenist exaltation of individual states of grace. The by-now ultra-Catholic Louis XIV had ordered its registration as the law of France in the following

year. But with the beginning of the Regency in 1715, the Parlements had regained (as the price for acquiescence to Philippe d'Orléan's abrogation of the old King's testament) their old right to delay the enactment of royal edicts and publicly to voice opposition to any found objectionable (the "right to remonstrate"). When, beginning in 1730, the Paris clergy began to refuse extreme unction to those who had not submitted to the bull in confession (or who had confessed to a priest who refused to do so) and therefore could not produce a *billet de confession*, the Parlement intervened to force the church to provide the sacraments for all believers. La Font's ascription of divinity to the judges is not so outlandish in light of the reaction in Paris to an order of the court in April 1752 definitively forbidding denial of sacraments to Jansenists and unbending Gallicans (the so-called *appelants*). Voltaire reports that more than ten thousand copies of the order were sold in the city and "everyone was saying, 'Here is my billet de confession!'"[35] The lawyer Barbier wrote in his journal that copies were being displayed in homes like holy scripture, under glass inside gold frames.[36] Historically, many Jansenist adherents had come from the ranks of the *parlementaires*, but by the middle decades of the eighteenth century, only a minority of the Paris court still belonged to the sect. Defense of those Jansenists refused the sacraments signified the larger protection of the liberties of the Gallican church, and thus the rights of the nation, against a foreign power (the Pope) and a powerful faction of dubious loyalty (the Jesuits, the ultramontane high clergy, and their ministerial symphathizers). The ideology that emerged from the remonstrances of the court justified the Jansenist cause in relentlessly universalistic terms: the appeal was continually to "liberty," "constitution," "rights of man," and the like. The "great" remonstrances issued by the Paris Parlement in 1753 contained the following proposition: "If subjects owe obedience to their kings, then kings, on their side, owe their obedience to the laws, the disregard of which prepares revolutions."[37]

Popular acclaim of the *parlementaires* as bringers of divine salvation and heroic opponents of tyranny was such that the government delayed striking down the ban on *billets de confession* until the end of 1752. In May of 1753, they finally went on strike over the issue, effectively stopping the judicial machinery of the state. A few days later, they were punished with exile to Pontoise, Bourges, and elsewhere; four of the most vocal Gallicans in the Parlement were imprisoned. Read in this context, La Font's passage on the need for inspirational portraits of these judicial activists becomes a passionate contemporary tract, its subjects still exiled or in prison, and identical rhetoric filling a flood of propagandistic pamphlets on their behalf. And this connection concerns more than La Font's personal politics. Durey de Meinières, a leader of the exiles, as well as Henri-Philippe Chauvelin, one of the jailed *parlementaires*, were both intimates of Bachaumont's and regular members of the "Parish," the salon of Madame Doublet over which he presided. These two men were among the authors of the "great" remonstrances that precipitated the banishment of the court.

It is time to look more closely at this tightly-knit little society. The special activity of the group was the production and distribution of *nouvelles à la main*, clandestine newsletters for well-off subscribers eager for the latest in scandal, gossip, and forbidden politics. They provided a kind of digest of all the prohibited literature the "parishioners" could lay their hands on—and in the early 1750s this was invariably on the side of the Parlements. Grimm recalled the sympathies of the Doublet salon as "très parlementaire."[38] The circulation of its *nouvelles* was extensive enough to attract the attention of the police. In October, 1753, Berryer, the Lieutenant of Police, received an order to suppress them:

The King is informed, sir [it read] that Madame Doublet receives among those who frequent her residence several persons who deposit their *nouvelles* of a highly dangerous character, which can only have a destructive effect when they come to be redistributed in public, that often these same persons engage in provocative discussions, and that Madame Doublet, instead of repressing such censurable license, permits them to maintain some sort of register from which are composed newssheets subsequently circulated in Paris and even sent off to the provinces. Such conduct on her part can only displease the King. His Majesty, before invoking more severe measures, has charged you continually to see Madame Doublet to make plain to her that she must bring such abuses to an immediate halt by expelling from her house those persons who perpetuate them.[39]

Though the Salon's principal agent in the gathering of *nouvelles*, Pidansat de Mairobert, had been briefly imprisoned in 1749, the high position of Doublet and Bachaumont appears to have protected its active members from further reprisals (or perhaps, in the mass of pro-*parlementaire* propagandists, they were just overlooked). Nine years later, a police informant reported: "It is true that for a long time the house of Madame Doublet has been a bureau of *nouvelles* ...; those who frequent this house are almost all *frondeurs*."[40] In 1762, the year this report was written, Chauvelin again emerged in a leading political role, orchestrating the campaign which led to the expulsion of the Jesuits—the arch-antagonists of the Jansenists and Gallicans—from France. Chauvelin's part in the affair made him a temporary popular hero; he was lionized in songs, verses, pamphlets, and prints—among the latter was one by Carmontelle—celebrating the "parishioner" as "the reef against which the pride, cunning, and machinations of the Jesuits have just been broken."[41]

But politics and the dissemination of *nouvelles* represented only one side of the group's interests. For the "Parish," in keeping with the aesthetic concerns of its central figure, was in many respects the direct descendant of the old Crozat circle.[42] Its members would assemble in a room overlooked by a de Troy double portrait of Madame Doublet with her brother-in-law, Louis-Antoine Crozat, nephew and heir of the old connoisseur. Mariette and Caylus, while not regular contributors, are known to have maintained ties with the group. La Font praises them as the most knowledgeable of connoisseurs, and they are mentioned with affection in correspondence between Bachaumont and other members. Mariette engraved Doublet's own portrait of Crozat, while Caylus did the same for her study of Camille Falconet. Caylus too held a nominal *robe* office. But where the orbit of Crozat, one of the dominant financiers of his day and a close ally of the Regent, provided an object lesson in the uses of high culture as a unifier of elites, his interests would have put him profoundly at odds with the political mission of the "Parish." At the beginning of the century, the pursuit of serious connoisseurship and art-historical expertise had retreated before the indifference of official institutions, thereby fostering a type of painting which celebrated marginality, fantasy, and nostalgia. Now those skills were bound up with a stance of active political opposition.

— v —

After 1747, the "Parish" began making a public connection between its political and its artistic interests. The critics who were most assertive in advocating a moralistic classi-

cism and most severe in their judgements of Rococo tendencies were almost all associated with the Doublet-Bachaumont circle.[43] Certainly after, if not before, the publication of the *Réflexions*, La Font and Bachaumont were in close, frequent, and friendly contact. The relationship between the two men is the subject of one of the latter's long memoranda. Dated May 1749 and apparently completed (according to a manuscript notation) in 1750, it is an artful effort both to place himself at a distance from La Font's rhetorical tone and at the same time to lend support to the younger critic's reform program.[44] His motive for writing (presumably to his usual *nouvelliste*'s clientele) was that many believed that the *Réflexions* was his work, or that he had encouraged La Font to write it. He states emphatically that their friendship began only after the appearance of the offending pamphlet, when La Font, who had been living nearby and had heard of his favorable opinion, approached him and asked permission to visit the "Parish": "He seemed to me an *honnête homme*, gentle, polished, having some education, and above all, an extremely zealous *amateur* of the fine arts. I asked around about him; I learned that he frequented good company, that he was judged to be a gentleman, undertaking worthy charitable tasks, displaying piety and good moral character." Thus thoroughly and favorably vetted, La Font began to appear regularly, the two of them conversing often, taking pleasure, says Bachaumont, in their mutual interests.

La Font came first seeking advice on how to deal with the hostility of the artists, and it was at Bachaumont's suggestion that he wrote his often-quoted apologia to the *Mercure*. The latter counseled silence for a while, and La Font obeyed. In 1748, however, he began appearing at Bachaumont's door in the late morning to read him short, disconnected bits of new work, always departing before lunch. Others of their associates were treated to the same puzzling behavior. These fragments eventually became his magnum opus on the renovation of Parisian civic architecture, *The Ghost of the Great Colbert*, published in April 1749. Though Bachaumont states that he never saw the work as a whole "until a *colporteur* brought it around," and apologizes for its occasional intemperance, he stoutly defends its worth and integrity. He points out the favorable reviews the work had received in the *Mercure*, the *Journal des Sçavants*, and the *Journal des Trévoux* (the last of which, he fails to mention, was his own work).[45] The point of the defense soon comes clear: though the "unprejudiced" praised it, the clamor of a few, who mostly had not read it and wanted belatedly to punish its author for the *Réflexions*, had it brought before the Lieutenant of Police as a "satirical and defamatory libel which deserved punishment." Berryer dismissed the charge out of hand and expressed, so we are told, the same high opinion which had generally greeted the work. Still, Bachaumont is concerned that the work should not be taken as his own:

> When this last work began circulating, some people believed they recognized a number of things they had often heard me say. I had even amused myself by writing some memoranda on very similar matters that I read or lent to a small number of friends who shared an interest in these things. On the basis of this, others have imagined that I had lent my memoranda to the author of *The Ghost of the Great Colbert* and that I had encouraged him to include them in his work, which is manifestly false, since it is true that I lent him a few of my memoranda only after his work had appeared, in the end only because having heard about them, he wanted to read them. Besides, it should not be surprising that persons who love the same things, who make them their occupation, who converse often about them, should write almost the same things; that is just about all I believe I can say on this subject.

While Bachaumont's account of his first acquaintance with La Font is convincing in its detail, the distinction he tries to draw in this last passage is far too fine. What did he contribute to their frequent conversations if not the stuff of his *mémoires* and, given the circumspect quality of those documents, far more besides? In fact the very elaborateness of his defense leaves the reader with a clear, and no doubt intended, admission of complicity (along with a generous refusal to take credit away from the younger man). La Font's public visibility and stylistic verve were useful vehicles for Bachaumont's own plans and projects. As he admits, the central concerns of *The Ghost* are practically identical to positions he had staked out long before. By 1752, the two presented a common front to the world; the second edition of that work was published bound together with some of Bachaumont's own writings. When he addressed the Salon of the following year, La Font had moved to the extreme pro-*parlementaire* stance discussed above. And the kind of imagery he urged painters to take up—a Brutus, a Socrates—unmistakeably conjured up the self-image and public rhetoric of the regime's most powerful opponents.

At the center of the "Parish" was another critic who has already appeared in the present account, the medieval historian La Curne de Sainte-Palaye. This figure represents a line between the anti-Rococo critics and the larger world of eighteenth-century literary and historical scholarship, which, as Lionel Gossman has shown, was intimately connected with *parlementaire* (*robe*) nobility.[46] His family, having been artisans and merchants in the sixteenth century, rose to noble status in the Burgundian Parlement. Having rejected judicial office for himself, he set out on a career of disinterested scholarship and erudition, eventually becoming a member of both the *Académie française* and the Academy of Inscriptions (by then a center of historical research). In 1751, he published *Letter of Monsieur de S. P. to Monsieur de B. on Good Taste in the Arts and in Literature*. The "Monsieur de B." is Bachaumont, and the essay echoes in its main points those of La Font's *Réflexions*, as well as reproducing Bachaumont's characteristic tone of studied naïveté.[47]

The abbé Laugier also found a place in the Doublet salon, where Sainte-Palaye and Doublet's godson, the poet Voisenon, assumed a particularly protective attitude toward him. In 1753, alongside his severe, utopian *Essay on Architecture*, he published a lengthy critique of the Salon,[48] and in 1759, came up with the idea for a regular arts periodical, which, as noted in the introductory chapter, was killed at birth by Marigny and Cochin.[49] Given the nature of Laugier's affiliations, their reaction was only to be expected. The criticism produced by the Bachaumont circle injected the terms of the political polemics of the *parlementaires* into the art-discourse of the period. Just as the Parlements presented themselves as the protectors of the nation against a king corrupted by *mauvais conseillers*, the early unofficial art critics presented themselves as preservers and defenders of a national artistic heritage corrupted by the ignorant and debased taste of the financiers and the court. Mariette and Caylus proposed that the Academy artists be officially subordinated to a select group of amateurs who would speak for the public: artistic Parlements in effect.[50] Following Montesquieu, Laugier even introduced a doctrine of artistic "separation of powers," stating that, "it is up to the philosopher to carry the torch of reason into the darkness of principles and rules. The artist has an executive, the philosopher a legislative function."[51] The monarchy, as they saw it, had shown itself incapable of maintaining the standards of the reign of Louis XIV. Those standards, they contended, had been based on the production and unchallenged preeminence of grand and noble history painting, a kind of painting which, by this time, accounted for less and less of

the national artistic output. The critics put the blame for this state of affairs on their social and political antagonists, thus attempting to use a nostalgic vision of the seventeenth-century monarchy as an ideological weapon against the monarchy of the eighteenth. They maintained that it had been left to men such as themselves to encourage *la peinture d'histoire*. La Font:

> It is important for a painter who, by talent for *l'histoire*, aspires to the most elevated rank, that he seek out enlightened people and *amateurs* of good reputation. The character of decorum and nobility, which, as a result, will diffuse itself into all his works, will add much to their value, and make them precious to *honnêtes gens*.[52]

In the same way that the *parlementaires* had become the new spokesmen for and defenders of nobility as a general social value, the connoisseurs and critics associated with the *robe* had become the self-conscious defenders of *bienséance* and *noblesse* in the arts, that is, everything that made art a symbol of status and worth.

If the critics in Bachaumont's orbit borrowed a sense of mission from the rhetoric of the *parlementaires*, they also shared with their political mentors a clear sense of who the enemy was. The rise of Pompadour and the Lenormand clan, with their longstanding connections to the financial empire of the Pâris brothers, was painted by the *parlementaires* and their sympathizers as the culmination of an unholy alliance between Crown and finance. The maneuvers of state bankers like the Pâris group were behind the new tax measures, which, as much as the *Unigenitus* issue, fuelled the resistance of the sovereign courts: the imposition of the *vingtième* in 1749, a prime cause of the subsequent confrontation, had originally been proposed by Pâris-Duverney. When Pidansat de Mairobert was arrested in that same year, it was for possession of verses slandering Pompadour. State and finance preserved a united front over the *billets de confession* as well. The marquis d'Argenson (the former Paulmy) records the King as losing his temper with the royal council when it failed to move decisively against the striking judges: "The King adjourned the council by saying: 'Do what you like, but I want to be obeyed.' ... His Majesty returned to Bellevue and said a few words in the ear of the Marquise, who applauded him, and his Majesty has never been seen to sup so gaily; she sang and whistled...."[53]

La Font, as we have seen, represented the despotic antagonists of the *parlementaires* as "inhuman opulence" and "omnipotent credit" always ready to victimize those without wealth and influence. Despite Tournehem's apparent commitment to reform, La Font would have seen his family as representing a double threat to the restoration of classicizing history painting in the grand manner. First, the segment of the Parisian high bourgeoisie from which they had emerged comprised the most conspicuous patrons of art and decoration in the Rococo mode; their money was tempting the artists away from higher things. Second, these financiers now commanded the only agency in the state capable of supporting ambitious history painting. In 1747, he was prepared to give Tournehem the benefit of the doubt; by 1754, he leaves the reader in little doubt that he sees the Lenormand reign as a ruinous one.

Other writers had already gone beyond La Font's metaphoric accusations of malfeasance to open polemic against the administration of the *Bâtiments*. They took over the most extreme constitutionalist rhetoric issuing from the *parlementaire* side in order to paint the academic leadership and its state sponsors as so many arbitrary despots. Actions like the institution of a Salon jury were interpreted as dictatorial violations of an egalitarian liberty essential in the arts.[54] An anonymous Salon critic writing in 1749

explicitly equated the hierarchy of the mid-century Academy to a feudal tyranny, decrying the establishment of

> . . . a kind of arbitrary and despotic authority within the Company, something completely contrary to the republican liberty which the sciences and the fine arts demand and which in turn inspires them. This authority is wielded in the manner of those conquerors who distribute among their captains the lands which surrender to them, without bothering themselves over whether the people are left with the means to live. As long as this evil persists, one sees only discouragement in the latter and vain glory in the former.[55]

La Font would never have produced such an explicit and openly radical indictment, but such statements represented the logical outcome of the position he and his allies had established. If rigorous, classicizing reform was the true will of the "public" and the "nation," then any authority that impeded that reform was therefore despotic and arbitrary in character.

This then is the larger conflict that underlay the debate over the character of the Salon audience reviewed in the introduction to this book. The high feelings it engendered should now come as no surprise. The Academy found itself presented, at least in theory, with a "public" not of its own making. La Font and the rest could assert as much at any rate, and the potential power of public opinion had become all too evident to anyone with an eye on political events. At the height of the confrontation between King and Parlement, a genuinely frightened marquis d'Argenson, doubtless expressing the anxiety of others in the government, wrote: ". . . it is the nation as a whole that speaks through the voice of these magistrates, and it is no trifling thing so to outrage a whole nation such as ours."[56] The activities of the extended Bachaumont circle had the effect of splitting the heritage of the seventeenth century in two, with rival camps of comparable authority staking claims to its guardianship. On one side were the family of Pompadour and their lieutenant Cochin. On the other were the most prominent connoisseurs and critics. It is significant that the last of Bachaumont's evaluative memoranda is dated 1750; afterwards he was no longer offering this kind of expertise to those in power. And Cochin's influence over the Academy increased at the direct expense of Caylus. Whereas Cochin had been deferential to the old *amateur* in 1749, on returning from his two-year sojourn in Italy where he had looked after the artistic education of the young Marigny, his attitude had changed. By 1752 Cochin had begun assuming effective control over academic affairs, and this entailed a strong campaign to undercut Caylus' influence.[57] The voice of the latter in *conférences* became less and less frequent and eventually went silent. His adherents among the artists—limited to Van Loo and the sculptors Falconet and Vassé— were in a clear minority against Cochin's party, which included practically everyone else.

In 1755, Cochin was given overall responsibility for the *détail des arts* in France. As the post of *premier peintre* had been suppressed since 1752, this courtier and minor talent now occupied the highest administrative post available to an artist, one he would retain for almost two decades.[58] He assured himself of support in large part through competent administration of day-to-day affairs and even-handed distribution of what patronage was available. But the Academy and the *Bâtiments* paid a price for this pragmatic leadership.

Faced with a camp which asserted that it had both public opinion and theoretical orthodoxy on its side, Cochin reacted by repudiating the aesthetic basis for almost any possible reform agenda, effectively surrendering ideological legitimacy to the opposition. Fidelity to the aesthetic certitudes of seventeenth-century classicism had come to signify the voice of the "public," as the *parlementaires* had defined it. And Cochin did not dispute that equation. Instead, following the conflicts of 1749–54, he was moved to contest the central authority of both Raphael and Poussin. His comments on the former are circumspect but deliberately provocative and pointedly meant to place his achievement at a relatively primitive stage in the history of modern painting:

> All the sustenance one has drawn from the school of Rome has, until now, been limited to the imitation of Raphael, who, although the greatest man who had ever painted, if we take into account the state of infancy from which he extracted his art, *was nevertheless not, if one can dare say it, the greatest painter ever to have lived.* . . . Raphael had doubtless carried purity of design, nobility of ideas, beauty in facial type and expression, simplicity and elegance of forms, correct choice of figures, drapery, and internal composition of figure groupings to their highest degree; but he had absolutely no awareness of the grand effects to be had from chiaroscuro and an understanding of the play of light. One almost never sees in him that art of arranging a large-scale composition in such a way that no part of it can be extracted without the whole falling apart and that a balanced linkage of light and shadow is achieved which yields a restful harmony. [59]

The list of attributes he concedes to Raphael constitutes, almost *in toto*, the aesthetic criteria at work in the criticism of Caylus or La Font. The effect of his revision is to shift attention away from cognitive meaning altogether in favor of formal arrangements and surface harmonies. He is fully prepared to place the formal achievement of Boucher — the command of evanescent light effects, atmospheric unity, and cheerful overall balancing of color and tone — against all the exemplars of a monumental and clarified classicism. As for Poussin, his comment in a later "Letter to a young artist" is curt; "Doubtless one must admire him, but he would not be a suitable object for too assiduous study by any student with an inclination toward the coldly correct." [60] Against that classicist benchmark, why not set a painter on the order of Pietro da Cortona, "charming master who some have tried vainly to dismiss. . . . Our exacting amateurs, *such as the late comte de Caylus*, have assured us that this artist and his school were the ruin of painting. . . . This sentiment is just the same as that of the persons who pretend that the rare talents of Monsieur Boucher have ruined the French school." Looking outside France, Cochin has no time either for the archaeologically inspired aesthetic fostered in Rome by the German painter Anton Mengs (soon to be codified by Winckelmann). French students at work there are to be particularly warned away from this artist, whose example "can be and has been pernicious to our pupils." [61]

It must be said, then, that with Cochin's ascendance, there simply was no official reaction against the Rococo. It is important to see Cochin's aesthetic position not simply as a laudably tolerant and broad-minded embrace of stylistic diversity, but as a rejection of the available positions from which criticism had been possible, from which the work of any successful artist could be found wanting in relation to a fundamental standard. He declared flatly in 1752 that works of art should be "things of feeling and not objects of discussion." [62] No discussion meant, in effect, no program. From the poorly-received

Galerie d'Apollon competition of 1747, in which Tournehem attempted to impose no order or thematic unity on the artists, to the onset of the seven-years War in 1756, which cut off funds to the point that even the Academy's basic annual pension was eliminated, there were no major initiatives in state patronage of large-scale historical painting. The only major commission to emerge from the *Bâtiments* in these years went to a French artist long resident in Rome, the landscapist Vernet. The iconographic program came from outside, courtesy of a bureaucrat in the maritime administration.[63] It was projected as twenty canvases depicting the topography and characteristic commerce of the principal ports of France (Plate 52). When he abandoned the project in 1762, Vernet had completed fifteen. They were a critical success and are of great aesthetic and historical interest today. But that very success pointed up the meagerness of the Lenormand regime's accomplishments when measured by any other standard. As the anonymous critic wrote in 1757, "... happy that century will be that will possess a history painter of his power! *But that blessed phoenix has yet to arise*!"

It important, however, not to see the 1750s as simply a dispiriting repetition of the 1680s and the first decade of the eighteenth century. If we place a pragmatic and eclectic Academy on one side and a theoretically-minded critical party on the other, it is apparent that each one had significantly raised the stakes. Not since the time of Colbert was officially-sponsored painting intended to signify so much about power, in this case a hoped-for permanent alliance between the monarchy and the large financial interests represented by bourgeois tax farmers and securities speculators. The stress Pompadour and her family put on a revival of the moribund artistic institutions of the state was bound to feed their eventual opponents. The encouragement given Caylus and Bachaumont, when their experience and prestige was needed, was the direct inspiration for La Font to go public; and the bridge made between Poussiniste aesthetics and a persistent current of political opposition meant that even if troublesome critics could be marginalized and silenced, their fundamental ideas remained an active component

52. Claude-Joseph Vernet, *The Port of Bordeaux*. 1759. Oil on canvas, 165 × 263 cm. Musée de la Marine, Paris

53. Carle Van Loo, *Saint Augustine disputing with the Donatists*. 1753. Oil on canvas, 400 × 550 cm. Church of Notre-Dame-des-Victoires, Paris

of public consciousness. The Salon now was an immoveable fixture; the obligation of the *Bâtiments* to sustain and enhance its appeal kept expectations high. It was no longer possible for the state, or the artists as a body, to control the definitions of what made painting successful and appropriate to the demands of its audience. The exhibition would remain the scene of dispute over those definitions.

Beyond politics, what made La Font's hectoring rhetoric intolerable to the Academy's leadership was the constant reminder of the gap between the theoretical basis for its legitimacy and the actual performance of its members, so much so that Cochin made a vain attempt to dispense with theory altogether. But if Cochin had ceded the ideological high ground to the oppositional critics, they too had to face a seemingly unbridgeable gap between theory and practice. In his 1754 critique, when La Font provided a long list of suitably ennobled subjects from Greek and Roman history, he could have had no realistic expectation that artists would follow his advice, or that the results would be adequate if they did. Carle Van Loo was the only important painter left who remained sympathetic to Caylus and not beholden to Cochin; but like Bachaumont, La Font found that Van Loo's talents fell short of the mark—lazy and slapdash in his large-scale efforts, incapable of strong and varied expression, better suited to modest subjects than grand ones. That artist's *Augustine disputing with the Donatists* (Plate 53), commissioned for the

church of Notre-Dame-des-Victoires and shown in the 1753 Salon, he found a farrago of errors in historical accuracy, theological focus, narrative clarity, and technical execution.[64] Younger artists would be—and proved to be—unlikely to go against the prevailing tide.

The anti-Rococo party—that short-hand term is as good as any—itself suffered from a deep ambivalence toward the Salon audience in whose name it spoke. The notion of a restive and potentially politicized public was unacceptable to the Academy, which clung to the seventeenth-century conception of *le public* as a cultivated elite. The actual, operative public for a La Font or Laugier, that is, the connoisseurs in the orbit of Bachaumont, was in fact a good example of just such an exclusive grouping. But it could not present itself that way, as the exaggerated tone of naïveté adopted by Ste-Palaye and Bachaumont in their critical writings makes plain. This was the result of their elision of the public for art with a borrowed notion of the "nation" and, as a necessary corollary, their identification with the everyman in the Salon. In the heat of political agitation, the *parlementaires* were able to make the ordinary, bourgeois citizen see himself mirrored and multiplied in that patriotic abstraction. But the behavior of the audience in the Salon was, as we have seen, another matter. Not giving Van Loo more than a glance, they headed for the kinds of modest pictures which so attracted our anonymous reviewer in 1741. Yet these later critics were not prepared to attach to them anything like the intrinsic social significance which their predecessor extracted from Chardin's *Morning Toilette*. They could make no use of that popular apprehension and re-ordering of the images on display.

It makes, in fact, for a revealing test case in this regard to note the inability of these *amateurs* to *see* Chardin's figural tableaux; that is, to register their distinctive iconography and his complex transformations of their seventeenth-century northern models. Bachaumont, for example, simply could not apprehend Chardin beyond the level of technique and simple dependence on previous genre painting. As he wrote in his resumé of 1750: "He excels at small naïve subjects in the Flemish manner. He draws well; his color is sometimes too gray. His method of painting is singular. He places colors next to one another with almost no blending, in such a way that a work by him somewhat resembles a mosaic or assemblage of parts, like that kind of needlepoint tapestry called *Point carré*."[65] That is the extent of his commentary. Laugier, in 1753, was prepared only to concede that, "if it is true that there can be good farces, then one must make room for certain low subjects which represent the actions of the populace."[66] For both, such pictures remain below a threshold of moral and intellectual seriousness. They appear to have had no equipment to gauge the special appeal Chardin's images of the domestic life of the Third Estate might have had for visitors to the Salon with interests other than their own. And they were not listening to those who might have told them. At most, the popularity of such pictures could serve to remind a painter of "noble and serious" subjects that ideal form should be grounded in accurate observation of nature.

This, clearly, was an insufficient concession to the active presence of a popular audience. To speak to and for that public in an effective way would have required some sustained attention to the heterogeneity of the crowd in the exhibition and to the lack of interest shown by the average Salon-goer in the aesthetic assumptions that these high-minded critics took for granted. The "public" they conjured up was as much a political fiction as the abstract "nation" which the Parlements claimed to represent, and for the same reasons. Consequently the critics could not help suppressing its concrete character and observed behavior from their accounts. The anti-Rococo program itself was, in its

rejection of the sensual, abundant, and worldly, as much a denial of popular impulses and pleasures as it was of the private tastes of the rich and the court.

Comparing the position of a Bachaumont or a La Font to the implicit stance of the anonymous 1741 critic, each presents a mirror image of the other. The earlier writer cannot see above a certain line; the later ones cannot see below it. In both, "inhuman opulence" (to use La Font's phrase) is set up as the enemy and opposite term. However, to make a rough and ready distinction, the 1741 text depicts the corrupt, Rococo-style artistocracy as the impotent enemy of the *audience*, that is, of free and open access to art; in the writing of the later critics, it is the enemy of the *public*, depriving the nation of an art of true virtue and nobility. In the first instance, we are dealing largely with actual conditions: a desire for access and for various forms of existing art that satisfy that desire. In the second, we are dealing with constructs, and with a potential reality only.

It seemed a dangerous potentiality to those in power, but that public was not yet "there" as a factor in the Salon crowd. Nevertheless, it is a measure of the distance we have travelled in a decade that a language now existed by which the broad Salon audience could at least be described as the primary audience for the most ambitious painting. The *parlementaires* had made possible an equation between nobility and speaking in the public's name. That equation served the social ambitions of the anti-Rococo critics in that their activities were thereby endowed with a doubly ennobled character: their advocacy served both a patriotic nation and the threatened noble genre of painting. It could be argued in fact that the linking of the two—the interest of an aroused nation and the reform of art in the direction of classicizing rigor—was the only possible underpinning left for a credible revival of history painting; the only available way out of the dilemma expressed by Diderot in his reflection on Monsieur Baliveu, *capitoul* of Toulouse. Since the beginning of its reign, the Bourbon dynasty had progressively devalued titles of nobility as a matter of policy: first by separating as much as possible the great feudal families from the administrative machinery of the state, and then by cynically exploiting the sale of offices carrying noble status as a source of revenue and credit. The cult of *honnêteté* was one response of the old nobility to this assault. But by the mid-eighteenth century the cultivation of an exquisitely crafted leisure had itself been appropriated by an obvious parvenu class, whose naked wealth had eliminated the necessity for lengthy governmental service as a prerequisite to social mobility. The actions of the state had thus seriously destabilized the concept of nobility and undermined any automatic equation between the "natural" social hierarchy and the actual distribution of power. The growing and formidable political opposition (organized to defend the interests of the established noble classes) was thus allowed to claim all the positive, transcendent qualities of an ennobled condition for itself. These were equated with the courage and gallantry shown in the defense of Gallican "liberties" and true faith against the assaults of ministerial despotism; they became the natural property of the *parlementaires*.

History painting, the precedence of which was sustained by an equation with nobility, was thus affected by the same ideological instability. If the state was represented by the Lenormand family and sustained by a class of grasping, philistine Baliveus wielding *lettres de cachet*, then on what grounds could it claim to foster a truly ennobled art? (Piron, the creator of Baliveu, was, it might be noted here, a central member of the Bachaumont circle.) The political sympathies of La Font and the rest apart, it was almost inevitable that the social base they imagined for a reformed history painting would follow

the shift of legitimacy away from the state and toward the opposition. There the equation between nobility and virtue, and therefore a painting of exemplary virtue, was still possible. There is an obvious affinity between Diderot's "grand patriots, incorruptible judges, philosophers steadfast unto death . . . who, after their deaths, provide us with great pictures" and La Font's "upright and irreproachable magistrates . . . who expose their property, their liberty, often their very lives in order to be a wall of impenetrable iron before the unexpected blows directed at religion and the beneficence of the Prince." Thus it was possible once again, by selecting from the hard, stoic end of the classical repertoire, to make a confident metaphoric connection between the moral exemplars of antiquity and noble contemporaries who, as Diderot put it, "made poetry of their lives."

The difficulty with the whole maneuver was that in the end it depended on a demonstrably positive response from some significant proportion of the Salon audience. As long as that failed to appear (and even the unofficial critics conceded its absence) the dismissals of that audience by a Coypel or a Cochin would remain unanswerable. Those critics were left only with their despairing excuses about the inability of pragmatic professional artists, indifferent to risky and non-remunerative demands, to summon up the requisite inner nobility of inspiration. This made meaningful reform appear, even to its staunchest advocates, as a doomed venture; the great modern history painter likewise is imagined only as a chimerical and impossible creature. But they offered little help to the actual history painter who might have wished to join their cause; they supplied almost nothing in the way of useable instructions as to how a painter in the grand genre might engage a larger audience. To do that, these writers would have to see "from below," to attend to pictures as did the critic of 1741, or at least to empathize with such habits of attention. Had they not been half-blinded by an abstract conception of nobility in painting, they might have found a way to flesh out their program with some adequate measure of material appeal and persuasive illusionism. What was required was a new breadth of vision sufficient to "see" on both levels—Chardin's and Van Loo's—at the same time. Failing that, the dissenting critics left themselves in a position comparable to that of Cochin himself, who, by abandoning the theoretical underpinnings of classicism, had left the *Bâtiments* unable to generate an artistic program adequate to the dynastic ambitions of its leaders. Neither side could chart a real change in direction away from the drifting status quo.

This impasse would be of secondary art-historical interest if we did not know that it was destined to be broken. The standard accounts, of course, cite Tournehem's reform efforts and La Font's criticism as having created the climate for David's ground-breaking successes in the 1780s. But that easy assumption of continuity is one the present account has held up to question from the start. Now, having looked at the developments of the late 1740s and early '50s in more detail, it seems even more problematic. Yet, just as clearly, there is a relationship. How do we get from deadlock in 1755 to breakthrough in 1785?

There are now four principal actors in the narrative: the artists of the Academy, the bureaucratic leadership which overlaps the Academy and *Bâtiments*, the increasingly articulate and popular art press, and the Salon audience. The relative influence of each on events will shift over time, and it would be difficult to assign one a dominant position over another. Before large-scale, morally serious narrative painting, produced within the entrenched institutions of the Old Regime, could command a significant public following, all four would have to change. The transformations of the last, the public, we shall as

usual have to measure seismically by its effect on the other three. The purpose of the following chapters then will be to trace first, the profound changes in the range and appeal of Salon painting (the key figure will be Greuze), as well as the continued fragility of the public sphere in relation to a seductive private one. Second, a critical community actually able to mediate between artist and public, and to provide useful instructions to both in place of impossible demands and abstract claims. (For this last development to occur, the writers of the high-minded, anti-Rococo variety would have to find some common language between their dry political aesthetic and the material possibilities of paint.) And third, the eclipse of the Lenormand regime in the final years of the reign of Louis XV and its replacement by one which boasted a real ideological program, one not so distant from the anti-Rococo agenda rejected by its predecessor. The impasse of the 1750s will at no point be resolved before the Revolution, any more than will the social conflicts which underlay it, but its contradictions will be made the stuff of art.

Greuze and Official Art

−i−

IT has been one of the preoccupations of this book that our received picture of the Academy as a monolithic, exclusionary body has been largely a myth. That myth has resulted from taking the legal basis of its bureaucratic power, and the reiterated ideological justifications for that power, at face value. The exclusionary energy of the company was directed at other artists who might challenge its various monopolies, but did not extend to any conformist compulsion toward artists of the most diverse kinds within its ranks. What it wanted to monopolize, to put it simply, was talent, and thus to prevent the *Maîtrise* from re-establishing a claim to priority on any artistic level. Though the heart of the Academy's life as an institution was its exclusive right to conduct serious training, it was able at the same time to recognize the insufficiency of its recruiting and procedures even in this crucial area. The official and semi-official discourse that surrounds eighteenth-century painting is in fact able to narrate this insufficiency, as well as the essential magnanimity and *inclusiveness* of the Academy, in the form of a stock type, one we might call the "surprise invader." The type is established in the various written lives of Watteau, repeated for Chardin, and vigorously re-enacted by Greuze in the mid-1750s. In order to understand the strategies and impact of Greuze, the dominant personality in the Salons of the 1760s, it will be useful briefly to review the history of the sign under which he appeared.

Antoine de la Roque, editor of the *Mercure* and Watteau's friend and patron, established the elements of the standard narrative in his brief biography published in the year of the artist's death.[1] He begins by stating (and this is the essential claim): "We offer high praise to him [Watteau] and at the same time to the Royal Academy of Painting when recounting the manner in which he came to receive his *agrément*." De la Roque then relates that Watteau, in 1712, "without being known to or under the protection of any person," entered a picture in the competition for the Grand Prix: "On the basis of this single picture, Watteau, who alone was unaware of his talent and capacity, obtained far more than he had requested: he was received as a professor of the Academy...." Even as knowledgeable a writer as this one exhibits a rather characteristic eighteenth-century indifference to actual academic usages. Watteau of course was never *professeur*, and would never have been elevated instantly to the top of the hierarchy from mere student status. A later rendering of the story by another intimate, Gersaint, preserves the lineaments of the earlier account, but refines and expands on them. Now the artist arrives at a session of the Academy on the rather eccentric mission of obtaining from the King a singular pension for travel to Italy, particularly to Venice. He sets two of

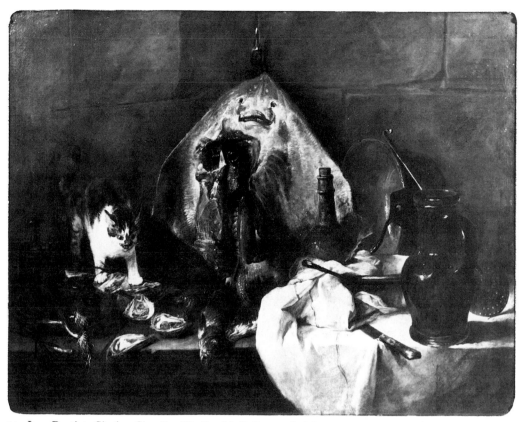

54. Jean-Baptiste-Siméon Chardin, *The Rayfish*. Before 1728. Oil on canvas, 114.5 × 146 cm. Louvre, Paris

his pictures up in an anteroom and withdraws discreetly to wait for the reaction of the passing academicians. Charles de la Fosse is one of those suitably impressed and assumes the work to be that of some established master. Informed otherwise, he summons Watteau inside: "My friend, said M. de la Fosse in a kindly manner, you are unaware of your talents and mistrust your abilities. Believe me, you are better endowed than are we; we find you capable of honoring our Academy. Take the necessary steps; we regard you as one of us."[2]

In reality, the occasion was a quite regular competition set up by the Academy when funds to send students to Rome had been restored after a lapse of several years. As a previous second-prize winner, Watteau was among a number of young artists eligible to compete. (And once again he was not selected.)[3] But these details are easily sacrificed to the legend. Likewise, the whole scenario of blind test and mock surrender appears, now in more elaborate form, in the accounts left of Chardin's entry.

As we have seen, the artist had established a considerable reputation in the Place Dauphine exhibitions. One version of his next step upward describes certain academicians passing by on Corpus Christi, 1728, and being so struck by the famous *Rayfish* (Plate 54), that "they went to Chardin, encouraged him to present himself before the Academy where he was unanimously accepted and at once received with the highest praise. He was allowed to submit as his admission piece that same *Rayfish*. . . ."[4] A much longer rendition, left by Cochin and Haillet de Courronne, is a closer retelling of the Watteau story.[5] In place of inadvertence, however, we now find conscious strategy:

As if by accident, he left his painting in the first room while he himself waited in a second. M. de Largillière arrives. . . . Struck by these paintings, he stops to examine them before proceeding to the second Academy room where the candidate was waiting. While going through the door, he said: "You've got some very good pictures there; surely they are by some good Flemish painter, and when it comes to color, the Flemish school is an excellent one. Now let's take a look at your work. . . ."
"Monsieur, you have just seen them."
"Oh," said M. de Largillière, "Introduce yourself."

The trick is then repeated on Cazes and the *Premier peintre* Louis de Boullogne. Following a bit of good-humored discomfiture and reproach at the ruse, Chardin is accepted on the spot.

It is enough to quote the original texts to see them for mythology: the senior academician closest in manner to that of the aspirant (de la Fosse or Largillière) wheeled on to play the dupe; the trial of three for Chardin in which the "king" (*Premier peintre*) rewards the trickster-hero. These elements of myth overlay others specific to the artistic profession, particularly those involving the miraculous discovery of talent. The best known variant is the apocryphal story of Cimabue inadvertently discovering the ability of the shepherd-boy Giotto and adopting him as his pupil, a tale with antique precedents and numerous subsequent repetitions.[6] Neither Watteau nor Chardin was of course unknown to influential artists and patrons at the time of their acceptances (Noël-Nicolas Coypel had, for example, been a witness at the wedding of the latter's sister in 1720). The old myths were being updated and filled in with anecdotal detail to serve as parables about the Academy itself. They respond to a mistrust of that body as a collection of narrow and self-seeking cliques, by demonstrating that, despite evident lapses, generous impartiality remained the rule. As Caylus moralized in his 1748 biography of Watteau:

It is thus that truth must function in the deliberations of the Academy, neither to accept nor exclude on the basis of particular opinions. The prejudice for or against individuals on account of their personal liaisons is a formidable obstacle. Talent alone must determine our decisions.[7]

There is also, in the case of the conspicuous reference to Chardin's exhibiting in the Place Dauphine, recognition of other venues and other constituencies which the Academy, with ease and good grace, incorporates into itself.

In the process, did it find itself reaching beyond its usual constituencies as well? Certainly it did not in the case of Watteau, nor is it possible to draw any definite conclusions about Chardin. We have the eloquent testimony from 1741 affirming the artist's innate appeal to the Third Estate, but he never capitalized on that appeal in public, at least in any way that we can measure. As the importance of the Salon grew, his production of figural, as opposed to still-life, compositions slackened off to a sporadic copy or two. Developing a bond with that audience based on his grasp of the details of everyday, middle-class life evidently held no great interest for him. His art was primarily addressed to two long-standing markets, both of which existed to the side of the new public sphere. The early collectors of his paintings were primarily knowledgeable insiders, aristocrats and fellow artists. As time went on, his figural pictures were almost entirely purchased or commissioned for foreign princely clients. What Chardin offered these collectors was northern genre (then the dominant taste among the European elite from Paris to St.

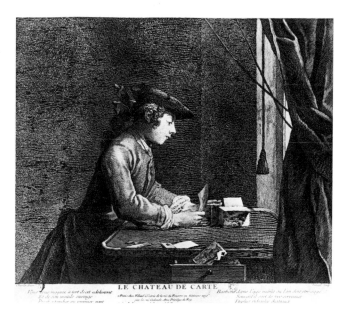

LE CHATEAU DE CARTE.

55. After Jean-Baptiste-Siméon Chardin, *The House of Cards*. Engraving

Petersburg) cleansed of its uncongenial moralizing or uncomfortably low humor. As the *philosophe* Raynal put it in 1753:

> ... the charm of the images offers a strong criticism of the Flemish painters in general. The fact of the matter is that smoker's kits, fist fights, the needs of the body—in short, Nature captured at its most abject—are the subjects most frequently treated by the Brouwers, Ostades, and Teniers, etc. M. Chardin has always avoided these images so humiliating to humanity.[8]

His careful exclusion of all but the most minimal references to the contemporary world beyond his interiors, of sexual and power relationships among adults, of singular narrative events, is the means by which this chastening is achieved. And so stripped of conventional incident and interest, their appeal is recuperated on the level of transcendent technique, one uniquely personal in character. His secrecy about his procedures, restricted output, and notorious slowness in fulfilling commissions only enhanced the desirability of his work on this level.

The ultimate connoisseur's artist in his original works, Chardin is pulled into another receptive space by means of the prints made after them. The reticence so carefully built into the images is there overruled by the very compulsion to moralize that Chardin had so artfully spared his primary clients. We have already noted this process in the transformation of the *Morning Toilette* into a *vanitas* emblem, and this is only a mild instance of the relentless textualization of the pictures, a filling-in of their de-textualized materiality by means of trivializing appended verses—trivializing in the sense that they erase the specificity of the images vis-à-vis their seventeenth-century antecedents. Thus the *Morning Toilette*, the *House of Cards* (Plate 55), and the *Lady Pouring Tea* could take their places in the printmaker Le Bas' catalogue alongside Teniers and Wouvermans (where they were a relative bargain at one livre, ten sols apiece, compared to three or four livres for their Flemish counterparts).[9] There is no evidence of course that Chardin resisted this secondary but lucrative use of his small and laboriously accumulated stock of images. According to Mariette, writing in 1749, they were as fashionable as any of the "little masters" and had supplanted the serious work of Le Brun, Poussin, and Le

Sueur.[10] His sights were thus firmly set on two older modes of consumption which were independent of and historically prior to the Salon experience.

But the myth of the surprise invader, generated as a kind of ironic defense-mechanism within the official art world, proved to have a deeper usefulness in the 1750s. This will be the first but not the last instance in the present account in which a discursive identity pre-exists the individual who comes to fill or enact it; a space is created by discourse which an artist, supported by knowing and influential partisans, is able to step into and deflect to his own purposes. The first such artist for us is Jean-Baptiste Greuze, and his early work was a key element in the response of the Marigny administration to the pressures being generated in the public sphere.

−ii−

Like Watteau, Greuze brought to the role an obscure provincial birth and irregular early training. He was born the sixth child of a Maconnais roofer in 1725, and baptized simply "Jean Greuze." Sometime between 1745 and his arrival in Paris around 1750, he passed through the studio of a Lyons painter, Charles Grandon. Once in the capital, he made a conspicuous display of operating "without being known or protected by anyone."[11] His later patron and companion, the abbé Gougenot, described the artist's behavior in these early days:

> His excessive temper did not permit him to submit to the lessons of any master. He came to Paris and attended the school of the Academy without competing for any prizes. Thus deprived of the prerogative held by those who had won them, that of getting better places in the life-drawing lessons, he contented himself with the last place, that which the students derisively called the "bucket" because, being directly under the lamp, the one who occupies it catches the drippings.[12]

Mme. de Valori, our other source on the artist's early life, modified the tale slightly, softening Greuze's willfulness, to make it one of simple injustice: "Unfortunately Greuze followed no school and no master, and this gave him a bad name among artists whom he might have had as supporters. . . . When he went to draw at the Academy, his talent was ignored and he was given the worst place. . . ."[13]

So the ignored outsider had become the persecuted one, voluntarily or otherwise, acting the outsider in the most conspicuous arena. But Greuze, no less than his predecessors, already did possess powerful friends, among them, the sculptor Pigalle and Louis de Silvestre, the director of the Academy's school. When the time came for the crucial test, it took on a novel performative aspect. Greuze, in order finally to gain a better position for drawing, assembled the requisite cache of astonishingly accomplished work. The academicians conceded this and more: he was to receive his *agrément* as well. However, Greuze having announced his intention to pursue portraiture as well as genre subjects, so relates Gougenot, "several envious persons then spread the rumor that he had received assistance on several of the heads which people had found very beautiful. As a result of this, it was determined that he should paint a likeness of the Director in order to remove all suspicion [Plate 56]. He succeeded in this so perfectly and under the eyes of all the Academy that his portrait was found to be worthy of Van Dyck."[14] His formal *agrément* came in June, 1755. In the Salon of that year he submitted the pictures which had won the day at school, including the Silvestre portrait.

56. Jean-Baptiste Greuze, *Louis de Silvestre*. 1753. Lost

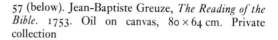
57 (below). Jean-Baptiste Greuze, *The Reading of the Bible*. 1753. Oil on canvas, 80 × 64 cm. Private collection

Though these anecdotes are repeated in each Greuze biography, it does not matter a great deal which version of events or how much if any is true. What matters is that the surprise invader as a type had entered the public space. The centerpiece of Greuze's Salon entries was an accomplished display of the kind of theme and composition that would make him famous, the *Reading of the Bible* (Plate 57). It shows one of the artist's patented aged fathers—improbably aged in light of the abundance of young children

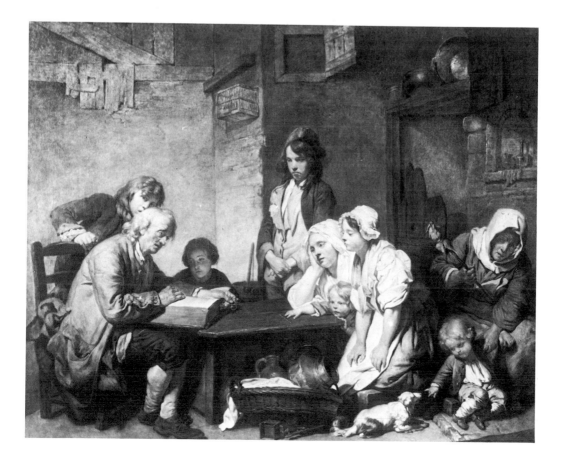

in the household—reading scripture to his family. The setting is not a peasant one, rather modest provincial bourgeois: the female servant disciplining the child at the right provides the foil for the pious attentiveness of the principal group. The picture's stress on private devotion and scriptural authority carry unmistakeable overtones of forbidden Protestantism and the historically dissenting Lyonnais from which Greuze had emerged— connotations fully consistent with his cultivated outsider persona. Its handling, it was noted at the time, was exceptionally rough and unfinished, but with a subtle exploitation of narrow tonal difference in monochrome areas, a quality much prized by connoisseurs. The picture had been sold to the progressive collector and financier Lalive de Jully, who had joined the Academy as *amateur honoraire* the year before. Lalive put the picture on display in his house and made sure it was seen by "all the artists and amateurs in Paris" before it went to the Salon.[15]

To judge from what critical commentary remains, the orchestration of Greuze's debut was a complete success. But in this instance, one needs to consider carefully whether an ecstatic critical reception is not in fact part of the orchestration rather than a record of some independently enthusiastic response. This is the case with one of the longest commentaries of 1755 and one most often cited to demonstrate that Greuze's imagery had struck some deep and immediate chord in the mid-eighteenth century audience.[16] It is by the abbé de la Porte, in fact an obliging Lenormand client-intellectual. His text concludes:

> This artist is only 29 years old. Here are works that can gain a man glory. They do honor to his mind; they sing the praise of his heart. One believes that he has a delicate and sensitive soul. One would like to come to know him. He is the Molière of our painters. I am sure that Monsieur Greuze is a man attentive to all that surrounds him; here is an observer who continually waylays nature and knows how to seize it in its most interesting aspects. He is justified; it is the greatest master. By following it, by imitating it, he will never be mannered; all that comes from his hands will be precious and new. When one sees a picture which is well drawn, carefully considered, full of finesse and always true, I predict that one will say, "This picture must be by Greuze."

Even within the hyperbolic standards of official Salon criticism, this encomium is far too extravagant to be trusted, that is, to be trusted as much more than a statement of intention or hope on the part of the artist's backers. The radiant soul described by de la Porte is difficult to reconcile with Greuze's other genre subject, the *Blind Man Deceived* (Plate 58), a dark and mean-spirited exercise in the low Flemish mode of sexual comedy (indeed there is a bit more of Tartuffe than his creator in evidence). This level of praise is far more than any untried artist, or practically any artist at all, had received in the young career of Salon criticism. His only rival in this regard was Vernet and one can see the developing convergence between two figures of fantasy, the surprise invader and the "heureux phénix" encountered earlier; he emerges from out of nowhere fully formed. By spurning service to a master or school, he frees himself from servile habits and debilitating conventions which blocked access to the pure source of "nature."

Unlike Vernet, however, Greuze offered an art in which significant human action was at issue, but where troubling questions of nobility—his own, his characters', his genre's—were not. Unlike the stories of Watteau and Chardin, the unfolding drama of the young Greuze spoke directly to active, present doubts about the fitness of the Academy

58. Jean-Baptiste Greuze, *The Blind Man Deceived*. 1753. Oil on canvas, 66 × 54 cm. Pushkin Museum, Moscow

to foster serious painting. He was not the miraculous history painter, but he was, or might be, close to one. With his Molière reference, de la Porte is reaching for an intermediate category with the right kind of authority. Already in 1755, it begins to be asserted that what Greuze offers is a more accessible, partial form of nobility, perhaps the only kind that the modern painters can summon up. As one writer, probably another art-world insider, put it in 1757, "Monsieur Greuze shows more ardor and a taste that steers closer to the grand form; he proves to us that: *the least noble style nevertheless has its nobility.*"[17] It was left to Grimm to draw the logical conclusion in 1763, to observe that the outsider owed his rise to prominence to the failure of the history painters: "This Greuze has only to continue, and he will be soon, with Vernet perhaps, the only man to envy in the Academy. Because finally, what are Van Loo and Deshays next to a Raphael, a Correggio, a Guido Reni, the Carracci? But even when one has seen the most sublime pictures, Greuze touches and arouses interest still."[18]

In 1755, however, it was decided that if Greuze was to play this part, his still rather rough skills—and rougher personality—needed polish. Pigalle arranged that he accompany a rich amateur, the abbé Gougenot, on an Italian tour, while Marigny saw to it that he would have lodging in Rome alongside the other students of the French Academy. Thus Greuze received an improvised version of the Rome prize. Away from Paris, he settled for a kind of light Italian costume picture. A suite of four of these was shown in the Salon of 1757 to good effect. But these efforts left him far short of the expectations raised two years before, and he came in for some criticism on technical grounds: hung next to Chardin, more than one writer observed excessive concentration on individual figures and accessories at the expense of pictorial unity. (Chardin himself, as the official in charge of hanging, had deliberately set up the comparison; he was not yielding to Greuze just yet.)

His triumph would not come until 1761, and in this Marigny took a direct hand. There

were two important factors in this intervention, both of them having to do with money. During the Seven Years' War, which began in 1756, even the Academy's modest royal pension for operating expenses was suspended. There was no state support available for major historical canvases of severe and moralizing character, or of any other kind. Without a destination, without direction and the prestige of a royal commission, no artist was in a position to undertake the kind of picture on which the program of the Academy and the *Bâtiments* depended. But to the degree that Greuze, and the expectations surrounding him, already represented a diversion of unrealistic demands for a heroic style into the realm of the possible, he could carry the program. As the 1757 commentator quoted above had framed the problem: "I dare to believe that a history painting where one encountered truth at every step would give this public a taste for the genre. It would find pleasure, settle itself there, and commune within a type of painting which customarily has displayed too much of a mere application of method."[19] If it was not to be *la peinture d'histoire* properly speaking, it could be something close, a painting with a "kind of nobility" to offer, and at the same time one that displayed that heedless devotion to "nature" which seemed out of reach for the painters of historical subjects. And this intermediate solution, so this last comment makes plain, might succeed in connecting official ambition with the broad Salon audience. The artist's headstrong and irascible character only made him a better vehicle for this project, in that Marigny's patronage would appear free of in-group favoritism and allay the suspicions of those hostile to his family.

Marigny could thus sponsor Greuze privately, but use his example and success to public ends, and it was for Marigny that he undertook the first of his triumphant tableaux of the sixties, the *Village Bride* (Plate 59, Color Plate 4).[20] This was to prove no small commitment. For Greuze's working methods were uncommonly expensive, even though his pictures were never of more than modest dimensions. For all of his major narrative pictures, he would make large numbers of preparatory drawings of individual figures, many hardly differing from one another, working out minute adjustments in posture and expression. Diderot informs us that he never stinted in the expense of hiring models and keeping them sitting as long as was necessary to get the likeness he needed.[21] In the reams of surviving studies (Plate 61), one senses the obsessiveness described by the great critic:

> Should he [Greuze] meet a head which strikes him, he would willingly throw himself at the feet of the bearer of that head to attract it to his studio. He is a ceaseless observer in the streets, in the churches, in the markets, in the theaters, in the promenades, in public assemblies. Meditating on a subject, he is obsessed by it, followed by it everywhere. Even his personality is affected: he is brusque, gentle, insinuating, caustic, gallant, sad, gay, cold, serious, or mad, according to the object he is rendering.

This is an evident romanticization of what was undeniably a long, intense working procedure. It was not for nothing that one contemporary compared Greuze to the Le Brun of the *têtes d'expression,* for he was conspicuously imitating the ideal procedures of the history painter.[22] This could not be more different than the practice of a Chardin, who abjured preparatory studies (he was held by Mariette to be unable to draw), and had to create his pictures from start to finish before a stationary motif.[23] The febrile volatility which Diderot ascribed to Greuze's personality and which contemporaries read in his pictures was beyond the conception of the older artist. Grimm gives us a cost estimate

Color Plate 4. Jean-Baptiste Greuze, *The Village Bride* (detail)

Color Plate 5 (following pages). Jacques-Louis David, *The Lictors returning to Brutus the Bodies of his Sons* (detail)

for all of this: *Filial Piety* (Plate 60), the pendant to the *Village Bride*, he states cost Greuze some 4,000 livres in out-of-pocket expenses, a figure which no doubt came from the artist himself and his calculating wife.[24] Even allowing for exaggeration, his costs were clearly far out of the ordinary. To sustain him through the period necessary for its preparation, Marigny parted with at least 3,000 livres, if not a great deal more—this when the maximum price for a full-scale historical picture had been set at only 6,000.[25]

And this was not because of competitive demand: Grimm's discussion of expenses is prompted by the failure of *Filial Piety* to find a buyer in 1763, though it was regarded as every bit the equal of its predecessor. It is now firmly established on the evidence of a letter to Cochin that Marigny had commissioned the *Village Bride* before the Salon, that its purchase was not a response to its popular acclaim.[26] The *Directeur-général's* commitment was not swayed by the notorious episode of 1760, when Greuze got a commission to do a portrait of the Dauphin. He managed, so it was reported, to insult the Dauphine's appearance to her face.[27] Given the longstanding enmity toward Pompadour on the part of the censorious royal heir, that episode cannot have much displeased her brother. And it could only enhance the artist's reputation for heedless, and honorable, disregard for privilege and favors from the powerful.

By all the evidence we have, Marigny's investment paid off. The relative dearth of sources in the 1760s has to be emphasized; Cochin's alliance with the Lieutenant of Police Sartines to suppress unofficial criticism was having its effects (by 1767, it would be completely successful). We fall back on Diderot and a handful of other texts. Yet there is no reason to disbelieve him, partisan of Greuze though he was, when we are told that the *Village Bride* could hardly be approached because of the ecstatic crowds which constantly surrounded it.[28] This was the final success of the strategem: not only was this an art to satisfy the intellectual demands of educated *amateurs* (while skirting the touchy and irresolvable issue of *noblesse*), it demonstrated that a complex and elevating art could reach the crowd (while withholding any concession that it had a claim to the truly noble genre). The key to this maneuver was for Greuze to deploy all the narrative resources of academic art without seeming to, that he make them seem to emerge "naturally" from a whole-hearted and unselfconscious immersion in the drama before him. This is exactly the note struck by Diderot:

> Its composition seemed to me extremely fine: this is the thing just as it must have happened. There are twelve figures; each one is in its place and does what it should. How they all are interlinked! What a flow and what a pyramid they make! I know that I normally make fun of these devices; however, when they appear by chance in a piece of painting without the painter having had the thought of introducing them, without having sacrificed a thing to them, then they please me.[29]

This is a nice exercise in having one's cake, and given the contradictions of the anti-Rococo position, that was exactly what was required. Diderot, as much as anyone, must have known the pains the *ondoyant* and *pyramidant* composition cost Greuze, yet the success of the effort, its apparent ease and nonchalance, is such that the critic can maintain the fiction that its thoroughly familiar narrative conventions had not been artificially imposed on the subject.

None of this, however, would have counted for much had the *Village Bride* not been the extraordinary, fully-realized picture it is. The years of preparation had been rewarded in a narrative tableau that combines complex attention to the generational, sexual, and

Color Plate 6. Jean-Baptiste Greuze, *Septimius Severus and Caracalla* (detail)

59. Jean-Baptiste Greuze, *The Village Bride*. 1761. Oil on canvas, 92 × 117 cm. Louvre, Paris

class dynamics of the subject within an immediate, embracing structural unity—a performance which indeed put to shame the typically mechanical exercises of the history painters. The pyramid of figures to which Diderot refers is not so much that as a single, flexed curve extending from each lower corner; the basket and chair which occupy those corners brace the fusion of the figures into the equivalent of an arch composed of individual stones, the inward pressure fusing the two male outsiders into the (literal) circle of the bride's family. The anchoring figures, posed in mirrored symmetry, are the equal and opposite signs of nature and culture: on one hand, the mother, who physically clings to her child and holds her with a tearful regard, and on the other, the notary. The gaze of the latter is also on the daughter, but he remains physically at a distance, linked to her only by the intervening transaction that explains his presence. He holds a legal document which parallels his look, while the attributes which orbit in the mother's zone all reiterate the physical bonds of reproduction and nurture: the two younger daughters extend and fill in her grasp on the one she is about to lose to the community; the small child is an extension of the large curves of her dress and apron; the two together create

one long line through the mother's back and head to an apex at the face of the bride. If this were not enough, a hen and her brood form a continuous line leading from the capacious apron which falls between her knees. On the other side, by contrast, the dominant bonds are not only legal but sealed by material exchange. The family's property is visible in the open cupboards, and the passing of the dowry, suspended just at the moment of exchange, receives concentrated attention via the interplay of hands: note the way the money sack just limns the outstretched thumb of the father.

The equal and opposite relationship of mother and notary is part of a division of the continuous arc into male and female zones. These are marked not only by the sex of the figures and their symbolic attributes but also by consistent differences in form and handling. The male, right-hand side is dominated by dark tones and the rectangular patterns delineated in the prominently angled table, the heavy cuffs on the coats of the older men, the chair back, the tricorne hat, the aforementioned document. The left side is dominated by the broad note of white in the bride's dress and the rhythm of white blended with pink and lavender in the linen of the other women and the child—his "finesse extrême des blancs" as Mauclair has put it.[30] Where the central point of contact among the men is an angular intersection of outthrust limbs, that between the women is a rhythmic, curvilinear enfolding of richly textured forms.

In general, Greuze's technique has a nervous, shifting range of qualities and in its variety is utterly foreign to that of Chardin. In the work of the latter, paint adheres to the canvas like a growth. It congeals, coagulates, bubbles; its look is non-temporal. With Greuze, the handling is itself a drama. In the subtle play of glazes set against thick passages of impasto (one flourish of which does the job of defining the point of the mother's shoulder) one can see Greuze now in complete technical control. The touch is alive, but in keeping with his persona and the message of the picture, resolutely without bravura. On the right side, he underscores the symbolic division by a significantly plainer, less differentiated touch. This underlying formal division affects the two, balancing exceptions to the sexual separation. The animated posture of the boy behind the mother, his flowing sleeve and locks, all conform to the determining rhythm of the left zone. Contrastingly, the by-passed older sister behind the father levels her gaze across the picture and obscures the line of her neck with a tense hand gesture; the handling in her plain clothing displays none of the delicate blending of hues seen on the left. These two complementary exchanges of gesture of course point to and are superseded by the one linking the couple themselves. The red waistcoat and wedge of white pull the central figures loose from the intertwined circle; parallel steps bring them forward. Her complicated pose in particular manages a series of gestures in both directions at once; she is the mediator, the one exchanged. This was Grimm's emotive reading of her state:

> . . . how do you paint all that is happening in her soul at the moment of this so
> thoroughly desirable and so thoroughly dreaded revolution about to happen in her
> life. The tenderness for her betrothed, the regret over leaving the paternal home, the
> movements of desire fighting with the modesty and shyness of a well-brought-up
> young girl; a thousand confused sentiments of tenderness, sensuality, and fear which
> emerge in an innocent soul at the moment of its transformation; you read all this
> in the face and in the attitude of this charming creature . . . in a few strokes of the
> brush. . . .[31]

Much has rightly been made of Greuze's exclusive concentration on the civic rather

than the religious moment of the marriage contract. This has been read as connoting resistant Protestantism, whose adherents had been banned from performing the sacraments since 1685. The Lyonnais was a traditionally Calvinist stronghold, and this connotation recalled the artist's remote and therefore untainted origins. (One would like to make a connection to the coincident scandal of the Calas execution of 1761, when an innocent Calvinist was condemned to death during an episode of anti-Protestant hysteria in Toulouse. There was no way, however, that Greuze could have anticipated the crusade against official intolerance undertaken by Voltaire in response to that atrocity.) This choice also lifted the subject out of the traditional category of "Noces de Village," so prominent in northern genre painting; it focused attention on the universal rather than the Christian initiation of the child into the social network of sexuality and extended affinities of kinship.

The picture is a living diagram (of the laws of kinship as the point of transition between nature and civil society) more than it is the reproduction of a possible moment. And to secure this level of generalization, Greuze had to work to prevent its being read, at least by sophisticated viewers, as a "mere" exercise in domestic genre. There are a number of ways in which Greuze can be seen to resist a simple anecdotal reading of the image. One is the exaggerated age of the father, just plausible but still difficult to reconcile with the age-range of the depicted children. He is a man of well past sixty surrounded by offspring from about four to twenty; he is "age" and they are "youth." The linked exchanges and compositional arc thus bridge a generational gap established at its widest possible point—a gulf which could contain any possible generational divide.[32] A second blocking of the kind of verisimilitude expected in genre painting is evident in the picture's deliberate indeterminacy of class and regional identity. Diderot's is one contemporary voice attesting to this:

A woman of fine intelligence [he relates] has recalled that this picture has a split character. She contends that the father, the fiancé, and the notary are truly peasants, people of the country, but that the mother, the bride, and all the other figures are of the Paris market. The mother is a fat vendor of fruits or fish; the daughter is a pretty shopgirl. This observation is at least subtle. See my friend, if it is not correct.[33]

In retailing this anecdote with apparent sympathy, Diderot is himself playing with indeterminacy of social location. The depicted household, from all its external trappings, appears to be that of a relatively prosperous *laboureur* wealthy enough to keep servants and aspire to a foothold in the country bourgeoisie. For the moment, however, Diderot is prepared to suspend distinctions between such folk and the peasantry, though one would think a small-town boy would be more attentive to the rankings which figure so importantly in rural society. Tolerance, even enjoyment, of such ambiguity contrasts sharply with the close attention to class differentiation which characterizes the contemporary *drame bourgeois* in the theater (the genre which Diderot helped invent) and such cult novels of *sensibilité* as Rousseau's *La Nouvelle Héloïse*. For viewers of Diderot's sophistication, Greuze's foregrounding of the picture's symbolic armature allowed a significant degree of freedom in reading and interpreting the image; it could thus absorb that moral projection on the part of the spectator which had been history painting's exclusive and ultimate *raison d'être*.

Diderot and Grimm used this freedom to project into the picture their learned taste in literary *sensibilité* derived from writers like Samuel Richardson ("Greuze has made,

without question, a 'Pamela,'" states Grimm, who also directs his largely Germanic readership to Gessner's *Idylls* as a point of reference.)[34] But did those members of the Salon audience closer in status and character to the figures in the painting, the bourgeois and artisan-class majority in the crowd, share the recorded enthusiasm of such exceptional witnesses? We do possess one document which affirms the artist's extraordinary success with the crowd and, in doing so, makes that theatrical analogy once so hateful to the academic leadership:

> In the theater, there are actors whom the public admires and to whom it pays the tribute due great talents; but there is always one it loves more than the rest because he provides it with a more familiar pleasure. The former are, as it were, the masters; the other is the friend of the *parterre*; and this friend is always the one whose playing comes closest to the narrative of nature. For some years it has been Monsieur Greuze who enjoys this advantage on the grand Pictorial Stage of the Salon. He had predecessors in the interesting practice he has made of his art; but he has expanded its effect by bringing to it the graces and energy of character; his brush knows how to ennoble the rustic genre without altering its truth.[35]

We could take this as one more testament to Greuze's popularity, but it becomes both less and more than this when we investigate its author. It is the abbé de la Garde, a literary man who had taken over the critical duties of the *Observateur littéraire* from its editor, de la Porte. His real position was one of librarian to none other than Pompadour herself, which makes him another Lenormand employee. In this light, de la Garde's remarks, while there is no reason to disbelieve them, are just as much a statement of intended effect as of achieved results: that is, the *Village Bride* represented for him (and his patrons) a managed public art which would flatter the Salon audience (presumed to be limited in its imagination to quotidian reality) with a modicum of "nobility." Given an artist of less than Greuze's abilities and a performance any less canny, intricate, and consistent, the results would have been far less certain. But pleasantly for Marigny, the effort seems to have succeeded on every level.

The problem for both patrons and artist was how to turn this success into a sustained project, and this proved to be difficult. In 1763, alongside portraits of the Orléans heir and the comte d'Angiviller, Greuze showed a picture to match the *Village Bride*, a scene similar in scale and cast of characters entitled *Filial Piety* (Plate 60). The already aged father has sunk into paralysis and in his distress is sustained by the deserved devotion of his household. The wedge-shaped composition is a less complex solution than the pliant, internally active ring of the earlier picture; there is more parallelism and repetition in their gestures. It lacks the underlying order of ritual, yet its internal drama and technical vibrancy are of a piece with its predecessor. The unmistakeable impression left by the image is that we have encountered the same family in a later year. There was some confusion among contemporary commentators as to the exact relationship between the two scenes, but the basic continuity of types was apparent to Greuze's audience.[36] Earlier this had been put down to insufficiency of invention; now it was registered as a new iconographic vocabulary. In the large numbers of drawings which attend these canvases, we can see Greuze working toward his "noble" expressive face (Plate 61); certain features are refined and repeated: the domed forehead, the wide and deeply set eyes firmly fixed on an object, and an adaptation of the conventional aquiline bone structure of the classicists to visibly French and modern physiognomies. The accumulated power of Greuze's

60. Jean-Baptiste Greuze, *Filial Piety (The Paralytic)*. 1763. Oil on canvas, 115.5 × 146 cm. Hermitage, Leningrad

61. Jean-Baptiste Greuze, *Head of a man* (study for *Filial Piety*). Red chalk on paper, 40.9 × 29.1 cm. Louvre, Paris

62. Jean-Baptiste Greuze, *Young Girl mourning her Dead Bird*. 1765. Oil on canvas, 52 × 45.7 cm. National Gallery of Scotland, Edinburgh

familial lexicon was sufficient to open the floodgates to sentimental hyperbole. One writer had it that an atheist *philosophe* was converted on the spot.[37] When Diderot concluded, "there is no critique that tears do not erase,"[38] these words no doubt fell agreeably on the ears of Cochin and Marigny.

—iii—

Reliance on Greuze to solve the Academy's problem with the Salon public was, like many of Marigny's initiatives, a short-lived experiment. And given the contradictions between the demands of the artist and the restricted scope for genre painting within the academic constitution, a succession of works on the order of the *Village Bride* and *Filial Piety* would have been nearly impossible to sustain. After the end of the Seven Years' War in 1763, official patronage resumed. It was not lavish, but it meant that Greuze would have to take his place as a mere painter of genre while Marigny dispensed public funds according to strict order of rank. The *Directeur-général* no longer had to finance a program out of his own funds, and it is questionable how much longer he could have gone on dispensing lavish sums like the 3,000 livres (or perhaps considerably more) he had paid for the *Village Bride*. He was not even in fact prepared to buy its pendant. *Filial Piety* remained unsold until 1765 when, thanks no doubt to the efforts of Grimm, Diderot, and Falconet, it went to the collection of Catherine the Great. There were thus strict limits to the cult of Greuze; no Parisian patron was prepared to step in for Marigny and pay the high price for which Greuze was presumably holding out. Perhaps for the same reason *Filial Piety* had not yet been engraved at the time of the following Salon.[39] It had taken all the hyperbolic rhetoric of the *Correspondence littéraire* to scarc up a patron from its far-flung subscription list. Greuze had been left hanging without a market in his resolutely "intermediate" status from which he could climb neither down nor up. Significantly, the only narrative pictures he showed in 1765 were sketches, projects for what might have been. And thus pressed for something of equivalent novelty and appeal, he came up with the prototype for his bread-and-butter picture, the *Young Girl mourning her Dead Bird* (Plate 62), the first of a legion of pathetic female adolescents that would both make his fortune and damn his posthumous reputation.

The year 1765 is further remarkable for the image that was made out of Greuze's

difficulties. For Diderot and Grimm, all the blame fell on Marigny. The surprise invader is transformed, at the first encounter with serious adversity, into a more characteristically modern figure—the heroically defiant, misunderstood, and neglected genius. It is a decisive ideological moment. In Grimm's commiserating words to the artist:

> You imagine that it requires only genius, a great talent, a proud and sensitive soul to make fine pictures and to expect that fortune will arrive to extract you from your garret in the Sorbonne quarter and offer you a sanctuary in some royal house. Where did you come from then? Haven't you learned to have a pliant gait, to play the lackey in the antechamber of *Monsieur le Directeur-Ordonnateur*, to toady your colleagues who are in his favor, to treat them as your masters, to assure them that you are but a child next to them? Perhaps, by means of servility, you will succeed in being pardoned for having genius and doing fine pictures; but what will it matter? You will have lodging in the Louvre, pensions, the order of St. Michel, perhaps. Your masterpieces will have ceased to wound the vanity of any of your colleagues, and all the Academy of Painting will exclaim that you are a great painter, since you will have ceased to be one.[40]

These words were prophetic, not only of a whole strain of anti-academic rhetoric which comes to the fore in the following decade (see chapter VI), but also of the actual disastrous end of Greuze's academic ambitions. The cause of that end would be his daring attempt to raise himself to the formal status of history painter by submitting a classical subject as his (much belated) reception piece. The picture was the *Septimius Severus and Caracalla*, shown in the Salon of 1769. There he would attempt, within the more austere conventions of the noble genre, to keep alive that brand of *sensibilité* which had given him his early success. His erstwhile official sponsors would reject that bid categorically, as we shall discuss in detail below, but they themselves were in fact thinking along similar lines.

In order fully to appreciate Greuze's successes and failures in 1769, we need first to consider the one serious effort by Marigny and Cochin to provide moralizing history painting in the grand manner. These were three (out of a projected four) scenes of benevolence on the part of Roman emperors, commissioned for the royal château at Choisy and displayed publicly in the Salon of 1765, the same one which marked the beginning of Greuze's eclipse. The commission had been made in October 1764 as part of a large parcel of works destined for this former royal hunting lodge. A substantial enlargement of the building, designed by Gabriel, had taken place nearly two decades before, but its décor had never been installed. Parrocel was to have done a cycle of pictures celebrating the successful War of the Austrian Succession. At his death in 1752, however, he had only completed one, the *Battle of Fontenoy*, and the project died. Marigny's formal proposal of the program to Louis XV makes reference to the longstanding gaps in the decoration of the château and to "circumstances having become more propitious" for filling them. The opportunity for a large-scale cycle of pictures came about by chance circumstances—the death of Parrocel, the hiatus of the war years—but Cochin was determined to turn the opportunity into a major demonstration of the new regime's capacity for sustained serious art.[41]

Though the building was in essence a country hunting lodge and retreat from the pomp of Versailles, Cochin began by rejecting the iconography expected in such a setting: nature metaphors like the four seasons or elements. "I consider," he said, "such subjects

63. Carle Van Loo, *Augustus closing the Doors of the Temple of Janus*. 1765. Oil on canvas, 299 × 224 cm. Musée de Picardie, Amiens

64. Noël Hallé, *The Justice of Trajan*. 1765. Oil on canvas, 265 × 302 cm. Musée des Beaux-Arts, Marseilles

hackneyed and providing very ordinary vehicles for superior artists."[42] Something heroic was called for; the old battle cycle indicated that much. The *Iliad* was a possibility, but that too seemed overdone and perhaps too martial in character. "We have so often celebrated," Cochin continued,

> warlike actions which have led only to the destruction of the human species; is it not reasonable sometimes to represent the generous actions, full of humanity, on the part of good kings, which have produced the happiness of their peoples; and when could one better display this sentiment than under the best of kings? Let us retrace for him, under the emblem of the most excellent princes who have ever governed, the portrait of the sentiments that all Europe recognizes in him.

Four events from the lives of Augustus, Trajan, Titus, and Marcus Aurelius were proposed and, with some adjustments, approved by Marigny. Some days later, Cochin proposed a list of artists: Carle Van Loo ("Augustus"), Deshays ("Trajan"), Boucher ("Titus"), and Vien ("Marcus Aurelius"). With the premature death of Deshays the following year, his subject went to Noël Hallé whose participation had previously been limited to an overdoor. Boucher never delivered his commission, but the other three were finished in time for the next Salon.

It would be a mistake to link, in any direct way, these pictures to the program of thematic reform adumbrated by La Font in 1754.[43] In that critic's long list of fitting subjects for painting, the common thread was the heroic devotion to duty on the part of the individual citizen; correspondingly, all but a few were drawn from the history of the Roman republic. Instances of truly exemplary heroism are, by contrast absent in the subjects selected for Choisy, in that the actions depicted are not repeatable by anyone but another absolute sovereign; or, to put it another way, their virtuous character only gains resonance from the condescension which the unique position of the actor makes possible. In the cases of Van Loo's *Augustus Closing the Doors of the Temple of Janus* (Plate 63) and also Hallé's *Justice of Trajan* (Plate 64), the actions do not represent decisive intervention in some conflict, but are of a largely symbolic or ceremonial interest. In this they conform to earlier allegories of peace-making on the part of both Louis

XIV and the reigning monarch.[44] Novel in such a major cycle, however, was the exclusive concentration on non-martial benevolence, unmixed with the traditional warrior virtues of his class. This experiment, as we shall see, would prove disastrous in the short run, both in the critical response to the pictures and their outright rejection by the King himself. But one can see a persuasive logic for the choice as it must have appeared to Cochin and Marigny, both in the political circumstances of the commission and in some immediate iconographic prototypes.

First of all, the Seven Years' War had gone badly for France and the peace terms had been dear. As the Pompadour party had been advocates of the Austrian alliance which helped precipitate the conflict, any memorialization of war would be doubly painful for those in charge of the program. It also would raise awkward comparisons to the successful conduct of the War of the Austrian Succession and popular perception of Louis XV's heroic role in that campaign. In one of the subjects which Cochin provisionally proposed in 1764, he essayed a comparison with the older days of glory: "We find further in the story of Titus a subject which can retrace to the King's pleasure this sentiment worthy of his humanity which he displayed after the battle of Fontenoy: Titus, after having reduced Jerusalem to ashes, returning from Egypt and looking again over the ruins of this great city!"[45] This, significantly, was the one rejected, and the Titus panel never came to fruition.

In general, appropriate subjects for the gallery were hard to find; as Cochin put it, ". . . actions famous for their benevolence are not numerous, or at least I can recall only a few."[46] One reason was that Cochin was trying to fit together two unlike forms of art, searching in the texts for narratives equivalent to a form of allegory which had figured importantly not in French painting during the eighteenth century but in monumental sculpture. Since the late 1740s, the initiative in the latter area had passed from the state to municipal authorities. Bouchardon's colossal equestrian statue of Louis XV was commissioned by the heads of the Paris merchants. In 1755, their example was taken up by the city authorities of Reims, who designated Pigalle to design a monumental group honoring Louis XV as a centerpiece and anchor for a rebuilding of the town center.[47] There was state money for this kind of project, and Reims eventually was receiving from the central government the annual sum of 20,000 livres over a 25-year period to pay for it. Pigalle's treatment of the monarch was something of a conscious reply to the martial character of Bouchardon's (which paradoxically he was engaged to finish on the death of the latter in 1765). The King appeared as a standing figure in Roman dress crowned with laurel (Plate 65). He extended one hand, in the artist's words, "to take the people under his protection."[48] He surmounted two allegorical figures. The first (Plate 66), a draped woman holding a rudder and leading a lion by the mane represented the "peacefulness of government," the lion standing for the French nation which despite its strength submits to a gentle regime. The second was a nude male figure (Plate 67), a "happy citizen," seated amidst symbols of abundance and representing the "happiness of peoples." The latter—in fact a self-portrait—has some of the same naturalistic insouciance evident in Pigalle's famous portrait of Voltaire.

One early sign of the direction taken by Pigalle and his sponsors comes from a memorandum by Bachaumont on the subject of Bouchardon's monument. At one point he questions the whole traditional format: "Why always equestrian statues? Why not a statue of the King standing calmly or seated in the middle of his palace and capital city? A calm King, pacifying and securing about him peace, abundance, the sciences,

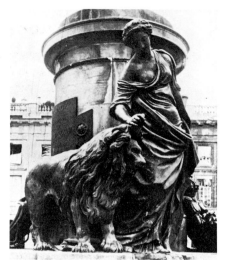

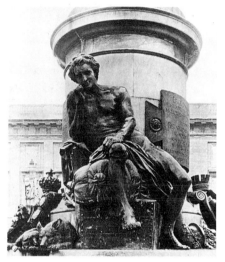

65. Jean-Baptiste Pigalle, *Monument to Louis XV*. 1763. Place Royale, Reims. Engraving by Charles-Nicolas Cochin and Pierre-Etienne Moitte

67. Jean-Baptiste Pigalle, *The Happy Citizen*. 1763. Place Royale, Reims

66 (top). Jean-Baptiste Pigalle, *Peacefulness under Government*. 1763. Place Royale, Reims

the fine arts."[49] The man who formally presented Pigalle's project to Louis XV was the same marquis de Puysieulx who appears elsewhere in the Bachaumont correspondence as an influential ally.[50] The sculptor himself had a similar "philosophic" rationale in mind, one he made plain in a letter of July 1763 to none other than Voltaire requesting an inscription for the pedestal:

> When I was chosen for the execution of this monument I had already been impressed by a thought I had read somewhere in your works, but which I have not been able to find again though I have looked high and low. There you condemn the practice, in which we still find ourselves, of placing shackled slaves around monuments of this genre, as if we could praise the great only by the evils with which they have crushed mankind. Inspired by this thought and what satisfaction I find from an artistic

perspective in dealing with the nude, I have taken a different path in my new subject.[51]

In 1755, it will be recalled, Pigalle played the part of protector to Greuze, thus displaying a taste for enlightened *sensibilité* and the common touch. The Reims group, particularly his striking self-portrait as the natural everyman, was meant to transfer these qualities into monumental allegory. The source of the Voltaire reference was probably his close friend, Gougenot, the same man who obligingly escorted Greuze on his Italian sojourn. Thus around this monument cluster a whole series of names which have figured in our account. It appeared to have effected a synthesis between official needs and the concerns of liberal critics and *amateurs*. In the context of the established iconography of Bourbon kingship, to recast royal legitimacy purely in terms of paternal benevolence and solicitude for the population was implicitly to borrow from Enlightenment conceptions of monarchy. As articulated, for example, in the articles in the *Encyclopédie* on "Patrie" and "Despotisme", these added up to a consensual model of government foreign to the legitimacy of either the feudal prince or the monarch of the absolutist state.

These implications, however, did not impede the success of Pigalle's design. This is not necessarily surprising; both Pompadour and the reigning minister Choiseul were receptive to Voltaire and flirted with ideas of the Encyclopédistes. The Dauphin and the hostile *dévot* party at court apparently failed to register the debt to their old enemy. After approval of the model in 1761, a large additional subvention was readily granted to cast the group in bronze rather than in lead. Before the figures were sent to Reims, the King came to see them in Pigalle's studio and congratulated the artist. The ensemble was inaugurated in a fortnight of festivities in August 1765 (simultaneously with the opening of the Salon). Pigalle was on hand and lionized; the *intendant* of the province made a speech in his honor. It was the triumph of his career.[52]

In the case of the Choisy pictures, the reliance on Enlightenment political thinking is even more apparent. One can find repeated instances in Montesquieu and Voltaire where three Roman emperors, Titus, Trajan, and Marcus Aurelius are singled out as exceptional examples of the just ruler.[53] One poem by Voltaire in particular, "Ode on the Clemency of Louis XIV and Louis XV in Victory," written as a celebration of Fontenoy, made an explicit comparison to the three virtuous emperors in the very first stanza.[54] The Augustus image was even less novel, having been treated as recently as 1757 by Silvestre.[55] In this almost inevitable classical allegory of peace-making, we see too a close similarity between the poses of Van Loo's emperor and of Pigalle's *Louis XV* (the statue was destroyed by Revolutionary iconoclasts in 1792) which attests to the perceived success of the sculptor's Voltairean model of benevolence. Whether this loaded emphasis on national models of leadership contributed to the King's summary rejection of the canvas is not recorded. Perhaps the *dévots* had caught the scent. It may have been a simple matter of discrepancy between theme and setting. Choisy was after all a country pleasure palace; already another room that was to have featured scenes from the Roman republic had been reassigned to Vernet; there was no need for admonitory, almost hectoring, public statements on princely conduct in the King's private space.

At a stroke then, Cochin's cobbled-together synthesis of official needs and enlightened opinion fell apart. If he had counted on salvaging some credit among the advocates of artistic reform, those hopes were just as quickly dashed when the canvases appeared in the Salon. What is striking about Diderot's reaction is that the usual allowances he

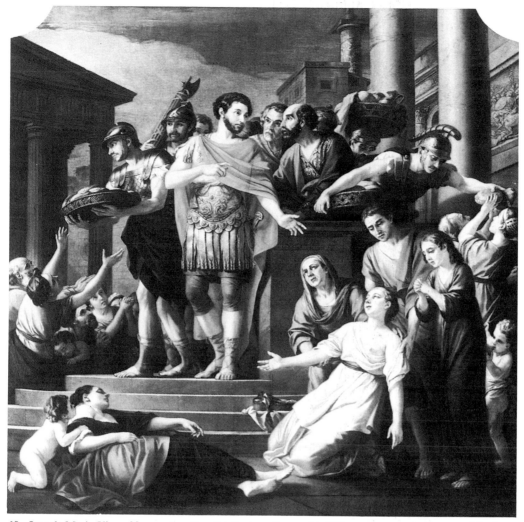

68. Joseph-Marie Vien, *Marcus Aurelius distributing Alms*. 1765. Oil on canvas, 299 × 299 cm. Musée de Picardie, Amiens

makes for the artists in question, if only for their worthy level of ambition, are entirely absent. The complaints of the unofficial Salon writers of the 1750s are qualified and generous by comparison. There is a striking anger and vituperation in his commentary, despite his past friendliness with Cochin. If we accept his judgement, failure was complete.[56] Even the normally amiable Mathon de la Cour, who wrote with the approval of the state censors, is forced into an out-of-character negativity on Van Loo and Hallé. On Vien (Plate 68) he is reduced to silence; after citing the subject of the picture, he evades judgement by reiterating the admirable intentions of the program: ". . . one will see there neither battles, triumphs, the crimes of the gods, nor the fury of conquerors, but precious lessons in benevolence and virtue . . ." and so on. Not a word on the image itself. Still the main hope of the reformers, Vien was let off lightly.[57]

In assessing the larger significance of the failure of these pictures to please, or appease, any constituency, we can point to certain immediate practical difficulties. There was the death of Deshays, the most admired young painter of the epoch, which may have pushed Hallé beyond his depth. There was the awkward and relatively small format of the panels,

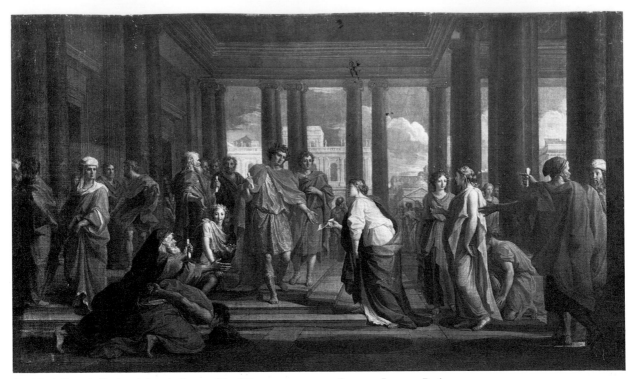

69. Noël Coypel, *Trajan giving Audience*. 1680. Oil on canvas, 49.5 × 87.5 cm. Louvre, Paris

dictated by the architecture of the gallery. Diderot observed that the "ingratitude du local," the necessarily stacked arrangement of figures and constricted space disallowed the stately intervals and ordered multiplicity of incident necessary for a "true composition."[58] This constraint prevented the artists from imitating more closely the one obvious prototype at hand. These were ceiling panels for the Room of the Queen's Guards at Versailles, completed in 1680 by Noël Coypel (Plate 69), which depicted an analogous series of episodes from the antique (Ptolemy-Philadelphus freeing the Jews; Alexander Severus distributing wheat to the public; Trajan giving public audience; Solon presenting his laws). Engravings had been made after these images and the oil sketches, purchased for the royal collection, were in Charles Coypel's studio up to 1753.[59] Their symmetries and ceremonial planarity come out of Poussin's Seven Sacraments, and had the painters of 1765 been able to incorporate more of those qualities into their efforts, Cochin might have had at least a *succès d'estime*. Their lack of imposing scale prevented them from having much physical impact in the Salon hanging. On the evidence of St. Aubin's richly descriptive watercolor rendering of the exhibition (Plate 8), they appear hard-put to hold their own against splashier and larger works like Fragonard's *Corésus and Callirhoé*, destined for the Gobelins tapestry works. And perhaps it was simply that none of the Choisy artists was on the level of Pigalle.

Such obvious practical obstacles might suggest caution in ascribing too much importance to their fate. Yet this series of contingent difficulties is the sign of a deeper, systematic one. Cochin and Marigny were forced to attach their claim to have renewed history painting to such an *ad hoc* and fundamentally misconceived commission because there were no others in the offing. They were forced back on a thin and partially untried pool of talent, further handcuffed by lack of space, money, and time. (To give one to Boucher!

It was a good thing he never finished it.) A public resonance natural to monumental sculpture could not easily be transferred to painting, and attempting to do so put the private requirements of the King and the public ones of the Salon squarely at odds. The demand that the pictures celebrate exclusively princely virtue eliminated most of the dramatic themes from the stoic repertoire, and Cochin admitted that he could come up with only a handful of appropriate possibilities. In the narrative space of history painting—that is, in an implied rather than overt allegory—the necessarily indeterminate gesture of benevolence supplied by Pigalle became insipid and static. This was Diderot's harsh judgement:

> As for your Augustus, Monsieur Van Loo, he is miserable. Could you not have found a pupil in your atelier with the courage to tell you that the figure is stiff, ignoble, and stunted . . .? This is what you call an Emperor! With that long palm frond that he holds glued against his left shoulder, this is just some member of the confraternity of Jerusalem returning from his procession . . . What does it all add up to? Where is the interest? Where is the subject?[60]

It was in his commentary on the very next Salon that Diderot, as noted in the previous chapter, advanced his proposition that the peaceful virtues were incompatible with effective historical painting, that art had a counter-morality to the one which obtained in everyday life.[61] Was it that heroic narrative and sentimental appeal could not with impunity be mixed in the same image? The painting of heroic virtue conjures up characters for whom exceptional courage and selflessness are constant conditions of life; they represent the true *exemplum virtutis*. But to paint an ordinary act of humanity, potentially accessible to anyone at any time, as exceptional can simply point up its more frequent absence among the privileged. It could in fact be read as a disguise for vice.

Such was the fate in the Salon of one kind of sentimental narrative picture, the kind that depicted not pathetic dramas played out among family members or social equals but rather charitable transactions between social classes. Though Greuze had painted both, his major narrative tableaux remained in the single-class category. The other, quite distinct variant of sentimental genre was a speciality of certain of Greuze's imitators, such as P. A. Wille, and pictures of this type begin to appear in greater numbers during the 1770s. This is the *livret* description of Wille's *Festival of the Good People*, exhibited in 1777:

> A young Queen of the May is crowned as the most virtuous maiden by the squire [*seigneur*] of the village. He holds another crown for a worthy old man who is followed by his blind wife. The nobility, of both sexes, is on one side, and the village people are on the other.[62]

In an anonymous critical dialogue of that year, a young girl visiting the Salon is made to ask, "But why are all the nobles on one side and the virtuous people on the other?" A knowing aristocratic companion replies, "Those nobles may well want to reward virtue, but they can't afford to get mixed up with it."[63] On a precisely parallel subject of 1781, Carmontelle is acidly to the point: "It is revolting in its truth; I see here all the impertinence of a little great lord, who is not in the habit of assisting others, and people stupid enough to trust their well-being to his unforeseeable acts of charity, because these are rare. . . . Where are the virtues of the rich . . . if we must praise them for being human!?"[64] In 1775, a similarly-minded Salon writer had proposed an alternative mode

70. Jean-Baptiste Greuze,
The Father's Curse. 1765. Ink
and wash on paper,
32 × 42 cm. Musée des
Beaux-Arts, Lille

of juxtaposing the classes, one in which the self-sufficient virtue and industry of France's common people would stand in bold contrast to elite parasitism and decadence:

> If it had been up to me to paint a sunrise, for example, I would have included, along with the morning sky, a château on one side where masqueraders in domino, weary and drained, would be returning from the ball to go to bed; one is tearing his hair for having lost his money gambling and would hurl his empty purse to the ground; a few steps away, another reveler wounded by a sword thrust would be carried along on a stretcher. On the other side would be a cabin from which a peasant would be emerging, fresh and joyous on his return to work; his children embrace him.[65]

These last texts all come from the decade following the one under discussion here, a period when unofficial commentary on the Salon was again relatively free. Comparable evidence from the heavily policed sixties is largely lacking. But the later commentary points to a source of resistance the Choisy commissions may have blundered into. In the genre subjects of an artist like Wille, dramatizing the homely virtues among the powerful only alerted the critical viewer to the possibility (or probability) of deceit.[66] "Where are the virtues of the rich if we must praise them for being human!?" The challenge in that question is indeed impossible to counter. Might not the 1765 images of benevolent Roman rulers have met the same skeptical query? For any time the benevolence of the ruler was removed from the level of universality, when that virtue was particularized by showing the pitiful supplication of miserable commoners, it was open to the same kind of resistance.

It was not of course that such scenes were unprecedented in the classical iconography of rulership; far from it. But the Salon had become a space in which the effectiveness of these particular pictures as legitimizing symbols was bound to be argued over and possibly negated. Certainly this is one of the principal reasons why Cochin had to forbear using more martial themes (which might well have pleased the King, the actual, though rather marginalized, patron of the project). The exclusion of such themes meant that the pacific virtues of the monarch were no longer seen in active, balancing relation to the often violent prerogatives of the commander, conqueror, and absolute ruler. Having lost confidence in much of the traditional imagery of power, including that part which

71. Jean-Baptiste Greuze,
The Punished Son. 1765. Ink
and wash on paper,
32 × 42 cm. Musée des
Beaux-Arts, Lille

made the monarch appear *unlike* other men, Cochin produced what amounted to an
iconography of excuses. As a concession to Enlightenment thinking, it was a doomed
half-measure. Its principal accomplishment was to anticipate that compromised and co-
opted variant of sentimental genre painting in which the virtues that Greuze had invested
in the middle-class family were unpersuasively appropriated on behalf of condescending
aristocrats.

<p style="text-align:center">—iv—</p>

When Greuze himself attempted to put classical iconography in direct touch with his
Salon audience, he too would opt for *sensibilité* in Roman dress. But instead of mixing
motifs of charity and warm fellow-feeling with the imagery of social hierarchy, he pre-
served the single-class, familial focus of his earlier work. His strength and originality
lay in his broader conception of sentiment in painting, which encompassed (like the liter-
ature of *sensibilité*) the pity and terror to be found in the dramas of everyday life. Already
in 1765, with the drawings for the *Father's Curse* (Plate 70) and *Punished Son* (Plate 71),
which he showed in the Salon of that year, Greuze had announced that the darker side
of domestic life would henceforth be his predominant concern. In the narrative sequence
that joins these scenes, a son foolishly deserts his family and aged father for the military
life only to find, on his return from the campaigns, that his father has died, presumably
from the grief and pain caused by his absence. Henceforth, Greuze was announcing,
his signature themes of generational passage, patriarchal loyalty, and the bonds of family
could be dramatized through conflict and suffering as well as through domestic harmony
and bliss. In his major Salon entry of 1769, Greuze would take his developing imagery
of middle-class familial discord and project it into the ennobled realm of Roman antiquity.
It was a maneuver with enormous promise of public success: David's Salon triumphs
of the 1780s, the *Oath of the Horatii* and the *Brutus*, would be based on precisely the
same strategy. Where the Academy and the *Bâtiments* had failed in 1765, Greuze might
well have succeeded. But far from encouraging the experiment, Cochin and company
summarily suppressed it, an action which gives a fair measure of the actual official commit-
ment to expanding the possibilities of public painting.

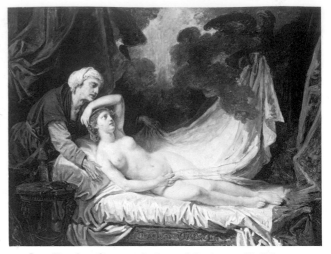

72. Jean-Baptiste Greuze, *Roman Charity*. About 1767. Ink and wash on paper, 32.6 × 41.6 cm. Louvre, Paris

73. Jean-Baptiste Greuze, *Aegina and Jupiter*. 1768. Oil on canvas, 146.7 × 195.9 cm. Metroplitan Museum of Art, New York

The sequence of events surrounding the picture were, briefly, these: by 1765, Greuze had lost a good part of Marigny's sympathy and indulgence. He had refused for a decade to provide the normal academic reception piece, and Cochin informed him that without it he could not exhibit in 1767. The exchange was sharp and Greuze did not show that year.[67] In the meantime, the artist was preparing the final act of the surprise invader, acceptance as a painter of history. The stakes were important: only a certified history painter could be a professor or hold any honorific position within the Academy. From the beginning, Greuze had aspired to nothing less than the first rank of artists (astonishingly, he appears to have had designs on the post then held by Michel Van Loo as director of the *Ecole des Elèves Protégés*[68]); there is no other explanation for the long delay between his *agrément* and reception: hesitating, calculating, gathering his forces for the big and final move.

Between 1767 and 1769, pressed no doubt by his exclusion from public exhibition, he essayed a series of classical subjects. Several drawings repeated, in a rather perverse way, his past stress on the bond between fathers and daughters: there was a *Roman Charity* (Plate 72) and a *Lot and his Daughters.*[69] The nearly finished *Aegina and Jupiter* (Plate 73), now in the Metropolitan Museum, represented an attempt at the traditional nude. In the end, he settled on a subject quite close to the drawing of the *Father's Curse* which he had exhibited in 1765, a tale of filial ingratitude and betrayal drawn from Dio Cassius' *Roman History*: "Septimius Severus confronts his son Caracalla with having planned to assassinate him in the defiles of Scotland, and says to him: if you want my death, order Papinian [colonel of the guards] to dispatch me with his sword" (Plate 74, Color Plate 4). It is a picture of relatively modest dimensions, prepared at his own expense and without the foreknowledge or approval of the academic hierarchy—or at least Greuze officially sought and received neither. To present oneself as a history painter, without having been admitted to academic membership at that level and without having informed the Academy prior to the day of delivery of the reception piece, was a spectacular extension of the surprise invader strategy: and it failed. After some talk of outright rejection— quashed because, in Cochin's words, "Europe would never have understood it"—Greuze was admitted "with the same rights as his *agrément*, that is to say, as a genre painter."

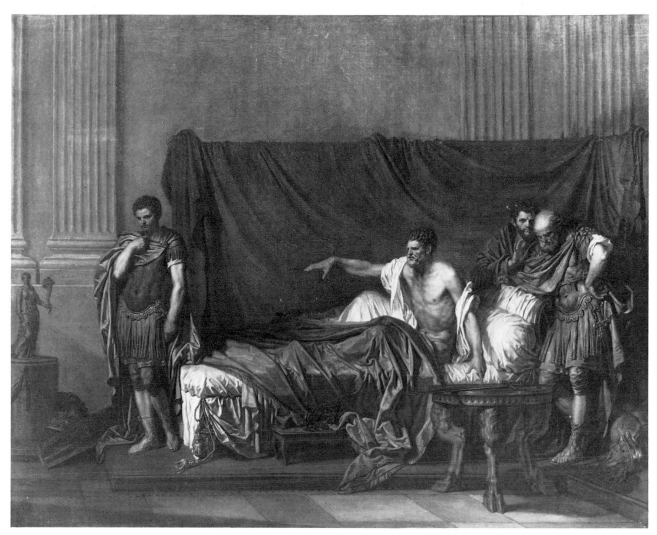

74. Jean-Baptiste Greuze, *Septimius Severus and Caracalla*. 1769. Oil on canvas, 124 × 160 cm. Louvre, Paris

The news, humiliatingly, was withheld from him until after his admission to the session and the formal oath of membership; his numerous enemies were after complete satisfaction. Only toward the end of the meeting did some awkwardness in the signing of the record alert Greuze that something was amiss, and having discovered the truth, he was goaded into a futile and embarrassing defense of his picture and his cause.

This is a famous and much-discussed incident in eighteenth-century art history (Jean Seznec has provided a well-documented and objective account[70]). Explanations have centered on Greuze's personal and artistic failings. He paid the price for past irascibility and self-aggrandizing contempt for his colleagues and the normal academic usages. On the aesthetic level, one can draw from the critical drubbing which the picture received in the Salon a fairly complete list of its shortcomings. The subject is unnecessarily obscure, and since it depends on a speech rather than an action, it is unsuitable for painting; the extended limbs of Septimius are grossly elongated and his gesture incomprehensible; the color is heavy and monotonously drab, the shadows without transparency, the drapery awkward and unnaturally agitated; there is an absence of picturesque martial

accessories; above all, the principal figures lack the nobility appropriate to their station and titanic passions.

The germ of these criticisms was contained in a long report written by Cochin for Marigny on the circumstances of Greuze's downfall, one designed to protect the Academy, himself, and, one assumes, Marigny from any accusations of unfairness.[71] This indicates the degree to which the artist was perceived to possess a powerful independent constituency. Greuze in fact counted on his admirers among the Parisian public to vindicate him and defiantly included the *Septimius Severus* among his Salon entries with that expectation. The results were precisely contrary to his hopes; but should he have anticipated that? The implication in the existing accounts is that his inappropriate ambition and over-estimation of his command of the classical mode blinded him to an inevitable fiasco. But if we try to reconstruct the situation from the artist's reasonable point of view, his failure may not seem so inevitable, and his blindnesses may have been to other, more structural constraints. Indeed, there is a good deal of compensating blindness on the part of his detractors.

The best known negative assessment of the *Septimius Severus* comes from Greuze's former ally Diderot. His dismissal is succinct: "*the picture is worth nothing*" [his emphasis].[72] But the artist had received precisely opposite signals from Diderot at the time of the picture's conception. Having seen a study (now apparently lost), he wrote to Falconet in August of 1767: "The Greuze has just brought off a *tour de force*. He has suddenly launched himself from genre into high painting [*la grande peinture*] and

75. Jean-Baptiste Greuze, *Septimius Severus and Caracalla* (study). Private collection

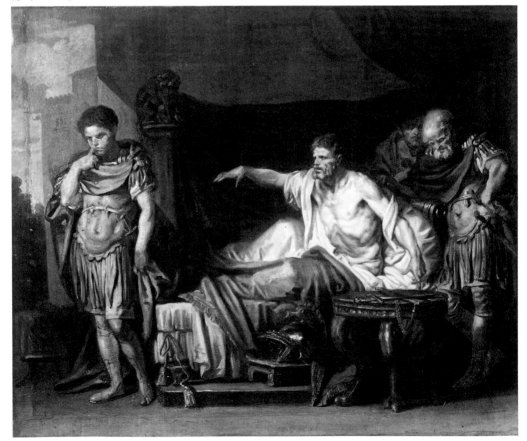

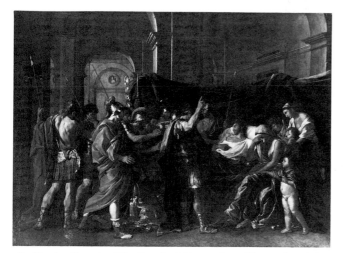

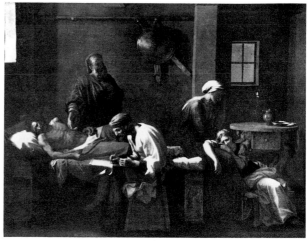

76. Nicolas Poussin, *The Death of Germanicus*. About 1627. Minneapolis Institute of Arts

77. Nicolas Poussin, *The Testament of Eudamidas*. 1650s. Statens Museum for Kunst, Copenhagen

with success, if I am any judge of it."[73] Diderot then sympathetically summarizes the narrative and delineates the character of each actor, concluding that there is "much simplicity in the accessories, a broad and unadorned background, with such a majestic silence that the voice of Septimius Severus seems to ring in the emptiness of the apartment." Later, he notes that the final composition is the same as the study which so moved him two years earlier.[74] To the degree that it resembled the other, known study (Plate 75), this version would, if anything, have magnified the faults leapt on by Greuze's detractors in 1769. In the surviving study, Caracalla has the proportions of a child and his gesture is that of a scolded brat; the Emperor's gesture is even more contorted and ambiguous; his anatomy is almost laughably out of control: the lumpishly raised right knee, for example, seems entirely discontinuous with the rest of his body. Yet there is no reason not to take Diderot's early reading seriously. By 1767, their earlier friendship had already deteriorated; his remarks to Falconet cannot be put down simply to personal loyalty. He was willing to look past the painter's technical difficulties and applaud a conceptual breakthrough more dramatic even than that of the *Village Bride*. And there should be no surprise in this; the surprise if any lies in his subsequent about-face. For Greuze, because of his ambition, his outsider status, and his often inspired literal-mindedness, was the first to take the "anti-Rococo" program seriously. If Poussin was continually held up as a model, he would re-organize his handling and his composition along Poussinesque lines. The finish of the picture is matte and uninflected, without the sparkle and play of impasto against glazes that distinguish his work of the early 1760s. By the standards of the time, he was scrupulous in his research concerning archaeological detail and antique likenesses of the figures. Though Poussin's *Death of Germanicus* (Plate 76) is most often cited as a formal presence, it is his *Testament of Eudamidas* (Plate 77), a picture which indeed functioned as a critical talisman of the period,[75] which Greuze evokes in the spare planarity and muted stillness of his composition. True, in altering his palette to signal the seriousness of the theme, he produced not the somber sonority of Poussin but a merely dismal murkiness of color. Deprived of an interlocked chain of figures, he is forced to make the extended forearm of the Emperor the sole physical link between father and son. One can sense him wrestling with the divided composition, realizing that that limb is the one fragile element holding the picture together; so he

twists and inflates it, trying to make it carry an impossible overload of meaning. But the broken-wristed attitude of the hand is a sign that in the end the gesture has no place to go. That point of failure only points up what a bold, and therefore risk-laden, venture the picture represents. There is a strong anticipation of David's successfully bifurcated compositions (or rather, a lesson to which the latter will attend) in the organization of the picture around a central gap or divide bridged by an extended hand.

It is no surprise that Cochin reacted with hostility to the ponderous sincerity of Greuze's homage to the master. As noted in the last chapter, Cochin was hostile to the very notion of a Poussinesque ideal, opposed to any hierarchy of stylistic value for his eclectic company. The problem for him was not, as he claimed, that the *Septimius Severus* dishonored the Academy, but that it was far too promising an initial effort. As Greuze himself complained later, in an accurate and almost touching way:

> I implore you to be persuaded that I have studied, as well as you [the critic of the *Avant-Coureur*] could do, the works of this great man, and that I have above all sought in him the art of putting expression in figures. . . . Why attack me so overtly on my first attempt at a new genre which I hope to perfect with time? Why oppose me, alone among my colleagues, to the most able painter of our school?[76]

The answer, of course, is that no other artist before him had ever raised the issue, thereby forcing the Academy and the critics to go beyond lip-service and contemplate the concrete prospect of a reformed history painting.

The simple truth of the matter is that Greuze's picture had to be unassailable on every point if his strategy was to succeed.[77] Inevitably, it was not. If he had taken some care to smooth the way, to stop playing the rebel and make some persuasive case in advance for his elevation, events might have gone differently. But he seems to have been temperamentally incapable of such a course and remained, to a degree, seduced by his initial, almost miraculous success. Having come so far so fast, how difficult could the final hurdle be? But playing the surprise invader had only worked when the Academy needed one; it was an assigned role and could be withdrawn. Marigny and Cochin had no need for such a figure at the level of history painting. Allowing its prerogatives to be, in effect, appropriated from below raised too many uncomfortable questions concerning the Academy's own fitness as keeper of the great tradition. Such a development would have forcibly reminded the Academy of its own recent failures: not only the disastrous results produced at Choisy by its senior members, but also its own inability to transform its best younger talent into consistent Salon performers.

The most important instance of this latter failure during the 1760s would have been the case of Fragonard, whose sensational debut in 1765 must have provided some welcome relief for Cochin and Marigny in that bleak year for the *Bâtiments*. His picture was the *Corésus and Callirhoé* (Plate 78), a magnificently lurid neo-Baroque melodrama in which an androgynous young priest immolates himself in place of a nubile young woman intended for sacrifice. Its extraordinary scale for an *agrément* piece was made possible by Marigny's purchase of the picture (reminiscent of the support given Greuze in 1761). Critical response was uniformly admiring, and Diderot was inspired to produce pages of brilliant digression on its vividly hallucinatory qualities.[78] But Fragonard never returned to the Salon with a picture like it, nor did he ever apply his talents to large-scale tableaux of greater narrative and moral clarity. In the year of the following Salon, in an act of almost purposeful defiance, he undertook the commission for that paradigm

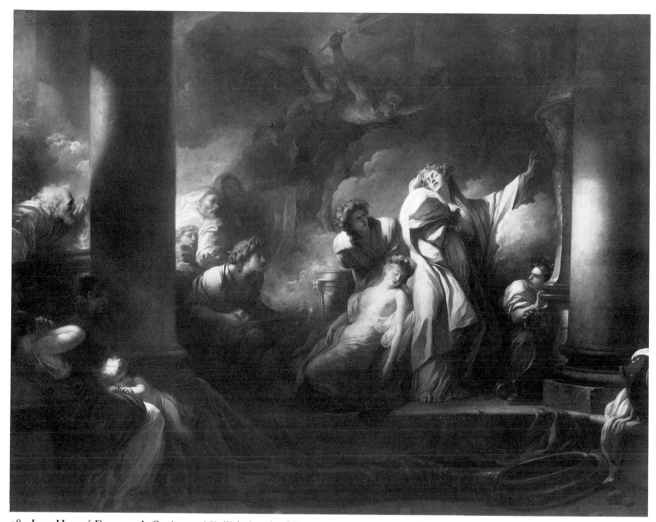

78. Jean-Honoré Fragonard, *Corésus and Callirhoé*. 1765. Oil on canvas, 309 × 400 cm. Louvre, Paris

of late-Rococo artifice and venality, the *Swing* (Plate 79) (the patron had requested that he be included staring up his lover's skirts, and so he appears in the picture).[79] With that, this pupil of Boucher abandons history painting and the public sphere to pursue the personal, sensual, and erotic possibilities of paint like no other artist of the century.

Fragonard's friend Gabriel-François Doyen established his considerable early reputation in the following Salon of 1767 with his vast altarpiece for the new church of St. Roch, *Ste. Geneviève interceding for the Plague-Stricken* (Plate 81). Again there might have been potential, in the dramatic muscularity and movement of Doyen's self-consciously Rubensian style, for important future Salon pictures on secular themes. But his Baroque stylistic tendencies went along with career ambitions more suited to that earlier era, and his energies after 1767 went largely into time-consuming projects of church decoration and official portraiture (Plate 82). Such undertakings accorded with what hostile commentators described as a habit of haughty, pseudo-aristocratic arrogance.[80]

Even Vien, who had emerged from the Choisy *débâcle* with his reputation largely intact, turned his energies increasingly away from the public space of the Salon. Among the academicians of the 1760s, he remained the dominant voice of classicizing sobriety and

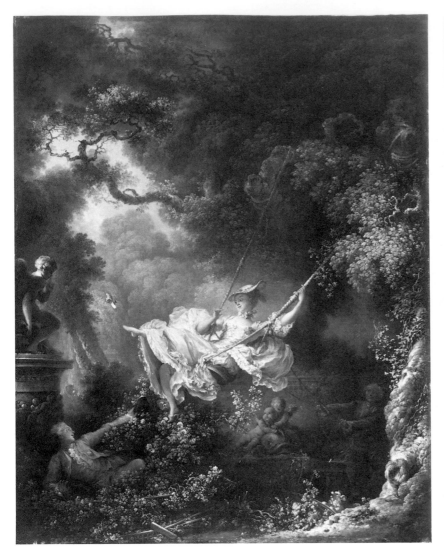

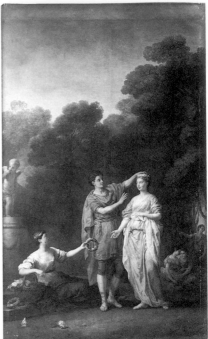

80. Joseph-Marie Vien, *Lover crowning his Mistress*. 1773. Oil on canvas, 335 × 202 cm. Louvre, Paris

79. Jean-Honoré Fragonard, *The Swing*. 1767. Oil on canvas, 81.3 × 64.8 cm. Wallace Collection, London

restraint, but he tended to apply those principles to chastely erotic pictures on classical themes for wealthy private patrons. When Madame du Barry, the King's titular mistress, rejected Fragonard's Progress of Love series (the artist's monumental revival of the *fête galante*) for her pleasure house at Louveciennes, it was Vien who was given the new commission (Plate 80).

But none of these lapses on the part of the approved candidates for the role of "brilliant younger history painter" meant that the field was going to be left clear for Greuze's self-election to that status. Cochin and the academic hierarchy made it utterly plain that such unorthodox presumption was intolerable, and they were determined to make Greuze himself feel naked and humiliated. An important part of this effort was Cochin's effective orchestration of critical response. When a journal like the *Avant-Coureur* reviewed the Salon, it was, in the words of Greuze's own protest, "content to list the productions, while paying to each one of them, in a small number of lines, the tribute of praise it deserved." But for him, this convention was abandoned; the normally bland official commentary is broken by a long excursion on how Poussin would have treated the scene. Greuze had been marked; Salon writers who would offer normally only the meekest

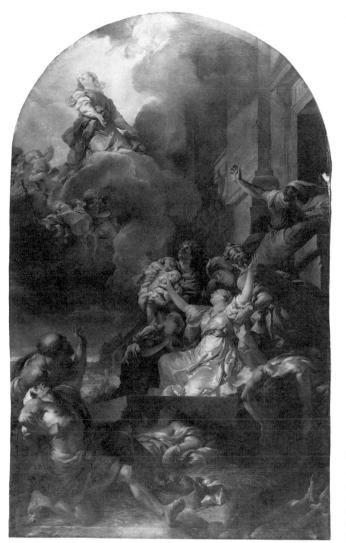

81. Gabriel-François
Doyen, *Ste. Geneviève
interceding for the Plague-
Stricken.* 1767. Oil on
canvas, 665 × 400 cm.
Church of St. Roch,
Paris

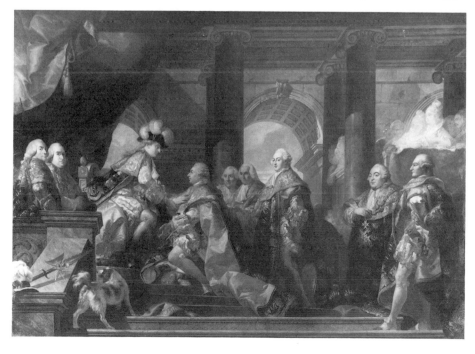

82. Gabriel-François
Doyen, *Louis XVI
receiving the Homage of
the Chevaliers of the
Order of the Holy Spirit
at Reims.* 1775. Oil on
canvas, 345 × 485 cm.
Musée National du
Château de Versailles

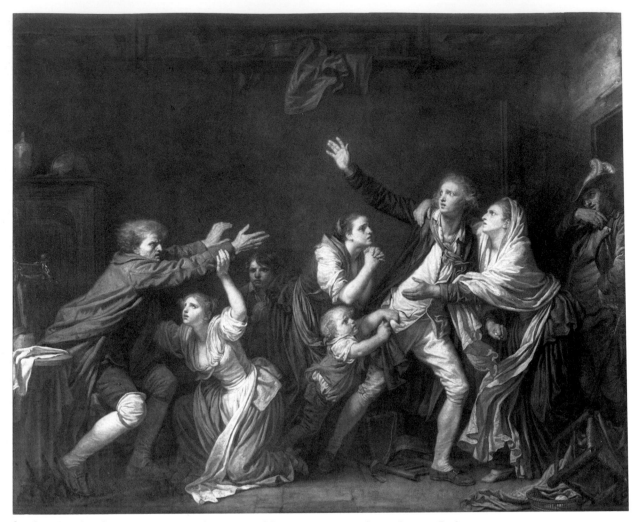

83. Jean-Baptiste Greuze, *The Father's Curse*. 1777. Oil on canvas, 130 × 162 cm. Louvre, Paris

reservations about the most meretricious pictures, were free to subject the *Septimius Severus* to a barrage of abuse. Because of Cochin's continuing tight lid on the production of clandestine pamphlets, it would have been difficult for an alternative voice to emerge on the artist's behalf. Only one anonymous pamphlet treats the picture with any sympathy.[81] Without a voice in the press able to articulate the force of the reforming logic in Greuze's image, there was little hope for the vindication he expected from the Salon public. And Diderot clearly was not willing to assume the lonely position of defending the picture and the ambition he had initially endorsed, even with qualifications. Given the atmosphere of intense concentration on the technical deficiencies of the work, it would have been an extremely difficult case to make: to argue that, in spite of all the awkwardness, the voice of the Emperor still rang in the silent room. He opted for the easier course and chose simply to reiterate received opinion.

What is most significant for our purposes here is the degree to which this internal academic affair was played out in public. It was a kind of repetition of the storm over La Font's criticism between 1747 and 1754. This time, however, there was a specific

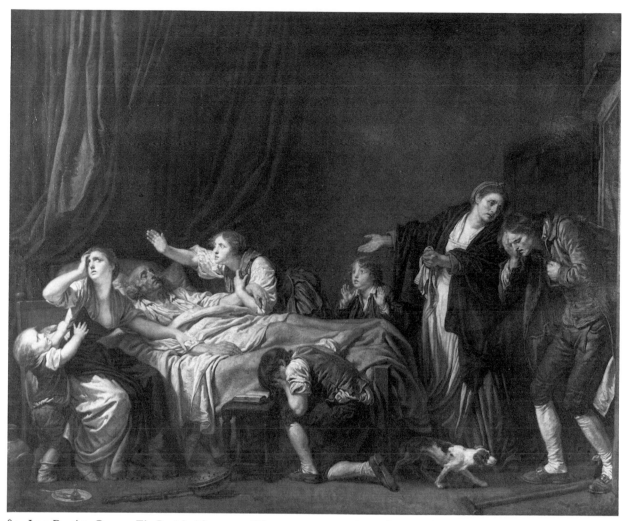

84. Jean-Baptiste Greuze, *The Punished Son*. 1777. Oil on canvas, 130 × 163 cm. Louvre, Paris

picture at issue; an artist in the embattled position protesting sincerity, learning, and good intentions in the face of a vicious counter-attack. Both La Font and Greuze reacted in the end by withdrawing from the arena, but the latter did so in such a way that his humiliation remained an active public issue through the '70s. During subsequent Salons, he would put his pictures on limited public display in his studio. As it was located in the Louvre, he was just steps away from the official exhibition and a palpable absence from it. There he would try to recover, on his own terms, the success that had eluded him in 1769. Particularly the monumental pairing of 1777, the *Father's Curse* (Plate 83) and the *Punished Son* (Plate 84), represents a reworking of the two essential aspects of the Septimius Severus narrative. Though the setting is again contemporary bourgeois life, Greuze preserves the dark monochrome tonality, the dulled handling, and fragmentation of gesture and expression which were for him the signs of high seriousness. He pays a considerable aesthetic price for this, evident in any comparison with his best work of the 1760s. The 1777 pictures present an array of diverse poses and facial expressions drawn from a highly limited vocabulary of agony and distress. Separated by clumsy,

static stretches of drapery or empty space, the only relationship between these expressive elements derives from simple parallelism and repetition. What remains of his distinctive animating impasto is randomly scattered, no longer working in an integrated way within the larger composition: it sputters, goes nowhere, like the useless spinning of disengaged wheels.

Greuze now had the satisfaction of that martyr's role already fashioned for him by Grimm in 1765: abused, misunderstood, heroically persistent, but with an unfailingly appreciative audience. In 1777, Du Pont de Nemours would advise his patron, the Margravine of Baden, that Greuze remained unsurpassed in the painting

> of morality, of goodwill, of *belles âmes*, but principally of nature and truth. It cannot be overly regretted that he had the weakness to go into a sulk toward the Salon because his *Emperor Severus*, somewhat too bronze in tone, was not a success. One pardons him on seeing the pictures that he shows only in his house, and since one only requires his rare talent and need not detach it from the irascibility of his character, which perhaps itself contributes to this talent, one must always choose him.[82]

His audience, however, was not really public, but one largely composed of the aristocratic visitors and buyers with access to the studio. And it is tempting to read the strain, abstraction, and one-dimensionality of the *Father's Curse* and *Punished Son* as marks of that isolation. This is painting catering to an idea of *sensibilité*, drawn from books, in which the domestic travails of the lower orders are aestheticized and contemplated from a distance. This is the "literary" painting which the whole of Greuze's narrative work is often thought to represent. It provides an image of the bourgeois family for those to whom the actual bonds of affection and interdependence which characterize that social form are of little consequence. So the expressive poses of individual figures become atomized, frozen ciphers to be read in sequence. It leads to reliance on bizarre attributes like the enraged father's improbably windblown hair. Once a reading of the manifest content is exhausted, the appeal of the image (in contrast to the *Village Bride*) drains away; there is little else there to sustain attention.

That quality of abstraction is determined also by Greuze's determination to reiterate his command of Poussinesque principles of design and pictorial narration. But like his bourgeois subject matter, that effort was disengaged from the only context where it would really have counted: the Salon. Outside that space, the correspondence between the daily experience of a broad public and Greuze's domestic dramas could never be tested and enlarged. Similarly, when a strong anti-Rococo critical voice revived itself during the 1770s, when the call was going out for a heroic national art that would bypass a corrupt Academy to engage the ordinary, naturally enlightened Salon-goer, Greuze was out of sight and in no position to exploit this oppositional current of public opinion. But if Cochin and company had succeeded in depriving the opposition of a standard bearer, it was one of the few satisfactions they would enjoy in these years. In his safe retreat, Greuze could be said to have prevailed over his tormentors. Both Marigny and his lieutenant would soon follow him into exile. There followed a period of drift and uncertain control over official art which nevertheless released energies sufficient to propel a new generation of history painters past the impasse of the 1760s.

VI

Painting and the Politicians

–i–

BY 1770, it was apparent that the Lenormand clan had succeeded all too well in cementing possession of the *Bâtiments* to the dynastic ambitions of the bourgeois royal favorite. The difficulty of their position was that this was now understood to mean *any* favorite. After the death of the marquise in 1764, Marigny and Cochin can be seen, in retrospect, to have been operating on borrowed time. Only the survival in power of her ally Choiseul as chief minister stood between her family and those hungry for the enhanced power and prestige with which the Lenormands had endowed the office of *Directeur et Ordonnateur-général des bâtiments, jardins, arts, académies, et Manufactures Royales du roi*. It was the belated arrival of the new favorite, just dubbed "comtesse," du Barry that brought their reign to an end. Choiseul unwisely appeared to oppose the King's choice and this made him vulnerable to his enemies at court. On the day before Christmas in 1770, he was asked for his resignation and exiled to his estate at Chanteloup. Power now shifted to the famous *triumvirat* composed of d'Aiguillon, the foreign minister, Maupeou, who had been Chancellor since 1768, and the abbé Terray, in charge of finances. Solicitude toward the new favorite had been for them a means to power, and they would retain it until the death of Louis XV.

According to one contemporary account,[1] Terray had been pressed from the start to turn the *Bâtiments* over to the "family" of du Barry. The term must be used advisedly given the minimal legitimacy of her past alliances, but she was their meal ticket and they were sticking close. They regarded Marigny's jurisdiction as the "apanage naturel de la famille de la maîtresse en titre du monarque." One obstacle was Louis' continued affection for the "petit frère" Marigny and his general reluctance to dismiss loyal officials. Terray's enemies later claimed that he had outlined the following plan to "les Dubarri":

> For a long time, that office has been short of funds. I am authorized to refuse them for reasons such that there has been no appearance of enmity or ill will on my part. Consequently, it is in the worst possible order, which has often displeased His Majesty. This will profit Madame du Barry when the time comes that the King demands some work and cannot obtain it. Let her suggest to her august lover that he confer the position of the marquis de Marigny on me. In order to please him and having funds at my disposal, I will never fail to fulfill his desires. Once we will thus have dispossessed the marquis, after a time I will let it be known to the King that my pressing duties do not permit me to continue my new functions and I will myself propose to transfer them to someone among you.[2]

That this transfer never took place was one more charge of duplicity leveled against

Terray after his eventual exit. Marigny hung on for more than two years, but by September, 1773, the bureaucratic war of attrition had succeeded; starved for money and support from above, he resigned, accepted a symbolic post as *Adjoint à la Directeur*, and Terray took over.

These bruising power plays did nothing for art; the Salon of 1771 came off as markedly poor in comparison to its recent predecessors. A disinterested observer, Charles Collé noted in his journal: "There was this year the exhibition of pictures in the old Louvre. The great masters have submitted nothing. People spoke of a few pieces by Vernet and Lagrenée; one said only the worst things about the rest."[3] The critic in the *Mémoires secrets* (a source invariably and erroneously credited to Bachaumont in the modern literature) wrote that the increasing quantity of works evident in every Salon

> hides an all too real sterility. With the appearance of wealth we are destitute. In effect, if one subtracts from the present exhibition the portraits, the minor genre pictures which can bestow glory neither on the nation nor on the artist, and the pictures in the more grand manner which are not worth the effort required to look at them or are only mediocre or contain some excellent qualities overwhelmed by enormous failings, this superb collection, which dazzles at first sight, soon collapses into nothing, or almost nothing.[4]

Hard words, and motivated by a deeper hostility than is apparent on the surface. At the beginning of that year, the chancellor Maupeou made the monarchy's decisive move against the resistance of the sovereign courts. Initially, the judges of the Paris Parlement were permanently exiled. Then, at a stroke, the ancient Parlements were dissolved, their officers exiled, venality and inheritability of offices in the magistrature suppressed, and an entirely new court structure (the members of which were to serve at the King's pleasure) was decreed. Despite the generally reactionary character of their opposition, the *parlementaires* proved as adept at marshalling public support for their side as they had been during the *Unigenitus* crisis and the campaign against the Jesuits. The alliance which had existed since the Fronde between the *robe* and the Parisian populace prevailed, and the Maupeou "coup" became deeply unpopular. That the power of the *triumvirat* appeared to rest on the accession of a favorite who was little better than a prostitute in the public mind provided the partisans of the exiled judges with an obvious and much-exploited target, one that lent a dubious moral cast to the whole attempt at reform.

In a display of glorious indifference—or glorious stupidity—du Barry commissioned a monumental seated portrait of herself "as muse" from Hubert Drouais which was put on display in the Salon of 1771 (Plate 85). The scale of the thing was probably offense enough, but the fact that she appeared, in Collé's words, "almost entirely nude"[5] made it the stuff of scandal. Since the picture was subsequently altered, we need to rely on documents to get an idea of its original appearance. The *Mémoires secrets* described it as follows: "She is partly veiled by a light and transparent drapery, which is gathered above the left nipple and leaves her legs uncovered to the knees and exposes nudity in all the rest of her body."[6] This spectacle overshadowed everything else in the Salon. In the face of the derisive reactions of the crowd, witnessed by the comtesse herself on a visit to the exhibition, the picture was withdrawn. Marigny, in a last show of authority, may have demanded its removal as a defense of decency.[7]

From 1765 on, we have seen the Salon audience put into an unaccustomed role; increasingly it was asked to ratify the outcome of decisions made or conflicts played out in

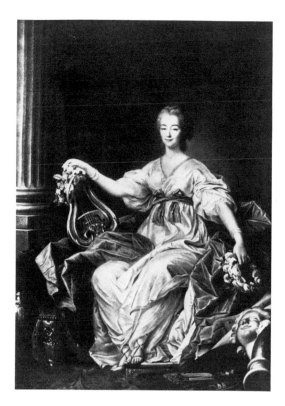

85. François-Hubert Drouais, *Madame du Barry as Muse*. 1771. Oil on canvas. Chambre de Commerce, Versailles

the higher reaches of the Academy and state. It was important that there be at least a perception of public applause for the Choisy program and its absence could not have escaped its unsatisfied patron. Both Cochin and Greuze played to the public in a second round of confrontation over the *Septimius Severus*. The Drouais portrait was an effort to monumentalize the favorite as a succoring goddess of the arts, in the words of the *Mémoires secrets*:

> . . . the artist, in order to convey her role as muse, has given her figure the grand proportions of the antique, to such a degree that, were she standing, she would be over six and a half feet tall. This colossal height, which can stamp a fantastic being with a more noble and imposing quality, is not in the least appropriate for a woman the whole disposition of whose body must be pleasing and whose principal character is an air of sensuality permeating her entire person.[8]

The implicit claim of the picture could not have been refuted more neatly than that. Du Barry had taken the risk of using a picture of pretentious scale, dimensions, and iconography to project a public image of queenly authority resting (literally) on the symbols of high culture. It was the concrete embodiment of the ambitions of "les Dubarri" to follow the path to power and legitimacy established by the Lenormands. But in the midst of the bitter, mocking attacks on her person provoked by her implication in the Maupeou coup, the transformation from courtesan to queen of culture was too bald and too sudden. The image would have reminded many of the general poverty of significant work elsewhere in the Salon, a result in part of her ally Terray's campaign to force Marigny aside. She would have appeared less a protective muse than a dissolute bringer of ruin.

It will be useful here to reiterate a general principle suggested earlier concerning the

gradual increase in opportunities for public opinion to make itself felt in the Salon. That initiative is rarely, if ever, organized and pushed from below. Would-be popular tribunes like La Font could not summon up real backing for their positions and they faded quickly from the picture. The public role can be seen to expand when the needs of one or another faction in power causes them to "go public" in an effort to enhance their position. The initial establishment of the modern Salon by Orry was a way for him to consolidate his position vis-à-vis the parochial, self-protective interests of the Academy. Tournehem worked toward a far greater quotient of intellectual seriousness in the policies of the *Bâtiments* in order to revive the lost luster and prestige of his office; that meant reaching out toward allies with potentially different agendas, and so on through the Choisy, Greuze, and du Barry "affairs." And gradually that last word, with its connotations of symbolic political battle, becomes an appropriate one for these episodes. As there came to be more at stake in the cultural apparatus of the state, the potential for conflicts over its resources increased, as did the likelihood that these conflicts would spill over into public discourse.

In the case of Terray, though there is little evidence of any special commitment on his part to an enlightened public art, his brief tenure produced advances which anticipated the better-known initiatives of d'Angiviller, the succeeding *Directeur-général*, after 1774. In his move to supplant Marigny, he had to be the provider of a new largesse. This appearance of generosity and commitment extended toward both artists and their large, urban audience. He was clever enough in this to receive credit, even from his sworn enemies, for things he did not actually accomplish. The author of the anti-Terray polemic quoted above, a young pro-Parlement lawyer named Coquereau, also conceded him a significant bit of grudging credit. The worthy practice of sending the winners of the Academy's annual *grand prix* to Rome for study had, he states, fallen victim to budgetary difficulties—until Terray:

> For some years now no student has undertaken this mission because of the calamities of the times which affected everything. Monsieur the Comptroller-General [Terray] then presiding over the arts, decided to see that this custom, so advantageous to their progress, was revived; he gave the order that those who won the prize in 1773 be sent to Rome.[9]

The fact is that through all the calamities the stream of prize winners arriving at the French Academy in Rome was never interrupted;[10] Ménageot, Vincent, and Suvée arrived within two years of one another around 1770; Peyron and David came on their heels. But changes introduced during Terray's drive for power over the *Bâtiments* did create the effect of a brilliant new "youth movement" in painting. From 1771 on, the interval between a pupil's gaining the prize and his departure for Rome was reduced from three years to one. No longer would he spend that long spell as a student in the *Ecole des Elèves Protégés* (the institution begun during the Tournehem administration to instruct the most promising students in history and literature). During Pierre's tenure as *Premier peintre*, he had systematically downgraded its function in academic education, perhaps because it remained administratively outside his control, and it would be abolished in 1775. Vien would move from the directorship of the *Ecole* to that of the Roman Academy with the mission of restoring it to "the splendor that it once possessed."[11] This had the effect of temporarily bringing together in the hothouse atmosphere of Rome a group of artists very close to one another in age and development, under a teacher dedicated to a chastened classicism. The telescoping of the stages of training

produced, for the students coming of age during the early 1770s, an acceleration of their careers and, in the public mind, a sense that d'Angiviller had produced an immediate bumper crop of zealous young artists. The appearance of a distinct, competitive new generation of Salon artists—Ménageot, Suvée, Peyron, David, Regnault—is one of the most important features of the d'Angiviller administration, but this concentration of new blood was in fact an effect of Terray's maneuvers. It was one that would have far-reaching consequences in the next decade as the public exhibition inevitably became the arena in which their rival ambitions would be played out.

The direction of Terray's thinking is revealed best by his plans for renovating the long gallery which then connected the Louvre and Tuileries palaces. At the time, this contained a series of models of fortifications which he proposed moving to the new *Ecole Militaire*. In their place would be paintings and sculpture from the royal collection, "the moveable riches of the Crown of every kind."[12] The creation of a museum in the Louvre had been put forward and officially endorsed in La Font's time; the article "Louvre" in the *Encyclopédie* also contained the proposal, and Marigny had revived it in 1768. But no real effort had been made to realize the plan, and where the initial intention had been educational in purpose, Terray conceived the project in far more ambitious terms of spectacle, organized diversion, and civic embellishment. It was to be a dazzling winter garden, "a place of public assembly that would provide a perpetual nourishment to our eyes and to our curiosity that no possible Vauxhall, no possible Coliseum [the glittering entertainment palace then operating on the Champs Elysées] would ever approach."[13] Such a massive and permanent extension of art into the public life of Paris would have far exceeded in scale the museum eventually to be established in the Louvre following the Revolution. In such a conjunction of art and entertainment, the universal expositions of the nineteenth-century and the Beaubourg of recent years are its closest approximations.

−ii−

Commitments to other building projects prevented Terray from even starting the project before his fall from power in 1775. He did, however, act in another way to encourage public participation in high culture, if only by omission. Whether it was out of a desire to play to the crowd or only a relative indifference to the sensitivities of artists, his policies opened the field of public discourse. The restrictions and harassment maintained by Cochin were relaxed, and the increase in the number of unofficial Salon pamphlets was immediate. The *Mémoires secrets* in 1773 was emboldened to blame the "palpable degeneration" of French painting in each successive Salon on the suppression of criticism:

> The excessive solicitude of the government for the *amour-propre* of the contestants has led to the smothering or enfeebling of useful critiques that might have been made of their works and put before the eyes of the public. Unquestionably this has been among the principal causes of the decay of which everyone complains. The excessive and undiscriminating praise with which one is successively besotted in the periodicals distributed under state auspices could only serve to spoil budding talents, encourage mediocrity, and perpetuate wretched taste.[14]

After this date, there was no shortage of critics determined to correct this state of affairs. Terray was not around long enough to take stock of the results; if he had been, he might

well have regretted this particular bit of liberality. For the voice that soon dominated this literature was of a piece with anti-government polemics generated by the Maupeou coup and the continued agitation on behalf of the exiled *parlementaires*. The leading figure in this resistance was the playwright/adventurer Beaumarchais. Having lost a lawsuit and a large sum of money in the new Maupeou court system, he sued the judge in the case, a certain Goezman, for soliciting a bribe from him (which this judge had in fact done, but he had received a larger pay-off from the other side). Beaumarchais mobilized public support for his cause in four published *mémoires* written over six months in 1773–74.[15] These constituted in fact the first of his developed literary work, and they moved from a statement of his case to an indictment of the whole corrupt structure of authority he saw ranged against him. The style of the pamphlets is that which would make his career as a playwright; he attacked Goezman and the new Maupeou courts with irony, sarcasm, darting wordplay, and old-style pro-*parlementaire* liberal sentiment. The available copies were snapped up in Paris, and the sensation they caused made them and their author known all over Europe. They did irreparable damage to what public support had existed for Maupeou's reforms and were widely credited for turning the tide against them. Even Voltaire, who saw the old Parlements as nests of reaction and intolerance, wrote of Beaumarchais' *mémoires*, ". . . I have never seen anything more singular, more brave, more comic, more interesting, more humiliating for his adversaries. He takes on ten or twelve people at a time and knocks them to the ground just like an enraged Harlequin overturns a whole troop of guardsmen."[16] Within a year, Maupeou had been dismissed, his court system abolished, and the old Parlements returned.

That same combination of humor, mockery, and political dissent made its appearance in the Salon critiques of 1773, just at the point of Terray's formal accession to the Directorship. One pamphlet, the anonymous *Dialogues sur la peinture*[17], begins a succession of extraordinary oppositional polemics which will attend every exhibition until the Revolution; a new critical genre which emerges just as Diderot effectively withdraws from the lists. The title page of the *Dialogues* states that it was "printed *chez* Tartouillis at the expense of the Academy and distributed at the door of the Salon." There may have been a few rustics who believed that its numerous acid dismissals of the leading academic artists was paid for by its victims, but everyone else was in on the joke. Unlike even the most hostile criticism of the 1750s and '60s, this writer does not stop with denouncing particular pictures, but goes on to attack the inherent failings of the artists themselves. On Doyen, for example, the dominant personality (certainly in his own eyes) among the younger history painters, he concludes, ". . . this one presents the appearance of having expression and grandeur at his command. With the air of possessing all the elements, he has none of them. I prefer obvious shortcomings to the shadows of talents."[18] On an ambitious entry by Lépicié: "The daredevil who undertook this composition without the benefit of talent and the blind man who entrusted it to him provoke me equally."[19]

The mocking humor and bursts of sarcasm do not however preclude entirely serious assessments of what had gone wrong with French painting. For this writer it came down to a failure of intelligence, an inability of both patronage officials and artists to comprehend the standards demanded by the informed public. Addressing the artists he states, "I would say like Despréaux to Racine: learn to paint in a difficult manner; some among us are capable of understanding it."[20] What was required on the part of all citizens was an ability to draw connections between the most urgent concerns of society and seemingly—but only seemingly—peripheral matters like art:

We would need among us strongly popular and public souls. . . . Such citizens bestir themselves on behalf of great interests because they are indifferent to nothing, and extend their passion into the arts, the overlooked and small things. Nothing is small in the public order. Can a public-spirited soul go into raptures over marble and pigments apart from their influence on morality? It is to this that Greece directed all the arts, which it made the mainspring of its politics; one string added and the lyre raised the threat of revolution.[21]

This line of thought now takes as a fact, rather than a hypothesis, that the state of the arts directly registers the worthiness of a given social order (this is the distance we have moved from Diderot's musings in 1767 on the possibility of history painting in a philistine society of Baliveus). A corollary of this assumption is that the organization of artistic practice is itself inseparable from politics and is directly susceptible to a political critique. It should be no surprise that one of the first questions addressed by the new, radicalized criticism was the failure of history painting to engage a broad audience. Again, an earlier suggestion that the fault lay with the providers rather than the consumers of visual culture is fashioned into a reasoned critique of fundamental failings on the part of the Academy. The artists had transformed themselves into an arrogantly exclusive body, a privileged corporation, which deliberately refused to recognize the interests of the public; and they painted accordingly. Another anonymous critic writing in 1773 complained of French artists that

> . . . they are nothing more than scrupulous analysts in their *tableaux d'histoire* . . . Instead of speaking the language [*langue*] of the passions, they produce a speech [*langage*] that they have contrived themselves and that they alone can comprehend. An arrangement of groupings, a fine fall of drapery, a faithful rendering of fabrics, that is what transports them, what they admire. But the beauty of compositional order, the sublimity of invention, and the truth of expression seem not overly to occupy their attention.[22]

Rather than the universal "*langue des passions*," the idiom of the academicians is a local and arbitrary "*langage*" which excludes all but the initiated; the "outdated maxims," which make of painting a mere *métier*, slavish to the petty demands of *les grands* and the borrowed exclusivity of the artists who serve them, stand in the way of great history painting. As long as artists preoccupy themselves with falls of drapery, the imitation of rich textures of cloth, contrived difficulties of composition, then nobility and truth are excluded. The awaited, true *grande peinture* might well be marked by seeming awkwardness and error; so states the author of the *Dialogues* of 1773, addressing the painters of the Academy:

> I believe that on the subject of composition, you have only ideas about embellishment, trivialities of taste and arrangement; you pay more attention to avoiding slight errors than striving for ideal beauty: the fear of a right angle, of a slight symmetry worry you more than conveying a great drama. Finally there is more of the *agreed-upon* than of true principles, and this is the source of endless monotony.[23]

The critic is pressed to give form to the crowd's indifference toward *la grande peinture*, and in his rationalizations, turns that indifference finally into a wholesale dismissal of the possibilities of painting that remains within the bounds of academic practice. The continual necessity to posit a public responsive to the anti-Rococo program in the end

subverts the original intentions behind that program. The early critics, La Font and Laugier, for example, show none of this categorical hostility toward the normal functioning of the Academy. The opposite, in fact, is true. They refer over and over to the Academy of the seventeenth century, to the great public projects overseen by Colbert and Le Brun, as the standard against which contemporary artists should measure themselves. There is little or no recognition on the part of the critics of the late 1740s and early 1750s that the models of seventeenth-century classicism might be inadequate for a painting that could address, in an authentic way, the new public for art. An unqualified statement of such an idea would have struck these critics as peculiar and perverse.

By the 1770s, as we see, critics appear who assert this idea in no uncertain terms. These writers are still functioning within the basic premises of anti-Rococo criticism, but their criticism carries implications unthought of in 1750. They straightforwardly attack the teaching of the Academy, and it is not long before this new generation of critics is attacking even the existence of an academy and the assumption that a collective body, by monopolizing teaching and entry into an artistic career, could set and perpetuate standards. The opposite, they say is the case: before the establishment of such a body, writes the anonymous author of *Sur la peinture*:

> . . . the fame of an artist would draw all eyes to him; he relied on his work alone, and impotent mediocrity could attack him only by attempting to equal his achievements. That rivalry was honest, without secret maneuvering, and the defeated artist could regard the victor without discouragement. But since there has existed an association composed of men whose status is assured, people believe that, outside of that body, there is nothing but second-rate talent. The honor of belonging to it is seen as the automatic sign of merit, and this further discourages those without power. If the academies had always been just and severe in the choice of their members, we would still endorse their judgement; they would be the instruments of truth. Unfortunately, mediocrity has installed itself in their ranks; thus everything has degenerated to the point that, if we ask where are the justice, the inflexibility, and the pride that must determine the choice of candidates, they can show us only favoritism, pity, and wishful thinking. Nevertheless, the judgement remains in force. That is what makes our great painters (methodical to a fault when it comes to their petty affairs) better suited to be academicians than to be worthy artists.[24]

Carmontelle, in his first Salon critique (1779),[25] puts this in stronger and more explicit terms. The control of the arts by a privileged corporation is, he states, the principal cause of their degeneration; the public is denied access to the rare artist of genius by the fears and prejudices of the mediocre majority of academicians:

> . . . above all in matters of taste, the judgements of a corporation are pernicious. As soon as a good number of men form a body, the enlightened minority gives way or seems to give way to the opinion of the rest; prejudices emerge and gain credit; frivolous and useless rules are dreamed up; a common manner is adopted which is nothing but an obvious failing; one grows accustomed to seeing Nature through defective eyes. The man of genius who scorns shabby success, withdraws into obscurity to escape the furious hostility of the self-interested cabals. Art degenerates, and it is always the establishment of an academy which begins or finishes its destruction.

–iii–

Why this bitter antagonism toward the Academy? I have tried to show how that antagonism figured in the dialogue between critic and public, but how do we account for the anger and frustration expressed in these texts? Though the mix of motivations doubtless varied with each individual writer, we need to situate their habitual rhetoric within a considerably larger field than that of art criticism. In their tone and language, these texts belong to a then-current and highly visible campaign against academies in general, against the entire system of privileged corporations that was the legacy of Colbert's determination to bring French high culture—art, architecture, poetry, *belles-lettres*, historiography, science, medicine—under centralized control. It was being carried on, in the name of the public, in hundreds of pamphlets and tracts.[26] "The ancients would never have imagined bodies as bizarre as our academies," states one:

> The empire of the sciences must recognize neither despots, aristocrats, nor electors.
> There, the most useful abilities are the sole title worthy of honor. To admit a despot,
> or aristocrats, or electors, who by certificate put the stamp of approval on productions
> of genius is to violate the nature of things and the liberty of the human spirit. It is
> to assault public opinion, which alone has the right to crown genius. It is to
> introduce a revolting despotism, make of each elector a tyrant, and slaves of all other
> thinkers . . .[27]

The specific grievance of this writer is against the Academy of sciences, but in the undisguised political terms in which it is framed, it is meant to take in all of them. This is the kind of anti-academicism which we need to consider in order to grasp the seeming suddenness with which open antagonism toward the Academy of Painting entered art-critical discourse.

The author of the last passage is Jacques-Pierre Brissot, the future Revolutionary leader and spokesman for the Girondin faction. But in 1782, when this was written, he was still an obscure young writer, existing from hand to mouth, and determined to influence all of enlightened Europe and America with the torrent of political and "philosophical" works he managed to produce. That he saw the closed character of established intellectual life in France as the principal obstacle to those ambitions is the unmistakable motive behind this outburst and many others like it. But it would be misleading to trivialize these attacks by reducing them to purely personal pique and frustration. The "tyranny" of these privileged bodies was, for the pre-Revolutionary radicals and their attentive readership, immediate proof of their larger political analysis. The obstacles which entrenched privilege seemed unfailingly to erect in the path of genius was one glaring symptom of a corrupt, oppressive state: complacent, established mediocrities brand the exceptional thinker as a fanatical outcast and thus are allowed to "crush the man of genius . . . because to say that a man is a fanatic is only to say that his ideas go beyond the sphere of received ideas, that he has public virtues under a corrupt government, humanity among barbarians, respect for the rights of man under despotism."[28] Brissot's is not the only familiar name from subsequent political history to figure in this campaign. Jean-Paul Marat painted pension-laden academicians as parasites draining the lifeblood of the nation. Nursing considerable resentment over the refusal of the Academy of Sciences to entertain his anti-Newtonian optical theory, he lashed out at the "immense gifts handed out to every

sort of intriguer, to the bloodsuckers of the court, . . . charlatans circulating among the in-groups, heads swelled by the trumpets of celebrity, fattened by the government, and devouring in pleasure and idleness the substance of the poor artisan, the poor yeoman farmer."[29]

When the occasion arose, some of these political writers were quite ready themselves to produce Salon criticism. Antoine-Joseph Gorsas was one of the ragged elite of radical pamphleteers in the later 1780s and another future Revolutionary deputy. He was also, in the same period, one of the more popular Salon writers; his pamphlets went into several editions and he had at least one imitator trying to pass off his work as Gorsas's own.[30] He had long been marked by the police as a producer of seditious and immoral literature: according to one police report:

> Gorsas writes libelous tracts. He operates in collusion with a journeyman in the political printworks, who had been thrown out of other shops. He is suspected of having had obscene works published. He retails prohibited books. He prides himself on being supported by the *conseillers* of the Parlement.[31]

That brief sketch condenses much that is of central interest to us in considering the new Salon criticism after 1773. First, the underground critics dimly perceptible in the 1730s and 1740s have come above ground; it is they who will create the dominant tone in public discourse on art. Many of them belong to the same literary subculture of radical opposition as did Brissot and Marat. And in a line that links back to La Font and the '50s they would find their polemical skills put to use in the political skirmishes still centered on the Parlements' resistance to royal prerogatives.

If Gorsas and company were stopped at the doors of literary success and thus turned to marginal pamphleteering as a vehicle for their ambitions, the same thing could happen to those in other occupations—including art. The author of *Sur le peinture*, the 1782 tract quoted at several points above, claimed to be and probably was trained as a painter (he is familiar with the practices and argot of the studio), but he was also a practiced and clever writer. In 1781 he produced a *genre-poissard* Salon critique entitled *Picnic suitable for those who frequent the Salon, prepared by a blind man*.[32] Written in dialogue form, it describes a drunken *homme du peuple*, careering about the Salon, heaping abuse, in pungent argot, on everything in sight. Though another character, "the critic", has the role of modifying or refuting the low-brow severity of his companion, the pamphlet was thought disturbing enough to warrant an outraged reply and condemnation from the *Journal de Paris*.[33]

It was this official reaction to the *Picnic* which elicited *Sur la peinture*, one of the extraordinary documents of eighteenth-century criticism. In it the author drops the light tone of this earlier work, and defends his worthiness to criticize the arts in a lengthy (143 pages) and plaintive demonstration of his unrewarded talent and education. Thus we have a record of the emotions and experiences of at least one educated young painter, who, like his literary counterparts, was defeated by the academic system. It also attests to the existence in the ateliers and cafés frequented by apprentice artists of the radical, Rousseauian conception of the artist's calling and of chafing desires for independence. (One of d'Angiviller's first acts as *Directeur-général* would be the suppression of the *Ecole des Elèves Protégés* as a "foyer d'anarchie."[34]) It begins with a long dialogue derived from Rousseau's *Social Contract*, in which the "First Painter" defends his right and duty to withdraw from the common labor of the primitive social group by pledging to

depict virtue and serve the interest of the group at whatever cost. Bristling with allusions to classical literature, *Sur la peinture* describes how this original purpose of painting has been perverted and the painter degraded by modern society. It develops into an impassioned indictment of every aspect of academic practice and the education of young artists, its passion frequently outrunning the ability of the author's prose to contain it; the enemy is the corrupt and decadent taste of the Parisian elites and the complacent accommodation and reflection of that taste by established artists. Suppose an unknown artist should overcome all the obstacles and produce a work of genius, asks the author: still he is lost; the second-rate and their protectors are sure to turn opinion against him. The *bon ton* of aristocratic society, its affected refinement, indulgence, and affability, mask the suppression of talent:

> If his picture were an astonishing work, then he would be lost. Mediocrity, with all the vices it engenders, would take the fore and implacably seek to discredit him: the "*ifs,*" the "*buts,*" the equivocation, the slanders would obscure its most beautiful attributes. . . . the titled cabal would arrive, their expressions stiff and gazes distracted, to pick over the work; they would say, stretching out their lips, affecting to pout: "But who is this man? One doesn't know where he comes from: to make a debut like this, all on his own, truly this is presumption: let him go; let us await a second work before we agree that this one is truly by his hand, then a third, then yet another; if afterwards this artist is still original, or defies our expectations, so much the worse for him: he will end up paying for his heedless conduct."[35]

This could just as well be Marat or Brissot speaking, and like them, this writer equates the bankruptcy of the system of literary and artistic patronage with the bankruptcy of the political and social order. He asserts, in fact, that the criticism of a work of art must be political and social in character:

> . . . the analysis of a work of genius engages considerations which are moral and political in character: how true it is that the pretensions of poorly accomplished art reflect less on the artist than on his social constraints, as well as on the course of events in which he is caught up.[36]

Like the Enlightenment itself, art criticism developed two opposing strains: a tame, subsidized, official variant challenged by a disenfranchised, embittered underground. The new unofficial critic imagined the crowd as a vast appreciative audience which would emerge in place of the corrupt patronage of *le grand monde*, and from which his personal vindication would come. One anonymous writer (Carmontelle or possibly a young musician named Lefébure) put this analysis in starkly explicit terms in a Salon critique of 1787, drawing the parallel between painting and the corrupt condition of the other arts:

> One fears to express the passions too strongly in front of intimate gatherings of perfumed men, always so careful to cover up their own; one trembles to attack a degenerate taste when one is reduced to the hard necessity of flattering that taste in order to survive. . . . It is true that some eloquent men are still heard in prohibited writings, but their genius raises itself so proudly only because they have sensed around them this crowd which is denied the right to assemble before them. It is imperative therefore that the people as a whole be in a position to judge the productions of an art in order to confirm its excellence. The applause of a single class too often confirms errors: as long as one sees in the same loges the same aristocrats,

one must expect to see the same vices on the stage; and it is a truth all too constant that wherever money takes precedence, good taste will never enter.[37]

The Salon of course was that one infrequent instance when something like the "people as a whole" was allowed the right to assemble before works of art. And if its actual behavior there failed to conform to the utopian role it was being called on to play, this was less of a problem for these writers than it had been for the relatively genteel critics of La Font's generation. Now accustomed to thinking of culture in avowedly partisan terms and in possession of a much more thorough-going social critique, they could imagine painting taking a vanguard role in the formation of an ideal public. Specifically it was eminently suited to the task of opening the eyes of a people hoodwinked by vice and corruption in their seductive disguises. The virtues of the grand genre would stand revealed when it was applied to this pressing necessity. So stated Carmontelle in 1781, the year of David's Salon debut:

> I acknowledge that the painters, the principal purpose of whose art is to imitate, would require, in order to enhance their taste for beautiful things, to have them habitually in front of their eyes. It is doubtless a taxing effort to invent fortunate physiognomies in the midst of people who display none; proud or generous features when one views only slaves and masters; true expressions in a country of dissimulation; strong and vigorous postures among models whom either poverty or debauchery have rendered hideous, and who, in order to provoke less disgust, carefully cover themselves in cloth of gold or in rags. But the more the obstacles are great and numerous, the more it is worthy to overcome them. . . . we are entering an epoch when this task has become a pressing one.[38]

−iv−

There were other admirers of Voltaire and Rousseau who were likewise committed to an educative, patriotic deployment of art, but who differed from these dissenters in almost every other particular. Chief among these was in fact Charles-Claude de Flahaut de la Billarderie, comte d'Angiviller, the new *Directeur* of the *Bâtiments*.[39] The death of Louis XV and the exile of du Barry had abruptly ended the tenure of Terray. D'Angiviller was a close political ally of the new Comptroller-General Turgot and was named to the arts post the same day as the latter was named to his, 24 August, 1774. The accession of Louis XVI brought on a brief summer of enlightened reform: Turgot, Malesherbes, Du Pont, Condorcet, Morellet, Suard, friends of the Encyclopédistes and Physiocrats now wielded power in the name of the throne. The twenty-year old king had hesitated long before consenting to Turgot's appointment (and thus allowed Maupeou and Terray to cling to power long past anyone's expectations). The old Dauphin, the new King's pious and reactionary father, had despised the *philosophes*, and Quesnay, the founder of Physiocracy as a school of economic science, was Pompadour's physician and her protégé. But the King's intimate advisers insistently put Turgot forward as the man of the hour. After more than three months of vacillation, the former *intendant* of the Limousin and the current Minister of the Marine was installed in the most powerful post of the kingdom.

One can understand the stolid and unimaginative Louis XVI hanging back on more practical grounds. Turgot never accepted the more extreme—and fundamental—tenets

of the Physiocrats (or, as they were more commonly known in the eighteenth century, the *économistes*): their notions of absolute property rights and the exclusive productivity of agriculture. But he did enact their most important practical corollary: the free trade in grains. The guiding assumption was that a "good," meaning higher, price for grain would ultimately increase general prosperity to the point that the existing elaborate mechanisms for provisioning towns and cities would no longer be necessary. Though temporary dislocations, shortages, and inflation in bread prices might ensue, the ultimate well-being of the kingdom depended on the economic concerns and well-being of producers not consumers.

This meant an abrupt turn away from Terray's policy of rigorously policing the grain trade, which had been motivated partly out of a traditional concern to forestall popular unrest. Bread riots are one of the most constant motifs in Old-Regime history, and the anger which fueled them was rooted in a conception of the state presiding over the economy, guaranteeing a "fair" price for a four-pound loaf (it worked out to about eight sous), local control over local produce, and adequate supplies in times of dearth. Turgot and his intellectual mentors were out to reverse that relationship: the autonomous functioning of an ideal economic order (for them a pure agrarian capitalism based on a free market in both produce and labor) was the social model provided by natural law and ultimately by God. They dismissed the long-standing claims of society to a direct role in the allocation of resources. It was the duty of the sovereign to comprehend and enforce that God-given law and resist the claims of individuals and groups to undeserved advantages not bestowed in the marketplace. The absolute sovereignty of the monarch embodied the absolute authority of the natural order. The self-seeking would always seek to evade its dictates, and the state would therefore be of necessity a "legal despotism," as the Physiocrats themselves provocatively phrased it.[40]

Though Turgot was prudently wary of their easy way with terms like "despotism" and "tutelary authority," he was recorded as demanding "six years of despotism to establish liberty."[41] And indeed, before a year was out, the machinery of an authoritarian order had to be called out in a direct and brutal way when Turgot's reforms sent the price of bread skyrocketing. His calculations had never included the immense importance that the "good loaf at a fair price" played in the fundamental cohesion of the French body politic. And the price of bread in most of France had reached a point that was clearly life-threatening to working men's families. The result was the Grain War of April and May, 1775. Outbreaks of looting and forced sales at the "fair" price converged on the capital along its supply routes, and Paris erupted on 3 May. Turgot was adamant in his resistance to any tampering with the price. A local official in Pontoise who decreed a price lower than market value (but still far higher than that demanded by the populace) was thrown in the Bastille for seven weeks. Ending the turmoil in Paris required a massive show of force, militarization of civil authority, large-scale arrests of suspects, and symbolic executions for the slightest offenses.

Those measures, the immediacy of the inflation and insurrection, and the interests arrayed against him forced Turgot's fall the following year. It is worth rehearsing these events as a prologue to the arts administration of d'Angiviller, for much of its character was determined by them. The close alliance between the two men produced the first occasion since Colbert's consolidation of power in which a dominant finance minister with a large-scale reforming vision was able to include the arts as a systematic component of that vision. Terray's efforts were anticipatory but off-hand and distracted by com-

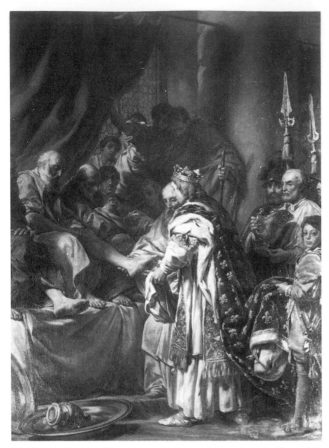

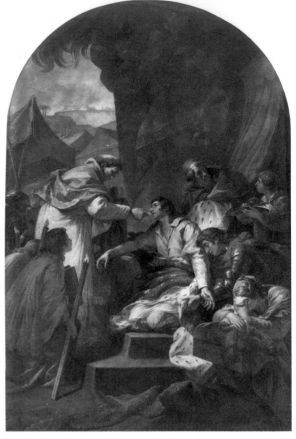

86. Louis-Jacques Durameau, *Saint Louis washing the Feet of the Poor*. 1773. Oil on canvas. Chapelle de l'Ecole Militaire, Paris

87. Gabriel François Doyen, *The Last Communion of Saint Louis*. 1773. Oil on canvas. Chapelle de l'Ecole Militaire, Paris

parison. The circle around Turgot had a plan for culture consistent with their program in other areas. We have one eloquent piece of testimony to this in the first Salon critique of Samuel Du Pont de Nemours, devoted disciple of Quesnay and Turgot. He in fact coined the term Physiocracy and would serve as royal Inspector of Commerce under Turgot. His account was written for his patroness, the margravine Caroline-Louise of Baden, and was the first of three covering those Salons of the 1770s that were not reviewed by Diderot.[42] The recipient was knowledgeable about the Parisian art world and attentive to its workings; she had gone so far as to attend a session of the Academy in 1771.[43] So Du Pont was able to write in a serious vein. He first takes up a major official spectacle of that year: the series of ten pictures on the life of St. Louis destined for the recently completed *Ecole Militaire* (Plates 86, 87). This major cycle was to be installed in Gabriel's stately classical chapel, and the War Ministry had delegated responsibility for overseeing the commission to Pierre. The latter hoped to provide an impressive demonstration of the Academy's collective strength in historical painting but the reception given this exercise in medievalizing national imagery was not much more positive than that accorded the Choisy program.

From all this emerges a poem in ten cantos, most of them cold, possessing unity in neither personages nor costume; ten different kings, five or six queens, gross anachronisms, in sum, an abortive enterprise. It would nevertheless have been easy

to have the subjects chosen by the *Académie française*, the costumes determined by the Academy of Inscriptions, to select the painters under the scrutiny of the Academy of Painting, and afterwards to force them all to make the heads of the same personages resemble one another and their figures exhibit the same proportions, and finally to show the sketches in public before the execution of the pictures. . . . This is the course to follow if one wants a consistent and rational policy. But in this case, only fragments of a muddled policy are in evidence. One commands while yawning; one is served by torpid subordinates; one has artists lulled into complacency and all are surprised that criticism has reawakened.[44]

For a body wary to its bones of ideological programming and ministerial control, such words would have been a chilling portent, had the Academy known of them. D'Angiviller never attempted to install a system of control so pervasive that artists would become simple executants in a grand and regulated cultural machine. On the announcement, however, of his first major series of commissions in 1777, it was apparent that he intended a new level of administrative investment in and management of history painting. Not only were eight large-scale pictures to be produced for that year's Salon, the series as a whole was to follow a governing conceptual scheme.[45] Each picture in the program, before being identified by its specific narrative content, was designated by a larger and more imposing moral category. The six subjects from ancient history conform to the following rubric: (1) Act of Religious Piety among the Greeks; (2) Act of Religious Piety among the Romans; (3) Act of Unselfishness among the Greeks; (4) Act of Unselfishness among the Romans; (5) Act of Incentive to work among the Romans; (6) Act of Heroic Resolve among the Romans. The two subjects from French national history are designated: (1) Act of Respect for Virtue; (2) Act of Respect for Morality.

Such a rigorously educative and moralizing conception of art might easily be read as a belated vindication of La Font's now decades-old agenda and of Diderot's later prescriptions. But to understand the "enlightened" character of d'Angiviller's iconographic program, it is in relation to Turgot's particular brand of enlightenment that we must consider it. The Physiocrats and the Encyclopédistes had much in common. D'Angiviller indeed had been well acquainted with both groups since the 1750s via the salon maintained by his lover and future wife, Madame de Marchais. Both groups were committed to toleration toward religious and political dissent; both wanted a rational and uniform system of justice and removal of the archaic encumbrances of entrenched privilege. But the Physiocrats could not envisage any intermediate authority between the body politic as a whole and the absolute monarch. They were thorough-going statists and accepted no check on the King's power. The stress on rational coordination from above, on *control*, visible in Du Pont's text is one sign of the distance that separates the thinking of those around Turgot from the likes of La Font. There could be no intermediate bodies with independent prerogatives interposed between the sovereign and the public. There would be no place for self-elected aesthetic arbiters, nor would the Academy serve as a semi-sovereign repository of tradition separate from the needs of the monarch: a national art was not conceivable distinct from the sovereign. D'Angiviller made this assumption concrete in 1777, the same year as the above list of commissions was issued. According to a new set of statutes, the election of academic officers would henceforth be subject to the approval of the King. Even the *Premier peintre* Pierre, whose autocratic character otherwise suited d'Angiviller's inclinations well, objected to this[46]—not too

strenuously however, as the new order made him Perpetual Director of the Academy, thus moving the basis of his authority away from a collegial body to a higher, external power. Cochin wrote in a letter of 1780 that "Monsieur d'Angiviller quite enjoys acts of authority without considering that this might make him appear as a despot, even as a tyrant."[47]

More than Turgot even, d'Angiviller, in his background and affiliations, represents the marriage of enlightenment rationalism to the needs of an authoritarian state. The former was a professional administrator who had made his reputation during a long tenure as *intendant* in Limoges. Though he fiercely opposed the fiscal obstructionism and religious intolerance of the *parlementaires*, he was, in the end, one of them, born of an established *robe* family. D'Angiviller, on the other hand, was of the ancient sword nobility and spent his early life in the expected military career. Connections at court brought him the post of Gentleman of the Sleeve to the Dauphin and responsibility for supervising the education of the royal grandchildren. One of his charges was thus the future Louis XVI, and he remained a faithful family retainer, personally devoted to the young King and enjoying access and candor with his former pupil on a level unknown to any previous occupant of his position. But like many of the important middlemen and mediators in the history of eighteenth-century French art, his personal life history was itself a negotiation between disparate group interests and points of view. His wife, the aforementioned Madame de Marchais, was the daughter of a financier. And like a mini-Pompadour, she cultivated safely "advanced" thinkers as one means of social self-expression. So this somewhat stiff-necked military man, employed in the reactionary atmosphere of the Dauphin's household, where even the mildest intellectual skepticism was an anathema, was drawn across a social line into alien territory. There he developed a particularly close attachment to the writer and second-generation *philosophe* Jean-François Marmontel (always something of an intellectual courtier). During the controversy over the latter's "philosophic" novel *Belisarius* in 1767, when its advocacy of religious toleration provoked the censure of the Sorbonne, d'Angiviller stood with his friend, as did Turgot, who came to Marmontel's defense in print.[48]

D'Angiviller, predictably, had been profoundly shaken by the violent opposition to Turgot's policies on the part of the Parlements, reactionary factions at court, and an insurrectionary populace. Though of vastly lesser national importance, his efforts to pursue comparably rationalized managerial policies in his own area also encountered substantial obstacles. The talents and entrenched ways of working among the available history painters were clearly not up to the job d'Angiviller had in mind. Du Pont doubtless spoke for others from the old Turgot circle when, in his letter to the Margravine of Baden on the Salon of 1777, he wrote off nearly all the senior academicians involved: "Do not," he implored his patroness, "believe a word of praise, however moderate, for the likes of Durameau, the Lagrenée brothers, or Lépicié." His remarks on Noël Hallé carry the force of his general dismissal of the established practitioners of the high genre.

> . . . Believe even less the compliments paid to Monsieur Hallé, who continues to paste his paltry cut-outs on blue paper and call these things pictures, show them in the Salon, and have the effrontery to remain at the head of both the *livret* and the Academy.[49]

If the new *Directeur-général* was to carry through his ambitious patronage agenda, a new pool of talent was required. The steady journeyman performers cited by Du Pont were

mired—hopelessly, according to his opinion as an insider—in the complacent inbred eclecticism that the old Academy had come to represent. The brilliant newcomers of the 1760s, Fragonard and Doyen, had proved to be false hopes as far as the Salon was concerned (as Grimm had in fact predicted to Diderot in the case of the latter).[50] Vien might possibly have made a difference, but he was occupied far away as Director of the French Academy in Rome.

Fortunately for d'Angiviller, the concentration of prize-winners in Rome, along with more exacting supervision of their studies, was beginning to produce results. The future now lay in the hands of the first cohort back from Rome; so Du Pont announced in his 1779 letter. Of Ménageot's *David before the Exterminating Angel*, he wrote: "This was a young man one year ago, this Monsieur Ménageot; but when one produces a picture like this, one is no longer a young man . . . nor must I forget Vincent and Berthélemy, his comrades, his rivals, his competitors, his friends. They have studied together. They successively took the *grands prix*. They were together in Rome. They live and struggle together in Paris."[51] A few pages later, he adds J. B. Suvée to the list. This was a widely shared perception. At the next Salon, the same point was made more categorically by the author of the *Mémoires secrets*, whose political vision diverged sharply from Du Pont's:

> It is no longer the Viens, the Doyens, the Van Loos, the Brenets that are admired; it is neither the Directors, the Chevaliers of the King's Order, the Professors, their Adjuncts, the Councillors, nor the first-ranking academicians. It is rather the young *agréés*, the *débutants*, the students who have hardly crossed over the threshold of the Academy and whose names only a few years ago were completely unknown or even today are being pronounced for the first time.[52]

By all indications, d'Angiviller shared this opinion as well. In the way that subjects were distributed for royal commissions, a pattern emerges in which the themes with the greatest personal and political resonance for the *Directeur-général* were largely held in reserve for the new generation. We shall find that his program of patronage possessed a strikingly greater degree of consistency and internal coherence than had those of any of his eighteenth-century predecessors; but in order to discern this coherence, it is necessary to look away from the whole range of historical commissions generated in such numbers by the *Bâtiments* in these years and toward those directed to a favored few artists.

—V—

There is an almost obsessive concern underlying the iconographic choices made by d'Angiviller, a recurrent figure we might designate as the wise adviser to the throne, unheeded and even persecuted, but still loyal to his sovereign. As a type, it emerges among the very first commissions he suggested after taking office. In June of 1775, well before the grand program of 1777 had been organized, d'Angiviller wrote to Pierre proposing that a series of four pictures be executed as tapestry designs by the established history painter L. J. Durameau.[53] Two of these were rather anodyne evocations of the age of chivalry: *The Death of Duguesclin*, in which this virtuous commander is honored even by the inhabitants of the town he was holding under siege; and *The Continence of Bayard*, in which the perfect noble refuses the sexual offer of a beautiful captive and gives her a dowry instead. Next to these medieval and Renaissance subjects, however,

were two others of a more recent and violently dramatic character: *Président Molé Seized by the Insurgents*, a subject which celebrated the courage of the most conservative and royalist of the *parlementaire* leaders during the Fronde when he was physically threatened by a mob following the lead of his more radical colleagues; and *Admiral Coligny Confronted by his Assassins*, an event from the later sixteenth century when this Huguenot boldly faced his killers from the ultra-Catholic "League."

The elevation of French national history to the same level of prestige previously enjoyed only by classical narrative is rightly seen as one of the hallmarks of the d'Angiviller regime. And this line-up of themes reveals some of the layers of meaning present in this policy. For a start, one overlooked motivation may well have been a readiness to signal, on behalf of the new King, a change in court style taking place at Versailles. This involved a calculated revival of archaic national dress by those courtiers partial to Louis XVI and Marie-Antoinette. As the comte de Ségur, who was particularly close to the young Queen, recounted in his memoirs,

> The opening contest pitting old courtiers against new entailed an effort on our part to revive the dress, the customs, and diversions of the courts of François I, Henri II, Henri III, and Henri IV. We soon persuaded the King's brothers, Monsieur and the comte d'Artois, to adopt these ideas . . . we soon encountered such remarkable success that the revolution in manners swept all before it. [54]

Ségur goes on to say that the fashion for Renaissance dress was short-lived at court; nor was d'Angiviller's 1775 proposal ever carried out in its original form. But the significance of the new *Directeur-général*'s early choices of subject matter for royal commissions goes well beyond any temporary coincidence of fashion to reveal, behind the broadly didactic formulae of 1777, a far more personal and lasting political agenda. Its motivation appears not to have come directly from this devotion to the monarch, but from his loyalty to Turgot. The letter proposing the Durameau tapestry designs was written one month after the grain riots in Paris, when, like Molé against the urban *frondeurs* and Coligny against the League's assassins, Turgot himself had personally confronted an insurrectionary populace backed by opponents in high places. In his memoirs, d'Angiviller declares that this great royal minister showed character worthy of his virtuous forbears "when in 1775, at the time of the bread riots in Paris, in my presence, his door besieged by the people, he ordered it to be opened." [55]

Thus the two more contemporary of the four 1775 subjects offer precise parallels to this display of courage and defiance, personally witnessed by d'Angiviller, on the part of his friend and protector. In both, the loyal and courageous senior official boldly defies mob rule, even unto death. The principles of these two men, moreover, offered historical justifications and precedents for Turgot's policies. Mathieu Molé of 1648 might well emerge as the figure most akin in word and deed to Turgot, the royalist son of a *parlement-aire* family. Molé, while not willing to surrender the prerogatives of the Parlements in 1648, had tried to steer his colleagues away from their eventual rebellion. At the same time, however, he was no uncritical apologist for royal power, having forcefully counselled Mazarin and the Queen-Regent that arbitrary taxation and unequal judicial procedures had to be curbed if domestic tranquility was to be ensured: wise words and unheeded ones. For his reasoned loyalty, Molé was left in the end to face the mob alone. [56]

The subject of Admiral Coligny provided a parallel moment of confrontation, with an added lesson on the costs of fanaticism and religious intolerance. More than any other,

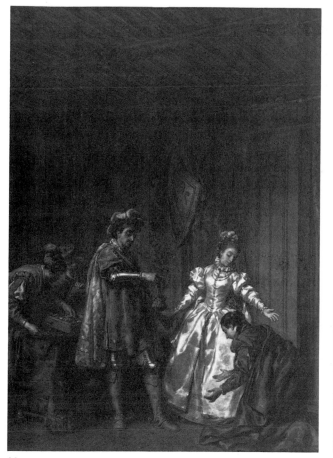

88. Louis-Jacques Durameau, *The Continence of Bayard*. 1777. Oil on canvas, 320 × 152 cm. Musée de Peinture et de Sculpture, Grenoble

89. Nicolas-Guy Brenet, *The Death of Duguesclin*. 1777. Oil on canvas, 317 × 224 cm. Musée National du Château de Versailles

the issue of toleration united liberal thinkers of all stripes during the 1760s and '70s. That cause had come to symbolize the struggle for a just, equitable, and *efficient* state. (Turgot was keenly aware of the economic damage done to France by the exile of so many Protestant merchants and industrialists.) D'Angiviller came to share the view of those like Turgot and Marmontel that the monarchy could only be saved by rationalizing its authority and eliminating such counter-productive vestiges of the past as judicial persecution of Protestants.

Of the four subjects proposed in the 1775 letter, only the first two were included in the actual commissions for the next Salon in 1777. These went to artists of the established generation. Durameau, in the end, was given only the *Continence of Bayard* (exhibited under the category "Act of Respect for Morality") (Plate 88); N. G. Brenet produced the *Death of Duguesclin* (under "Act of Respect for Virtue") (Plate 89). But the projected Molé and Coligny pictures were not forgotten; each would go to an artist of the new generation. J. B. Suvée's *Coligny* (Plate 90) would not appear for ten years, but F. A. Vincent, who had shown for the first time in 1777, was given the *Molé* as a conspicuous demonstration piece for 1779 (Plate 91).

In both technical and expressive terms, it was an audacious picture, which stood out in sharp contrast to the tame efforts of his elders. It not only depicted an act of risk

90. Joseph-Benoît Suvée
*Admiral Coligny confronts
his Assassins.* 1787. Oil on
canvas, 325 × 260 cm.
Musée des Beaux-Arts,
Dijon

and daring, but displayed those same qualities on the part of its maker. A somewhat shocked writer in the official *Journal de Paris* found the praise Vincent had reaped for the work uncomfortable:

> As Monsieur Vincent is a young artist, who justifies the highest expectations, we permit ourselves more extended reflections concerning him than any other, not to discourage him but to avert him from the false paths onto which one wanders easily in the heat of that age. What must appeal and what will always appeal in this work is the tumult of the composition, which responds perfectly well to the subject, and also the firm and bold touch of this intrepid brush that seems to doubt nothing. This forcefulness is, without argument, the announcement of talent, but it becomes a dangerous gift of nature when it is not directed by reason. . . . This young painter will rise to the highest degree if he learns to take greater pains with his pictures and if he does not let himself be dizzied by the concert of praise with which his imprudent friends may intoxicate him.[57]

When one is going for the bold artistic stroke, it is useful to have a pedant appear wringing his hands over the decline of standards. The picture in fact was in no way displeasing to d'Angiviller, who directed that a replica be painted for one of Molé's descendants.[58] Even the laudatory Du Pont admits the picture displayed severe faults: "His color is dirty and careless. . . . After being dazzled, one notices with effort that almost all the

91. François-André Vincent, *President Molé and the Insurgents*. 1779. Oil on canvas, 305 × 305 cm. Chamber of Deputies, Paris

figures are on the same plane, that the *Président* and above all the principal insurgent are gigantic, and that there is a fathom's distance between the legs of the latter."[59] But for all that, it had, he claims, deservedly enjoyed the greatest success of any picture in the Salon. Its impetuosity could be indulged because it was that quality itself which had allowed Vincent to break through stale conventions to achieve an immediate intensity of expression appropriate to its charged subject.

The perception of an intensely concentrated and competitive "youth movement" in history painting led to a lively critical interest in handicapping the contestants and assessing their relative standing from exhibition to exhibition. An artist had to find ways continually to match his rivals or be left aside. Vincent, for example, suffered seriously in

92. François-André Vincent, *The Intervention of the Sabine Women*. Oil on canvas, 330 × 430 cm. Musée de Peinture et de Sculpture, Angers

93. François-Guillaume Ménageot, *Leonardo da Vinci dying in the Arms of François I^{er}*. 1781. Oil on canvas, 298 × 352 cm. Hôtel de Ville, Amboise

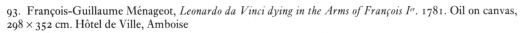

1781, saddled with the charge that his failings now overshadowed his strengths.[60] With a subject of less power and topical interest—a pale, disjointed, and strangely compressed *Intervention of the Sabine Women* (Plate 92)—he was easily overshadowed by another artist with whom he had made his Salon debut in 1777. Ménageot's suave *Leonardo dying in the Arms of François I*[er] (Plate 93) was the unanimous critical choice of the 1781 exhibition.[61] It wears its Poussin credentials on its sleeve, being probably the eighteenth century's most thoroughgoing tribute to the *Death of Germanicus* (Plate 76). The normally censorious author of *Sur la peinture* called it "incontestably the pearl of the Salon," and his discussion of the picture continues in that rhapsodic vein.[62] This Renaissance costume drama could well be the purest distillation of d'Angiviller's iconographic vision: the arts, hitherto embattled and misunderstood, find a safe refuge in the direct, unmediated intervention of the monarch. In that embrace, all the obstacles otherwise in the way of unity between sovereign and subject are eliminated; the crown embraces the enlightened sage. It is a vision of a state-patronage utopia to which even the most embittered artist-critic could respond. "Truly the subject, which is extremely honorable for artists, could not have been better chosen," wrote the critic of the *Mémoires secrets*; "It is astonishing that no one has treated it before and that it took a commission to produce it."[63]

By 1781, however, that spontaneous accord between power and enlightenment captured by Ménageot stands out as exceptional among the kinds of themes which d'Angiviller most encouraged and which seem, in personal terms, to have engaged him most. Still less do we find new subjects along the lines of those conceived in 1775: virtuous royal officials defiantly intervening against the enemies of the crown. The fall of Turgot begins a shift away from imagery conceived when the chief royal minister and the *Bâtiments* were presenting a bold united front against hostile forces toward themes expressing the disillusionment of an orphaned agency carrying on under its own slightly embittered momentum. D'Angiviller had come to power with Turgot, but his unquestioned personal rapport with the King meant that his tenure was not dependent on Turgot's retaining power. Neither was he beholden to any ascendant faction at court, nor, being of ancient lineage, did he need the arts for the purposes of personal advancement. This made him a far more disinterested *Directeur-général* than his three predecessors had been. At the same time, he had secured a much more solid financial base for the support of ambitious history painting. This allowed him to continue his program for painting with no lessening of either administrative independence or material resources.

By the end of the 1770s, this meant principally two things. First, a retreat from French national history, so full of parallels with contemporary events, and a return to the more removed realm of classical antiquity. (This turn coincided as well with the interests of the even more advanced young painters whose training in Rome had coincided with Vien's advent as director there. These students were more disposed to the classical repertoire in both subject matter and style, and their rivalry with slightly older colleagues like Vincent and Ménageot was bound up with the "reform" ethos Vien was meant to carry with him to Italy.) Secondly, a replacement of the active Molés and Colignys as subject matter by equally virtuous servants of the state, but ones whose virtue had provoked abandonment and suffering. In the aftermath of Turgot's fall from power, d'Angiviller had used his intimacy with the King personally to intervene on behalf of the deposed minister, urging that the counsel of a wise and virtuous servant should not be thrown aside and offering himself as an informal go-between.[64] That request was predictably ignored (there was no one Louis XVI liked to see or hear about less than a deposed

minister). But what he could not provide in actual political life, d'Angiviller would increasingly direct his artists to provide in symbolic form.

— vi —

The concerns of the *Directeur-général* and those of the young painters who came to the fore in the early 1780s converged around two themes in particular: the blind Belisarius, and, to a lesser degree, the lessons of Socrates. Durameau had been the first to take up the Belisarius theme in a now-lost picture, which, to judge from the remarks of Diderot and others, justified Du Pont's later dismissive assessment of his ability.[65] Vincent was the first of the new painters to seize on the theme, producing in 1777 a cabinet-sized, half-length rendition of the recognition scene between the general, now a blind and out-cast beggar, and one of his former officers (Plate 94). This was one picture out of fifteen which he put on exhibition that year. That display of industry and confidence had the desired effect, but the *Belisarius* was relatively neglected in the critical commentary. Perhaps the reason was simply its relatively small dimensions, since the picture's power-fully compact composition, rapid and brilliant impasto, and investment of the scene with a barely suppressed aggressive charge are just the qualities for which he was praised elsewhere. Vincent, too, was the first deliberately to link the figures of Belisarius and Socrates. The pendant to the picture was *Alcibiades receiving Instruction from Socrates* (Plate 95), an equally assured effort built around a magnificent contrast between the earthy intensity of the Socrates figure and the abstracted classicism of the Alcibiades. The pairing suggests we read the two subjects as being in some way analogous, and there was in fact one immediate source in which Belisarius, too, appears as the enlightened instructor of a youth destined for power: Marmontel's 1767 novel *Bélisaire*.[66]

Marmontel had remained strongly in d'Angiviller's favor. The latter used his position to install the *philosophe* as *historiographe du roi*; a coveted sinecure recently occupied by Voltaire. (Even years later, exiled after the Revolution, d'Angiviller would write his memoirs by weaving them around Marmontel's in the form of commentary.) And his image of Belisarius now came to serve d'Angiviller's devotion to Turgot's past exemplary service and to his present ignored wisdom. For the Belisarius created by Marmontel bears little resemblance to the ruthless commander of Justinian's armies described in the historical accounts of Procopius.[67] In the novel he appears as the perfected Enlighten-ment philosopher and exemplary public servant, still loyal to his sovereign despite Justinian's having charged him, falsely, with treason and ordered that he be blinded and dispossessed. The social evils denounced by the fictional Belisarius in lengthy monologues are the same ones attacked by establishment *philosophes* like Marmontel himself: official intolerance, a parasitical nobility, the reign of luxury, and the domination of favoritism over merit. And conforming to the perennial dream of the policy-intellectual, Belisarius' voice brings the mighty to him: over the course of the narrative, the aged general's long-winded advice is sought out secretly by Justinian in the company of the future Emperor Tiberius.

Vincent's pairing thus points to aspects of Marmontel's narrative which are not given in the image itself (or in iconographic precedents like the seventeenth-century picture attributed to Van Dyck and known in France through Scotin's engraving). At the same time, it encourages reflection on those aspects of Socrates' biography that most resemble that of the invented Belisarius. The pairing is symmetrical: on the one hand, Socrates,

94. François-André Vincent, *Belisarius*. 1776. Oil on canvas, 98 × 129 cm. Musée Fabre, Montpellier

95. François-André Vincent, *Alcibiades receiving Instruction from Socrates*. 1776. Oil on canvas, 98 × 128 cm. Musée Fabre, Montpellier

the enlightened tutor doomed to betrayal and disgrace; on the other, Belisarius, redeemed from a parallel betrayal which left him maimed if not dead, who would go on to instruct a future emperor.

The addition of Socrates, in fact, does more than underline the theme of statecraft guided by philosophy, for the special significance of that theme emerged from the same nexus of events and causes as did Marmontel's text. The image of Socrates in prison as a symbol of the persecutions suffered by the *philosophes* had long been in circulation; Diderot had translated Plato's *Apology* while imprisoned in Vincennes in 1749; and Voltaire referred to him as "Socrate-Diderot" in a letter of that year.[68] That equation became far more common and public during the 1760s. In 1762, the Paris police stopped production of a play by Billardon de Sauvigny entitled *The Death of Socrates* and subjected the text to searching censorship before it was allowed to go on in the following year. The cuts and the delay were regarded as expressions of official animosity toward the party of *philosophes*, and, more specifically, analogies were drawn between its fate and the condemnation in the same year of Rousseau's *Emile* by the Parlement of Paris. According to the *Mémoires secrets*:

> It is feared that it will be stopped by the police because of the circumstances of the Jean-Jacques affair, which presented an identical scene to that offered by this illustrious Greek to the Areopagus of Athens.[69]

Rousseau was Socrates and the Parlement of Paris the corrupt, reactionary tribunal that condemned him to death.

By 1767 there was, as noted above, no shortage of martyrs to *parlementaire* justice with whom the comparison could be made. One case in particular was still an active source of conflict in the later 1770s, that of Lally-Tollendal. A battlefield hero at Fontenoy, Lally-Tollendal had been commander-in-chief during the disastrous French expeditionary force to India at the start of the Seven Years' War. He was captured by the British in the course of the French defeat and taken prisoner to London. On his repatriation, he became the official scapegoat for the loss of Pondicherry, and after a trial on charges which went far beyond his actual responsibility, was executed in May 1766. The case remained alive largely due to the persistent efforts of the younger Lally to secure his father's exoneration. Repeatedly drawing public comparisons to the fate of Socrates among others, the son succeeded in enlisting formidable backers, including, by the early seventies, Voltaire and Turgot. In 1778, the Royal Council, in a blow against the sovereign courts, overturned the original verdict and sent it back to the Parlements on appeal (though the definitive reversal of the original verdict would not come until 1786).[70]

D'Angiviller had distinguished himself at Fontenoy, and the advocacy of Turgot would dispose him even more favorably to the rehabilitation of Lally. After Turgot's exile from power, comparisons were made between them. In the month before his fall, Voltaire, in a letter to d'Argental, compared the Parlement's hostile campaign against the minister to its persecution of Lally.[71] 1778 would bring at least a symbolic triumph which would make the real defeat of Turgot in 1776 easier to bear. Lally, as idealized by his partisans, was the next thing to a contemporary Belisarius, though his ultimate fate was that of Socrates. This fluid cross-symbolization lay behind a relentless repetition of the two themes in these very years. The same message that Vincent had acted on in 1777 was picked up in the following year by the most favored student during the Vien directorship

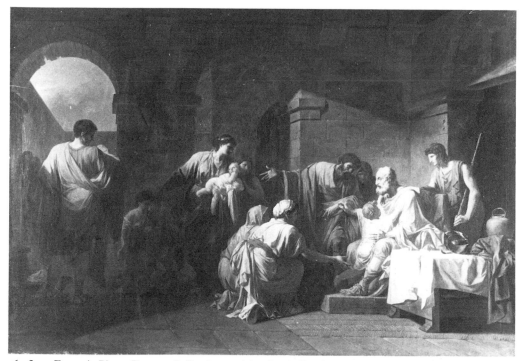

96. Jean-François-Pierre Peyron, *Belisarius receiving hospitality from a peasant who had served under him*. 1779. Oil on canvas, 93 × 132 cm. Musée des Augustins, Toulouse

in Rome, Pierre Peyron. Pompadour's old confidant Bernis now had his cardinal's hat and was French ambassador there. He was in close touch with both d'Angiviller and Vien, and it was he who commissioned Peyron in 1778 to paint *Belisarius receiving hospitality from a peasant who had served under him* (Plate 96). Rather than the well-established begging scene, Peyron chose a far more literal rendering of one specific episode found in chapter 4 of Marmontel's text.[72] Moving away from the charged, confrontational moment selected by Vincent allowed him to multiply significant incident across an extended, Poussinesque planar frieze. The arrangement and positioning of the arms on the wall make it a deliberate homage to the *Testament of Eudamidas* (Plate 77), the master's own canonical depiction of an exemplary act of old age. Peyron joins that prototype so literally to Marmontel's narrative that it presumes knowledge of the text for its readability. One would have to know, for any adequate comprehension of the scene, that the aged general, having protected these peasants from the Huns, is received as their liberator, that "one mother after another presented her son and placed the child on his knees," that the old man to the immediate left is his principal interlocutor, and that the gesture of that figure is towards his son, the veteran soldier of the title who, "standing before the hero, regarded him with a pensive expression, his hands joined, his head lowered, amazement, pity, and respect showing in his face."[73]

This is an episode in which Belisarius is held up as the protector and guardian of productive agricultural labor, a point certain to appeal to adherents of Physiocratic doctrine and the policies of Turgot. All the evidence indicates that Vien and d'Angiviller were highly pleased with the results. After its public exhibition in the Palazzo Mancini, Vien wrote to the *Directeur-général*: "I sense with satisfaction that this academy takes on a new luster in Rome."[74] D'Angiviller responded that Peyron "was one of those on whom I am counting to elevate our painting."[75] In the same letter, he requested a drawing

97. Jean-François-Pierre Peyron, *The Funeral of Miltiades*. 1780. Oil on canvas, 98 × 136 cm. Louvre, Paris

of the composition for his own collection. Only a month later, he commissioned a pair of historical pictures from him, suggesting that one of them treat the death of Socrates.[76] Peyron postponed fulfilling that request until 1787 (when it would figure in a fateful confrontation with David). He did, however, choose to treat a more active call to virtue from the life of the philosopher, *Socrates pulling Alcibiades from the charms of sensuality* (now lost). And as Vincent had done, he paired a depiction of Socrates in a tutelary role with one of a virtuous warrior disgraced. D'Angiviller had wanted one tenebrous scene, "treated in a mysterious tone favorable to chiaroscuro."[77] Peyron chose to give him another variation on the Belisarius/Socrates theme, one which offered a precise mythic parallel to the tale of Lally-Tolendal: the *Funeral of Miltiades* (Plate 97). The protagonist here is the great victor of Marathon, who was subsequently accused of treason by his fellow citizens. First condemned to death, he was thrown into a prison and left to die of old wounds. In order to retrieve the body for proper burial, the son Cimon volunteers to take his father's place in prison, and in the picture we see the moment when the body of Miltiades is carried from the dungeon; one servant bears the insignia of the victory at Marathon, while the jailor chains the faithful son to the broken pillar.

It is a stark, finely calculated picture which represents the horrifying generational substitution in terms of a simple, ponderous rhythm of parallel limbs. One can sense, like Vien and d'Angiviller, Peyron's burgeoning strengths and confidence as an artist. It is still, however, a work of small scale, not quite a meter and a half across. Even at the age of thirty-six, he is not yet producing true Salon pictures. He had been in Rome for more than four years, but his superiors were taking no chances with their prize pupil. When he wanted to return to Paris toward the end of 1781, d'Angiviller insisted that

he stay another year. In terms of Peyron's own interests, this cautious delay before unveiling his abilities in front of the Parisian public worked decidedly against him. For they were reckoning without the drive and ambition of David. The latter had been passed over for the *grand prix* by Peyron in 1773, and as readers of every biography of the artist know, was almost suicidally bitter over his rejection. It is clear that he was determined not to let Peyron stay ahead of him. While the latter was being passed the choicest commissions from Bernis and d'Angiviller, David had to make do with slightly less prestigious projects. One was a commission from the public health office of Marseilles for a picture of the Virgin and St. Roch to commemorate the end of the plague that struck that city in 1720 (Plate 98). The request came through Vien who selected David for the job in the fall of 1779; the price was 550 livres. The picture was finished by May of the following year, and unlike Peyron's contemporaneous exercises, was large enough to hold its own on the Salon walls. In the meantime, he had procured a commission for a life-sized equestrian portrait from a Polish nobleman on the Grand Tour, the Count Potocki, for the princely sum of 3,600 livres (Plate 99).[78]

Both of these pictures were to appear in the Salon of 1781, and that was where he had his sights. Though d'Angiviller was intent that he, like his rival, remain in Rome, David, according to Vien, was "too preoccupied by the thought of contending alongside his comrades who were already *agréés* and whose works in the last Salon had attracted so much favorable comment. The praises he had received for his picture [*St. Roch interceding for the plague stricken*] have filled him with the greatest desire to be of the [Paris]

98. Jacques-Louis David, *Saint Roch interceding for the Plague-Stricken.* 1780. Oil on canvas, 259 × 193 cm. Musée des Beaux-Arts, Marseilles

99. Jacques-Louis David, *Count Stanislas Potocki.* 1781. Oil on canvas, 304 × 218 cm. National Museum, Warsaw

100. Jacques-Louis David, *Belisarius* (study). Ink, wash, and gouache on paper, 45 × 36 cm. Ecole polytechnique, Paris

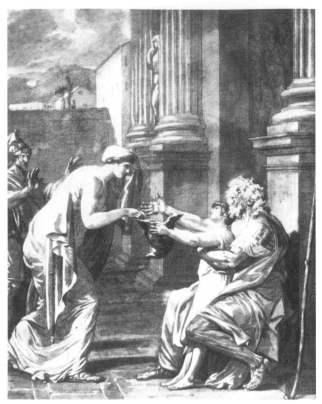

101 (facing page). Jacques-Louis David, *Belisarius*. 1781. Oil on canvas, 288 × 312 cm. Musée des Beaux-Arts, Lille

Academy . . . nothing could make him stay."[79] He left in July of 1780, leaving behind a number of lucrative commissions. But he had sufficient time to digest Peyron's responses to official favor and the kinds of subjects on which the latter was being encouraged to concentrate. We know from Peyron's own notes, that it was he who lent David a copy of Marmontel's *Belisarius*.[80] While still in Rome, David completed a highly finished drawing (Plate 100) which displays most of the elements present in his monumental painting of 1781 (Plate 101). He completed the latter on his return to Paris in time for it to serve as his *agrément* piece and to appear the following day in the Salon.

When compared to Peyron's picture, David's *Belisarius recognized by a soldier who had served under him at the moment that a woman gives him alms* is starkly simplified, in both narrative and compositional terms (and is also eight times its size). It is a public picture in every way, and the first of the latter-day depictions of the Belisarius subject to take on these dimensions. When Vien wrote that the success of the young *agréés* in the preceding Salon had moved David to contend immediately for a place among them, it is likely that Vincent's *Molé* was in the minds of both. And the *Belisarius* repeats the risk-taking strategy behind Vincent's canvas: go for the bold stroke; if the drama of the pictorial statement exceeds your technical control, push forward regardless; your mistakes can work in your favor if they are read as signs of a fervent and original imagination with great promise for the future.

Errors there were in the picture—plenty of them. Perhaps the most telling is the perspectival awkwardness and resulting spatial ambiguity in the left foreground; the scale of the astonished soldier in relation to the foreground figures cannot, for example, be reconciled with the position of his right foot just behind if not touching the heel of the woman. The verticality of the orthogonal line at that point provides no clue to the rate

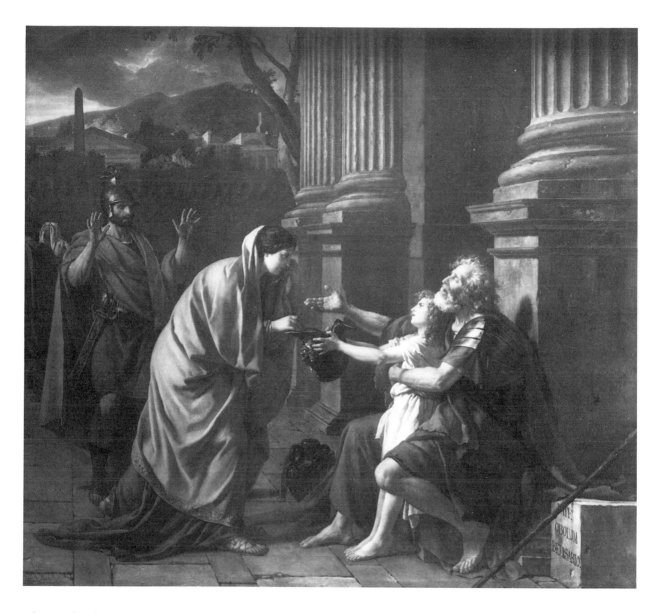

of recession into space or the position of the ambiguous personages in the background.[81] The obelisk in the distance completes this vertical sequence and gives it enough strength to close the composition at the left and balance the heavy triumphal arch, but in doing so only underlines its problematic character. Diderot stated simply that he preferred not to speak of the soldier, and went on to list a series of other shortcomings.[82] So did Carmontelle, and both were highly sympathetic to the young artist.[83] Part of these difficulties results from a fidelity to Marmontel's text different from Peyron's. Though David returned to the more familiar recognition scene which demanded no specific knowledge of the novel, he reproduced, with an almost ponderous literalness, the compositional arrangement of several of its original illustrations designed by Gravelot.[84] But what would pass in a small, relatively indistinct engraving produced intractable problems when subjected to the rigorous organizational demands of monumental painting. In addition, almost every serious critic concurred that the picture was too "black," that it lacked convincing interplay of light and atmosphere.

Yet for all its various shortcomings, the picture accomplished what its author intended. It catapulted him into direct contention with Ménageot as a focus of public attention: "... after Ménageot, the artist who deserves the most praise"; "the only rival to Monsieur Ménageot"; wrote two critics otherwise far apart in their preferences.[85] The intensity of discussion by other writers sustains that judgement. The author of the *Mémoires secrets* saw it as overwhelming even the possibility of criticism. He begins his Salon review with a lengthy discussion of David as the first of the triumphant new generation, but suddenly breaks off and apologizes: "but I ramble, Monsieur: the justice I render to this young artist must not render me unjust to the others and blind me to their merit."[86] David had succeeded, in his somewhat heavy and over-direct way, in making a genuinely public statement out of the Belisarius theme. Looking at the versions by Vincent and Peyron, one cannot easily imagine them on a larger scale than they are; Vincent's liquid touch and Peyron's rather fussy handling are suited to cabinet dimensions. In technical terms, the most impressive aspect of David's canvas is his consistent economy of touch, his ability, for example, to sustain broad, unbroken surfaces of foreground drapery as unified form in terms of both drawing and material facture. There is the requisite precision, but with a direct, almost rough quality as if adjustment and indecision had been dispensed with (though we know he could agonize about the smallest pictorial decisions). As a painter, he seems to think on a public scale, so that a picture with only four figures has all the monumentality of a crowded machine.

For all the tactical audacity which the *Belisarius* embodied both in aesthetic and career terms, it is astonishing to read the writer of the *Mémoires secrets* praise the returning David for "his modesty [!]," the story being that he had brought his pictures before the Academy only to solicit the judgements and advice of the members, and, much to his surprise, had received his *agrégation* on the spot.[87] This is an interesting reappearance of the old surprise-invader motif. And David was no less shrewd in his preparations than Watteau, Chardin, and Greuze had been before him. The theme had a proven appeal to men in high places. Clermont d'Amboise, French ambassador to Naples during the artist's first stay in Italy, purchased David's fine *Belisarius* drawing mentioned above; the same man commissioned a replica of the *Miltiades* from Peyron.[88] As for d'Angiviller, David had made no mistake; the *Directeur-général* requested a full-scale replica. And the original picture went to another military man whose memory went back to Fontenoy and the brief glory days of the eighteenth-century French monarchy: the nephew of the Maréchal de Saxe, the duc Albert de Saxe-Teschen, who was also the possessor of a preparatory study for Peyron's version (Plate 102).[89]

The immediate audience for these images was composed of public servants devoted to an ideal of state service. But the attitude their preferred iconography projects toward the kind of urban public evident in the Salon is decidedly ambivalent if not hostile. Sometimes a public is literally present: irrational, easily manipulated insurrectionaries as in the depictions of Molé and Coligny. Elsewhere it is an implied presence, the fickle mass easily turned against the virtuous leader, reducing him to abject powerlessness, as the crowds, egged on by the Parlement, had turned against Turgot during the Grain War. We need to take seriously the brooding, sinister onlookers who surround the central group in Vincent's *Belisarius*: an angry, half-hidden countenance, a hushed, muttered exchange. Peyron shows the abandoned general finding refuge and comfort only among an obedient peasantry. Looking at the two highly finished preparatory drawings for Peyron's picture (Plates 102, 103), we first see Belisarius depicted as a beardless, square-

102. Jean-François-Pierre Peyron, *Belisarius* (study). Ink and wash heightened with white on paper, 30 × 46 cm. Graphische Sammlung Albertina, Vienna

103. Jean-François-Pierre Peyron, *Belisarius* (study). Ink and wash heightened with white on paper, 53.2 × 83 cm. Louvre, Paris

shouldered, and bare-chested figure with an alert, wide-eyed expression and aggressive jaw; by the final version, he is a pathetically sightless, slumped, and fully draped ancient. There is a parallel transformation in the progress from David's Rome drawing to his Salon picture. His Belisarius begins in the state of apocryphal blindness but displays a strong, level profile surrounded by an energetic corona of wild white hair and beard. Here the child begs while the hero lives inside his own grandiloquent blindness. In the painting the head has been angled upward in a supplicating posture and turned enough to the side so that the angular force of the profile is lost. As Diderot wrote of the picture, "Do you not find Belisarius humiliated enough in receiving alms? Must he beg for them too?"[90] An apt question: the cumulative effect of both Peyron's and David's artistic decisions is to stress the isolation and victimization of the hero, to render the urban political sphere as alien, irrational, and hostile to virtue.

Ultimately, David's image serves this vision, which is public-spirited but anti-popular in effect. The populace, after all, was on the side of the hated, mendacious Parlements; it sided against the rational and proper exercise of royal authority; it had welcomed the perfidious Necker after Turgot's fall. This complex of imagery attempts to convert the self-image and nostalgia of one, relatively isolated group of state functionaries into the basis for a renewed public art. That aim ranged d'Angiviller squarely against the utopian populism of the best unofficial critics. He was a King's man, committed to firm direction from above. And precisely because of this, his zeal on behalf of history painting was viewed by those politically to his left as inherently counter-productive. In 1779, for example, the writer of *Mémoires secrets* pointedly refused to join the automatic chorus of praise for his intentions. Why make the effort, he asks, if the efforts are bound to be mediocre? "Several causes," he asserts,

> converge to render unfruitful all the attempts to make genius blossom and develop; dictated subjects, recommended forms, limited time, are so many shackles in which it is bound, which impede it, which lock up and smother it. What is more, each artist wants to have a share in the favors of the court . . . and then strategems, intrigue, cabals, and perhaps treachery and slander come into play; the rivals aspire less to surpass one another on merit than to take over the place of another; they become courtiers instead of superior men.[91]

There is a good deal more invective on this order through the 1780s, much of it caught by the imperious Pierre. One can sense at once how the self-described benevolent despotism of royal officials formed by Physiocracy and the goals of Turgot could become a target of those for whom any notion of despotism was a touchstone of political evil, particularly as openly applied to an artistic academy.

It was precisely the alleged tendency of the academies to foster a despotism of the intellect that the unofficial critics had raised as an explanation for both the mediocrity of French painting and the indifference of the public to art's noblest aspirations. D'Angiviller was going to get no easy time from that quarter. And one has to doubt the ultimate success of a public iconography that carries a subtext of suspicion and even contempt for its actual audience. Did David, in seeking to break the confines of his managed career, sense this in 1781? There is a suggestion that he did in the response of the most radical critic of that Salon, the author of *Sur la peinture*. It comes not in that polemical text, but at the end of his rather lightly satirical *Picnic suitable for those who frequent the Salon, by a blindman* of 1781. In the last few pages he drops the fictional

characters that populate the preceding dialogue and assumes his own voice. He uses his conclusion first to envision a time when the envy and malice "that obstruct true talent" would be overcome, and "the success of the arts would recall us to the social and civic practices which few among us seem to remember. This conduct by artists would make them demi-gods, wise enough to edify, powerful enough to instruct."[92] And his immediately preceding words, and final ones as a critic, are addressed to David: "Keep on, Monsieur David, you are destined for greater things. I want to see you next to Jupiter: then your elevation will inflame my zeal and speaking a second time the language of truth, I would have the pleasure of confronting the hissings of envy by drowning them in the sounds of your success."[93] There was something then in the *Belisarius* that appealed as strongly to the radical opponents of d'Angiviller's autocratic, liberal nationalism as the various recent treatments of the theme had appealed to those in power. Was this an accident? Or did David perceive that to carry his art to the broad Salon audience, he would have to build into his art some legible protest against the dictates of authority? Was the combination of surprising awkwardness and cool control in that picture the result merely of impetuous talent or itself a message to a popular constituency represented by this writer? To answer these questions, and bring the present inquiry to a close, we will of course have to look closely at the responses to and the character of David's great pictorial statements of the 1780s: the *Oath of the Horatii* and the *Brutus*.

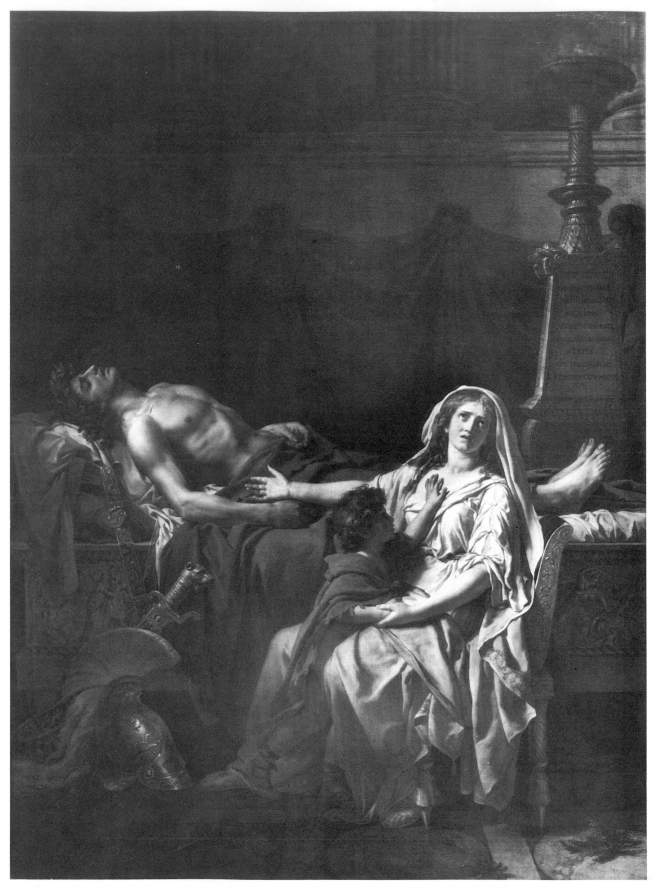

104. Jacques-Louis David, *Andromache mourning Hector*. 1783. Oil on canvas, 275 × 203 cm. Louvre, Paris

VII

David and the Salon

–i–

To judge from David's planning for the Salon of 1783, the "modesty" discerned by the author of *Mémoires secrets* seems closer to the mark than does any desire to reach over the heads of his superiors to some radicalized public. The closest he came to incurring official displeasure was in postponing work on the royal commission he had been given in order to prepare his reception piece. This was the *Andromache mourning Hector* (Plate 104), which was accepted by the Academy in August of 1783 and shown in the Salon almost immediately afterward. In practically the shortest time possible, he had fulfilled his ambition as a precocious student in Rome to be "of the Academy." And he took no chances in doing so. In choosing a Homeric subject, he was moving into the territory most favored by Vien, who was again a powerful presence in Paris. The latter's major salon entries during the eighties were invariably drawn from the *Iliad*. This particular exhibition in fact contained two other pictures on the theme of Hector, one by Vien and the other by the young David's most formidable senior rival, Ménageot. This was also a period of more than usual interest in Poussin; two monographs on the seventeenth-century master appeared in 1783.[1] David's picture managed to combine artful references to no less than three of Poussin's most canonical images: the *Death of Germanicus*, the *Testament of Eudamidas*, and the *Extreme Unction* from the Orléans Seven Sacraments in the Palais Royal. In order to project a complete and consistent Poussinism, he seems to have been willing to risk censure from the critics. The most repeated complaint about the *Belisarius* had been its unrelievedly somber tonality. The *Andromache*, in keeping with the notion of a stylistic mode appropriate to the theme of grief, is darker still, with little play of light to relieve the gloom or painterly flourish to make the surface breathe. With its unsurprising subject and conservative technical strategy, it was not a picture calculated to please the likes of Carmontelle—and he said so at caustic length.[2] On the other hand, the press which hewed to the official line was generally pleased.

In these few years, he had managed to acquire other tokens of established academic success. There may have been as many as forty students working in his atelier,[3] and one of them, Jean-Germain Drouais, won the *grand prix* in 1784; yet another clear mark of official favor for his master. The bond between David and Drouais was already extra-ordinarily close, and this was just one more reason to return to Rome in order to complete his delayed royal command, work in which his student would be intimately involved. To withdraw from Paris for a year, to undertake a long and potentially hazardous journey for the sake of one picture (the rumor spread through Paris that David's party had been murdered en route), was a sign that yet again he was preparing his forces for a bold

105 Jacques-Louis David, *Horatius the Elder defending his Son*. Black chalk, ink, and wash on paper, 21.6 × 28.9 cm. Louvre, Paris

106 (below). Jacques-Louis David, *The Oath of the Horatii*. 1785. Oil on canvas, 330 × 445 cm. Louvre, Paris

107 (facing page). Pietro Antonio Martini, *The Salon of 1785*. 1785. Engraving

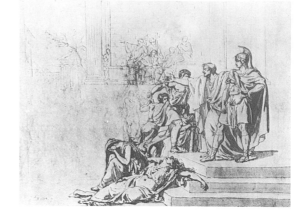

public stroke. This time his choice of narrative was a departure from the carefully conformist themes on which he had relied in the previous two Salons. Over the objections of some close associates, he was determined to treat the same narrative material on which Corneille had based his *Horaces*, the tale of the three sons of Horatius, heroic champions of the ancient Roman kingdom.[4] The story of the Horatii derives ultimately from the Roman histories of Livy, Plutarch, and Dionysius of Halicarnassus. These triplets were selected to represent the city against the Curiatii, the three corresponding champions of neighboring Alba. The horrific (and sentimental) twist to the story is that the two families were related by marriage: one of the Horatii was married to a sister of the Curiatii, while their only sister, Camilla, was betrothed to one of their opponents. The two sets of brothers nevertheless fought to the death, and only one of the Roman warriors survived: thus Rome triumphed. The story has a violent coda as well: the returning victor, finding his sister mourning her betrothed, killed her in patriotic rage. Their father, however,

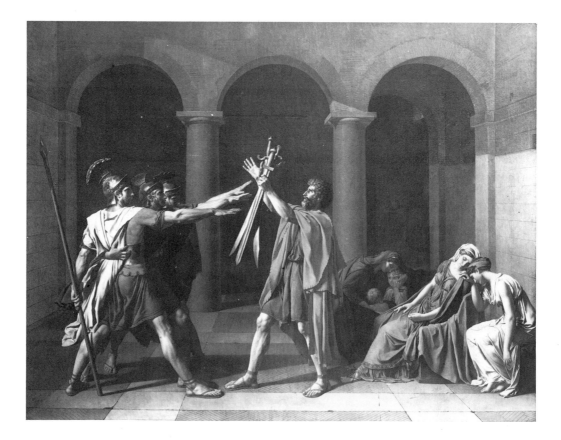

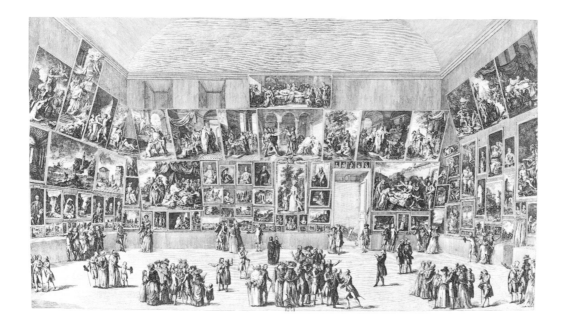

putting zeal for country above all else, defended him before the assembled people of Rome and succeeded in winning his exoneration.

It was this last episode that David initially selected (Plate 105). That choice drew objections from one expert on dramaturgy, the playwright Sedaine, who was the artist's former guardian. His criticism was that the meaning of the scene depended too much on words rather than on action.[5] That conception was quickly abandoned for one that appears in none of the texts: Horatius presenting weapons to his sons and receiving in return their pledge to defeat the enemies of Rome or die in the attempt (Plate 106, Color Plate 2). The public world of battlefield or civic square is no longer visible; the fatal pledge takes place in a private interior and within the bonds of the family. The final picture is fashioned out of nothing more than these minimal elements; the essential action of the story is present only by implication.

There will be much to say, before we are finished, about the extraordinary pictorial concision and rigor which this narrative invention allowed. But the first observation we can make is that it produces a scene quite different from those d'Angiviller tended to encourage. It is not that the *Directeur-général* did or could object to the theme. It speaks after all not of republican virtue, but of a very military loyalty to a monarchy. The murder of the mourning Camilla was the subject given to the students of the Academy for the *grand prix* competition of 1785. But the context in which civic virtue is displayed has changed. David's first impulse was much more in the mold of Vincent's *Molé* or Suvée's *Coligny*: extreme patriotic dedication contrasted to an antagonistic massed citizenry; the beleaguered patriarch facing down the crowd through sheer force of character. But the final picture takes its distance from that particular, sentimental form of patriotic imagery. The body politic appears in the form of the sons, its chosen representatives; they stand on an equal footing with the father as his multiplied mirror image and receive from him, in a charged and ecstatic exchange, the instruments of power. Virtue is no longer in the exclusive keeping of the old, but passed on to the young in a moment of triumphant celebration.

In more explicit ways, David signaled his unwillingness to conform to the preferences of those above him. The original commission called for a picture in a square format,

about ten feet a side, which would have put the *Horatii*, in physical dimensions at least, in the second rank of pictures in the Salon (Plate 107). Without consulting anyone, he expanded the picture along its horizontal axis and thus unilaterally moved it into the highest category of royal command. "I left off making a picture for the King and made one for myself," he wrote to one of his protectors, the marquis de Bièvre, in 1785.[6] Not only was the picture too large, he failed to deliver it in time for the opening of the exhibition, an act of calculated delay which served to heighten public anticipation already stirred by reports of its rapturous reception in Rome. But did these acts of disobedience, petty when taken by themselves, accompany some deeper message of antagonism toward authority? A first reading of the evidence would indicate that they did not. In Rome certainly, the entire international artistic community seems to have been united in admiration for the picture; even the Pope demanded a viewing. And, on the surface at least, critical opinion in Paris was also united in its favor. When the picture finally took its place in the Louvre, high praise issued from both ends of the political spectrum. Carmontelle was ecstatic: "Finally I have seen this 'Oath of the Horatii,' so longed-for, so praised, so admirable. I owe my readers a confession of the keen pleasure it awakened in me."[7] The official *Mercure* declared itself equally enthralled: "The composition is the work of a new genius; it announces a brilliant and courageous imagination... we regard it as the most distinguished production to come from a French brush in many a year."[8]

But the praise David received from the latter quarter, even the enthusiastic praise, was in fact seriously qualified. The conservative critics were disturbed by the *Horatii*. They tender their favorable verdicts, but under protest: something is going on in the picture—and in front of it—which they don't like, but which they are hard put to find expression for. The *Mercure* ends its commentary on the *Horatii* with the following postscript, one which makes us read its praise as forced, dictated by a lack of language in which to express its unease:

> No doubt this painting, which is so generally and justly admired, is now inspiring a great number of our young painters to take M. David as a model. It is relevant therefore to point out that the severity of style and extreme expression on view there are very particular virtues, appropriate to the subject, the abuse of which would be extremely dangerous. A skilled artist permits himself a boldness which others must deny themselves, because genius knows its powers and its intentions, proceeding with a firm tread toward its goal, and to it alone belongs the duty to blaze and follow new trails.[9]

We can wonder how admirable this writer actually found the picture, for he has little desire to see any more like it; its virtues, far from representing a new standard for history painting, are mere "beautés locales". He entertains the hope that, whatever it is that the *Horatii* represents, it will be read as peripheral to the main stream of practice.

Another conservative critic was more openly alarmed by the kind of public enthusiasm that surrounded the picture:

> I have noticed something which seems to me so senseless that I could not help recounting it. These are the students of that master who form a party and take over the whole Salon, seeking out one another, hectoring and crying in the ears of the public: "This is sublime! This is a rock on which the others are dashed to pieces." I have even heard it said that Raphael and Rubens, who are the fathers of painting,

never produced a work so perfect. I am outraged to see young men destined for so
fine an art who are such poor connoisseurs and so deprived of common sense. The
others say that its color and composition are superior to Poussin. It is finally a scandal
that this worthy picture is praised to the skies by intoxicated dunces who give the
greatest offense to this famous artist. The fact is that great works have no need of
such partisans, that in painting we admire Michelangelo, Raphael, the Carracci,
Domenichino, Titian, and Rubens; in poetry Corneille, Racine, Molière, and others,
without the need for anyone to say: the works of these great geniuses are superb;
you are a fool if you do not adore them. They speak for themselves, and that
constitutes their true merit.[10]

Like the writer in the *Mercure*, he claims a concern for young painters, that they not
fall victim to heedless enthusiasm. But the anger is out of proportion, it outruns its
immediate object; he is faced with something larger than a claque of students, something
which he doesn't understand. He sees in the response to David an extravagance, an
impropriety, that offends the rules of normal discourse. It is public discussion of art
itself, we sense, that he dislikes: "great works speak for themselves"; let the Salon
audience hold its collective tongue. David's offense is precisely the enthusiasm of his
public reception. This sort of complaint becomes a standard reaction to David and his
public: in 1787, a critic discussing the *Death of Socrates* makes a similarly weak plea
for moderation and respect for the past:

Oh empire of fashion! when will you cease to turn heads in France?... this picture
is not such an extraordinary thing that we must all cry miracle. Let us show modesty
in the arts, and let us not boast of a talent which is well below the painters of the
century of Louis XIV, our true and only titles to glory in painting.[11]

The most recent interpretations of David's art present the *Horatii* as the outstanding
embodiment of the teaching of the Academy and the philosophy of the official patronage
program.[12] These accounts do not prepare us for a consistent pattern of inarticulate
hostility toward David on the part of those critics who identify themselves with the inter-
ests of the Academy and the state. His popular success appears to them as something
mysterious and vaguely dangerous. What then does this hostility mean? What is the
source of their unease, their perception of threat?

Those critics whose stance is basically hostile to official institutions can help us answer
these questions. Their praise of the *Horatii*, unlike that of their conservative counterparts,
was whole-hearted and immoderate. For them, as for the intemperate students described
in the passage above, David's art stands beyond comparison with the efforts of his con-
temporaries. Such was the reaction of Gorsas, the future Girondin and Revolutionary
leader, who was, as we have seen, eking out a living in these years as a popular journalist
and sometime art critic. His commentary on the *Horatii* (which takes the form of a conver-
sation between a well-meaning but uninformed narrator and the great critic Aristarchus)
is the longest and most detailed produced by any critic. He dismisses all objections to
the picture as absurd, undeserving of consideration or reply. To demonstrate this, he
lists every one of the "mistakes" pointed out by other critics, reciting them almost with
pleasure, as if their sheer quantity were proof of their irrelevance:

I don't know in which critique I read [says the narrator] that the groupings are too
dispersed. Throw that critique in the fire, he [Aristarchus] responded, and say to the

author, if you have the misfortune to know him, that he should read his history and fill himself with the particular emotions that must animate the different characters in this tableau. If M. David has divided his groups without reflection, then I give thanks to chance . . . If this critique had said, for example, that there is a monotonous tonality in these same groups, that the brother closest to us displays an eagerness which is perhaps too extreme, that his arm is too heavy, the proportion of his legs and thighs too long in relation to his torso, that the elder Horatius and his sons are too uniform in color, that the shadows are too solid, that the third woman, in the highlights of her figure, *pierces* the column behind her, and in the shadows, blends with the obscure background of the interior; that David, instead of placing the three Horatii by order of height and age, should have placed them randomly. In such a case, one could well complain of a rather unbalanced man with a mind narrow enough to calculate meanly these small errors in detail which are absorbed in the eye of the man of genius, who does not and should not see in the admirable picture of the student of M. Vien anything but its truly dramatic emotion, nobility of form, appropriateness of style, purity of intention, and finally enthusiasm so fitting for returning the grand genre to its true purpose in the French school of painting.[13]

What is striking about the criticisms which Gorsas enumerates is the reasonableness of most of them, their accuracy in terms of the rules of contemporary artistic practice; a fervent supporter of David produces the longest and most specific list of the short-comings of the picture. For him, it stands beyond both the language of the critic and the "language" of academic painting. An anonymous critic, writing in 1787 about the *Socrates*, makes the same assertion in so many words:

> It is here that criticism should be disarmed—what am I saying?—I hardly dare take up my pen to praise it. I lack the words to render all that I feel at the sight of this superb picture. Let us leave aside all principles of art; it disappears here and allows nature alone to appear.[14]

This becomes the common refrain of David's critical allies: in the face of his achievement, the hard-won *métier* of the painter and the confident expertise of the connoisseur become irrelevant. Indeed, these dissident critics attend to the *Horatii* in almost exclusively negative terms. When they attempt finally to describe David's positive accomplishment, they fall back, like Gorsas, on received abstractions such as "noblesse de formes", "goût de style", "pureté d'intention", etc. (These terms, of course, had certain precisely coded significance for eighteenth-century readers; but they do not direct us to anything specific in the picture. They could have been and were used to characterize vastly different works of art.) Every text we have which could serve as *description* of the picture stresses David's errors, his departures from accepted practice, his defiance of rules and tradition. This may seem to us a strange way to look at David, one far from our conception of him as the practitioner of a controlled and finished classicism. To most of the critics of his time, it surely seemed a strange way to look at any picture—to be told that attending to the fine points of the painter's craft was to "calculate meanly," to hear the presence of awkwardness and error celebrated.

For Carmontelle, Gorsas, and others, the measure of David's success is the distance which separates him from the rest of the history painters of the Academy. Gorsas suggests that the "sublime" expression of Horatius "would have escaped any other but

108. Jean-Simon Berthélemy, *Manlius Torquatus condemning his Son to Death*. 1785. Oil on canvas, 328 × 266 cm. Musée des Beaux-Arts, Tours

M. David.''[15] This sort of claim, that the *Horatii* was unique, that it defied comparison with the masterpieces of the past and with the work of David's contemporaries, challenged the basic premises of an academy: that art is a matter of skills learned in common, a shared vocabulary of forms, the continued authority of past models. In fact, David's admirers disqualified the work of any artist, no matter how accomplished, who remained within the bounds of accepted artistic practice. We can take as an example of this sort of thinking Carmontelle's reaction to another royal commission on view in the Salon of 1785. *Manlius Torquatus condemning his Son to Death* by Jean-Simon Berthélemy (Plate 108). Like the *Horatii*, it deals with the extreme consequences of Roman patriotism: in this case, a consul compelled by law to order his own son's execution. "One could not better render the overriding love for the law in a severe Roman," said one official

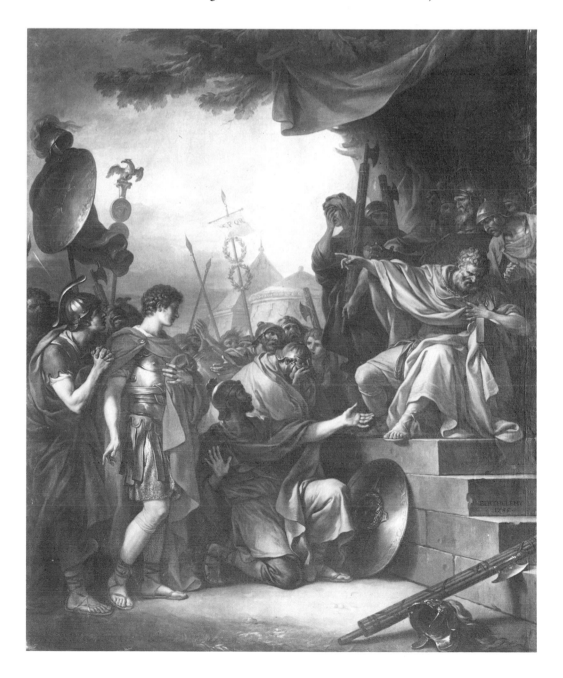

critic,[16] and most others agreed: it was a fine effort by a young artist in his first maturity. To the government, the Academy, and most critics, the *Manlius* was a perfectly satisfactory example of what *la grande peinture* ought to be like. Carmontelle, however, in his discussion of the picture (presented as a conversation with a painter-acquaintance in the Salon) is at his most caustic:

> *Narrator*: I see here men of talent pulling against their short leashes.
> *Painter*: Explain yourself.
> *Narrator*: The picture of Manlius Torquatus holds tightly to the old maxims and antiquated taste.
> *Painter*: The artist knows his trade perfectly.
> *Narrator*: All the better if painting is a trade, then we will value the work by the yard.[17]

The key word here is trade or craft (*métier*). It is Berthélemy's confident display of the traditional technical repertoire of the history painter which, in Carmontelle's eyes, fatally compromises his material: a composition and spatial order drawn, via numerous Baroque intermediaries, from Titian's *Pesaro Madonna*; direct quotations from that picture meant to remind us of Berthélemy's subtlety and inventiveness in his use of that model; layered interrelationships of posture, gesture, and nuance of emotion; chiaroscuro and atmospheric effects which mellow and soften the contrived complexities of the picture; displays of virtuosity in elegant falls of drapery, the sheen on armor rendered in heavy impasto, the still-life which serves as a repoussoir device—all this is reduced to "old maxims and antiquated taste". Carmontelle especially condemns Berthélemy for his treatment of the emotional content of his subject:

> The father who yields to such momentous concerns has neither a furious nor a pathetic appearance; he shows in his features a grandeur of form in which we can read an equivalent grandeur of feeling. One must not depict a momentary passion, but a passion which has never ceased to exist at the core of his being. To contort his eyes, his mouth, and his arms as a bad actor would do in his turns on stage, this is an offense to truth; to hide half his face and give him a melodramatic gesture is to banish nobility and distort the subject.[18]

The artist's whole approach to depicting the fearsome moral and emotional conflicts of the story is, to Carmontelle, hopelessly shallow and conventionalized. The theatrical expressions and gestures traditionally used by the history painter to convey narrative now appear not as a means but as an obstacle to dramatic truth.

The condemnation of Berthélemy expressed here is categorical, and it takes in all the history painters of the Academy save David. Carmontelle follows his remarks on the *Manlius* with a discussion of Vien in which he continues his argument. That artist, he says, in his repeated Homeric offerings had succeeded in turning the *Iliad* into an utterly empty and exhausted display of academic cliché:

> The beautiful Helen, who has been posed so much, isn't it about time that we gave her a rest? Seated, standing, lying down, from behind, from the front, in profile, from two thirds: this Greek household has appeared in every possible aspect. In order to exhaust the combinations of their poses once and for all, only one more is needed—to paint them all with their feet in the air.[19]

This sort of crude and uncompromising attack on painting as it was normally practiced (Vien after all was the premier history painter of the time) was perceived as something senseless and shocking. The conservative critics quite rightly linked it to David: one angrily declares that David's admirers,

> . . . with their absurd ramblings, tarnish the reputations of the Vernets, the Viens, the Doyens, the Vincents, and the Regnaults! No, their campaign has not succeeded. These artists have proved themselves and continue to demonstrate talent so superior that one cannot discount so quickly what thirty or forty years have formed. They should therefore keep their opinions to themselves.[20]

But the very vehemence of this passage is evidence that the efforts of David's partisans were not as its author claims, "inutiles," vain and unavailing, but had drawn blood.

When the conservative critics are actually paying attention to the *Horatii*, when they focus on particular aspects and details, they see it in much the same way as did Gorsas. They too are able to describe the picture only in terms of awkwardness and error. (Because of this, the *Horatii* is probably the only picture in the Salon of 1785 which the critics do describe; only in discussions of David does real seeing enter the critical texts.) For reasons we have touched on, these moments are rare—reviewers are simply not used to criticizing an artist's work directly. But occasionally their normal restraint breaks down, and half-hearted praise is replaced by real feeling. In the following passage, there is a kind of awakening hostility ending in a sputtering condemnation of David's whole enterprise:

> . . . this picture displays a sublime execution, superb drawing and a fine style—in places. The first of the Horatii shows an astonishing severity and strength; the characterization in this case is good. His brothers are not so lucky. This affected uniformity in their poses is disagreeable and looks too much like bas-relief, which in painting is a mistake. I believe that if these warriors were more varied, they would then produce a more pleasing effect without spoiling the simplicity which M. David has a tendency to overdo in all his works. The architecture is handsome, but too obtrusive. . . . The women in the picture are stiff. It is apparent that they have been copied after clay mannequins draped with wet cloth. They lack all grace and suppleness—and this is what they are calling good style! . . . Truthfully I no longer know where I am. What has spirit and movement is called folly, while what is cold and stiff is called genius. This is a depravity of taste which I absolutely fail to comprehend.[21]

Behind this text is a public its author refuses to recognize, one which nevertheless impinges on the comfortable relationship between connoisseur and work of art. He feels himself edged aside by a crowd that calls *this*—strained, awkward, obvious thing that it is—a work of incomparable genius; such unfathomable taste he can only call depraved. He protests the absence of those qualities which marked "le goût suranné"—pleasing variety, grace, suppleness, mellowing atmospheric effects, etc.—but as description, it is perfectly congruent with the account of the picture offered by Gorsas. The *Horatii* seems to have imposed one particular kind of attention on its audience, or at least on the critics in its audience. They can focus only on its negative qualities, on errors, disregard of tradition, refusal to exercise the full range of the painter's craft. And this kind of attention to the picture is accompanied by evocations of some public responsive to

precisely these qualities. The alarm, anxiety, and fear expressed by the conservative critics are accompanied by a perception that David has made an unholy alliance with a public whose desires and interests are alien to their own. They sense that this new and imperfectly known public is being appealed to by the violation of those artistic values they most prize.

– ii –

An ecstatic reaction coming from someone like Gorsas did nothing to lessen their suspicions in this regard. For this writer was at the center of a fairly circumscribed group of intellectuals—Brissot, Marat, Jean-Louis Carra among them—which produced the most influential body of radical propaganda in these critical, pre-Revolutionary years. It was influential in the sense that their pamphlets could help sabotage crucial government initiatives, undermine ministries, put angry crowds into the streets, and dispose a large public to see its discontents as the work of a pitiless and evil aristocratic cabal. By the mid-1780s, a significant segment of the population of Paris began to follow the lead of these writers, to share and act on the vision of French society they offered. It was they, more than any other group, who defined the language and symbols of pre-Revolutionary radicalism.

But was the connection between the political identity of a Gorsas and the positive value he set on David's "errors" a deeply determined one? That is, was the demonstrably large and responsive readership of the pamphlets that he and his colleagues produced the same one being addressed at that point in his art criticism? In our previous discussion of the dissident art criticism of the 1740s and '50s, the language and symbolic references of La Font revealed codings in his text derived from the propaganda used by the *parlementaires* in their running dispute with the Crown. In that instance, a public responsive to his language and symbols existed outside the Salon, but in the absence of any significant painting that could be said to embody and sustain the critic's position, the presence of a parallel public inside the exhibition remained ephemeral at best. There was no positive object around which to mobilize some important segment of the Salon audience into an oppositional public. In 1785, on the other hand, if the responses to the *Horatii* should prove to be coded along similarly political lines, the picture would then represent just such a rallying symbol within the confines of the exhibition space. The question before us then is whether the responses of the critics, both positive and negative, do indeed provide us with clues as to where such a common aesthetic and political coding might be readable.

To start, we could return to a passage written by Carmontelle in 1781 and quoted in the previous chapter.[22] There he declared that it was the task of the painter to see through the dissembling guises of endemic social corruption and the hideous effects on the human body wrought by economic inequality. The ideal artist would thus produce an implicit critique of a society in which true nobility and grace could exist only in imaginary form. "It is doubtless a taxing effort," he had stated, "to invent . . . proud or generous features where one views only slaves and masters; true expressions in a country of dissimulation . . ." But nevertheless it was up to the painter to overcome these obstacles: "We are entering an epoch when this task has become a pressing one," he concluded. The "correct" drawing and composition perpetuated by the Academy was, for Carmontelle and critics like him, a false perfection of technique which counterfeited real grandeur

and truth of expression. The eye, they said, must not be fooled by affected postures, silken textures, or sensually liquid play of the brush; these were the resources of mechanical artisans whose only concern was to please the elite that employed them. The demand was for an art that would, by the strength of its commanding counter-example, unmask both the deceits of the academicians and the reign of false appearances by which a despotic elite escaped public scrutiny and censure.

There was in fact a direct continuity between this line of thought and certain central concerns voiced in the radical propaganda of the immediately pre-Revolutionary period. This becomes clear when we ask what sort of politics the pamphlets of Gorsas, Brissot, and the rest actually added up to; that is, what sort of distinctions, analyses, and choices did they offer their readers as guides to action and belief? Their political tracts read like a particularly fierce variety of anti-Rococo art criticism applied to persons instead of pictures. The insistent emphasis of this literature is on the action of unmasking; the reader is urged over and over to attend to the outward signs by which the virtues or vices of individuals can be recognized. This unmasking, this laying bare of true character, is most often reduced to questions of style—style in manner, in appearance, in written and spoken expression. Villainous *gens en place* hide their true characters behind façades of rococo refinement which invariably serve to disguise greed, depravity, and tyrannical designs. Gorsas writes in one pamphlet, addressing words to a prominent government official: ". . . with this gracious appearance! with this ingenuous countenance! this smooth and prepossessing affability! this always tender manner . . . you in this pestilential sewer! you, you, in the den of serpents."[23] Jean-Louis Carra, a close associate of Gorsas, was another frustrated intellectual who found purpose and notoriety as a radical pamphleteer in this period. In one widely circulated tract written in 1787, he warns his readers that the lies of his opponents are to be recognized by the elegance of the style in which they find expression:

> . . . the liar and the rogue (two synonymous words) are always smooth-tongued, soft-spoken, and flattering in their writing as well as in their speech; . . . a work designed to impose fraud and wickedness on the public . . . must be written with an affected and contrived moderation, and above all in a honeyed style. This moderation is but one more trap. These are the conditions without which lies and trickery will fail to produce the intended illusion in the mind of the reader; and it is from such illusion that the man of good will must protect his fellows, whatever the cost to himself. [24]

As Carra states in the last sentence of this passage, the virtuous man, "l'homme de bien", makes it his task to awaken the public to the connection between urbane, aristocratic style (*bon ton*) and the falsity and evil of those who display it. His voice, in contrast to those of falsehood, corruption, and oppression, is marked by its *im*moderation, its freedom from the restraints of propriety and refinement: ". . . to foil the oily and perfidious progress of swindlers and rogues, one cannot detach their masks with kid gloves. One must forcefully tear them away."[25] By the standards of society his discourse may be awkward, over-direct, embarrassingly impassioned, but these qualities are themselves the sign of the truth of his words; as Brissot put it,

> This general tendency toward gentility is a mark of a preponderance of vice and absence of character in a nation. I hold that a virtuous man must be severe in all things . . . and never affect a dangerous moderation.[26]

The language of truth is opposed to convention, to arbitrary rules, and is to be found, in their words, "in Nature alone." Carra, in one of the most influential pamphlets of the period, writes,

> No doubt the abuse of words is not as dangerous as the abuse of things; unfortunately, however, the latter abuse can derive and often derives from the former. Today above all, when a universal morality seeks to purify its language and to fix once and for all our ideas on the true nature of good and evil, of justice and injustice, it is of the utmost importance not to evade the positive meaning of words, for fear of leaving the mind in a state of uncertainty and sidetracking it from the central issues. The idiom of virtue can know no accommodation with that of vice; the language of truth cannot allow, in the direct construction of its sentences, any vague and uncertain nuance; and that of justice cannot permit, in the severe framing of its verdicts, contradictory and improper expressions of indulgence and pity.[27]

Carra, in this passage, explicitly recognizes that there is a connection between control of the economy of "things" and the control of language and ideology, and that the disaffected public he is addressing had yet to exert the necessary control over either one. We sense here the magnitude of the task faced by the pre-Revolutionary radicals, that of finding language clear and powerful enough to stand against the formidable symbolic structure of the old order. To them, every form of social and individual expression—emotion, sexuality, speech, morality, wealth, politics, art—appeared tainted and compromised by privilege. And they responded by reducing economic, social, and political conflict to bizarre caricature and simple distinctions between good and evil based on unmistakable external signs.

The pamphlet in which this last-quoted passage appeared was one entitled *M. de Calonne tout entier*. It was first published in 1787, and its title refers to Charles-Alexandre Calonne, then finance minister and head of government. Carra's pamphlet is a fierce attack on Calonne and all those around him, and the circumstances in 1787 were such that we can measure its effect. When *Calonne tout entier* appeared, Calonne was desperately pushing for administrative and financial reforms needed to rescue the monarchy from the fiscal chaos produced by its intervention in the American War of Independence. These reforms were designed to rationalize government revenues, remove some of the most glaring inequalities in taxation, and promote economic growth as the ultimate solution to the state's financial difficulties. They were measures which might well have warded off the events of 1789. Powerful groups opposed to reform, however, the Parlement and the ad hoc Assembly of Notables of 1787, were able to defeat Calonne's program. They succeeded in doing so in part because of mass demonstrations of public support, demonstrations which were often violent and prolonged.

Carra had much to do with bringing those demonstrations about. One contemporary witness tells us that, thanks to his pamphlet,

> . . . in him [Calonne] we see only a pillager who has yielded to every desire of the princes, to all the demands of the courtiers, in order to curry favor with them, and who is leading the nation into this state of crisis which will cease only when the people and all the orders of citizens are loaded with new taxes.[28]

This is indeed what Carra told them: Calonne's reforms were a cover for the depredations of an alien elite of ministers and courtiers, who, in order to finance their extravagance

and depraved excesses, had hoodwinked the King, milked the treasury, and dissipated millions in endless debauchery. Calonne himself he described in the best, scandal-mongering tradition of the popular press as a "monster," a "serpent," a "pestilential swamp," a "Pericles of libertinism," engaged in a "perpetual orgy [with] libertines, mountebanks, prostituted women, [and the] corrupt and irresponsible men with whom the government is so often infected."[29]

The Parlement and the Notables seized on these charges, and borrowed the language of their denunciations of the government directly from Carra. Gorsas, Brissot, and others followed him into the fray. A pamphlet war was being mounted against the government. Some were so popular they were rented out page by page in the cafés of the Palais Royal. In August of 1787, when the Parlement had been exiled for its refusal to sanction Calonne's program, there were two weeks of continuous rioting outside the Palais de Justice; copies of new disputed tax decrees were publicly burned; the crowd ransacked the home of a wine merchant, forced the police to release two of their leaders, and wrecked the house of a police official who refused to release a third. 1,900 guards had to be stationed on the Ile de la Cité to suppress political agitation and the sale of pamphlets.[30] (All this was going on, let us note in passing, within sight and earshot of the Louvre where the Salon of 1787 was in progress.) By 19 September, the government was forced to allow the return of the Parlement; the new tax edicts were withdrawn; the ministries of Calonne and Loménie de Brienne fell in rapid succession. Morellet writes in this period, "One cannot hide the fact that the power of public opinion has brought the government to heel."[31] By early 1788, the government's only recourse was the fateful decision to convene the Estates General so that the "nation" as a whole could be consulted on matters of reform.

—iii—

The conflict between style and anti-style as an organizing principle in radical discourse had been worked out in advance of its application to day-to-day political events. Its source lay in the anti-academic polemics of the 1770s and early 1780s that we considered in the previous chapter. Art critics had made their own contribution to that campaign against entrenched privilege in the sphere of culture, and the visual stress of their attacks on academic sterility was forcefully carried over into the political language of pre-Revolutionary radicalism. It took no great effort then to shift that language back to the Salon with all of its newly acquired overtones intact. The distinction between style and anti-style figured, it should be apparent by now, in the critical responses to the *Horatii* we considered at the beginning of this chapter. Before turning to David directly, however, it will be useful to discuss briefly the contemporary reputation of another artist whose work has been linked to the coming Revolution—the playwright Beaumarchais. His *Marriage of Figaro* has come down to us as a statement of advanced political views, and its overt political content has been cited to point up the lack of such content in the *Horatii*.[32] We find, however, that Beaumarchais was far from being a symbol of political dissent in the 1780s, that he instead stood in the public mind for the forces of reaction and despotism. In this we can see operating the political "aesthetic" described above.

Beaumarchais' role in pre-Revolutionary politics was partly inadvertent. Its discourse, as we have seen, revolved around purported revelations of scandal in high places. Following Calonne's resignation and flight to England, the most important of these were

generated by a protracted adultery and divorce case known as the Kornmann affair, a case in which Beaumarchais became personally entangled. The plaintiff was Guillaume Kornmann, an Alsatian banker and stock-speculator, whose much younger wife had left him for a young aristocrat named Daudet de Jossan.[33] Kornmann was a friend and patron of some of the most important radical pamphleteers—Brissot, Gorsas, and Carra belonged to a schismatic Mesmerist group which had met at his house for several years—and his suit was soon transformed into a public issue.[34] His wife and her lover had received aid and protection from a number of courtiers and associates of Calonne, including Beaumarchais, and his friends produced in his cause pamphlets which continued the themes of *Calonne tout entier*. The most effective of these were written by another member of the group, a young lawyer named Nicolas Bergasse.

Bergasse came from a wealthy commercial family, but was ambitious for public influence (he too would become a prominent revolutionary). He published three *mémoires* concerning the Kornmann affair and several supplementary pamphlets. Even more than Carra, he exploited public interest in the scandals of high society. That interest had been excited and intensified by the recently concluded Diamond Necklace affair, which, in the eyes of the public, had permanently discredited Marie-Antoinette. Besides Calonne, Bergasse accused Beaumarchais, the prince de Nassau, the Lieutenant-General of police Lenoir among others of conspiring to corrupt Mme. Kornmann and throw her into the arms of her seducer. His first *mémoire*[35] on the subject purported to describe aristocratic techniques of seduction, complete with love nests, secret doors, spies, and attempted assassinations; he reproduced letters allegedly written by principals in the affair with blank spaces marked "phrase obscène"; Kornmann was described as abandoned, suffering piteously, and all the while harassed and persecuted by Calonne's creatures. Gorsas too entered the field on Kornmann's behalf, concentrating his attacks on Lenoir, who, he claimed, exploited gambling and prostitution rackets and corrupted virtuous young women.[36] They used the intrinsic appeal of this kind of subject matter to carry a political message. By the time of his third *mémoire*, Bergasse had made his political aims explicit; the trials of Kornmann illustrated the urgent need for radical social change:

> Finally in reflecting on the way in which arbitrary power has been exercised in the majority of the circumstances which I have laid before you—always to favor evil ways, always to oppress unfortunate probity, even to stigmatize, if it were possible, the blessed energy with which an innocence beleaguered by the cruelest persecutions has proclaimed or defended itself—you will have one more proof, and the most striking proof, of the profound immorality of your political laws, laws which constitute your system of administration. You will feel more than ever how such laws, designed to validate all the caprices of those in power, are incompatible with the just order of society, with public and private virtues, with the rational development of man's faculties and all the advantages, both physical and moral, that this development, when wisely encouraged, can produce.[37]

He ended this *mémoire* with a call for convocation of the Estates General, and, fearing the Bastille, fled to Switzerland.

This was indeed explosive stuff. Bergasse became a popular hero. Crowds came seeking him at Kornmann's house, and Kornmann emerged to read them a letter Bergasse had left behind; his portrait was sold in the streets, celebrating, according to the journal of the bookseller Hardy, "his courage in repelling the blows of an arbitrary authority."[38]

The fall of the ministry which followed Calonne's, that of Brienne and Lamoignon, Hardy attributes to the effect of Bergasse's pamphlet war.

In the absence of the fugitive Calonne, Beaumarchais emerged as the most visible public opponent of the radicals. He had drawn their fire already in 1785 because of financial dealings he had with Calonne. In 1787, he used his influences at Court to have Mme. Kornmann released from prison (where her husband had placed her under a *lettre de cachet*). Already in retreat from the earlier attacks of the Kornmann group, he now faced public accusations of leading the woman into debauchery and using his corrupt friends to hound the aggrieved husband. He was singled out as a public symbol of corruption and tyranny.

There is an obvious element of historical irony in this. In the early 1770s, Beaumarchais' polemics against the judge Goezman and Maupeou's "coup" against the Parlements had made him a symbol of resistance to government "despotism." His pamphlets had demonstrated both advanced political liberalism and the ability to attract a large popular following. Their style, however, was that which would make his career as a playwright: he attacked Goezman and the new *parlements Maupeou* with self-conscious wit, irony, play with meaning, sexual puns, all combined with apt insertions of pro-*parlementaire* rhetoric. He himself gave this self-congratulatory account of the style and success of these tracts:

> Society folk were astonished at the variety of tone produced by the author of *Mémoires*, whose gaiety is nevertheless but a fine shade of scorn for all his cowardly adversaries. He rightly recognized moreover that this was the only way to get himself read in Paris: changing his style on every page, amusing the indifferent, striking sensitive people in their hearts, reasoning with the strong; it got to the point that many began to believe that several different pens were working on the subject at the same time.[39]

The style of his public statements during the Kornmann affair was much the same. In one *mémoire*, he addressed Bergasse and Kornmann in this way:

> Oh shameless politicos! with these tracts the love and respect of the people, those great supports of a monarchical state, are being disturbed! Herdsmen of a vast flock! in letting slip ill-tempered beasts you teach the ox to try out his horns! It was so docile to the yoke! The domination of Louis XVI is so gentle on the best of peoples.[40]

The ironic tone, the stylized diction, the involved play on the cuckolded Kornmann's unfortunate name are typical of the kind of writing that had served Beaumarchais before. By the 1780s, however, the language of political dissent had changed. Public opinion now appears to him as a dangerous beast of burden, dangerously less "docile au joug". It was not his politics (no one was then disputing the virtue of Louis XVI) but his style which made him such a vulnerable target for the radicals: "the style of Beaumarchais," writes Bergasse, consists of "unfit expressions . . . tangled sentences . . . trivial turns of phrase, an incoherence of ideas . . . an absence of logic . . . all that one encounters in the numerous works which spring from his pen."[41] Gorsas ridicules Beaumarchais's "usual weapons . . . his puns, his trivial witticisms, his tasteless plays on words, his cynical pamphlets, his ambiguous sarcasms, his burlesques, his filthy double-meanings."[42] Play with meaning, the nuanced terrain of humor and sexuality, "les tons variés", no longer appealed to a public which had arrived at a precarious political consciousness attending

to the dour single note sounded by Kornmann's defenders. The politically-aware element of the Parisian populace now indeed believed that "the language of virtue cannot allow, in the direct construction of its sentences, any vague and uncertain nuance . . ." La Harpe wrote of Beaumarchais's fall from public favor, ". . . the public has taken against him as fervently as it had declared itself in his favor during the Goezman suit."[43] Beaumarchais, then supervising rehearsals of his opera *Tarare*, was harassed and reviled as he walked through the streets.

Even in 1784, his liberal politics were obscured and neutralized by the style and stylishness with which they were presented. He certainly wanted the *Marriage of Figaro* taken as a statement of fashionable liberalism; he wanted to recapitulate the popular success he enjoyed during the Goezman affair: Figaro's famous speech in act V laments inequalities of birth, the pretensions of the aristocracy, censorship of the press, and the difficulties of low-born artists; there is even an evil judge called "Gusman" among the cast of characters. But he failed to bring it off. The play was a success, but contemporary commentary emphasizes the sexual "immorality" displayed by the characters almost to the exclusion of its political content.[44] The radicals went so far as to read it as a parody of the liberal ideals expressed in the text, all on account of its light, playful character. Brissot, writing with Etienne Clavière, the primary financial backer of the Kornmann group, called the play:

> a scandalous farce where behind an appearance of defending morality, morality itself
> is held up to ridicule; where behind an appearance of defending the great truths, they
> are debased by the despicable interlocutor who voices them; where the aim seems
> to have been one of parodying the great writers of the century, by putting their
> language in the mouth of a rake's valet, and of encouraging oppression while leading
> the people to laugh at their own degradation . . . and lending to the entire nation,
> by a heinous imposture, this character of insouciance and triviality found only in the
> capital.[45]

The political Right as well as the Left seemed unmoved by the Enlightenment rhetoric contained in the play: it was due to pressure from the King's notoriously reactionary brother, the comte d'Artois, that the Comédie produced it in the first place. Dissenting politics were by this time being spoken in a language Beaumarchais did not know. David, however, if we are to believe his partisans, did know that language and how to use it.

−iv−

If we needed any help applying this political distinction of style versus anti-style to the reception given the *Oath of the Horatii*, Gorsas' commentary on the picture explicitly distinguishes the public receptive to David's message from the decadent, aristocratic devotees of Beaumarchais's play (the full title of which is *Le mariage de Figaro, ou la folle journée*); while the former will be moved by total empathy with the depicted heroism, the latter will see but not understand:

> . . . I was seeing two or three hundred perfumed, overdressed, and affected people,
> who in the morning were contemplating David's *Horatii* with admiration, and who
> would go in the evening to *La Folle journée* to cry "bravo" at some nonsense, and
> who would not go the following day to see the last of the three brothers return

victorious to his household gods and restore peace and the palm to his aged and honorable father.[46]

By his account, what the *Horatii* accomplishes is a division of the Salon audience; it distinguishes between those who understand the special significance of its language and those who do not. The former will draw a line between David and Beaumarchais; the latter, the "perfumed, overdressed, and affected" as he describes them, are not necessarily repelled by David, but they do not comprehend the crucially significant *difference* between the two kinds of language. The *Horatii* addresses itself to a new group of initiates, and carries a message for them alone. Gorsas has his fictional narrator fall into an ecstatic delirium in front of the picture:

> I was beginning in effect to lose my head; after having pledged along with them to conquer or die, I had already seized a sword . . . [the speaker returns to his senses and regretfully takes in his actual surroundings] I remember that I was not born on the proud banks of the Tiber, but at the edge of the modest Verdou; that I was living in the good city of Paris and not in Rome the great; that I was not on the Capitoline hill in the midst of those august Romans whom we admire so much and imitate so little, but in an exhibition of pictures. . . .

Here follow his remarks on Beaumarchais' public, the unseeing *mondains* whom the picture fails to transport bodily from picture gallery to "Rome la grande". Gorsas then offers the lengthy and triumphant catalogue of David's "errors" from which I quoted in the first section of this chapter.

We are now in a position to understand the significance of that catalogue, why a desperate and committed radical would produce it. David's artistic language is Carra's "langage de la vérité": strained, stiff, awkward, obvious. His art stands in lonely opposition to the servile *métier* of the academic artist, its *political* significance declared in its emphatic plainness of expression, its renunciation of sensual appeal and emotional nuance, its refusal to display the full range of the painter's craft, and its perceived avoidance of sterile academic cliché, contrived complexity of form, and dissembling correctness of manner. Gorsas put this reading of David to use in an explicitly political pamphlet of 1787 entitled *Le Mannequin*. An attack like the others on Calonne, Lenoir, Beaumarchais and company, it is the pretended work of a painter commissioned to produce a series of pictures illustrating the progress of the Kornmann affair. This painter invokes "my master David" and makes a mock apology for the style of both his painting and his writing:

> I ask your indulgence if my style is not as ornate as you deserve. I am not an Academician and I practice no rhetoric whatever. So expect from me neither beautiful phrases that signify nothing, nor elaborate exaggerations that say nothing but a lot of words.[47]

Thus Gorsas is able to use David's name to announce the popular and political thrust of the tract, as the sign of its truth. By the mid-1780s, any piece of art or literature that was intended to mobilize a large popular following *had* to declare itself in this way, had to declare that it belonged, like David's art, to the special language of truth and virtue. Beaumarchais, yesterday's hero but no longer part of the subculture of opposition, failed to grasp this when it was in his every interest to do so. Those Salon critics who were sympathetic to the Academy proved to be no more capable. The extent and character

of David's popularity exceed their comprehension and therefore appear a mysterious and vaguely dangerous thing. We recall the eloquent bewilderment of one: "Truthfully I no longer know where I am! What has spirit and movement is called folly, while what is cold and stiff is called genius. This is a depravity of taste which I absolutely fail to comprehend."[48]

Gorsas, in his reaction to the *Horatii*, also strikingly expresses the resonance that early Roman subject matter possessed for liberals and radicals soon to become revolutionaries. This phenomenon is well-known and well-documented,[49] and as we try to sum up the political significance of the *Horatii*, we need to take full account of it. A large public had been conditioned by the propaganda of the Parlements to see in the history of early Rome metaphors for contemporary political conflicts. The radical pamphleteers, with their unrewarded classical educations, put Livy and Plutarch at the disposal of a large public audience. The use of Roman imagery was a way of defining and imagining "nobility" as heroic self-sacrifice and service to the nation, that is, as a quality distinct from the existing structure of privilege.[50] But it should be clear by now that it would be a mistake to see the possible political significance of the *Horatii* as ending or even primarily residing in its subject matter. This is where most previous accounts have gone wrong. While the *Horatii* could not have carried the politicized message it did had it not taken antique virtue as its subject, and had it not been history painting of the highest, "noblest" ambition, we have seen how little it availed Berthélemy to take on a subject from Roman history fully as severe as David's. The politically dissenting critics were indifferent and the rest undisturbed; nowhere is there evidence of an unruly crowd collecting around his *Manlius Torquatus*. Unless the "murderous valor, the patriotic and cruel mores of the first Romans"[51] were convincingly reiterated on the level of form, it all remained harmless costume-drama. And the Salon audience, by 1785, possessed criteria by which the "idiom of virtue" could be recognized.

Neither should we conclude that we are dealing here with the simple application to art of politically-charged distinctions of style developed elsewhere, a reading of David imposed from outside. Pre-Revolutionary radicalism never in fact left the realm of culture, and if we are to understand David's special impact, we need to keep this in mind. The ideology on which it operated was formed out of the confrontation between the official organs of culture—chiefly the academies—and the new literate public of whose existence those institutions took little or no account. And nowhere was the disparity between the reigning culture of the Old Regime and the needs and expectations of a largely bourgeois audience more apparent than in the public exhibition. By 1787, the Salon, far from being a refuge from social conflict and disorder, seems to have been given over to politics:

> You would never have imagined, Monsieur, [writes the critic in the *Mémoires secrets*] that the ferment which has reigned for some time in France and above all in the capital, ferment that the government is at pains to suppress or at least to quiet by every means at its disposal, could have at all affected the Salon. I will begin by giving you an account in this regard of two anecdotes which will convince you of the contrary: these will interest you more than the cold discussion of a picture. . . .[52]

One of these anecdotes concerned the portrait of Marie-Antoinette by Vigée-Lebrun, which was at first withheld from the exhibition because officials feared the likely negative response of the audience, and then, out of embarrassment, belatedly put on display; the *Mémoires secrets* go on to comment:

. . . I recognized in these trivialities the true character of despotism, which on one hand takes the harshest official measures against its magistrates, the defenders of the nation, defying the nation itself and grinding the most sacred rights under its heel; and on the other, displays a miserable weakness, a puerile faint-heartedness.[53]

As the writer notes, the Salon was taking place during the exile of the Parlement and at the height of the agitation surrounding the Assembly of the Notables. The intrusion of politics into the Salon, moreover, went beyond words and opinions, and became openly disruptive. A crowd sympathetic to the Parlement planned to break up the concert which traditionally took place in the Tuileries gardens the night before the opening. They intended forcibly to remove the musicians to the Pont-Neuf and make them play before the statue of Henri IV.[54] This attempt to turn the concert into a public reminder of past days when the monarchy was believed to have been strong and just was only prevented by the dispatch of armed troops to the Tuileries. There were days, we should remember too, when visitors looking from the steps of the Salon toward the Ile de la Cité could see the rising smoke.

— v —

Having gained some understanding of the politics present in the reactions to the *Horatii* and in the charged atmosphere of expectation that surrounded the picture, we need to consider David as an individual actor in all of this. This will be another way of asking how a picture carrying this kind of significance came to be made.

To begin with, David figured as a personality in the Salon criticism of the 1780s; the political discourse of the period centered on personalities, as we have seen, and when radicals wrote as art critics, they did not depart from this. David's triumphs are described by his admirers as ones of persecuted virtue prevailing over jealous intrigue in high places. In this drama, the *Premier peintre* Pierre stands in for a Calonne or a Lenoir. The enmity that existed between Pierre and David was well-known and worked to David's advantage. For example, when he failed to deliver the picture commissioned for the Salon of 1787 (the subject was to have been Coriolanus sparing Rome), this was seen as a sign of his honorable defiance of Pierre's arbitrary and despotic practices:

No doubt, Monsieur, [writes the critic in the *Mémoires secrets*] you would have been surprised not to find the name of David among those of the painters employed to work for the King: but do not therefore allow yourself to believe that he no longer enjoys the high esteem in which he had been held and that he has been judged to be of inferior merit. Beyond the fact that intrigue and favoritism have much to do with these decisions, it must be understood that it is the *Premier peintre* who determines the subjects and distributes them. M. David has refused to submit to this yoke; his proud and independent inspiration will deal only with themes that suit his spirit and passion. Moreover, if by a crying injustice he was excluded from such a goal, the public will have avenged him well enough by raising him to the first rank in its estimation.[55]

Pamphlets retailed anecdotes about Pierre in the best tradition of the political *libelle*; it was said that he forced painters to debase themselves before him in order to receive commissions; the wives of worthy artists were reported to have thrown themselves at

his feet, begging that their husbands be given work so that their children could eat, only to receive a sneering, haughty dismissal.[56] David, for his part, seems to have done everything possible to use this popular image of the arts administration in order to set himself apart from and against it. By various gestures of defiance, he managed to encourage both Pierre's hostility and the rumors of an official vendetta against him. Not once did he deliver a royal commission on time: this created both drama in the Salon as the public waited for the picture, and anticipation that the Academy might act against him. When he delivered the *Horatii*, one and a half times larger than the dimensions set by his commission, he not only had it accepted, but demanded the 6,000 livres appropriate for the largest pictures rather than the 4,000 originally due him—and got it. As time went on, his antagonism toward the Academy became more and more public: in one famous tirade addressed to his students, he declared,

> The Academy is like a wigmaker's shop; you cannot get out of the door without getting its powder on your clothes. What time you will lose in forgetting those poses, those conventional movements, into which the professors force the model's torso, as if it were the carcass of a chicken. Even the latter, with all their tricks, is not safe from their mannerisms. They will doubtless teach you to do your torso, teach you your *métier* in the end, because they make a trade out of painting. As for me, I think as little of that *métier* as I think of filth.[57]

Those words, clearly, could have been written by Carmontelle, Gorsas, or the author of *Sur la peinture*. David had made the language of their anti-academicism his own. Indeed, a few months after the Salon of 1789, he assumed leadership of the successful movement by radical artists to suppress the Academy altogether.

From the beginning, David had been set apart—by his family origins, education, and quality of ambition—from most other artists. The facts of his early life have often been set down, but it is seldom remarked what an extraordinary upbringing he had.[58] His father was successful enough in the metal trade to have purchased a minor administrative office: the classic pattern of middle-class upward social mobility. When David was nine, his father died in a duel, an act which bespeaks pretensions to the honors due a gentleman. The child then lived with two uncles, the architects Buron and Desmaisons. The latter was a man of real standing—architect to the King and ennobled since 1769. Under their guardianship, he received a proper high-bourgeois education at the Collège des Quatre Nations. When he entered the Academy of Painting as a student, he went to live with a *protégé* of his uncles, the playwright Sedaine, author of the highly successful *Le Philosophe sans le savoir*. Sedaine held the sinecure of secretary to the Academy of Architecture and, as one of his privileges, had lodgings in the Louvre. There David was surrounded by well-known literary men, musicians, and theater people. Sedaine was welcome in circles of the liberal nobility and wealthy bourgeoisie, particularly in the salon maintained by the *intendant* Trudaine de Montigny. David, in his turn, was made welcome in this milieu, and all reports indicate that he carried with him the requisite interests, sophistication, and social gifts.

David's exploitation of his independent resources to control his career moves, where other artists might be diverted by simple material necessity, was cause for comment. Pécoul, his well-off father-in-law, financed the crucial trip to Rome in 1784, and that instance of long-term entrepreneurial thinking was seized on by at least one hostile critic, a partisan of rivals Berthélemy and Regnault. "I will say no more," he complained,

109. Jacques-Louis David, *Antoine and Marie-Anne-Pierrette Lavoisier*. 1788. Oil on canvas, 286 × 224 cm. Metropolitan Museum of Art, New York

than that the means employed to produce this picture were means to which other artists had no recourse. M. David fled to Rome, spent 15,000 francs to produce a picture at 4,000, for which he received 6,000 in the end. If M. David, who has always enjoyed comfort and possessions, had been deprived from earliest childhood of even life's bare necessities, would he then be as superior as he seems now. If, for example, I gave the same advantages to M. Regnault and put M. David in the place of the latter, I dare ask what then would be the distance separating these two men.[59]

As this resentful commentary makes plain, David was far from a typical eighteenth-century painter. He had enjoyed the company of Sedaine's circle while other apprentice artists were sleeping on the floors of their masters' studios. He married a wealthy woman at a time when Cochin was advising artists that it would be foolish to take on a wife who could not make herself useful around the studio.[60] Madame de Genlis speaks of him fondly as a frequent and honored guest at Saint-Leu, the country château of the duc d'Orléans.[61] His portrait of the wealthy, polished, and immensely gifted Lavoisier is a tribute not to a patron but to an equal (Plate 109).

For a man of David's background, given the unchallenged social values of the time, it would have been impossible to imagine his chosen career as a *métier*; he would have to have seen it as a somehow "noble" enterprise. And like the radical writers with whom we have been concerned, he saw an academy as an obstacle to that ambition, though for a somewhat different reason. The Academy of Painting, with its reputedly mercenary and small-minded membership ("pleins de méthode pour leurs petites affaires"), still had about it the fatal scent of the artisan class. David, in choosing a career in painting, had taken what threatened to be a step downward from the status his family had achieved (they had groomed him for law, medicine, or architecture). He had, therefore, for all his success in the academic system, to distance himself from what the Academy represented. His own image—the wigmaker's shop where one emerges soiled, the powder clinging to one's clothes—perfectly sums up the class-based character of his antipathy

toward it. We find this rigid distinction between the artisan and the artist constantly reiterated by the dissenting unofficial critics; and always a certain notion of nobility, one linked to a public political role, is the basis for that distinction. A passage from *Sur la peinture* will serve as an example:

> Who is not struck by the difference between an Artisan and an Artist, in the understanding each possesses of happiness, in their respective ideas of the civic good? The Artisan makes his wellbeing completely dependent on riches and he ensures his social existence only by their consumption. The Artist has as a spur only public esteem: he does good only through a complete denial of self, and the sacrifice of his life is repaid only in the coin of honor. The virtue of the latter is not vulgar or obvious; it requires moreover an extraordinary courage and intelligence. It may be that the Artisan, who pays no attention to public opinion, believes himself an independent agent because he acts. On the contrary, he is simply a rough cog in a machine that is propelled by some directing power. Properly speaking, the Artisan is the matter of the state, the Artist is its spirituality.[62]

This text can serve as a good description of the reputation David strove to create for himself. Categorical, uncompromising, extending to a distinction between gross matter and exalted spirit, it gives us a sense of the urgency with which David courted the public, for it was only in playing the grand public role that painting could be raised above the petty commerce in which it was perceived to be languishing.

Out of this urgency comes the thread of fretful anxiety which runs through David's career in the 1780s, and which is inseparable from his calculated rebellious gestures: the hesitations, repeated indecision, quarrels with officials, protestations of persecution and conspiracy against him, failure to deliver commissions on time or at all; we hear of him painting and re-painting twenty times the left foot of the elder Horatius.[63] He had staked everything on the public response to his pictures; there was no retreat to the comfortable round of academic chores and an obliging routine of private patronage. He was not above writing wheedling letters to a titled acquaintance, the marquis de Bièvre, begging him to use his influence with d'Angiviller to obtain the best position for the *Horatii* in the hanging of the Salon, hinting darkly, "It is always our Pierre that I fear."[64] He also gave thought to the material and economic implications of his ambition. When the German painter Tischbein went to see the *Horatii* in David's studio in Rome, he found him preoccupied with engineering a massive public response in Paris. He complained to Tischbein that, in contrast to the poet who publishes his work for a wide audience, the painter must sell his work to a single person. He suggested that he might reserve for himself the right to display the picture in public for a year before surrendering it to the government.[65] He did not carry this plan through, though this is exactly what he would do in 1799 with his *Intervention of the Sabine Women* (he put that picture on display for five years, charged 1fr.80 per person for admission, and bought a country estate with the proceeds).[66] The artist moves from artisan to entrepreneur.

Despite his anxiety—or more probably because of it—David's moves were canny and sure in a public arena where most artists proceeded uncertainly, half-heartedly, and with small effect. He seems, for example, to have had an unerring sense of just how far he could push, at each particular moment, his rebellion against academic restrictions. In each of his confrontations with authority he prevailed—to public applause. Carmontelle, in a moment of more sober analysis, recognizes that David is not operating according

to traditional measures of artistic success, and that he had eclipsed his chief rivals out of shrewd understanding and manipulation of the Salon audience:

> M. David is an extremely daunting rival for several academicians. If they slack off for a moment, this skillful man will crush them with all the weight of his talent. It is not that he is in fact a greater painter than they are . . . M. Peyron arranges a scene better, puts more depth into it, and distributes his light with more intelligence and effect. M. Regnault draws better and uses color more truthfully. M. Vincent paints with a bold vigor that leaves his fortunate competitor far behind. But M. David collects more praise than all of them, because his fundamental ability always attracts partisans, and his sustained application of that ability holds those partisans to him. While the other academicians, more capable perhaps of achieving a higher perfection, wander in their direction and in a moment lose their admirers.[67]

Cold comfort to Peyron, Regnault, and Vincent that their skills surpassed those of their "fortunate competitor"; praise and partisans went to David. Carmontelle hints too that the artist's success came out of a conscious strategy designed to build a permanent constituency. He was certainly in a position to understand and draw lessons from the demonstrated popular appeal of anti-academic hostility and to understand that there was a public looking for a *painter* to give form to that hostility and to the larger antagonisms it represented.[68] He had grown up around literary men, and his ambitions were on a level with theirs. We can understand too a special attraction that might have drawn him to the most radical writers, for whom the normal routes to literary or scientific success were closed: they lacked the skills and polish to rise into the charmed circle of subsidized intellectuals; David, because his calling was inherently less "noble" than theirs, could not submit to the demands of a "despotic" patronage which would have demeaned him. He created for himself a public image of antagonism to the Academy and to the patronage system as aggressive in its way as theirs. They in turn embraced him, describing his person and his work in the same terms they applied to the words and actions of Kornmann and the other heroes of radical literature.

There is nothing in the documentary record to indicate that d'Angiviller and the rest of the academic hierarchy felt any particular hostility toward David until the arrival of the *Horatii* and its aftermath. But after this date, the artist's programmatic defiance of his superiors, his casting them in the role of jealous despots, had the predictable result of arousing real animosity toward him. The first ones to feel its effects were his students. Early in 1786, d'Angiviller suggested in a letter to Lagrenée that no *grand prix* in painting was likely to be awarded that year.[69] Not that there was any shortage of talent in view; Girodet, unquestionably the best young painter since Drouais, was in the running, as was the more senior Fabre, who had done the bulk of the work on d'Angiviller's own replica of the *Belisarius*. The trouble was that they were both David's pupils. When the competition was held, the prize was indeed withheld, the jury pointing to an unacceptable "similarity of styles." There was no doubt as to whose style was generating this dangerous regularity; the author of the *Mémoires secrets* saw only a "new despotism on the part of the professors."[70] So from this real instance of official malice, David's admirers were all the more ready to interpret any reverses he suffered, or appeared to suffer, as more of the same. Thus his failure to complete his royal commission for 1787 was read, as we have seen, as an act of aggrieved defiance of Pierre's tyranny. When David campaigned for the directorship of the Rome Academy in 1787, it was against the more

110. Jean-Germain Drouais, *Marius at Minturnae*. 1786. Oil on canvas, 271 × 365 cm. Louvre, Paris

favored and senior Ménageot; he had no reasonable expectation of the job, plenty to do in Paris, and a reasonable certainty that the post would come to him in time. Yet that became another cause, another martyrdom. Drouais's troubled and emotional letters to his mentor indicate the real feelings of injustice that motivated the Davidians; it was no expedient pose and would not, in all likelihood, have been credible otherwise. Drouais himself, staying on in Rome, remained aloof, secretive, resistant to every pedagogical requirement and restriction: in short he was the junior version of his master and perceived himself as such.[71] His premature death from smallpox and overwork in 1788 gave the Academy a further, sad opportunity to overplay its hand. The masterful, extreme *Marius at Minturnae* (Plate 110) (Drouais's *Belisarius*) had been painted in Rome and therefore could not qualify for his *agrégation* piece. His fellow students called for a waiving of the rules and a posthumous acceptance so that his work might appear in the Salon. The Academy refused the request. And for David, whose affection for and identification with Drouais had been intense, this may have been the final, irredeemable offense.

David's passage from the "modest" recipient of academic favor in 1781 to the embattled radical hero of 1787 represents yet another—and culminating—instance of the dynamic underlying the passage of art into the public sphere. The initiative invariably comes from above, from a state bureaucracy eager to use culture for its own ends. That official ambition expands the potential claim of art to stand for public interests and makes it imperative that some broadened audience be assembled to ratify that claim, if only by its simple existence. But certainly since the permanent establishment of the Salon, and perhaps before, some segment of that audience is going to exceed its assigned role. The despised anti-Rococo critics of the late 1740s did little more than reiterate the approved institutional ideology of the Academy and *Bâtiments*; their sin was to recognize its greater affinity with the program of the Crown's opponents. The habitual response of a Marigny, a

Terray, a d'Angiviller, born in a sense of both fear and opportunity, was to try to outflank the critics, to win over an aroused public on the state's own terms. This tactic could enjoy temporary success, but served finally to stimulate energies and demands that could not be managed. The Choisy commissions were thrown back in the faces of Cochin and Marigny; Greuze became a permanent embarrassment to his erstwhile protectors. D'Angiviller went further than any of his predecessors in trying to use his power to pursue—if only symbolically—a particular political agenda. And he was greeted with the most politicized counter-reaction. Further, as the education and support of young history painters had so improved as a result of the *Directeur-général*'s ambitious attempt to make painting into a reliable instrument of persuasion, so it was far more likely that a David would emerge, that is, an artist who could orchestrate the public counter-reaction in his favor.

In the end, it is in the nature of the work itself that we have to discover that public. If David was in a position to want to include in his art the politicized expectations of a significant part of the Salon audience, to see this as a way of giving form to his particular kind of ambition, then we have to ask how he achieved this. How did he build those expectations and that ambition into painting? To answer this we need, first of all, to attend more closely to the *Oath of the Horatii*.

—vi—

The reactions of the critics and other contemporary witnesses have already provided us with a good deal of guidance in this: the defiance of convention, the asperities, dissonance, austerity, and awkwardness to which they responded are there for us to see. The lining-up of the three sons, the gaps which separate the figure groups, the assertively simple and declarative order of the picture as a whole, communicate a willful rejection of compositional complexity and difficulty as values in themselves. Painterly flourishes and obvious demonstrations of virtuosity are absent. There is no seductive variety of texture, either of the objects depicted or of the painted surface itself; the surfaces of things—stone, metal, cloth, flesh—have a brittle, unrelieved hardness. Except for a few broad, flag-like patches of red, colors are muted and contrasts subdued; even the shine on the swords is flat and dull ("Rubens would have painted them in black with a few touches of white for relief," advised one critic[72]). David renounces as well dramatic and emotional nuance, both of which were very much at issue in 1785. Carmontelle, for example, advised Berthélemy not to trivialize his subject by depicting fleeting passions of the moment, but to seek a "passion which has never ceased to exist at the core of his being."[73] We can question whether it would be possible for such a passion, if it could exist, to be depicted at all. Carmontelle could believe that David had succeeded in representing such a passion because, by compressing his narrative into the ritual of an oath, he chooses a moment which temporarily banishes emotional complexity altogether. (This oath, it has often been pointed out, appeared in no ancient or modern version of the tale.) The Horatii, further, are all shown in rigid profile, the least revealing view of the expression of the face. And it would be difficult to carry out any involved emotional reading of what is expressed in their splayed stances and stabbing gestures, or in the flat open hand and glassy upward stare of the father. David gives emotional expression a place in the picture, but confines it to the group of women and undercuts it even there. The women appear more unconscious than overcome by grief; their poses are slack, and they seem,

though correct in their scale, strangely diminished creatures. They also make the only group of figures composed in a traditional way; David makes a gesture toward established convention, gives it a place in the picture, but shoves it to the side, relegating it also to the devalued realm of femininity. Two opposed notions of how to compose simply abut one another, masculine versus feminine, without transition or modulation, juxtaposed in a rigged test of strength.

The picture refuses to find form for the relationships between men and women which are central to its narrative content. Reciprocity exists only in the strained, frozen oathtaking; anything that would include that action in a wider network of relationships—sexual, emotional, social—is excluded: the impassive back wall shuts out the world; the viewer's only escape, the opening behind the right-hand arch, is obscure and uninviting. In the shallow space before this screen, no reciprocated glance passes between the actors. The three arches, like great parentheses, mark and separate the figures from one another according to which of the three distinct roles they play in the drama. Everything is abstracted; no form calls on the complex, learned routines stored in our bodily memories. On every level, a lack of a common, unproblematic language of the body is underlined.

One critic objected to the picture precisely for this reason (in a pamphlet entitled, interestingly enough, *Important Opinion of a Woman*):

> . . . it is far more agreeable to the eye as it is to the hand to traverse the whole extension of an object without encountering rough spots or gaps which arrest its progress, repel it, and make it jump; its sensibility wants to be led gently and wander without difficulty through all the parts of the chain of a composition. That is why one rightfully demands in every subject a gradually progressive series of bodies, light effects, and color transitions. According to these criteria, the picture of the Horatii is faulty; it presents three groups on three barely distinguishable planes: the group of brothers, then a hole; the old Horatius, then a hole; and finally the group of women who alone preserve among themselves that graduated linkage demanded by the example and the teaching of the great masters.[74]

This writer rightly perceives that the effect of the *Horatii* is to deny freedom to the play of the imagination, a play which, existing as it does in the correspondence between visual and tactile sensation, always has an erotic component. This David interrupts and interferes with. The "série étroite et progréssive des corps, des lumières, et des passages de couleurs" represents, beyond sexuality, a whole world of finely adjusted relationships between persons. If we recall Berthélemy's picture, his Baroque pictorial formulae and theatrical vocabulary of the passions were bankrupt conventions, but in using them, he makes the attempt to include the action depicted in the fate of a larger social order: the crowd of posturing onlookers stands in for a society; the hazy recession into space corresponds to the reverberation of Manlius's stoic resolve into an implied physical and social beyond. David, on the other hand, does not show the relationship either between the Horatii themselves or between them and Rome, he only asserts it; he cannot demonstrate it, he can only declare it, and the strain involved is written into the picture—is finally its message.

We can see in his preparatory sketches that this austerity and dissonance were carefully arrived at. The subject of his commission had been the elder Horatius defending his son after the murder of Camilla (Plate 105), an episode ambivalent in its moral significance and one which requires an outdoor setting and the depiction of the reactions of a crowd.

A sketch of this scene, with its assymetrical composition and complicated distribution of emotion, action, and reaction, promises a picture closer to the *Manlius* than to the final version of the *Horatii*. David turns away from the problems presented by this subject, and makes the unexpected and unapproved decision to depict the moment of an oath. An early sketch of the oath (Plate 111) is close in conception to J. A. Beaufort's *Oath of Brutus* of 1771 (Plate 112): the male and female groups overlap; the father's gesture is a more intimate one, directed down and toward the viewer; the group of male figures is more naturally turned in on itself, their postures varied. In what appears to be a somewhat later study (Plate 113), he has arrived at the strong unitary plane that organizes the final composition. The positions and gestures of both the male and female figures are taking on a far more abstracted angularity. The highly finished study in Lille (Plate 114) is close to the final version, but a comparison between them shows that David is still working to pare down the image, to build into it more tension and more discontinuity: there is a male figure on the right side of the drawing, whose presence and standing posture compromise the male/female, straight-line/curved-line, erect/supine oppositions that rigidly order the painting; the group of women has a weight equal to the male group; there is a certain opulence promised— a large amphora looming in the upper right, an intricately carved chair; the receding stairway is clearly lit, and the figure at the top marks out a habitable deep space; the right hand of the elder Horatius, seen in more natural profile, is not the flat emblematic sign it finally becomes. Here, at the center, the trembling tenseness of the picture is focused. Its full title, we might remind ourselves, is *Le serment des Horaces entre les mains de leur père*; yet the outstretched hands of the sons *just* fail to meet the hands of their father—a whole drama of anticipation and release in this small incident, one which, however small, creates a sensible rift down the center of the tableau. Even the bond between father and sons is interrupted.

The *Horatii*, of course, is not *only* dissonant, unnuanced, and disjointed; the control David renounces—that of conventional academic practice—he reasserts on another level. First of all, there is the picture's visibly mathematical rationality, the rigorous geometrical structure which underlies the composition: the spacing of the figure groups, the perspective construction, the heights of the columns, even the angles of limbs, swords, and spear are interrelated in a precisely adhered-to geometry based on the golden section (this has been described and charted by Hautecoeur).[75] There is the sustained evenness of the painted surface, in Robert Herbert's words, "this taut, astricted vision which is David's own, and which reaches through the large canvas, stretching the membrane of paint tightly over the minimum number of images."[76] Coupled with this is the unrelieved clarity of the scene, the hard raking daylight, the transparent atmosphere, the preternaturally sharp delineation of things.

These qualities of the image—the mathematical order, the flattened-out, even attention to surfaces, the clarity of description—are offered by modern art historians as the essence of David's achievement:

> The box space, with its rigidly plotted ground plane and rectilinear alignments, invests the preliminary reforms of the 1760's and 1770's with an all-pervasive intellectual control . . . within the precise boundaries of this stage-like atrium, the figures firmly take their earthbound poses with a consonant sense of geometric predetermination. The tonic clarity of the spatial order pertains as well to the lighting, which, once and for all, destroys any vestiges of Rococo haze and glitter. In this cool

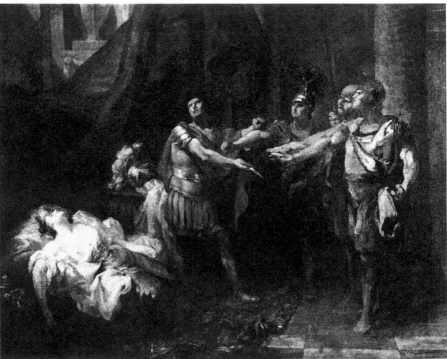

111 (above). Jacques-Louis David, *The Oath of the Horatii* (study) Black chalk and ink on paper, 20 × 26.8 cm. Ecole des Beaux-Arts, Paris

113 (facing page top). Jacques-Louis David, *The Oath of the Horatii* (study). Black chalk on paper, 25.9 × 35.4 cm. Louvre, Paris

114 (facing page bottom). Jacques-Louis David, *The Oath of the Horatii* (study). Black chalk, ink, and wash heightened with white on paper, 21.9 × 32.5 cm. Musée Wicar, Lille

112. Jacques-Antoine Beaufort, *The Oath of Brutus* (study). 1769. Oil on canvas. Private collection

and limpid ambience, and theatrical light of Caravaggesque sharpness, if not warmth, defines with maximum plasticity the figures, whose incisive contours are echoed in the sharply delineated shadows. . . . This clarity is the product of the painting's magnificent fusion of form and ethos. [Robert Rosenblum][77]

This tonic compositional lucidity is reinforced by the limpid early-morning clarity of the lighting and pristine purity of color, as well as the rudimentary simplicity of the setting . . . a perfect fusion of form and content in an image of extraordinary lucidity and visual punch. [Hugh Honour][78]

These statements represent eloquent visual readings of the picture, and they are certainly not wrong as far as they go. The qualities they identify, however, rather than constituting some new, coherent aesthetic system, exist to sustain and validate the more immediate message of discord and provocation. They represent the imposition upon picture-making of systems which declare themselves to be drawn from the world beyond the edge of the canvas, the world of the already-seen and already-known, of physical laws and some fixed, immutable order of nature. Their effect, finally, is to oppose nature to art.

This opposition is there to be read in the disruptive force with which these "natural" systems are imposed on the picture, for David makes no effort to disguise its effects. The geometric structure does not simply order the composition and the placement of the figures; we are too aware of its operations, too aware of David's efforts to make every part of the picture do a preordained job (for example, the weird and pointless way the foremost son holds his spear; his distorted and misproportioned right forearm; the fact that the two sons to the rear are taking the oath with their left hands; the almost comic uniformity of the poses of all three). Other relationships between bodies and space are too consciously excluded, and as a result, David's geometry has something desperate and strained about it. Part of its message is that composition as distinct from mere order— all the small adjustments, accommodations, and correspondences between forms which translate into these same processes and connections between persons—is no longer possible.

David's handling of paint works to the same end. Its even, sustained application involves a suppression of those qualities which make paint a record of the body, of play, of expressive accident, of the sometimes unruly demands of persons and objects perceived individually. The picture, further, works to efface itself as a product of labor. The handling is plain, undemonstrative, neither polished nor broad. Artful brushwork, for David, was the sign of the artisan; it represented a carry-over of values from the private to the public sphere: "What does it matter if one makes one's hatchings to the right, to the left, from top to bottom, from one side to another?" David wrote to Wicar in 1789. "Provided that the lights are in their proper place, one will always paint well. Woe to him who says that he doesn't know how to paint when he means that he doesn't know how to blend [fondre]. That one will never know how to paint even when he knows his blending well."[79] To merge, to coalesce, to subordinate a world of distinct objects to a unified process of seeing: this is what a confident, shared system of pictorial conventions accomplishes. David sets himself against this. Here another observation by a Salon critic is useful: ". . . it is by the opposition of objects one to another that he seeks to produce an effect rather than by what painters call the magic of chiaroscuro."[80] The word to attend to is "opposition"; objects in the world David conjures up appear as opposite, separate, equivalent, without the connecting glue of "clair-oscur". Thus the

vividness of the scene, the hard and artificial light, and the tense concentration on outline which the planar arrangement of figures permits. The picture partakes less of the mediated properties of vision than of the overly vivid yet generalized and disassociated character of hallucination.[81] This particular quality of the image is insisted upon most in the hands of the male figures. The complicated, edgy pattern of their outstretched hands occupies the center of the picture as we have already noted; their visible hands, furthermore, are separated from the body, severed at the wrist: the swords cut off the open hand of the elder Horatius; the edge of the column severs the three extended hands of the sons; the spear shaft detaches the left hand of the first son from his forearm; the clenched right hand of the second son is disembodied entirely as it appears from behind the waist of the first, a fold of cloth casting a sharp dark shadow across the wrist. The logic of "opposition des objets entr'eux", of a world of discrete, equivalent objects, imposes itself even on the unity of the human body.

In this heightened, overall equivalency of vision, the picture stands for an impassive and impervious "thereness" of things. The space of the picture is not an imaginary continuation of the viewer's own; it is *another* space, and a somehow daunting one. It does not transform the space where the viewer stands, providing attractive spatial paths for him to follow into the picture; it confronts him where he stands and denies the pleasures of fiction, which are pleasures of play within a symbolic order. (It is a space, moreover, which the figures themselves do not know how to occupy.) "Leave aside all principles of art; it disappears here, and only allows nature itself to emerge": that is the message of the kinds of control which David so rigorously exercises over his image. They stand opposed to art; their effect is to naturalize the image; they make possible the dissonances and calculated "errors" of the picture by linking them to the order of nature itself.

—vii—

When we turn to the *Brutus*, David's next official commission and his last under the Old Regime, we find that picture confirming and extending what he had achieved in the *Horatii*. Before taking up that picture, so final an image in so many ways, there are two interim canvases to consider: the *Death of Socrates* (Plate 117) and the *Paris and Helen* (Plate 118), both of which diverge, even regress, from the line established by the great state commissions. David's inability to finish an official successor to the *Horatii* may or may not have been caused by an injury incurred in a fall, but the hiatus certainly was useful to him in at least two respects. First, it bought him time to work up a sufficiently dramatic and provocative follow-up (and it was going to take the extraordinary and daring originality of the *Brutus* to accomplish that). Second, there was the matter of Peyron to be disposed of. By this time, the rivalry implicit in David's actions since 1780 had come into the open. In the short run, he saw Peyron as a rival for the Rome directorship and knew that the latter still enjoyed d'Angiviller's favored patronage. In October 1786, Drouais wrote the following to his teacher from Rome: "Your apprehension on the subject of M. Peyron is not perhaps unfounded, in that they say he never moves from the side of M. d'Angiviller, but it cannot be possible that M. d'Angiviller so scoffs at us as to send us M. Peyron [as Director]. For me, it would take only this to make me get out. We apparently have the same antipathy toward his person and toward his abilities."[82] In this instance, we can thus make more specific Carmontelle's evocation of David's fundamentally competitive strategy. David, despite having thoroughly outdis-

tanced Peyron, was determined to eliminate him as a rival once and for all. The latter had delayed his Salon debut until 1785 and had then produced a picture, the *Death of Alcestis* (Plate 115), a subject taken from Euripides, which represented his first effort at a canvas of grand dimensions. Its subtitle was *Heroism of Conjugal Love*, and it depicts the self-sacrifice of the loving wife so that her husband might live. Its somewhat diminutively scaled group emerges from a background which is dark to the point of murkiness and barely readable from any distance. Like David's *Hector and Andromache*, it pays homage to Poussin's *Death of Germanicus* and takes even further the idea of a morbid palette to represent grief. It was almost indecipherable in its position in the top rank of pictures in the Salon hanging. In its implicit contest with the *Horatii*, it was both literally and figuratively overshadowed. Cochin, in a letter, put this down yet again to David's adroit tactical mind. Having established a trend toward muted, somber color in the previous two Salons, he had deftly changed direction and watched others fall into the trap he had prepared: "He has pulled himself out and left them inside," Cochin concluded, and that left David the "*véritable vainqueur.*"[83] This is certainly a far-fetched

115. Jean-François-Pierre Peyron, *The Death of Alcestis.* 1785. Oil on canvas, 327 × 325 cm. Louvre, Paris

116. Jean-François-Pierre Peyron, *The Death of Socrates*. 1787. Oil on canvas, 98 × 133 cm. Statens Museum for Kunst, Copenhagen

reading of the situation, perhaps offered with tongue in cheek, but it indicates the sort of suspicions that David's maneuvering had already aroused.

The *Alcestis* reveals the fact that Peyron, whose skills were honed so carefully on cabinet-sized pictures, was going to have trouble with large formats and was thus unlikely to pose a challenge to David anytime in the near future. But the latter was not going to let the matter rest and would deliver the final humiliation precisely at the point where the bond between d'Angiviller and his protégé was most exposed. Peyron had by now received a major royal commission for the theme of Socrates in prison, the one first broached to him by the *Directeur-général* in 1780. The commission was made in early 1786, but Peyron, in another display of short-sightedness, gave first priority to his reception piece (the unremarkable *Curius Dentatus* shown in 1787). The completed *Socrates* would be delayed until 1789, but in the meantime, he began work on a smaller version destined for d'Angiviller's private collection, which they planned to exhibit in the next Salon (Plate 116). This was before the date (March 1786) that David obtained from Trudaine de la Sablière (*conseiller* in the Paris Parlement and younger son of Trudaine de Montigny) the commission for his own version of the subject of Socrates in prison. The initiative for this choice almost surely came from the artist,[84] who was thus able to use his elite connections to bypass the state patronage system and outflank his rival.

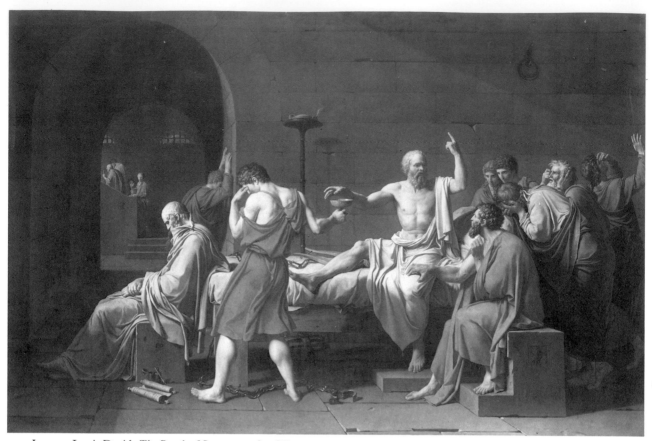

117. Jacques-Louis David, *The Death of Socrates*. 1787. Oil on canvas, 130 × 196 cm. Metropolitan Museum of Art (Wolf Fund 1931), New York

The need to meet Peyron on his own ground occasioned David's only return to what we might now call the iconography of Turgot nostalgia. And it also meant that David would forego the disruptive compositional strategies of the *Horatii* for a Poussinesque *enchainement* of mutually supportive and interactive figures. He would show that when appropriate (for a modestly-scaled, privately commissioned picture with a contemplative, "philosophic" theme), he could surpass Peyron effortlessly at the point of the latter's maximum strength. And there can be no question that he proved it. By comparison with David's version, Peyron's is confused and incoherent. Its basic planar structure works at literal cross-purposes with a set of interlocking diagonal elements (the shaft of light from the left, the sinuous downward descent of forms which extends from the slave with the poison to the sprawled disciple on the floor). Socrates' inflated, directionless gesture, reminiscent in some ways of the one Greuze gave his Septimius Severus, floats above a diffuse array of grief-stricken poses; the crucial meeting of hand and cup is smothered in drapery. Put next to Peyron's, David's composition is all clarity and stately rhythms, weighting and unweighting the figural frieze as it reads from right to left, letting the massed emotions on the right side open dramatically into the suddenly released pose of the philosopher. The opposed vertical and horizontal gestures of Socrates anchor the scene securely around the moment of choice. That aching distance between cup and hand is the point of maximum narrative charge, which is gradually diminished and dispersed as one's attention moves to the left and finally back into the world beyond the cell.

118. Jacques-Louis David, *Paris and Helen*. 1789. Oil on canvas, 146 × 181 cm. Louvre, Paris

Poor Peyron was all but paralyzed by the time the Salon opened. David's picture was predictably late, but Peyron's was even later, not appearing until the last days of the exhibition. It was no contest. The critical evidence is somewhat slim, because most of the articles and pamphlets had long since been written and printed, but the official *Journal de Paris* as well as the *Mémoires secrets*, both keenly aware of the combat between the two artists, marked Peyron's version as inferior in every particular.[85] After delivering his ill-fated *Socrates*, Peyron would never again be a serious factor in the Paris art world. The large state version of the *Socrates* was an anticlimax in the 1789 Salon.

David's undeniable if mysterious infirmity during this period did, however, prevent an intended pairing of his *Socrates* with the almost identically sized *Paris and Helen*. The latter picture would appear in rather anomalous juxtaposition to the *Brutus* in 1789, but two texts from 1787 indicate that this was not the artist's original intention. One critic wrote: "the public will learn with much regret that a long illness of this great artist has prevented him from finishing another picture, the gracious and *galant* composition of which would have provided a contrast to that of the Socrates; this is Paris and Helen."[86] The *Mémoires secrets* speaks of an expected effort "in an opposed genre."[87] The patron was the King's brother, the comte d'Artois, reactionary to the core, but attracted to the glamor of the forbidden and to anything that might discomfit his royal sibling. In 1786 he took it into his head to play the patron of advanced art and gave commissions to Vincent and Suvée as well as to David. Régis Michel has put this down to the influence

of his new passion, the vicomtesse de Polastron, who "transformed this Valmont into a Saint-Preux"[88] (that is, from a sexual desperado out of Choderlos de Laclos into a virtuous pedant out of Rousseau). But as Michel goes on to point out, it was d'Artois's notorious reputation as a libertine and a spendthrift that David managed to underline in his picture. The prince might have perversely enjoyed the parallel between his own liaison and the adulterous bond between Paris and the wife of Menelaus; but the precise textual reference of the scene and its saturation with symbols of illicit eroticism far outrun that single metaphoric equation. In previous Salon entries by Vien (1779) and Lagrenée (1781), Paris is shown as lazy, cowardly, and a slave to pleasure. The episode selected by David takes place in the aftermath of his combat with Menelaus, from whose revenge Paris was saved only by the intervention of Aphrodite, who had also prevented Helen from leaving him in disgust. Untroubled by his recent humiliation, Paris again applies his seducer's talents to his prize—and once again succeeds.

This depiction of suave desire, unimpeded by any sense of duty or any shame, could only have reminded David's audience of d'Artois's prodigious reputation as a womanizer, a public connoisseur of a long succession of courtesans. The suffocating luxury of the setting would have evoked the infamously extravagant Bagatelle, his *maison de plaisance* in the Bois de Boulogne. And there was a closer parallel to the Homeric triangle readily at hand: d'Artois was popularly regarded not only as the corrupter of Marie-Antoinette, her mentor in a life of unseemly conduct and dangerous pleasures, but as her lover as well. Her constant association with d'Artois kept alive the slanders engendered by the Diamond Necklace affair. The Orléans group, among others, was happy to keep alive rumors of her infidelities.[89] In the summer of 1776, when the Queen had taken to her bed because of illness, the King was said to have surprised his wife and d'Artois together in a state of compromising intimacy.[90] The public audience was going to be alert to evocations of royal cuckolds and princely seducers.

It is probable that d'Artois understood all these connotations and cynically enjoyed, as he always seemed to do, the luster it added to his reputation as an uncaring rake, whatever discredit it cast on the royal family. Still, these same associations allowed David to escape complicity with the morals and politics of his patron. The projected confrontation between the indolent sensuality of Paris and the stoic self-abnegation of Socrates would have driven the point home, all the more so in that the exiled Parlement had once again appropriated the martyr's mantle. D'Artois, for his part, had been conspicuously on the side of Calonne (the latter had ensured the prince's support by paying off his colossal debts).[91] Further, by the time of the Salon, a memorable confrontation had taken place in the Assembly of Notables which lent an even deeper political sense to the proposed juxtaposition. D'Artois presided over one of the seven "bureaus" of the Assembly, the same one which included Lafayette, the emerging leader of the opposition. The two clashed repeatedly, and one of their sharpest confrontations was over Lafayette's proposal that the King be petitioned to grant full civil rights to Protestants and that the criminal code be reformed. D'Artois was immediately on his feet to declare the matter out of order.[92] So the old issues of tolerance and despotic injustice which were most closely linked to the figure of Socrates had been raised again in opposition to Paris/d'Artois. Contemporary commentators were clearly comfortable, as modern ones have not been, with thinking about David's pictures in relational terms. The *Paris and Helen* represented the transformation of an awkward commission into a dramatic foil for the *Socrates*, underscoring the stoic virtues of the philosopher by pointedly juxtapos-

119. School of David. *Hector admonishing Paris and Helen*. Oil on canvas, 121 × 148 cm. Princeton Museum of Art

ing them to an example of their absence. This was a point not lost on the unknown later artist of a picture (Plate 119) now in the Princeton University Museum on the subject of Hector upbraiding Paris for lingering in the arms of Helen and avoiding battle (the same episode depicted by Vien in 1779). It is an undisguised David pastiche which itself makes the connection for us, with Hector assuming the pose of one of the Horatii stepping out of his own picture and reproachfully striding into the later one.

−viii−

The *Paris and Helen* was probably not completed until sometime in 1788. In the meantime, David had embarked on another major act of defiance. The approved subject of his next royal commission had been Coriolanus restrained by his family from seeking revenge on Rome. When that picture did not appear in the Salon, the popular explanation, as we have seen, was that he had nobly defied official efforts to impose a subject on him (presumably this one) to which he was indifferent. He had, in fact, already begun work on the *Brutus* (Plate 120, Color Plate 5). There is no sign in the correspondence between government and Academy officials that they were aware of David's switch in themes until well into 1789,[93] though the *Mémoires secrets* indicate that a knowledgeable public had gotten wind of it already in 1787.

The change in subject had, moreover, a special edge and a sense of deliberate purpose

120. Jacques-Louis David, *The Lictors returning to Brutus the Bodies of his Sons*. 1789. Oil on canvas, 323 × 422 cm. Louvre, Paris

from the beginning. Coriolanus was a contemporary of the first Brutus who, in the early years of the Roman republic, became a leader of its aristocratic faction. The populace agitated successfully for his banishment when he opposed measures to alleviate a famine, and he went over to Rome's enemies. At the head of an army about to attack Rome, he was implored by his mother, wife, and children to give up his revenge. Hearing their pleas, he relented, and the city was spared.[94] In place of this theme, David chose the story of a man whose devotion to Rome and to the cause of the republic was fearsome and unrelenting. Brutus had led the rebellion against the last of the Tarquin kings. That rebellion had its roots in the sexual depravity of the reign of this king, Tarquinius Superbus. Both he and his wife, the daughter of the preceding king, had murdered first spouses in order to marry one another; he had usurped the throne by murdering his new wife's father and had carried on a campaign of persecution and murder against those virtuous Romans who opposed him. He then, in Livy's words, "governed the state solely on the advice of his own friends . . . without the confirmation of the people or the Senate."[95] This monarchy came to an end as a result of one final act of sexual excess. Sextus, the son of the usurper, raped Lucretia, the wife of Brutus' friend Collatinus. Brutus was the lone survivor of a family wiped out by Tarquinius. After the noble Lucretia killed herself in shame, he drew the knife from the fatal wound and with his friends swore an oath to expel the Tarquins from Rome and found a republic in place of the discredited monarchy. In this they succeeded, and Brutus and Collatinus were elected the first ruling magistrates of the Roman republic.

David takes his subject from events which followed these. Brutus, having lost his family once as a result of aristocratic conspiracies, would do so again. His sons were drawn by members of their mother's family into a plot to restore the monarchy. The conspiracy discovered, Brutus was obliged to order and witness his sons' execution. David depicts the aftermath of the event: Brutus brooding in silence in his house, clutching the incriminating document, and the women grief-stricken and swooning at the sight of the bodies being carried inside. The full title of the picture would be *J. Brutus, first consul, returned to his house after having condemned his two sons who had allied themselves with the Tarquins and conspired against Roman liberty; the lictors return their bodies so that they may be entombed.*[96]

Discussions of the possible political significance of the *Brutus* have centered around

parallels between the story of Brutus and the events of the summer of 1789. Certainly the potential was there for parallels to be drawn, and the responsible officials, d'Angiviller, Cuvillier, and Vien, anticipated and feared they would be.[97] Remembering, however, that the picture was conceived in 1787 and 1788, it would seem more useful to compare David's theme to what was the focus of political consciousness in those years, namely, the Kornmann affair. Sexual depravity, the ruthless persecution and elimination of those who stood in the way of the lusts of the powerful, these are principal themes of the stories of both Brutus and Kornmann. The supposedly innocent Mme. Kornmann is seduced from her home and family by a conspiracy of officials and courtiers. Though she lacks the good grace to kill herself, the noble Bergasse takes up the cause of his friend, the aggrieved husband, and vows to bring down those responsible for her disgrace. The political message of Bergasse's pamphlets, and those of Carra and Gorsas as well, revolve around tales of sexual violation, conspiracy and revenge: Gorsas writes of Lenoir, "Look at him seduce a young peasant girl from the hearth that gave her birth, seizing her from the bosom of a family which is left to water the earth with its miserable tears . . ."[98] And Bergasse:

> . . . how many unfortunates groan today in obscurity, victims of the numerous abuses which authority allows itself! . . . how many are there who, amid the horrors of cruel imprisonment, still are dying at the very moment I speak, their crime having been to offer a moment's resistance to its passions.[99]

Bergasse further described in heart-rending detail the destruction of Kornmann's family: his children longing piteously for their mother, Kornmann himself crying out, "How melancholy, like a deep and heavy night, weighs on my battered senses! . . . I feel an anguish in my shattered heart like a vulture tearing at a fresh and bloody wound!"[100] In his second *mémoire* on the affair, Bergasse pretends to gaze into the future and, addressing Beaumarchais directly, summons him to witness the ignominious death of Mme. Kornmann. During a period when the central symbols of political radicalism were a family destroyed by the schemes of aristocrats, an aggrieved husband alone in his sorrow, friends of the husband joined in opposition to tyranny, David takes on the story of Brutus. At the height of the Kornmann affair, Hardy made this entry in his journal:

> Everyone was speaking in whispers of a shocking placard discovered, it is said, last Sunday . . . affixed in the front of the Queen's box in the Italian theater: "Tremble, tyrants, your reign is about to end."[101]

Thus the peril to family ties in times of political crisis was not a generalized theme, but one with specific references to the politics of 1787–89. David abandoned a theme, that of Coriolanus, in which political virtue and family stability appeared to be in harmony. In turning to Brutus, he also returned to the *Horatii*. The model for his first conception of the oath was Beaufort's *Oath of Brutus* (which was derived from Gavin Hamilton's version of the same subject done in the early 1760s). The oath indeed was an element of the story of Brutus inserted into that of the Horatii. David's image of Brutus, in turn, carries with it the image of the elder Horatius, his own family divided and destroyed in the aftermath of his sons' defense of Rome.

That David had been occupied with Brutus since 1783 or so is indicative in itself of his intentions. Though Brutus had long been thought of as an acceptable subject for the Academy's history painters, by the 1780s it had acquired new, critical political signifi-

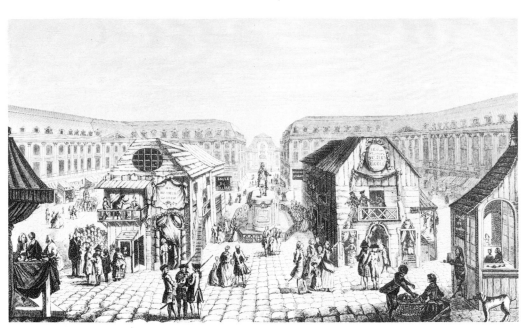

121. *The Theatre of Jean-Baptiste Nicolet in the Foire St. Ovide.* Anonymous engraving

cance, one which might explain David's avoiding the channels of official approval in undertaking the subject in earnest. On 25 January, 1786, there had been a revival of Voltaire's tragedy on the subject of the first Brutus at the Théâtre français. This had been halted, despite evidence of critical success, after just one performance and all the signs point to an official intervention.[102] The probable fears of the police seem reasonable in light of the uses to which the figure of Brutus was being put in radical tracts. Four years earlier, for example, the radical polemicist Brissot had written the following, part of a passage in which he questions whether a writer can speak the truth "if he sees prison and the stake as the reward for his efforts;" he asks,

> Will he dare to return to the cradle of societies and show us peoples equal to their kings, contracting with their rulers for their security in return for their obedience, their happiness as the reward of their faith? Will he dare paint with darkened colors the tyrants, who have torn apart the social contract, and crown the Brutuses, who with courageous hands punished them?[103]

By 1787, David was daring openly to "crown the Brutuses," and from Brissot we get some idea of the significance this act could carry. And if the *Horatii* represented the "idiom of virtue, the language of truth," the *Brutus* does so in even more uncompromising terms. On this, we have no less an authority than the *Premier peintre* Pierre: on seeing the picture in David's studio in the summer of 1789, he pronounced,

> Go on sir, keep it up. You have in your *Horatii* given us three personages set in the same plane, something never seen before! Here you put the principal actor in shadow! It's just like at Nicolet's, *de plus fort en plus fort*! Moreover, you're right; the public finds it all beautiful; there is nothing more to say. But where have you seen, for example, that a sensible composition can be made without using the pyramidal line?[104]

There is an affinity here between Mercier's vision of the Salon audience (see the

introductory chapter) and Pierre's nightmare, revealed in this outburst, that some debased "popular" sensibility had taken over high art. The key reference is the one to "Nicolet." Jean-Baptiste Nicolet was the principal Parisian entrepreneur of popular theater in the later eighteenth century (Plate 121). "De plus fort en plus fort" was the slogan emblazoned above his theater in the Temple entertainment district. His experiences were much like those of the *forains* in Watteau's time. Licensed only to produce physical spectacle—rope dancing, acrobatics, pantomime—Nicolet was forever introducing spoken drama into his productions and being shut down by the police for infringing the monopoly of the *Comédie*. The conflict was still, after all these years, a game followed eagerly by the public audience, which looked to Nicolet for a steady supply of daring, transgressive effects. Nicolet's *Grands Danseurs du Roi* (as his company was called) moreover were known for their elaborate musical and comedic productions on classical themes. The popularity of these performances was sufficient to create fears for the future of the official *Comédie* and Opera (the latter having become financially dependent on Nicolet's royalty payments for use of its repertoire). Anxiety was expressed that even the classical tradition itself, Corneille and Racine included, would be taken over by the popular troupes. Already the new and substantially larger theater audiences nurtured by Nicolet's and the other boulevard theaters were beginning to frequent the *Comédie* as well and were altering the traditional composition of its audience.[105]

Pierre is attemping a joke, but it seems not far from the truth as the First Painter saw it: that David's rule-breaking was a kind of low (and otherwise incomprehensible) appeal to a naturally seditious mass, an appropriation of high culture on behalf of an illegitimate audience of once safely excluded outsiders. This was likewise the opinion of the young painter Prud'hon, who wrote to a friend from Rome sometime in 1786–7 on the subject of Drouais:

> . . . he follows the manner of M. David in avoiding everything that might fascinate and dazzle the eyes of those who lack a fine and delicate sensibility. The violent desire to cause an uproar and the ambition for glory and applause are the guides that they prefer; but my friend, ambition is often a faulty guide. . . .[106]

Prud'hon's syntax here and in the rest of the letter is peculiar, but it is clear that he puts himself on the side of those who possess a "fine and delicate sensibility," and that David and Drouais mean to violate that and somehow arouse those who conspicuously lack it, a low audience whose crude sensibilities are overwhelmed in the presence of "affectation" (a positive term for Prud'hon) and refinement.

This artist would doubtless have agreed with Pierre's assessment of the *Brutus*. "De plus fort en plus fort" will do as a description of the progression from the earlier picture to the later one. David had been criticized in 1785 for painting "two pictures" on one canvas; in 1789, he painted, in Carmontelle's words, "a scene which joins together three such diverse pictures under a single terrible conception."[107] Where David subjected traditional compositional principles to extraordinary strain in the *Horatii*, he pushes the *Brutus* almost to the point of compositional break-up. Both pictures have at their centers a single flat open hand: in the *Horatii*, the hand signals an electric point of contact in the planar, linear pattern which organizes the composition; in the *Brutus*, the hand gestures toward a neutral void, underscored by the presence of the empty chair. The various elements of the drama have scattered to the sides of the canvas—in the case of the one visible corpse, to flickering, obstructed visibility at the extreme edge; the central actor vacates

the center of the picture and sits in shadow in one corner. The arrangement of figures in the *Horatii* was seen to be interrupted by "trous", gaps opening into space; one great gap occupies the center of the *Brutus*. Across it, the opposition between male and female, between clenched angularity and supple, curvilinear form, between controlled and uncontrolled emotion, verges on disassociation; these terms of opposition had been at least contiguous in the earlier picture. The radical separation of male and female is played out not only in the empty distances of the picture, but in an elementary drama of light and darkness. The dark bulky mass of the statue which shelters Brutus and to whose shape he bends his body is opposed to the brightly-lit and animated group of women; together they make up a skewed pair of isolated and equivalent triangular shapes around which the picture is constructed.

David organizes the *Brutus* at a new level of dislocation and disassociation, and he seems altogether more assured and confident in doing so. Gone is the flattened-out, frozen, over-managed quality of the *Horatii*. It is as if he no longer feels the need to exercise such stringent, anxious kinds of control over the image. The figures are no longer lined up on one plane; the drama penetrates the pictorial space and interacts with it in various ways. The underlying geometrical grid is there, but it is interrupted and interfered with, a scaffolding gestured to rather than imposed on the composition. The *Brutus* departs as well from the emotional and temporal stasis of the earlier picture. The women are revived into consciousness, registering varied, open emotional reactions to the sight of the corpses. Their clustering together implies a rush of movement, to which the empty chair and abandoned sewing bear witness. In the picture as a whole there is a sense of time and the interaction of events which David only now seems able to permit himself. As has often been observed, the position of Brutus' hand and head indicate that he has just been roused from reverie by the arriving cortège. The sense of a moment in time captured and not imposed continues in incidents like the sidelong glance of one of the litter-bearers, the separate gesture of the servant, the cushion which slides from Brutus' chair.

Rather than the hard even light of the *Horatii*, the light here is softer, less artificial, and more varied. It highlights the women and the corpse behind the statue of Rome, falls at Brutus' feet, but leaves the rest of the picture in a transparent gloom. The hard-edged, "trop entières" shadows of the *Horatii* are not present here. The color is higher-keyed, and David uses a strong contrast of near-complementary colors to oppose the grief of the weeping servant to that of the women of the family. There is a new freedom and variety in the handling of paint. He introduces here the thinly-rubbed application of paint which will become one of his trademarks; it appears nowhere in the *Horatii*. He uses this technique, with its abstract and matter-of-fact pattern of touches, to varied effect: from the uncanny naturalism of the woodgrain in the empty chair to broad approximate effects of atmosphere in the shadowy upper reaches of the picture. Against these passages, he sets the even, almost polished treatment of the flesh and drapery of the women and juxtaposes to both a thick, Chardin-like application of pigment in the isolated still-life of the sewing basket. With these varied means, he introduces a scattered multiplicity of incident: the tricky passage where the statue intervenes in front of the lighted doorway; the gesture and corded neck of the servant; the highlighted gesture Brutus makes with his feet; the furniture taken from models constructed by the *ébéniste* Jacob; the sewing basket; the sliding cushion.

David's once over-anxious imposition of unity over the larger discontinuities of the

composition (the mimicry of some real *other* space; the even, self-effacing application of pigment; the wrenching of human limbs into an artificial order; the rigorous elimination of the emotional, the particular, the contingent) is thus relaxed. The *Brutus* is more fully and confidently pictorial. This is not to say, however, that he has returned to the artfully modulated variations of the traditional painter; he is farther than ever from, in the words of the 1785 *Important Opinion of a Woman*, the "gradually progressive series of bodies, light effects, and color transitions . . . that graduated linkage demanded by the example and the teaching of the great masters." The picture's scattered foci of attention are isolated or at odds with one another. The varied use of paint makes the canvas a kind of great mixed metaphor: wholly different kinds of handling juxtaposed with deliberate artlessness, one simply starting up where another leaves off. He is able to make use of abrupt transitions of color and tone to underline and enforce the larger oppositions. With the *Brutus*, David can be said to have made dissonance and discontinuity into elementary constituents of picture-making. And this is entirely appropriate to a subject that concerns political and emotional conflicts which admit of no immediate resolution. "A new order is born from an excess of disorder itself," wrote Carra in 1787.[108] This could serve as a watchword for David's enterprise in the late 1780s. By 1789, he has extended fully the implications of the *Horatii*; a deliberate excess of disorder has become a new order with its own particular coherence and appropriateness.[109]

Without this audacity on the technical level, it is doubtful that David could have sustained the iconographic dislocations required by his unprecedented concentration of the narrative. For not only was the scene, like that of the *Horatii*, entirely his own invention, it involved the willful violation of readily available knowledge concerning Roman rituals of burial. Anger at this transgression of historical accuracy comes pouring out in the commentary of one hostile critic writing on the second public exhibition of the picture in 1791. "One cannot," he writes,

> without offending all the natural proprieties, suppose that Brutus, after having had his sons butchered, would have withdrawn to the room where his mother, wife, and two daughters were working; that next the bodies of the two sons would be carried through this same chamber to give them their burial. One can easily see from this one instance that the subject contains nothing truthful and that the artist was not then instructed in the nature of antique customs, since all the historians as well as the poets say that the Romans never buried their dead inside their cities. . . . If a play were replete with so many incoherencies, it would be intolerable; but in painting anything is allowed, because people are not at all in the habit of looking beyond the picture.[110]

What do we make then of what was indeed a colossal "mistake," a patent disregard for Roman custom (interment within the city was specifically forbidden in the Laws of the Twelve Tables) which any erudite Salon visitor would have recognized.[111] Two factors would seem to have been at work. First, the picture, among other things, is about the limits of erudition; David was obviously unconcerned about the reactions of a pedantic minority. Let them register their bookish complaints; the success of the picture would show him to be as little bound to their narrow constraints as to any others. Second and much more important, David's lack of iconographic correctness allows him to situate all the essential elements of the tragedy, in terms of both cast and narrative, within the domestic interior and thus within a single pictorial tableau. His first conception for the

picture had been, as for the *Horatii*, a public scene—the father's act of condemnation—but, just as he had in 1784, he retreated to the concentrated and emblematic space of the family circle.[112] The reproach of the critic of 1791 repeats a simple notion of the relationship between painting and tragic drama which had always worked against a true equivalence in depth and richness between the two narrative media. Painting, since it is denied the dimension of duration, was always impelled to search out the most pregnant moment for depiction. But if that choice was conceived as one from the literal narrative sequence of the text, picturing was always going to be deficient in relation to its text, a compromised and secondary expression, since literary form nowhere has to meet such demands for compression. In the *Horatii* and the *Brutus*, David refused that limitation, inventing his pregnant moments independently of his written sources. The results were pictures which grasped, in an unprecedented way, the elements of classical tragedy in pictorial terms and which far surpassed for example, in terms of sheer aesthetic quality, the contemporaneous dramas of Voltaire and Alfieri on the Brutus scheme.

I stress this last positive point to underline that the *Brutus* was far from being just a disruption and subversion of established artistic values; Pierre and Prud'hon had only got it half right. The picture would never have come to be had not David found an oppositional public to sustain his conceptual and technical audacity. Using that support, however, he was able to breathe life into a moribund genre. David's art represents yet another instance in which the "handling" of high-cultural materials by a broadly popular audience allowed an artist, who was attentive to that process, to push beyond the given limits of his genre and redefine its capacities. This was the case with Watteau and the once-secondary northern category of the pastoral music party; with Greuze and the domestic iconography likewise derived from lowland painting; and with David and classical history painting. And it is via these effects that we have charted the growing intersection between artistic interests at the highest social levels and the collective political life of the city. If, when seeking the exhibition public, we search for some stable entity, a coherent body of like-minded individuals we can assemble and count, the concept will dissolve in contradictions (and that remains just as much the case today as it was then). Yet, by 1789, a significant segment of the Salon audience had mastered the art world of Paris and put its intransigent champion in a position of unassailable superiority over his contemporaries. The emergence of that public over the course of the eighteenth century is traceable as a force of disruption and recombination, accommodated at intervals, but always exceeding and challenging the received categories of high culture. And how could it have been otherwise? A public audience in the ideal modern sense—articulate, independent, potentially resistant—was fundamentally at odds with the rigorously corporate character of Old-Regime high culture. The Salon audience never achieved positive recognition because there was no place for it in the interlocking network of definitions, maintained by the Academy and the state, which determined artistic values and purposes. But we can say that the public had arrived when disruption became the organizing principle of the dominant art of its time, for then the once-disenfranchised audience, via its representation as an oppositional public, had itself come to dominate.

POSTSCRIPT

THE initial agenda of this book was to map the expanding public sphere that surrounded French painting in the later seventeenth and eighteenth centuries, a sphere that was at once a discursive formation and a site of actual social practice. This inquiry has generated something of a parallel project, that is, a narrative history—selective to be sure—of the central artistic institutions of the period and several of its most prominent practitioners. The year 1789 obviously marks the end of this or any history of Old Regime painting. It just as decisively brings to an end this first stage in the formation of the modern public space for art. After this date, the connection between advanced painting and the demands of public life rapidly ceased to be a matter of resistance to cultural hierarchies, becoming rather one of expected and even legislated identity between the new, egalitarian political order and the practice of art. In 1791, in the first Salon of the Revolutionary period, David showed a highly finished drawing for a new kind of history painting. This was the *Oath of the Tennis Court* (Plate 122), an incident from the history that was being made in the present by the self-declared representatives of the body politic. The subject of the picture was the moment during the Estates-General of 1789 when the delegates of the Third Estate pledged to remain in permanent assembly until they had achieved a constitution for France: they would "die rather than disperse before France was free."[1] To capture the moment, David conceived a vastly multiplied oath of the Horatii, which now bound the assembled representatives of the nation to a new foundation of civil authority. Outside was the presumed menace of the King's troops, with orders, so the delegates feared, to interrupt their revolution by force. With the collective resolve and defiance of Brutus and Collatinus, they pledged their lives to the ending of tyranny.

The source of the commission was not the state, but an unofficial political body calling itself the "Society of the Friends of the Constitution," more commonly known, after its meeting place, as the Jacobin club. This was not, however, in these first years of the Revolutionary period, the sectarian party of Robespierre, but a capacious group whose membership included conservative monarchists as well as more visionary reformers. Its common cause was the advancement of constitutional rule, and in this spirit the commission to David (though certainly conceived by the artist prior to its collective acclamation in October 1790) was organized as an expression of the national will. The gargantuan final picture—the foreground figures were to be life-size—was to be paid for by 3,000 subscribers to the engraving of the image. The final destination of the painting was the hall of the National Assembly itself, and when the subscription campaign fell short, that body, on behalf of the nation, assumed direct responsibility for the project.

122. Jacques-Louis David, *The Oath of the Tennis Court*. 1791. Graphite, ink, sepia, heightened with white on paper, 65 × 105 cm. Musée national du Château de Versailles

Both act and image hark back to the antique models of patriotic fervor and sacrifice so powerfully emblematized by David in the previous three Salons. But the conception, subject, and patronage of the picture together cross a decisive boundary that divides Revolutionary art from even the most provocative images produced under the Old Regime. By 1790, the equation between the public good and the most advanced art was no longer a question of contested metaphor. In the *Oath of the Tennis Court*, the relationship was rather one of *a priori* identity: the event, the form of its depiction, the project's initial ratification by the Jacobins, the apparatus devised for its financial subsidy, and the planned installation of the canvas in the National Assembly were all parallel representations of one thing: the enactment of the public will.

David had chosen perhaps the one subject capable of generating such profound unity. And this literal identification between history painting and the public sphere appeared at that moment to be the only conceivable response of ambitious painting to the emerging new order. The veteran critic Charles Villette was not the only one to remark on the general failure of the painters to immortalize the heroic deeds of the previous two years: "We are somewhat surprised," he wrote, "to see in the Salon only one picture of the great events of the Revolution. Have the artists therefore not raised themselves to its exalted level?"[2] That failure seemed all the more acute given the fact that dissident artists had forced the abolition of the Academy's monopoly over the exhibition, and the most impatient new talents were thus theoretically free to make themselves known.

But this literal bonding of art and the primal moment of Revolutionary public life proved less a solution than a cul-de-sac for history painting. The lesson of David's exper-

123. Jacques-Louis David, *The Death of Marat*. 1793. Oil on canvas, 165 × 128 cm. Musées royaux des Beaux-Arts, Brussels

ience is that when the painter identifies his work completely with the contemporary public sphere, forsaking the distance of metaphor, that sphere will perpetually escape representation. This was the fate of the Tennis Court painting, which he abandoned in 1792 with only a few figures sketched in the nude. Completion of the project, giving form to the general will, would have required an impossibly stable political consensus. Especially after the King's attempted flight from France in June 1791 and the resulting split of the "Friends of the Constitution" into hostile monarchist and anti-monarchist factions, the accord dreamed of in 1789 became more chimerical than ever. The prominent position of the late Mirabeau, since revealed as a secret royalist conspirator, was already an issue at the time of the Salon. Who to put in, who to leave out? Which contemporary persons and actions would in the end represent the "public"? This was not a task that the atemporal and time-consuming medium of painting could perform.

David's own career, as is well known, moved toward the complete commitment of his talents to the demands of Jacobin rule. This meant leaving behind the confines of canvas and studio, however large, for the orchestration of mass symbolic behavior in the streets: the famous Revolutionary festivals that David planned and supervised. The commemorative festivities that followed the royalist assassinations of the regicide deputy Le Pelletier and the radical publicist Jean-Paul Marat, the "Friend of the People," occasioned his only completed memorials to the Revolution: the martyr portraits. His one surviving Revolutionary masterpiece, the depiction of the dead Marat in his bath (Plate 123), does therefore emerge from the attempt to make art unambiguously transparent to public life, in this case, to the struggle for a democratic order. But the immediate effect of that achievement was a regression from the precariously created space for *argument*, for the enfranchisement of competing voices, that had existed in the Old-Regime Salon.

The picture was unveiled on 16 October 1793 during a long funerary celebration organized by David's local political *section*. In the court of the old Louvre, the portrait of Marat was hung above one of a pair of sarcophagi alongside the earlier (now lost) portrait of Le Pelletier; a chapel-like structure had been erected above them, and the ritual line of march ended before the resulting double altar. The assembled celebrants sang funeral hymns before it and recited oaths of patriotic loyalty to the death.[3] The presentation of these images was thus distinctly pre-modern in character. David's painting of Marat, for all its complex personal engagement with the subject and proto-modernist daring of composition and handling, reverts to the status of coercive cult object.

But the fall of Robespierre in 1794 would remove David from power and end such attempts to collapse art into political ritual. Within a few years, he and others were at work reconstructing the capacity of art to address the public interest from its own distinct preserve. That reconstruction and its effects begin another phase in the public life of art.

NOTES

Introduction

1. Eighteenth-century estimates of total Salon attendance vary from *c.* 20,000 to 100,000 or more; see Richard Wrigley, "Censorship and Anonymity in Eighteenth-Century Art Criticism," *Oxford Art Journal*, VI, no. 2, p. 25 and note, for a discussion of these estimates. For a compact, useful survey of the history of the exhibitions, see J. J. Guiffrey, *Notes et documents inédits sur les expositions du XVIIIᵉ siècle*, Paris, 1886. A more recent account can be found in Georg Friedrich Koch, *Die Kunstausstellung*, Berlin, 1967, pp. 124–83. For a brief, well-documented discussion of the Salons between 1759 and 1781, see Udo van de Sandt, "Le Salon de l'Académie de 1759 à 1781," in Marie-Catherine Sahut and Nathalie Volle, *Diderot et l'art de Boucher à David*, Paris, 1984, pp. 79–84.

2. Louis-Sebastien Mercier, "Le Sallon (*sic*) de Peinture," *Le Tableau de Paris*, Amsterdam, IV, 1782–8, pp. 203–6; anonymous, "Entretiens sur les tableaux exposés au Sallon en 1783," n.p., 1783, pp. 6, 12.

3. "Note extraite du *Mercure de France*," Deloynes Collection, Cabinet des Estampes, Bibliothèque Nationale, Paris, no. 3, pp. 28–9. For this and all further references to texts and documents contained in this collection, consult Georges Duplessis, *Catalogue de la collection de pièces sur les beaux-arts imprimées et manuscrites recueillie par Pierre-Jean Mariette, Charles-Nicolas Cochin et M. Deloynes, auditeur des comptes, et acquise récemment par le départment des Estampes de la Bibliothèque nationale*, Paris, 1881.

4. For a survey of the process by which some state and aristocratic collections were opened to public view in this period, see Niels von Holst, *Creators, Collectors, and Connoisseurs*, B. Battershaw, trans., London, 1967, pp. 169–214.

5. "Lettres sur l'Académie Royale de Sculpture et de Peinture et sur le Salon de 1777," reprinted in *Revue Universelle des Arts*, XIX, 1864, pp. 185–6.

6. "Note extrait du *Mercure de France*," Deloynes no. 1203, p. 113.

7. [La Font de St.-Yenne], *Lettre de l'auteur des Réflexions sur la peinture et de l'examen des ouvrages exposés au Louvre en 1746*, n.p., n.d., Deloynes no. 22, p. 10.

8. [La Font de St.-Yenne], *Réflexions sur quelques causes de l'état présent de la peinture en France avec un examen des principaux ouvrages exposés au Louvre le mois d'aoust 1746*, The Hague, 1747.

9. See Duplessis, *Catalogue* for the most comprehensive listing. An early and basic work of bibliography is Anatole de Montaiglon, *Le Livret de l'exposition faite en 1673, dans la cour du Palais-Royal . . . suivi d'un essai de bibliographie des livrets et des critiques de Salon depuis 1673 jusqu'en 1851*, Paris 1851. The fundamental synthetic account of this literature has been Albert Dresdner, *Die Entstehung der Kunstkritik*, Munich, 1915, pp. 149–234. A more recent study of the first generation of Salon critics—misleadingly sketchy and questionable in some of its attributions—can be found in H. Zmijewska, "La Critique des Salons en France avant Diderot," *Gazette des Beaux-Arts*, 6th series, July/August 1970, pp. 1–144; see also her *La Critique des Salons en France au Temps de Diderot (1759–89)*, Warsaw, 1980. A more sophisticated treatment of the Salon literature between 1759 and 1781 is Else Marie Bukdahl, *Diderot, Critique d'Art*, J. Pilosz, trans., Copenhagen, 1981–2, II, pp. 161–358. For a highly informative discussion of the clandestine and semi-clandestine character of the majority of eighteenth-century art criticism, see Richard Wrigley, "Censorship and Anonymity in Eighteenth-Century French Art Criticism," pp. 17–28.

10. Marc-Antoine Laugier, *Essai sur l'architecture*, The Hague, 1753.

11. Reproduced in M. Tourneux, "Un Projet de journal de critique d'art en 1759," *Mélanges*

offerts à H. Lemonnier, Archives de l'art français, n.s., VII, 1913, p. 322.

12. Van de Sandt, "Le Salon de l'Académie," p. 82, has produced precise figures for the printing and sales of Salon *livrets* from 1759 to 1781. The number sold increased in fairly steady increments from 7,227 in 1759 to 17,550, in 1781.

13. Jean Locquin, *La Peinture d'histoire en France de 1747 à 1785*, Paris, 1912.

14. [La Font de St. Yenne], *Lettre de l'auteur*, 1747, p. 18.

15. [Charles-Nicolas Cochin], "Réflexions sur la critique des ouvrages exposés au Sallon du Louvre," extract from the *Mercure de France*, October, 1757, Deloynes no. 86.

16. For two examples of contemporary comment on the controversy, see the anonymous *Lettre sur la cessation du Sallon de peinture*, Cologne, 1749, Deloynes no. 40; Charles Collé, *Journal et Mémoires*, H. Bonhomme, ed., Paris, 1868, I, p. 232.

17. [L'abbé Leblanc], *Lettre sur l'exposition des ouvrages de peinture, sculpture, etc., de l'année 1747, et en général sur l'utilité de ces sortes d'expositions, à monsieur R. D. R . . .*, 1747, Deloynes no. 26.

18. [Leblanc], *Lettre*, p. 85; see manuscript note added to Deloynes copy, probably by Pierre-Jean Mariette.

19. See *Lettre sur la cessation*, 1749.

20. Quoted in Guiffrey, *Notes et documents*, p. 8.

21. For a somewhat harsh contemporary analysis of the move in these terms, see "Lettres écrites de Paris à Bruxelles sur le Salon de peinture de l'année 1748," *Revue Universelle des Arts*, X, 1859, pp. 435ff.

22. [Cochin], 1757, p. 12; see also [Leblanc], *Observations sur les ouvrages de MM. de l'Académie de peinture et de sculpture exposés au Sallon du Louvre en l'année 1753, et sur quelques écrits qui ont rapport à la peinture. A Monsieur le président de B***, n.p., 1753, pp. 57–61.

23. Reproduced in Tourneux, "Un Projet de journal de critique d'art," p. 324.

24. The pamphlet in question was *Lettre sur les peintures, gravures et sculptures qui ont été exposés cette année au Louvre, par M. Raphael, peintre, de l'Académie de St. Luc, entrepreneur général des Enseignes de la ville, fauxbourgs et banlieue de Paris, à M. Jérosme, son ami, rapeur de tabac et riboteur*, Paris 1769, Deloynes no. 123; see manuscript note to Deloynes copy by Mariette. On the suppression of uncensored Salon critiques see manuscript note by Cochin to the Salon *livret* of 1767, Deloynes no. 114; also *Mémoires secrets pour servir à l'histoire de la république des lettres en France depuis 1762 jusqu'à nos jours*, London, 1777–89, 7 September, 1773.

25. For later examples, see the anonymous *Le littérateur au Sallon, l'examen du paresseux suivi de la critique des critiques. Au Sallon et se trouve à Paris chez Hardouin*, 1779, Deloynes no. 216; anonymous, *Rafle de Sept ou Réponse aux Critiques du Sallon*, The Hague, 1781, Deloynes no. 266; anonymous, *Réponse à toutes les critiques sur les Tableaux du Sallon de 1783 par un frère de la Charité*, "a Rome," 1783.

26. [Cochin], "Réflexions." See also [Leblanc], *Observations*, pp. 57–61, for an extended version of the same argument.

27. [La Font], *Lettre de l'auteur*, 1747.

28. Charles Coypel, "Dialogue de M. Coypel, premier peintre du Rois sur l'exposition des Tableaux dans le Sallon du Louvre en 1747," extract from the *Mercure de France*, November 1751, Deloynes no. 28, pp. 5–6.

29. [La Font], *Réflexions*, p. 12.

30. [La Font], *Sentimens sur quelques ouvrages de peinture, sculpture et gravure écrits à un particulier en province*, n.p., 1754.

31. See Albert Babeau, *Les Bourgeois d'autrefois*, Paris, 1886, pp. 83–5.

32. See Locquin, *La Peinture d'histoire*, p. 7.

33. *Lettre sur la cessation*, p. 27.

34. See below, chapter V.

35. [Leblanc], *Observation*, pp. 63, 65, 105–6.

36. For an overview of this industry see the essays of Robert Darnton collected in *The Literary Underground of the Old Regime*, Cambridge, Massachusetts, 1982.

37. *L'Ombre du grand Colbert*, Paris, 1751.

38. [Cochin], *Réflexions*, p. 12.

39. *Lettre sur la cessation*, pp. 6, 8.

40. [Cochin], *Réflexions*, p. 12.

41. See John Lough, *Paris Theatre Audiences in the 17th and 18th Centuries*, Oxford, 1957, pp. 178–81.

42. Grimod de la Reynière, *Le Censeur dramatique*, Paris, 1797–8, II, pp. 120–1; quoted by Lough, *Theatre Audiences*, p. 219.

43. Anonymous, *Dialogues sur la peinture, seconde édition, enrichie de notes*, Paris, 1773, pp. 19, 30. Taraval's sketches were "Apotheosis of Psyche", "Hercules, Pan, and Syrinx," and "Sunrise Accompanied by the Hours Led by Cupid."

44. "Lettres écrites de Paris à Bruxelles," 1748, p. 435.

45. For example, see Louis Carrogis, called Louis de Carmontelle, *Le Frondeur ou Dialogues sur le Sallon par l'auteur du Coup-de-patte et du Triumvirat*, n.p., 1785, Deloynes no. 329, pp. 19–20.

46. *Dialogues*, 1773, pp. 42–3.

47. *Mémoires secrets*, 25 August, 1777.
48. Carmontelle's Salon critiques can be found in the Deloynes collection, nos. 202, 263, 305, 329, and 415. All were published anonymously but each one contains some reference in its title page to the title of the 1779 pamphlet, *Coupe de patte sur le sallon de 1779.* All are explicitly announced as the work of the same author. Carmontelle is identified as the author of the 1781 pamphlet in the *Mémoires secrets*, (6 October, 1781), and one other Salon critique (anonymous, *Le Pourquoi ou l'ami des Artistes*, Geneva, 1781, pp. 10–11), both of which describe Carmontelle as the "Coup-de-Patte" author at length and in no uncertain terms. The biographies of Carmontelle are few and brief; see A. Augustin-Thierry, *Trois Amateurs d'Autrefois, Paradis de Moncrif, Carmontelle, et Charles Collé*, Paris, 1924; Carmontelle, *Comédies et Proverbes*, Louis Thomas, ed., Paris, 1941. Richard Wrigley has recently disputed this by now traditional attribution (*Criticism of Contemporary Art in Eighteenth-century France (1739–1789): a thematic study*, unpublished D. Phil dissertation, Oxford, 1983, pp. 318–22) and reattributed the "Coup-de-Patte" series to a young musician and polemicist L.-F.-H. Lefébure. He bases his case on an 1839 obituary written for the latter by one M. Voiart in Nancy ("Notice historique et biographique sur M. Lefébure, ancien sous-préfet à Verdun et membre de l'Académie de Nancy," *Mémoires de la Société Royale des Sciences, Lettres et Arts de Nancy*, 1840, pp. 233–4). The relevant part of the single sentence in question reads, "On vît aussi paraître une suite d'articles sur le salon de l'exposition des tableaux, qui furent publiés sous le titre de *Coup de Patte* sur le salon de 1788. . . ." Since there was no Salon in 1788, and the *Coup de Patte* was published in 1779, we are dealing with an imprecise memory recalled a half century after the supposed event. There is a "Coup-de-Patte" pamphlet of 1787, Deloynes no. 378, entitled *Encore un coup de patte pour le dernier ou Dialogue sur le Salon de 1787*, which is at least close in date and title to the work recalled by Voiart. The title page also lacks any explicit credit to the author of the original *Coup de Patte* of 1779, which all the others include. This is the only one attributed to Lefébure by Montaiglon (*Le Livret de l'exposition . . .*, p. 47). The author's statement (p. 6) that he had five times written antagonistic pamphlets on the Salon might be used to argue for his having produced the whole series, but the wording of that statement implies a series that would have begun in 1777, not 1779 when the first "Coup-de-patte" critique appeared. Such a claim would be consistent with the work of an imitator. The author also declares that his pamphlet would be his last. Wrigley has not, however, disputed my previous characterization of the pamphlets nor my argument for their special importance as documents (in Crow, "The *Oath of the Horatii* in 1785", *Art History*, I, December 1978, pp. 424–71 and chapters VI and VII below). Recent scholarship is otherwise generally unanimous in accepting Carmontelle's authorship of the series: see J. Seznec, *Diderot: Salons*, Oxford, 1967, IV, p. 305; R. Michel, *David et Rome*, Académie de France à Rome, 1981, pp. 118, 128; Bukdahl, *Diderot, Critique d'Art*, II, pp. 310ff.; Annie Becq, "Expositions, peintres, et critiques, vers l'image moderne de l'artiste," *Dix-huitième siècle*, no. 14, (1982), pp. 131–50; R. May, *Diderot et la critique du Salon*, Musée du Breuil de Saint-Germain, Langres, 1984, p. 173. Zmijewka, *La Critique des Salons*, pp. 99–108, re-attributes the pamphlets to Lefébure solely on (entirely undemonstrated) stylistic grounds.

49. [Carmontelle], *Le Triumvirat des Arts ou Dialogue entre un peintre, un musicien et un poëte sur les tableaux exposés au Louvre—Année 1783—pour servir de continuation au "Coup de Patte" et à la "Patte de velours"*, "Aux Antipodes," 1783, pp. 3, 4.

50. J. P. Marat, *Les Charlatans moderns, ou lettres sur le charlatanisme académique, publiées par M. Marat, l'Ami du peuple*, Paris, 1791, p. 18. (This pre-Revolutionary pamphlet was reprinted by Marat in 1791.)

51. [Carmontelle], *Coup de patte sur le sallon de 1779. Dialogue précédé et suivi de réflexions sur la peinture*, "A Athènes et se trouve à Paris chez Caileau," 1779, pp. 6–7.

52. [Carmontelle], *Le Frondeur*, p. 1.

53. Mercier, "Sallon de Peinture," pp. 203–6; the same seamless joining of these two views of the Salon audience can be found in anonymous, *Lanlaire au Salon académique de peinture par M.L.B . . . de B . . . de plusieurs académies, auteur de la Gazette infernale*, Paris, 1787, p. 9.

CHAPTER I

1. The primary source for the history of the early Academy is the anonymous *Mémoires pour servir à l'histoire de l'Académie royale de peinture et sculpture depuis 1648 jusqu'en 1664*, (Anatole de Montaiglon, ed., Paris, 1853), most probably written by the Academy's secretary during most of those years, Henri Testelin. The best modern history is Ludovic Vitet, *L'Académie royale de peinture et sculpture, étude historique*, Paris, 1861. Most of the brief account provided here is

derived from these sources. For further documentation, see Bernard Teyssèdre, *Roger de Piles et les débats sur le coloris au siècle de Louis XIV*, Paris, 1964. On the colony of Flemish artists in Paris, see Montaiglon, "Confrérie de la nation flamande à Saint-Hyppolite et à Saint-Germain-des-Près de Paris (1626–1691)," *Nouvelles archives de l'art français*, XXIII, 1877, pp. 158–63; also the abbé Jean Gaston, *Saint-Hyppolite*, Paris, 1908, pp. 51–3. On the independent guilds of the Saint-Germain quarter, see J. J. Guiffrey, "La Maîtrise des peintres à Saint-Germain-des-Prez (sic)," *Nouvelles Archives de l'art français*, XXII, 1876, pp. 93–123.

2. There are innumerable historical accounts of the Fronde. For one which concentrates on the role of the Paris Parlement, see A. Lloyd Moote, *The Revolt of the Judges: The Parlement of Paris and the Fronde, 1643–1652*, Princeton, 1971.

3. *Mémoires pour servir à l'histoire de l'Académie*, pp. 38–9.

4. Vitet, *L'Académie*, p. 72.

5. For a brief discussion of previous artistic theory in France, primarily architectural theory, see A. Fontaine, *Les Doctrines d'art en France de Poussin à Diderot*, Paris, 1909, pp. 1ff. On the state of discussion concerning painting in France during the first half of the seventeenth century, and for the best overview of the history of French connoisseurship in the late seventeenth and eighteenth centuries, see the excellent study by Louis Olivier, *"Curieux," Amateurs, and Connoisseurs: Laymen and the Fine Arts in the Ancien Régime*, unpublished Ph.D. dissertation, Johns Hopkins University, 1976, pp. 55ff and passim.

6. It is interesting to note that Chambray, before beginning his discussion, feels it necessary to provide his readers with extended definitions of such exotic terminology as "estampe," "esquisse," "élève," and "attitude (of a figure)" (*Idée de la Perfection de la Peinture*, Paris, 1662, pp. ii–vi). On the legal status of the academicians, see Olivier, *Curieux*, pp. 67–71.

7. See Georges Dethan, *Gaston d'Orléans: Conspirateur et prince charmant*, Paris, 1959, pp. 319–20.

8. For a summary of literature on the princely *Kunstkammer* see Thomas DaC. Kaufmann, "Remarks on the Collection of Rudolf II: the *Kunstkammer* as a Form of *Representatio*," *Art Journal*, XXXVIII, Fall, 1978, pp. 22–8; Elisabeth Scheicher, *Die Kunst- und Wunderkammern der Habsburger*, Vienna, 1979.

9. Pierre Borel, *Les Antiquitez, raretez, plantes, minéraux et autres choses considérables de la ville et du comté de Castres d'Albigeois (contenant une liste des cabinets curieux de l'Europe)*, Castres, 1665, pp. 133–49.

10. See Olivier, *Curieux*, pp. 59–61.

11. Antoine Schnapper, colloquium lecture, the Institute for Advanced Study, Princeton, November, 1983.

12. On Poussin's patrons, see Anthony Blunt, *Nicolas Poussin*, New York, 1967, I, pp. 213ff. On the *nobles hommes* and their culture, see the excellent study by George Huppert, *Les Bourgeois Gentilshommes: An Essay on the Definition of Elites in Renaissance France*, Chicago, 1977.

13. On Sorbière, see René Pintard, *Le Libertinage érudit dans le première moitié du XVIIᵉ siècle*, Paris, 1943, pp. 334ff., 418ff., 552ff. Sorbière's remarks appear in his "Lettre IX, à Monsieur Boucherat, conseiller du Roy en ses Conseils d'Estat et Privé, et Maistre des Requestes de son Hostel. De l'excessive curiosité en belles Peintures," in *Relations, lettres et discours de Mr. de Sorbière sur diverses matières curieuses*, Paris, 1660, pp. 235–69; see also Olivier, *Curieux*, pp. 31–3.

14. Sorbière, *Relations*, pp. 257–9.

15. Fréart de Chambray, *Idée de la perfection de la peinture*, Paris, 1662, preface.

16. See Teyssèdre, *Roger de Piles*, pp. 121–3.

17. *Procès-verbaux de l'Académie royale de peinture et de sculpture, 1648–1792*, Anatole de Montaiglon ed., Paris, 1875–92, (31 August, 1669); see also Teyssèdre, *Roger de Piles*, p. 123.

18. See A. Fontaine, *Les Collections de l'Académie Royale de Peinture et de Sculpture*, Paris, 1910, passim.

19. See Fontaine, *Collections*, pp. 43ff; the text of article XXV (with the rest of the 1663 statutes) can be found in Vitet, *L'Académie*, p. 270.

20. *Procès-verbaux*, (5 July, 1664).

21. See *Procès-verbaux*, (25 August, 1664; 27 June, 1665; 4 July, 1665).

22. See *Mémoires inédits et opuscules de Jean Rou (1638–1711)*, Francis Washington, ed., Paris, 1857, II, p. 19; also Teyssèdre, *Roger de Piles*, pp. 634.

23. Rou, *Mémoires*, II, pp. 17–18.

24. See for example *Entretiens sur les Tableaux exposés au Sallon en 1783 ou Jugement de M. Quil, Lay, procureur au Châtelet et son épouse, madame Fi, delle, et mademoiselle Descharmes, nièce de maître Lami, et de M. Dessence, apothicaire-ventilateur*, n.p., 1783, Deloynes no. 300.

25. *Procès-verbaux*, (28 March, 1671).

26. *Liste des Tableaux et pièces de sculpture exposés dans la Cour du Palais Royal par messieurs les peintres et sculpteurs de l'Académie royale (1673)*, Deloynes no. 1.

27. *Procès-verbaux*, (26 February, 1673).

28. See, for example, A. Blunt, *Art and Architecture in France 1500–1700*, Harmondsworth, 1973,

p. 361. Teyssèdre, *Roger de Piles*, provides an exhaustive account of the debate.

29. See Teyssèdre, *Roger de Piles*, pp. 459–67, on the transition. On the inaugural conferences of de Piles, see the *Procès-verbaux*, (6 July, 1699), also Olivier, *Curieux*, pp. 91–3. The text makes plain that de Piles no longer sees his role as one of advocate for color in relation to line; he is now after a universal body of theory.

30. See the accounts of the Salons of 1737 and 1738 from the *Mercure de France*, Deloynes nos. 1203 and 1207.

31. *Liste des tableaux et des ouvrages de sculpture exposés dans la grande galerie du Louvre par MM. les peintres et sculpteurs de l'Académie royale en la présente année 1699*, Paris, 1699, p. ii, Deloynes no. 2.

32. *Liste des tableaux et des ouvrages. . .*, Paris, 1704, p. ii, Deloynes no. 4.

33. *Liste des tableaux et des ouvrages . . .*, 1699, p. 3–4.

34. Florent Le Comte, *Cabinet des singularitez d'architecture, peinture, sculpture, et gravure*, Paris, 1700; his account of the Salon appears on pp. 241–69, the discussion of the frames on pp. 245–6.

35. See the *Mercure* review, Deloynes no. 1190, Ms.

36. On de Piles' pension, see Teyssèdre, *Roger de Piles*, p. 519; on Crozat as collector, patron, and art-world entrepreneur, see M. Stuffman, "Les Tableaux de la collection de Pierre Crozat," *Gazette des Beaux-Arts*, 6th series, LXXII, 1968, pp. 1–144; for a briefer overview of Crozat's career, see Barbara Scott, "Pierre Crozat: a Maecenas of the Régence," *Apollo*, XCVII, January, 1973, pp. 11–19.

37. See Stuffman, "Les Tableaux de Crozat," p. 13.

38. P. J. Mariette, *Description sommaire des dessins des grands maîtres d'Italie, des Pays-Bas et de France au cabinet de feu M. Crozat*, Paris, 1741, p. ix.

39. See l'abbé Du Bos, *Réflexions critiques sur la poésie et sur la peinture*, Paris, 1719; On the subsequent careers of Caylus and Bachaumont, see chapter IV.

40. See F. Haskell, *Patrons and Painters*, New Haven and London, 1980, pp. 284–5, 341.

41. On the crucial role of Crozat in the acquisition of the core of the Regent's collection, see the extensive correspondence concerning the sale between Crozat and the French ambassador, the marquis de Torcy, and between the *Surintendant* d'Antin and the Director of the French Academy in Rome, Charles Poerson, published in *Correspondance des directeurs de l'Académie de France à Rome avec les Surintendants des Bâtiments*, Montaiglon and Guiffrey, eds., III, 1887, pp. 362–90.

42. Joachim C. Nemeitz, *Séjour à Paris, c'est à dire, Instructions Fidèles pour les Voyageurs de Condition*, Leiden, 1727, pp. 384, 37.

43. Dubois de Saint-Gelais, *Description des Tableaux du Palais Royal avec La Vie des Peintres à la tête de leurs Ouvrages, dédié à M. le Duc d'Orléans, Premier Prince du Sang*, Paris 1727.

44. Dubois de Saint-Gelais, *Description des Tableaux*, p. viii.

45. Dubois de Saint-Gelais, *Description des Tableaux*, pp. i ff.

46. Dubois de Saint-Gelais, *Description des Tableaux*, p. viii.

47. Jean Chatelus, "Thèmes picturaux dans les appartements de marchands et artisans parisiens au XVIIIᵉ siècle," *Dix-Huitième siècle*, no. 6, 1974, pp. 302–24.

48. Chatelus, "Thèmes picturaux . . .," p. 315.

49. Chatelus, "Thèmes picturaux . . .," p. 318.

50. [J. B. La Curne de Sainte-Palaye], *Lettre de M. de S. P. à M. de B. sur le bon goût dans les arts et dans les lettres*, Paris, 1751, p. 8; (reprint, Geneva, 1972).

51. Chatelus, "Thèmes picturaux . . .," p. 315.

52. Quoted in M. J. Dumesnil, *Histoire des plus célèbres amateurs français et de leurs liaisons avec les artistes, Pierre-Jean Mariette, 1694–1774*, Paris, 1858, I, pp. 46–7; see Gossman, *Medievalism and the Ideologies of the Enlightenment*, Baltimore, 1968, p. 131.

53. J. B. d'Argens, *Lettres Juives*, The Hague, 1754, VII, pp. 226–7.

54. See Georges Wildenstein, "Le Goût pour la peinture dans le cercle de la bourgeoisie parisienne, autour de 1700," *Gazette des Beaux-Arts*, 6th series, XLVIII, September, 1965, pp. 113–94; this earlier survey of notaries' inventories tends to support this interpretation. Wildenstein chose a selected number of Parisian districts and accumulated records of privately owned works of art for the entire first half of the eighteenth century. Besides the wider time frame, the principal difference between this and the Chatelus study was that it included petty noble, *parlementaire*, and *rentier* individuals as well as merchants and artisans. Some of the results tally—the prints encountered most frequently by Wildenstein were Gérard Audran's renderings of Le Brun's Battles of Alexander. But there are significant differences, among them the presence of several dozen painted copies of Watteau, some as early as 1710. A good number of mythological subjects turn up as well, but only in the hands of the nobility or the magistrature.

55. See D. Posner, *Antoine Watteau*, London, 1984, p. 124.

Chapter II

1. E. F. Gersaint, "Abrégé de la vie d'Antoine Watteau," *Catalogue raisonné des diverses curiosités du cabinet de feu M. Quentin de Lorangère*, Paris 1744, p. 173. The eighteenth-century biographies of the artist have been collected in an appendix to Hélène Adhémar, *Watteau, sa vie—son œuvre*, Paris, 1950; Gersaint's text appears on pp. 169–72. The best collection of the early biographies is the annotated edition of P. Champion, *Notes critiques sur les vies anciennes d'Antoine Watteau*, Paris, 1921; I have kept my references, however, to the far more accessible Adhémar.

2. For a recent overview of the documents and literature on these fairs during the eighteenth century, see Robert M. Isherwood, "Entertainment in the Parisian Fairs in the Eighteenth century," *Journal of Modern History*, LIII, March, 1981, pp. 24–47.

3. Charles Sorel, *Polyandre, histoire comique*, Paris, 1648, p. 473.

4. Sorel, *Polyandre*, p. 456.

5. See *Les Œuvres de théâtre de M. Dancourt*, Paris, 1760, IV, pp. 276–358.

6. Nemeitz, *Séjour à Paris*, p. 170.

7. Nemeitz, *Séjour à Paris*, pp. 180–3.

8. On the Flemish colony and its guild, see above, Chapter 1, note 1.

9. See Louis Hourticq, "Les Parisiens aux Salons de peinture," *La Vie parisienne au XVIIIe siècle, Conférences du Musée Carnavalet*, Paris, 1928, p. 212.

10. See Anita Brookner, *Greuze*, Greenwich, Conn., 1972, pp. 38–42; also Oliver Banks, *Watteau and the North*, New York, 1977, pp. 60-105.

11. Chatelus, "Les Thèmes picturaux," pp. 319–20.

12. Wildenstein, "Le Goût pour la peinture," p. 133.

13. Nemeitz, *Séjour à Paris*, pp. 183–4.

14. Sorel, *Polyandre*, p. 473.

15. Nemeitz, *Séjour à Paris*, pp. 182–3.

16. "La Vie de Watteau par le comte de Caylus," delivered at a session of the Academy of Painting and Sculpture, 3 February, 1748; reprinted in Adhémar, *Watteau*, p. 176.

17. Nemeitz, *Séjour à Paris*, pp. 172–3.

18. There is a long tradition of scholarship on the fair theaters and their relationship to the Comédie française. It begins in the eighteenth century with the Parfaict brothers, *Mémoires pour servir à l'histoire des spectacles de la foire*, Paris, 1743, and includes: Jules Bonnaissies, *Les Spectacles forains et la Comédie française*, Paris, 1875; Emile Compardon, *Les Spectacles de la foire, documents inédits recueillis aux Archives Nationales*, Paris, 1877 (reprint Geneva, 1970); Maurice Albert, *Les Théâtres de la Foire (1660–1789)*, Paris, 1900; Mary Scott Burnet, *Marc-Antoine Legrand, acteur et auteur comique (1673–1728)*, Paris, 1938; O. G. Brockett, "The Fair Theatres of Paris in the Eighteenth Century: The Undermining of the Classical Ideal," in M. J. Anderson, *Classical Drama and its Influence, Essays Presented to H. D. F. Kitto*, New York, 1965, pp. 249–70.

19. Nemeitz, *Séjour à Paris*, pp. 180–2.

20. See Parfaict, *Mémoires*, I, pp. 63–4, 100–1, 108–10, 137; also Burnet, *Marc-Antoine Legrand*, pp. 81–5.

21. Nemeitz, *Séjour a Paris*, pp. 180–2.

22. Quoted in Pierre Mélèse, *Le Théâtre et le public sous Louis XIV, 1659–1715*, Paris, 1934, p. 59n.

23. See Burnet, *Marc-Antoine Legrand*, p. 89.

24. Dubois de St. Gelais, *Histoire journalière de Paris*, January–March, 1717, pp. 76–7.

25. See Brockett, "The Fair Theatres of Paris," passim; for an excellent account of the interpenetration and exchange between elite and popular theater in the later eighteenth century, see Michele-Marie Root-Bernstein, *The Revolution of the Boulevard: Parisian Popular Theater in the Late Eighteenth Century*, unpublished Ph.D. dissertation, Princeton, 1981, pp. 83ff.

26. See H. G. Harvey, *The Theater of the Basoche*, Cambridge, Mass., 1941; Natalie Zemon Davis, *Society and Culture in Early Modern France*, Stanford, 1975, p. 111. For a more general discussion see Peter Burke, *Popular Culture in Early Modern Europe*, New York, 1978, pp. 22ff.

27. Mikhail Bakhtin, *Rabelais and his World*, Hélène Iswolsky, trans., Cambridge, Mass., 1968, pp. 107–44.

28. Norbert Elias, *The History of Manners: The Civilizing Process*, Edmund Jephcott, trans., New York, 1978, I, p. 16.

29. See Burnet, *Marc-Antoine Legrand*, p. 89.

30. Antoine de Léris, *Dictionnaire portatif, historique et littéraire des Théâtres*, Paris, 1763, pp. 332–3.

31. See J. E. Gueullette, *Un Magistrat du XVIIIe siècle, ami des lettres, du théâtre, et des plaisirs, Thomas-Simon Gueullette*, Paris, 1938; quotation appears on p. 63.

32. On Caylus' large contribution to the vogue for mock-popular literature among the Parisian elite, as well as for regular mock-academies in which learned discourse was parodied in *poissard* dialect, see A. P. Moore, *The Genre Poissard and the French Stage of the Eighteenth Century*, New York, 1935, pp. 92–125.

33. Eugène-François Lintilhac, *Histoire générale du théâtre en France*, Paris, 1904–11, IV, p. 379.

34. Quoted in Gueullette, *Un Magistrat au XVIIIe siècle*, p. 69.

35. See, for example, D. Posner, "The Swinging

Women of Watteau and Fragonard," *Art Bulletin*, LXIV, March, 1982, p. 77.

36. See Caylus, in Adhémar, *Watteau*, p. 181; René Démoris, "Les Fêtes galantes chez Watteau et dans le roman contemporain," *Dix-huitième siècle*, 1971, p. 354.

37. On Gillot and his relationship to Watteau, see B. Populus, *Claude Gillot*, Paris, 1930.

38. See Populus, *Gillot*, pp. 24–34.

39. Nemeitz, *Séjour à Paris*, p. 175.

40. See Populus, *Gillot*, pp. 24–34; also Emile Dacier and Albert Vuaflart, *Jean de Jullienne et les graveurs de Watteau au XVIIIᵉ siècle*, Paris, 1929, I, p. 17.

41. On Claude III Audran's surviving designs, see Carl David Moelius, "The Carl Johan Cronstedt Collection of Drawings by Claude Audran," *Gazette des Beaux-Arts*, 6th series, XXVIII, October 1945, pp. 237–56; on Audran and Watteau, see Dacier and Vuaflart, *Jean de Jullienne*, pp. 17ff; on the French antecedents of Audran's *arabesque* or *grotesque* mode and their links to Renaissance and antique prototypes, see Roger-Armand Wiegert, *Jean I Bérain: Dessinateur de la chambre et du cabinet du Roi (1649–1711)*, Paris, 1937, pp. 193–219; on Watteau's *arabesques*, see L. de Fourcaud, "Antoine Watteau, peintre d'arabesques," *Revue de l'art ancien et moderne*, XXIII, December 1908, pp. 431–40, January 1909, pp. 49–59, XXV, February 1909, pp. 129–40.

42. See Populus, *Gillot*, pp. 27–8; see also entry on a painting by Gillot (private collection) based on Fuzelier's 1905 production, *The Abduction of Helen*, in E. Zafran, *The Rococo Age*, Atlanta, 1983, p. 110.

43. The classic compendium is H. W. Janson, *Apes and Ape Lore in the Middle Ages and the Renaissance*, London, 1952.

44. Nemeitz, *Séjour à Paris*, pp. 177–8.

45. See Champion, *Notes critiques*, p. 82.

46. See Calvin Seerveld, 'Telltale Statues in Watteau's Painting," *Eighteenth-Century Studies*, XIV, Winter 1980–1, pp. 152–5; see also Posner, "Swinging Women," on the theme of the swing in early eighteenth-century painting.

47. See Seerveld, "Telltale statues," pp. 152–5; also Démoris, "Les Fêtes galantes," pp. 352–3; on the links between Watteau's imagery and earlier pastoral allegory, see Mussia Eisenstadt, *Watteaus Fêtes Galantes und ihre Ursprunge*, Berlin, 1930, pp. 85ff.

48. Caylus, in Adhémar, *Watteau*, p. 181.

49. See Banks, *Watteau and the North*, pp. 151–230.

50. Banks, *Watteau and the North*, pp. 52–3.

51. See Barbara Scott, "The Comtesse de Verrue: A Lover of Dutch and Flemish Art, *Apollo*, XCVII, January, 1973, pp. 20–4; on the link between Watteau and Rubens' *Garden of Love*, see Seerveld, "Telltale Statues," p. 160.

52. See Annegret Glang-Süberkrüb, *Der Liebesgarten: eine Untersuchung über die Bedeutung der Konfiguration für das Bildthema im Spätwerk des Peter-Paul Rubens*, Bern, 1975, pp. 13ff.

53. Bakhtin, *Rabelais and his World*, pp. 115–19.

54. Dora Panofsky, "Gilles or Pierrot? Iconographic Notes on Watteau," *Gazette des Beaux-Arts*, 6th series, XXXIX, May–June, 1952, pp. 324–37.

55. A. P. de Mirimonde, "Les Sujets musicaux chez Antoine Watteau," *Gazette des Beaux-Arts*, 6th series, LVIII, November, 1961, pp. 272–6.

56. Only Démoris has suggested this line of interpretation; see his "Les Fêtes galantes," p. 354.

57. It is worth noting certain technical peculiarities which bear the traces of this passage from, we might say, simple to complex allegory. There is Watteau's habitual practice, as Caylus informs us, of conceiving the landscape and figural elements separately from one another: first he would paint the complete landscape setting, then paint the figures on top of it. Even the latter were not developed as unified groupings, but were most often taken whole from his drawings of single or paired figures. In terms of procedure, he had travelled no great distance from his additive copying after Gillot in the *Departure of the Italian Comedians*. Figures are often repeated from picture to picture. As Norman Bryson (*Word and Image: French Painting of the Ancien Régime*, Cambridge, 1981, p. 84) and others have observed, the compositional management of more than two linked figures can cause him considerable difficulty. Delacroix found the same use of fixed and interchangeable types in the landscape as well: "With Watteau," he wrote in his journal in 1854 (*Journal de Eugène Delacroix*, A. Joubin, ed., Paris, 1932, II, pp. 219–20), "the trees are always done according to a formula: they are always the same trees and they remind one of theater décor rather than the trees in a forest. A picture by Watteau put beside an Ostade or a Ruysdael loses a great deal. The artificiality becomes glaring." How much Watteau loses depends of course on what one is looking for. The inherent "imperfection" of Watteau's working methods, which recall the naive and theatrical and are inseparable from his professional history, is precisely what made them so open to the play of meaning present in the lives of his clients. They could, at times however, get him into real technical difficulty, as in two related images in the Wallace Collection, The *Champs Elysées*, and its larger re-working, the *Fête in a Park*. Bryson (p. 259 n. 81) has pointed out how, in the smaller version, the "uncertainty

of ground plan, uneven massing, and reliance on filling intervening spaces with crude grass notation recall the rudimentary solutions of naive painting." What is true there is even more emphatically the case when the composition is expanded and augmented in the second version.

58. The most comprehensive general study of this phenomenon is M. Magendie, *La Politesse mondaine et les théories de l'honnêteté en France au XVIIᵉ siècle de 1600 à 1660*, Paris, 1925; for a recent review of the subject see Domna C. Stanton, *The Aristocrat as Art*, New York, 1980.

59. See Nicolas Faret, *L'Honnête homme ou l'art de plaire à la cour, édition critique*, M. Magendie, ed., Paris, 1925.

60. See Huppert, *Les Bourgeois gentilshommes*, pp. 162ff.

61. See Antoine Gombard Méré, *Lettres*, 2 vols., Paris, 1689; also *Œuvres posthumes*, C. Boudhors, ed., Paris, 1930.

62. Pierre Lenet, "Mémoires," in *Nouvelle collection des mémoires sur l'histoire de France*, J. P. Michaud and J. J. Poujoulat, eds., 3rd series, Paris, 1850, II, pp. 230-1; see also John Lough, *Writer and Public in France*, Oxford, 1978, p. 140.

63. Méré, *Lettres*, p. 350; see also Stanton *The Aristocrat as Art*, pp. 119-20.

64. Vincent Voiture, *Poësies, édition critique*, H. Lafay, ed., Paris, 1971, I, p. 26.

65. See Gustave Lanson, *Choix des lettres du XVIIe siècle*, Paris, 1906, p. 67.

66. See Faret, *L'Honnête homme*, p. 24. On the general hostility to learning among the old nobility in the seventeenth century, see Magendie, *La Politesse mondaine*, p. 725; Lough, *Writer and Public*, pp. 137-8.

67. See Lough, *Writer and Public*, p. 147.

68. In E. Gherardi, *Recueil de toutes les comédies et scènes françaises jouées par les comédiens italiens du roi*, Paris, 1741, VI, p. 525; this text has been linked to Watteau by Julie Ann Plax in "Watteau's *Voulez-Vous*: An Interpretation and Inquiry into the Theme of Love," unpublished M.A. thesis, University of Missouri, 1979.

69. Plax, "Watteau's *Voulez-Vous*."

70. On the rudimentary interest in painting among the mid-century *honnêtes gens*, see Anthony Blunt, "The *Précieux* and French Art," *Fritz Saxl: A Volume of Memorial Essays from his Friends in England*, D. J. Gordon, ed., London, 1957, pp. 326-38.

71. See Posner, *Antoine Watteau*, pp. 116ff.

72. *L'Œuvre d'Antoine Watteau, Peintre du Roy, gravé d'apres ses Tableaux et ses Dessins originaux tirez du Cabinet du Roy et des plus curieux de l'Europe par les soins de M. de Jullienne*, Paris, 2 vols., n.d.; the monumental study of the *recueil* is Dacier and Vuaflart, *Jean de Jullienne*.

73. On sale prices, see P. Rosenberg and E. Camesasca, *Tout l'œuvre peint de Watteau*, Paris, 1970.

74. Quoted in R. Raines, "Watteau and 'Watteaus' in England before 1760," *Gazette des Beaux-Arts*, 6th series, LXXXIX, 1977, p. 51.

75. See Raines "Watteau and 'Watteaus'," p. 52.

Chapter III

1. See Pierre Rosenberg, "Le Concours de peinture de 1727," *Revue de l'Art*, no. 37, 1977, pp. 29-42; on the Salon d'Hercule commission, see Jean-Luc Bordeaux, "François Le Moyne's Painted Ceiling in the 'Salon d'Hercule' at Versailles: A Long Overdue Study," *Gazette des Beaux-Arts*, 6th series, LXIII, May–June, 1974, pp. 301-18.

2. See J. Silvestre de Sacy, *Le Comte d'Angiviller, dernier directeur général des Bâtiments du Roi*, Paris, 1953, p. 55n.

3. *Explication des peintures, sculptures et autres ouvrages de messieurs de l'Académie royale dont l'exposition a été ordonnée, suivant l'intention de Sa Majesté, par M. Orry. . . . à commencer le 1er septembre 1741 pour durer trois semaines*, Paris, 1741, pp. 5-6, (Deloynes no. 13).

4. On the Place Dauphine exhibitions, see E. Bellier de la Chavignerie, "Notes pour servir à l'histoire de l'Exposition de la Jeunesse," *Revue Universelle des Arts*, XIX, 1864, pp. 38-72; for the reports of the *Mercure de France* on the exhibitions held before the re-establishment of the official Salon, see Deloynes nos. 1185, 1188, 1189, 1196, 1197. The *reposoir* depicted by della Bella was erected in the gardens of the Palais Royal in 1645. The boy Louis XIV and his mother, Anne of Austria, appear approaching the altar, while fireworks can be seen exploding in the grounds just beyond, as well as on the distant hill of Montmartre.

5. See Dacier and Vuaflart, *Jean de Jullienne*, I, p. 142.

6. "Exposition à la place Dauphine le jour de la fête-Dieu," *Mercure de France*, 1722, Deloynes no. 1185, p. 619. The accounts of the *Mercure* in this period were most probably written by its editor, Antoine de la Roque, who was also a well-known connoisseur and friend of Watteau.

7. See "Exposition de tableaux à la place Dauphine le jour de la petite fête-Dieu," *Mercure de France*, 1724, Deloynes no. 1188, p. 627; also Dacier and Vuaflart, *Jean de Jullienne*, I, p. 142.

8. "Exposition de tableaux à la place Dauphine le jour de la fête-Dieu," *Mercure de France*, 1732, Deloynes no. 1196, pp. 35-8.

9. "Exposition . . . à la place Dauphine," *Mercure de France*, 1724, p. 627.

10. "Exposition de tableaux à la place Dauphine en 1725," *Mercure de France*, 1725, Deloynes no. 1189, p. 631.

11. "Exposition des tableaux, dessins, sculptures, gravures et autres ouvrages des peintres, sculpteurs et graveurs de l'Académie royale de peintre et sculpture," *Mercure de France*, 1737, Deloynes no. 1203, p. 60.

12. "Exposition de tableaux à la place Dauphine le jour de la petite fête-Dieu, tiré de la *Feuille nécessaire*," 1759, Deloynes no. 1265, pp. 931–3.

13. See "Exposition ... à la place Dauphine," *Mercure de France*, 1724, pp. 627–30.

14. See "Exposition ... à la place Dauphine," *Mercure de France*, 1725, p. 633.

15. See "Exposition ... à la place Dauphine," *Mercure de France*, 1732, p. 37.

16. For a discussion of Chardin's source in Duquesnoy, see Pierre Rosenberg, *Chardin*. Cleveland, 1979, pp. 154–5.

17. See Bakhtin, *Rabelais and his World*, pp. 229–30.

18. *The Histories of Gargantua and Pantagruel*, Book 2, chapter 22.

19. *Lettre à Monsieur de Poiresson-Chamarande, Lieutenant-Général au baillage et siège présidial de Chaumont en Bassigny, au sujet des tableaux exposés au Salon du Louvre*, Paris, 5 September, 1741, Deloynes no. 14.

20. See Georges Wildenstein, *Chardin*, Paris, 1933, p. 72.

21. *Lettre à M. de Poiresson*, p. 2.

22. *Lettre à M. de Poiresson*, pp. 4–9.

23. [J. B. L. Gresset], *Vers sur les tableaux exposés à l'Académie Royale de Peinture, au mois de septembre 1737*, Paris, 1737, Deloynes no. 1204, p. 1.

24. On the literary underground in general, see Darnton, *The Literary Underground of the Old Regime*, also his unpublished dissertation, "Trends in Radical Propaganda on the Eve of the French Revolution (1782–1788)," Oxford University, 1964, the unsurpassed work on the subject; on the *Nouvellistes* of the mid-eighteenth century, see Robert S. Tate, *Petit de Bachaumont: his circle and the Mémoires secrets*, Geneva, 1968, pp. 129ff; on state efforts to suppress the trade in *nouvelles* and prohibited literature in the eighteenth century, see also John Lough, *Writer and Public in France*, pp. 182–3.

25. See Lough, *An Introduction to Eighteenth-Century France*, London, 1961, p. 249.

26. See Emile Jolibois, *La Haute-Marne, ancienne et moderne, dictionnaire*, Paris, 1967, pp. 421–2.

27. See Huppert, *Les Bourgeois Gentilshommes*, pp. 99–102.

28. See *Lettre sur les peintures, gravures et sculptures qui ont été exposées cette année au Louvre, par M. Raphael ...*, 1763; on the *genre poissard* in prose, see Moore, *The Genre Poissard and the French Stage of the Eighteenth Century*, pp. 96–125.

29. *Raffle de sept ou réponse au critiques du Sallon*, The Hague, 1781, p. 1.

30. *Marlborough au Sallon du Louvre; première édition contenant discours préliminaire, chansons, anecdotes, querelles, avis, critiques, lettre à Mlle. Julie, changement de têtes, etc., etc., etc., ouvrage enrichi de figures en taille douce. A Paris, aux dépens de l'Académie royale de peinture et de sculpture et se trouve au Louvre*, 1783, Deloynes no. 301.

31. Gorsas' pamphlets on the Salon can be found in the Collection Deloynes, nos. 333–5, 382–3.

32. [Joly de St. Just], *Promenades d'un Observateur au Salon de l'année 1787*, London, 1787, Deloynes no. 372.

33. *Lettre à M. de Poiresson*, p. 9.

34. *Lettre à M. de Poiresson*, pp. 9–11.

35. *Lettre à M. de Poiresson*, p. 11.

36. *Lettre à M. de Poiresson*, pp. 11–15.

37. *Lettre à M. de Poiresson*, p. 27.

38. *Lettre à M. de Poiresson*, pp. 34–5.

39. *Lettre à M. de Poiresson*, pp. 32–4.

40. *Lettre à M. de Poiresson*, p. 35.

41. See Root-Bernstein, *The Revolution on the Boulevard*, pp. 63ff.

42. Mercier, "Le Sallon de Peinture," pp. 203–6.

43. *Mémoires inédits et opuscules de Jean Rou*, II, p. 19.

44. Certain privileged visitors, chiefly members of the royal family, were of course able to visit the exhibition when it was closed to the public. Over the course of the century, the numbers of people able to exercise this privilege seems to have increased steadily; see J. J. Guiffrey, *Notes et documents*, pp. xl–xli. This writer obviously finds it convenient to pretend otherwise, and indeed, at the time of his writing, the exercise of privileged access may not have been particularly conspicuous.

CHAPTER IV

1. *Extrait des Observations sur la physique et les arts, Lettre à l'auteur (sur l'exposition de cette année)*, Paris, 1757, Deloynes no. 83, p. 8.

2. *Lettre à l'auteur ...*, 1757.

3. "Seconde lettre aux auteurs du *Journal de Paris*, de M. le comte D ...," 1777, Deloynes no. 185, p. 17, Ms.

4. Louis Petit de Bachaumont, Arsenal Ms. 4041, p. 364; the correspondence between Bachaumont and Pierre has been published by Paul Lacroix, "Correspondance de Pierre avec Bachaumont," *Revue Universelle des Arts*, V, 1857, pp. 260–4.

5. Marmontel, *Mémoires*, M. Tourneux, ed, Paris, 1891, II, p. 103.

6. *Sur la peinture. Ouvrage succinct qui peut éclairer les artistes sur la fin originelle de l'art et aider les citoyens dans l'idée qu'ils doivent se faire de son état actuel en France, avec une réplique à la Réfutation insérée dans le Journal de Paris no. 263*, The Hague, 1782. Deloynes no. 276.

7. *Sur la peinture*, pp. 66–9.

8. Diderot, *Salons*, J. Seznec and J. Adhémar, eds., Oxford, 1967, III, pp. 148–50.

9. Piron, *La Métromanie*, in *Œuvres de Théâtre*, Amsterdam, 1755, pp. 321–437. The *capitouls* were the eight municipal magistrates of the city, whose nobility was of a more recent and subordinate character in relation to other noble groups. For a discussion of the elites of Toulouse, see Robert Forster, *The Nobility of Toulouse in the Eighteenth Century*, Baltimore, 1960, pp. 20–3 and passim. Diderot's vignette supplies a good deal of sociological information not present in Piron's text: for example, the speculative activity of the *capitouls* in the grain trade (see Forster, pp. 75–6) and their reputation for ignorant obstructionism as official censors of local theaters (see Forster, pp. 158–9).

10. See for example, George V. Taylor, "Non-Capitalist Wealth and the Origins of the French Revolution," *American Historical Review*, LXXII, January, 1967 pp. 469–96; also Colin Lucas, "Nobles, Bourgeois, and the Origins of the French Revolution," *Past and Present*, n. 60, August, 1973, pp. 84–126.

11. See Huppert, *The Bourgeois Gentilshommes*, pp. 103–44.

12. For a useful summary of the recent literature on the interaction of classes and subclasses in the period, see Lucas, "Nobles, Bourgeois, and the Origins of the French Revolution," passim.

13. Cochin, quoted in Rocheblave, *Essai sur le comte de Caylus*, p. 166.

14. See E. J. Delécluze, *David, son école et son temps*, Paris, 1855, p. 426.

15. See Jean Nicolle, *Madame de Pompadour et la société de son temps*, Paris, 1980, pp. 61–2.

16. On Marigny and his succession, see Alden Rand Gordon, *The Marquis de Marigny, Directeur-Général des Bâtiments du Roi to Louis XV, 1751–1773: A Study in Royal Patronage*, Ph.D. dissertation, Harvard University, 1978; also Nicolle, *Madame de Pompadour*, p. 123.

17. See Rocheblave, *Les Cochin*, Paris, 1893, p. 190.

18. See, for example, R. G. Saisselin, "Neo-classicism: Images of Public Virtue and Realities of Private Luxury," *Art History*, IV, March, 1981, pp. 14–36.

19. See Nicolle, *Madame de Pompadour*, p. 129.

20. Bachaumont, Arsenal Ms. 3505, published in a nearly complete version by Adolphe Van Bever as an appendix to his abridged edition of the *Mémoires secrets de Bachaumont, 1762–1771*, Paris, 1912, II, pp. 219–88. The best study of Bachaumont in the context of the Parisian art world is Olivier, *Curieux*, pp. 175–248. For a more extended biographical account, see Robert S. Tate, "Petit de Bachaumont: His Circle and the *Mémoires secrets*," *Studies on Voltaire and the Eighteenth Century*, LXV, 1968; also Rosalind Ingrams, "Bachaumont: A Parisian Connoisseur of the Eighteenth Century," *Gazette des Beaux-Arts*, 6th series, LXXV, January, 1970, pp. 11–28.

21. Bachaumont, Arsenal Ms. 4041, p. 364.

22. Bachaumont, Arsenal Ms. 4041, p. 364.

23. Bachaumont, Arsenal Ms. 4041, p. 584.

24. See Arsenal Ms. 4041, passim.

25. Arsenal, Ms. 4041, pp. 144–51, 336–8; the last of his lists, that of 1750, was reprinted in an edited version by the abbé Raynal, *Correspondance littéraire, philosophique et critique par Grimm, Diderot, Raynal, Meister, etc.*, M. Tourneux, ed., Paris, 1878, IV, p. 366; the list is reproduced verbatim by Ingrams, "Bachaumont," pp. 26–7. The fate of this last and most elaborate evaluative list of academic artists and their special strengths and weaknesses illustrates the continuity between Bachaumont's informal aesthetic brokerage and the move to public criticism. Bachaumont's private advice to those in power was the direct forerunner of Diderot's *Salons*.

26. Arsenal, Ms. 4041, pp. 49–51.

27. See Rocheblave, *Essai sur le comte de Caylus*, passim.

28. See Moore, *The Genre Poissard*, pp. 92–125; Posner, *Watteau*, p. 102, is one art historian who has noted *Caylus'* other side.

29. On the revival of the *conférences*, see Rocheblave, *Essai sur le comte de Caylus*, pp. 142–3; Caylus' text can be found in "Les conférences inédits du comte de Caylus," Rocheblave and Fontaine, eds., *Bulletin de la société de l'histoire de l'art français*, 1907, p. 101.

30. See L. Courajod, *L'Ecole des Elèves Protégés*, Paris, 1874; also Locquin, *La Peinture d'histoire*, pp. 10–11.

31. See Diderot's caustic epitaph for Caylus in the *Correspondance littéraire*, IV, p. 366: it reads, "Ce-gît un antiquaire aciâtre et brusque/ Oh! qu'il est bien logé dans cette cruche étrusque."

32. See Rocheblave, *Essai sur le comte de Caylus*, pp. 103–4.

33. La Font, *Sentiments sur quelques ouvrages de peinture, sculpture et gravure, écrits à un particulier en Province*, Paris, 1754, pp. 90–3.

34. La Font, *Sentiments*, pp. 137–8. See Psalm 82.

35. Quoted in Jean Egret, *Louis XV et l'opposition parlementaire*, Paris, 1970, p. 58.

36. E. J. F. Barbier, *Journal historique et anecdotique du règne de Louis XV*, A. de la Villegille, ed., Paris, 1851, III, p. 375.

37. See Bernard Mercier de Lacombe, *La Résistance janseniste et parlementaire au temps de Louis XV: l'abbé Nigon de Berty (1702–1772)*, Paris, 1948, p. 109; also Tate, "Petit de Bachaumont," p. 152. Egret, *Louis XV et l'opposition parlementaire*, is the fundamental account of the political conflicts of the period. A fuller account of the entangled relationship between the ecclesiastical and political issues in the 1750s can be found in Dale Van Kley, *The Damiens Affair and the Unraveling of the Ancien Regime, 1750–1770*, Princeton, 1984. On the role of the *parlementaire* nobility in producing liberal ideology subsequently deployed by other groups, see D. Richet, "Autour des origines idéologiques lointaines de la Révolution française: élites et despotisme," Annales *E.S.C.*, XXIV, 1970, pp. 85–126. A summary and bibliography of the literature in this area can be found in Lucas, "Nobles, Bourgeois, and the Origins of the French Revolution."

38. *Correspondance littéraire*, IX, p. 318. On the activities of the "Parish" as a *bureau de nouvelles*, see Tate, "Petit de Bachaumont," pp. 129–62. For the most convincing account of the (problematic) relationship between these *nouvelles* and *Mémoires secrets*, see Olivier, "Bachaumont the Chronicler: A Doubtful Renown," *Studies on Voltaire and the Eighteenth Century*, CXLIII, 1975, pp. 161–79.

39. Quoted in Tate, "Petit de Bachaumont," p. 147.

40. Quoted in Tate, "Petit de Bachaumont," p. 148.

41. *Mémoires secrets*, 26 March, 1762.

42. See Tate, "Petit de Bachaumont," p. 110; on Louis-Antoine Crozat, see Stuffman, "Les Collections de Crozat," pp. 34–5.

43. See Gossman, *Medievalism and the Ideologies of the Enlightenment*, pp. 44–149; also Tate, "Petit de Bachaumont," pp. 97–128.

44. Arsenal Ms. 4041, pp. 109–11; some of the material is quoted in Tate, "Bachaumont revisited: some unpublished papers and correspondence," *Studies on Voltaire and the Eighteenth Century*, LXXIV, 1971, pp. 259–62. Curiously, this material was not included in Tate's earlier monograph on Bachaumont.

45. *Journal de Trévoux*, November, 1751, cited in Ingrams, "Bachaumont," p. 22.

46. See Gossman, *Medievalism and the Ideologies of the Enlightenment*, passim.

47. See *Lettre à M. de B. (Bachaumont) sur le bon goût dans les arts et dans les lettres*, Geneva, 1972; on Ste.-Palaye's biography, see Gossman, *Medievalism and the Ideologies of the Enlightenment*, passim.

48. *Jugement d'un amateur sur l'exposition des Tableaux. Lettre à M. le marquis de V****, n.p., 1753.

49. See M. Tourneux, "Un projet de journal de critique d'art en 1759."

50. See Gossman, *Medievalism and the Ideologies of the Enlightenment*, p. 135.

51. Laugier, *Observations sur l'architecture*, The Hague, 1765, p. 4.

52. La Font, *Réflexions*, p. 4.

53. *Journal et mémoires du marquis d'Argenson*, E. J. B. Rathery, ed., Paris, 1859–67, VIII, pp. 20–21.

54. See "Lettres écrites de Paris à Bruxelles," 1748, pp. 435ff.

55. *Lettre sur la cessation*, p. 27.

56. *Journal*, p. 20; Van Kley, *The Damiens Affair*, has described the early 1750s as the period in which public opinion became a clearly operative force in French politics.

57. See *Mémoires inédits de Charles-Nicolas Cochin sur le comte de Caylus, Bouchardon, les Slodtz*, C. Henry, ed., Paris, 1880, p. 47.

58. See Rocheblave, *Les Cochin*, pp. 132ff.

59. Cochin, *Voyage d'Italie ou Recueil de notes sur les ouvrages de peinture et de sculpture qu'on voit dans les principales villes d'Italie*, Paris, 1758, II, pp. 182ff; see Rocheblave, *Les Cochin*, pp. 104ff.

60. Cochin, *Lettre à un jeune artiste peintre, pensionnaire à l'Académie royale de France à Rome, Par M.C.*, n.p., n.d., pp. 31–2.

61. Cochin, *Lettre à un jeune artiste peintre*, p. 72; see Rocheblave, *Les Cochin*, pp. 112–16.

62. *Procès-verbaux*, 26 February, 1752.

63. See Conisbee, *Joseph Vernet, 1714–1789*, Musée de la Marine, Paris, 1976, p. 19.

64. La Font, *Sentiments sur quelques ouvrages de peinture*, pp. 12–18.

65. See Ingrams, "Bachaumont," pp. 26–7.

66. Laugier, *Jugement d'un amateur*, pp. 62–3.

CHAPTER V

1. Published in Adhémar, *Watteau*, p. 166.

2. Published in Adhémar, *Watteau*, pp. 170–1.

3. See Posner, *Antoine Watteau*, pp. 64ff.

4. "Eloge historique de M. Chardin," *Le Nécrologe des Hommes célèbres en France*, Paris, 1780, XV, p. 178, published in Pierre Rosenberg, *Chardin, 1699–1779*, Cleveland, 1979, p 117.

5. Quoted in Rosenberg, *Chardin*, p. 116.

6. See Ernst Kris and Otto Kurz, *Legend, Myth, and Magic in the Image of the Artist*, New Haven, 1979, pp. 13ff.

7. Published in Adhémar, *Watteau*, p. 178.

8. *Mercure de France*, November, 1753, quoted in Rosenberg, *Chardin*, p. 289.

9. See Arsenal, Ms. 4041, p. 404; for an extended discussion of the captioning of prints after Chardin, see E. Snoep-Reitsma, "Chardin and the Bourgeois Ideals of his time," *Nederlands Kunsthistorisch Jaarboek*, no. 24, 1973, pp. 147–243.

10. *Abécédario*, pp. 359–60.

11. L. Gougenot, "Album de voyage en Italie," Ms., quoted in Edgar Munhall, *Jean-Baptiste Greuze, 1725–1802*, Hartford, 1976, p. 18.

12. "Album de voyage," quoted in Munhall, *Greuze*, p. 18.

13. "Notice sur Greuze et sur ses ouvrages," *Revue universelle des arts*, XI, 1860, p. 250.

14. "Album de voyage," quoted in Munhall, *Greuze*, p. 18.

15. Anita Brookner, *Greuze: The rise and fall of an eighteenth-century phenomenon*, New York, 1972, p. 166.

16. J. de la Porte, *Sentimens sur plusieurs tableaux exposés cette année dans le grand Sallon du Louvre*, Paris, 1755, Deloynes no. 73. pp. 16–18; see Michael Fried, *Absorption and Theatricality: Painting and Beholder in the Age of Diderot*, Berkeley and Los Angeles, 1980, pp. 8–11.

17. *Extrait des Observations sur la physique et les arts, Lettre à l'auteur (sur l'exposition de cette année)*, 1757, p. 13.

18. Diderot, *Salons*, I, p. 238.

19. *Lettre à l'auteur*, 1757.

20. On the picture and its reception, see Munhall, *Greuze*, pp. 84–6.

21. Diderot, *Salons*, I, p. 236.

22. See the letter of the Swedish engraver Floding, then resident in Paris, in G. Lundberg, "Le Séjour de P.G. Floding à Paris (1755–64)," *Nouvelles archives de l'art français*, XVII, 1931–2, p. 292. This quality in the artist's draftsmanship was recognized elsewhere. A collection of Greuze's drawings, particularly of heads, was taken to Russia during his lifetime for use as teaching material in a new academy of art. They are today preserved in the Hermitage. See F. Monod and L. Hautecoeur, *Les Dessins de Greuze conservés à l'Académie des Beaux-Arts de Saint-Petersbourg*, Paris, 1922.

23. *Abécédario*, pp. 359–60.

24. Diderot, *Salons*, I, p. 149.

25. Grimm gives a figure of "mille écus" (Diderot, *Salons*, I, P. 238). The partisan Grimm is concerned to show that the artist is getting less for his pictures than it costs to produce them (400 louis, says Grimm, for the *Paralytic* of 1763). The figure may therefore be somewhat underestimated. Seznec and Adhémar have given a figure of 39,000 livres (*Salons*, I, p. 99), a truly staggering sum that has, oddly, received little comment in the literature. It was repeated by Munhall, *Greuze*, p. 84, who now, however, rejects the figure and accepts that given by Grimm (personal communication).

26. "Correspondance de M. Marigny," *Nouvelles archives de l'art français*, XIX, 1903, p. 203.

27. See Lundberg, "Le Séjour de P. G. Floding," p. 292.

28. Diderot, *Salons*, I, p. 141.

29. Diderot, *Salons*, I, p. 141.

30. Camille Mauclair, *Greuze et son temps*, Paris, 1926, p. 58.

31. Diderot, *Salons*, I, p. 145.

32. See Bryson, *Word and Image*, p. 127.

33. Diderot, *Salons*, I, p. 144.

34. Diderot, *Salons*, I, pp. 144–5.

35. [Abbé de la Garde], *Observations d'une société d'amateurs sur les tableaux exposés au Salon cette année 1761 tirées de l'Observateur littéraire de M. l'abbé de la Porte*, Paris, Deloynes no. 94, p. 46. The preceding discussion is not meant to imply perfect accord among the established powers in the intellectual and artistic worlds. De la Garde comes in for satirical treatment in Cochin's own pamphlet, *Les Misotechniques aux enfers* of 1763, (Deloynes no. 103).

36. See Diderot, *Salons*, I, p. 236; also [de la Garde], *Description des tableaux exposés au Salon du Louvre avec les remarques par une Société d'Amateurs*, special number of the *Mercure de France*, September, 1763, Deloynes no. 99.

37. The story appeared in the *Petites affiches*; see the notes of Seznec and Adhémar in Diderot, *Salons*, I, p. 183.

38. *Salons*, I, p. 238.

39. Diderot, *Salons*, II, p. 149.

40. Diderot, *Salons*, II, p. 148.

41. Accounts of the painted decoration at Choisy can be found in B. Chamchine, *Le Château de Choisy*, Paris, 1910, pp. 176–212; Jerrine E. Mitchell, "The Decoration of the Gallery of the Royal Château at Choisy," unpublished M.A. thesis, University of California, Los Angeles, 1976 (the best analysis of the commission to date); Gordon, *The Marquis de Marigny*, pp. 175–236.

42. "Correspondance de M. de Marigny," XIX, p. 234.

43. La Font, *Sentimens*, pp. 75ff. Cf., for example, Robert Rosenblum, *Transformations in Late Eighteenth-Century Art*, Princeton, 1967, pp. 56–7.

44. For example, Lemoyne's *Louis Gives Peace to Europe*, Versailles, Salon de la Paix, 1729; Dumont le Romains' *Publication in Paris of the Peace of Aix-la-Chapelle of 1748*, commissioned by the city of Paris in 1761.

45. "Correspondance de M. Marigny," XIX, pp. 324–5.
46. "Correspondance de M. Marigny," XIX, p. 331.
47. For an account of the Reims projects, see Rocheblave, *La Vie et l'œuvre de Jean-Baptiste Pigalle*, Paris, 1919, pp. 57–63, 229–39.
48. In a letter to Voltaire, quoted in Rocheblave, *Pigalle*, p. 229.
49. Arsenal Ms. 4041, p. 148.
50. Arsenal Ms. 4041, pp. 49–51.
51. Quoted in Rocheblave, *Pigalle*, p. 229.
52. Rocheblave, *Pigalle*, pp. 62–3, describes the events.
53. Montesquieu, *Considérations sur les causes de la grandeur des Romains et leur décadence*, in *Œuvres complètes*, D. Oster, ed., Paris, 1964, pp. 465–6; Voltaire, preface to "Le Temple de la gloire," *Œuvres complètes*, L. Moland, ed., Paris, 1877–85, IV, p. 350; both cited in Mitchell, "Decoration at Choisy," pp. 38–9.
54. *Œuvres complètes*, VIII, pp. 453–5; see Mitchell, "Decoration at Choisy," p. 40.
55. Livret for 1757, no. 1.
56. See *Salons*, II, pp. 61–2, 82–4, 87–9.
57. *Lettre à Monsieur** sur les peintures, les sculptures et les gravures exposées au Sallon du Louvre en 1765*, Paris, 1765, pp. 16 17.
58. *Salons*, II, p. 89.
59. See Gaston Brière, *Le Château de Versailles*, Paris, 1907–9, I, p. 12; Mitchell, "Decoration at Choisy," p. 53.
60. *Salons*, II, pp. 61–2.
61. See *Salons*, III, pp. 148–9.
62. *Livret* for 1777, no. 169.
63. *Les Tableaux du Louvre où il n'y a pas le sens commun. Histoire véritable*, Paris, 1777, Deloynes no. 186, p. 18.
64. Carmontelle, *La Patte de velours*, p. 39.
65. *Coup d'œil sur le Sallon de 1775 par un aveugle*, Paris, 1775, Deloynes no. 162, pp. 17–8.
66. Between the years in which the above texts appeared, Choderlos de Laclos was composing a novel which contained the ultimate unmasking of *sensibilité* in its condescending mode. This was the bitter and magnificent epistolary novel *Les Liaisons Dangereuses*. One of its principal plot lines concerns the efforts of Valmont, the malevolent sexual desperado, to seduce the virtuous wife of a high magistrate, Madame de Tourval, for the sheer perverse pleasure of the chase. Having insinuated himself into her country house, he takes long daily walks, knowing that the servants of his hostess and prey are spying on him. He seizes this opportunity to stage a scene of touching charity sure to convince her that he is no longer the fearsome rake her friends have warned her about. Discovering that a poor family is about to be dispossessed for non-payment of taxes, he contrives to happen by at the moment of eviction. Producing the required 56 livres, he receives the prostrate, tearful gratitude of the family and their neighbors. Feeling a rush of almost voluptuous pleasure, he finds himself dispensing 200 more livres—though repetition does not generate quite the same "delicious" effect as his first, surprise intervention, even though he has worked harder for it (letter XXI).

The obvious equation with orgasm is meant to debase the cult of virtue—and for the Goncourts, it identified that always present and disturbing note of sensuality in Greuze's most high-minded tableaux (leaving aside the Greuze female adolescent, each one a Cécile Volanges) (*L'Art du dix-huitième siècle*, I, pp. 365–6). More than this, Valmont's strategem results, at the end of the novel, in the woman's sacrilegious violation and extinction as a personality. "I cannot believe that he who does good is the enemy of virtue," she writes on learning of Valmont's beneficence (letter XXII). "Madame de Rosamonde and I are just going to see this honest and unfortunate family and to add our tardy succor to that of Monsieur de Valmont. We are taking him with us. At least we shall give these good people the pleasure of seeing their benefactor again, I am afraid it is all he has left us to do." It is her naïve equation between virtue and a trivial act of charity, remarkable only in the context of Valmont's normal conduct, that begins her tragic undoing. She even pathetically joins in the fatal charade.
67. See *Mémoires secrets*, 26 August, 1767; Jean Seznec, "Diderot et l'affaire Greuze," *Gazette des Beaux-Arts*, 6th series, LXVII, May–June, 1966; Munhall, *Greuze*, p. 22.
68. See Diderot, *Salons*, IV, p. 189.
69. See Munhall, *Greuze*, pp. 128–34, 138–42.
70. Seznec, "Diderot et l'affaire Greuze," pp. 339–56.
71. See "Correspondance de M. Marigny," XX, pp. 181–4.
72. *Correspondance générale*, G. Roth, ed., Paris, 1962, IX, p. 132.
73. *Correspondance générale*, VII, pp. 102–3.
74. *Salons*, VII, p. 103.
75. See Diderot, *Salons*, III, p. 115; Seznec, "Diderot et l'affaire Greuze," p. 351; for an account of the place of Poussin's *Eudamidas* in eighteenth-century artistic culture, see Richard Verdi, "Poussin's *Eudamidas*: Eighteenth-Century Criticism and Copies," *Burlington Magazine*, CXIII, 1971, pp. 513–17; see also Fried, *Absorption and Theatricality*, pp. 41–2.
76. "Lettre de M. Greuze à l'Auteur de l'Avant-

coureur," 25 September, 1769, Deloynes no. 138, pp. 1–2.

77. See Diderot, *Salons*, IV, p. 105.

78. Diderot, *Salons*, II, pp. 188–200.

79. See Charles Collé, *Journal et Mémoires de Charles Collé, (1748–1772)*, H. Bonhomme, ed., Paris, 1868, III, pp. 37 8.

80. On Doyen's career, see M. Sandoz, *Gabriel-François Doyen 1726–1806*, Paris, 1975. On his personal reputation, see chapter VI, note 18.

81. *Sentimens sur les Tableaux exposés au Salon*, 1769, Deloynes no. 122, pp. 19–20.

82. "Lettres sur les Salons de 1773, 1777 et 1779 adressées par Du Pont de Nemours à la margravine Caroline-Louise de Bade," *Archives de l'art français*, new series, II, 1908, p. 61.

CHAPTER VI

1. J. B. L. Coquereau, *Mémoires de l'abbé Terrai, contrôleur-général, nouvelle édition*, Paris, 1776, p. 228.

2. Coquereau, *Terrai*, pp. 229–30.

3. Charles Collé, *Journal et mémoires*, H. Bonhomme ed., Paris, 1868, III, p. 323.

4. *Mémoires secrets*, 7 September, 1771, pp. 65–6.

5. Collé, *Journal*, III, p.323.

6. *Mémoires secrets*, 14 September, 1771, p. 78.

7. See Diderot, *Salons*, IV, p. 123.

8. *Mémoires secrets*, 14 September, 1771, p. 79.

9. Coquereau, *Terrai*, p. 240.

10. See Henry Lapauze, *L'Histoire de l'Académie de France à Rome*, Paris, 1924, I, pp. 256–7.

11. See *Correspondance des directeurs*, XIII, p. 116.

12. Coquereau, *Terrai*, p. 272.

13. Coquereau, *Terrai*, p. 272.

14. *Mémoires secrets*, 7 September, 1771. In 1787, in a letter to d'Angiviller, Cochin blamed Pierre for the relaxation of censorship on Salon critiques and urged its reinstatement; see Guiffrey, *Notes et Documents*, pp. 92–6.

15. See Pierre-Augustin Caron de Beaumarchais, *Mémoires dans l'affaire Goezman*, Paris, 1873.

16. Voltaire, *Correspondence*, T. Besterman, ed., Banbury Oxfordshire, 1975, XL, p. 257.

17. *Dialogues sur la peinture. Seconde édition, enrichie de notes*, Paris, 1773; this pamphlet was suppressed by the police on its initial appearance; see Wrigley, "Censorship and Anonymity," p. 18.

18. *Dialogues*, pp. 6–7.

19. *Dialogues*, pp. 8–9.

20. *Dialogues*, p. 127.

21. *Dialogues*, p. 164.

22. *Vision du Juif Ben-Esron, fils de Sepher*, Amsterdam, 1773, Deloynes no. 152 p. 25.

23. *Dialogues*, p. 99.

24. *Sur la peinture*, pp. 124–5n.

25. Carmontelle, *Coup de Patte*, 1779, pp. 8–9.

26. See Darnton, "The High Enlightenment and the Low-Life of Literature in Pre-Revolutionary France," *Past and Present*, no. 51, 1971, pp. 79–103; also Nina R. Gelbart, "Frondeur Journalism in the 1770s: Theater Criticism and Radical Politics in the Prerevolutionary French Press," *Eighteenth Century Studies*, XVII, Summer 1984, pp. 493–514.

27. Jean-Pierre Brissot, *De la vérité, ou méditations sur les moyens de parvenir à la vérité dans toutes les connaissances humaines*, Neuchâtel, 1782, p. 165.

28. [Brissot], *Un Mot à l'oreille des académiciens de Paris*, n.p., 1783, p. 14.

29. *Les Charlatans modernes, ou lettres sur le charlatanisme académique, publiées par M. Marat, l'Ami du peuple*, Paris, 1791 (a pre-Revolutionary text reprinted by Marat in his *L'Ami du Peuple* and as a separate pamphlet in 1791).

30. On Gorsas' criticism, see chapter 3, note 31.

31. Quoted in Darnton, *Trends in Radical Propaganda*, p. 47.

32. *Pique-nique convenable à ceux qui fréquentent le Sallon, preparé par un aveugle*, n.p., 1781, Deloynes no. 267.

33. "Examen d'une critique intitulée: Le pique-nique preparé par un aveugle," Ms., Deloynes no. 268.

34. See J. Silvestre de Sacy, *Le Comte d'Angiviller*, Paris, 1953, p. 116.

35. *Sur la peinture*, pp. 80–1.

36. *Sur la peinture*, pp. 122–3.

37. *Encore un coup de patte*, 1787, p. 4.

38. *La Patte de velours*, 1781, p. 36. For a discussion of the "nouvelle critique" of the 1770s and '80s, which concentrates on the Salon of 1781, see Régis Michel, "Diderot et la modernité," in Sahut and Volle, *Diderot et l'art de Boucher à David*, pp. 119–21.

39. On d'Angiviller, see L. Bobé, *Mémoires de Charles Flahaut. Comte de la Billarderie d'Angiviller. Notes sur les Mémoires de Marmontel*, Copenhagen, 1933; Silvestre de Sacy, *D'Angiviller*.

40. For a recent synthetic account, see Elizabeth Fox-Genovese, *The Origins of Physiocracy: Economic Revolution and Social Order in Eighteenth-Century France*, Ithaca, NY, 1976.

41. See M. A. Baudot, *Notes historiques sur la Convention Nationale, le Directoire, l'Empire, et l'exil des votants*, Geneva, 1974, p. 157.

42. Du Pont, "Lettres sur les Salons."

43. *Procès-verbaux*, 31 August, 1771.

44. Du Pont, "Lettres sur le Salon," pp. 14–5.

45. See Silvestre de Sacy, *D'Angiviller*, pp. 108–9; Locquin, *La Peinture d'histoire*, pp. 48–51.

46. See Silvestre de Sacy, *D'Angiviller*, p. 120.
47. Quoted in Silvestre de Sacy, *D'Angiviller*, p. 103.
48. *Œuvres de M. Turgot, ministre d'état*, Paris, 1810, IX, pp. 299–338. For an account of the affair, see John Renwick, *Marmontel, Voltaire, and the Bélisaire affair, Studies in Voltaire and the Eighteenth century*, CXXI, 1974; Albert Boime, "Marmontel's *Bélisaire* and the Pre-Revolutionary Progressivism of David," *Art History*, III, March, 1980, pp. 81–101, provides a summary of these events as they involved Turgot and d'Angiviller. (The present study, however, differs with Boime on how the artistic consequences of that involvement should be interpreted.)
49. "Lettres sur les Salons," pp. 52–4.
50. Diderot, *Salons*, II, pp. 197–8.
51. "Lettres sur les Salons," pp. 81–2.
52. *Mémoires secrets*, XIX, p. 286.
53. "Correspondance du comte d'Angiviller avec Pierre," 27 June, 1775.
54. *Mémoires, Souvenirs, et Anecdotes*, F. Barrière, ed., Paris, 1859, I, pp. 27–8.
55. Bobé, *Mémoires du comte d'Angiviller*, p. 64; see also Francis Dowley, "D'Angiviller's *Grands Hommes* and the Significant Moment," *Art Bulletin*, XXXIX, December, 1957, pp. 259–78. Along with this recollection of Turgot's moment of courageous confrontation, d'Angiviller's memoirs include a more extended retelling of a parallel action on the part of Turgot's *father*, one which appears to be bound up with memories of Vincent's rendering of the Molé subject (Plate 91). The virtuous heart of Turgot *fils*, says d'Angiviller (p. 63), "was developed and formed after that of a father from a distinguished family of the judiciary nobility, ... imposing because of his superb figure and more imposing still because of his firm and quiet courage. I will cite only one characteristic instance. A quarrel had arisen between two regiments of the King's guards, the French and the Swiss. Escaped from their officers, they marched to do battle ... sabres drawn. Mr. Turgot was passing by and saw them; without weapons and still wearing his robe, he launched himself out of his carriage, leapt between the two troops, and commanded them, in that imperious tone of a strong and generous soul, to halt and sheath their swords. They obeyed, and their anger subsided and disappeared at the sight of his calm and unarmed courage and virtue." The soul of the son, continues d'Angiviller, "showed that it had not degenerated when, in 1775, during the bread-riot in Paris and with his door besieged by the people, he gave the order that it be opened." A subject precisely parallel to those of Molé

and Coligny was also included among the first four of the famous statues of "grands hommes" commissioned by d'Angiviller for the Salon of 1777: *The Chancelier de l'Hôpital ordering the doors to be opened to his assassins* by the elder Glois. The dutiful Du Pont declared it "truly the first among the four statues" ("Lettres sur les Salons," pp. 48–9). L'Hôpital, like Coligny, had been a Huguenot and, in addition, a particular opponent of the claim of the Parlements (rather than the Estates General) to represent the true nation of France. In 1775, the Parlements were Turgot's principal adversaries. They were well aware that his plans for France included the elimination of their traditional prerogatives; his "six edicts," which accompanied the freeing of the grain trade, struck at the heart of noble fiscal privileges, and they acutely resented his usurpation of police power during the Grain War. The significance of the l'Hôpital theme was not lost on them either. An *éloge* to him by the abbé Rémy was read at the *Académie française* in 1777 (*Éloge de Michel de L'Hôpital, chancelier de France, Discours qui a remporté le prix de l'Académie française, en 1777*, Paris, 1777). Rémy had used the occasion to make an unfavorable comparison between the incompetence and narrow self-interest displayed by the Parlements in comparison to the validly representative Estates as advocated by l'Hôpital. It won the *prix d'éloquence*, but the Paris Parlement attempted to suppress the published text.
56. See Moote, *The Revolt of the Judges*, passim.
57. "Examen du sallon de l'année 1779," Ms., Deloynes no. 201.
58. See Fernand Engerand, *Inventaire des tableaux commandés et achetés par le direction des bâtiments du Roi (1709–1792)*, Paris, 1900, pp. 519–20.
59. "Lettres sur les Salons," p. 84.
60. See *Panard au sallon*, the Hague, 1781, Deloynes no. 265, p. 24.
61. See the *Mémoires secrets*, XIX, p. 301.
62. *Pique-nique*, p. 23.
63. *Mémoires secrets*, XIX, p. 290.
64. See Bobé, *Mémoires du comte d'Angiviller*, pp. 119–20.
65. *Salons*, IV, p. 289.
66. *Œuvres complètes*, Geneva, 1968, III.
67. Procopius of Caesarea was, from 527, secretary, legal adviser (*assessor*), and aide-de-camp to Belisarius, and his service extended through most of the general's major campaigns. Belisarius thus figures throughout his *History of the Wars of Justinian* and clandestine *Secret History*. Belisarius' disgrace took place in 562 when he was implicated in a plot against the emperor's life. No reliable contemporary account documents his subsequent fate. See

L. M. Chassin, *Bélisaire*, Paris, 1957, pp. 208–13. The story of his being blinded and reduced to beggary at the end of his life derives from much later medieval sources.

68. See Jean Seznec, *Essais sur Diderot et l'antiquité*, Oxford, 1957, p. 1; also Raymond Trousson, *Socrate devant Voltaire, Diderot, et Rousseau: la conscience en face du mythe*, Paris, 1967, p. 54.

69. *Mémoires secrets*, 30 June, 1762; see Seznec, *Diderot et l'antiquité*, pp. 78–9.

70. For an account of Lally's career and the posthumous campaign for his vindication, see Marc Chassaigne *Le Comte de Lally*, Paris, 1938.

71. Letter dated 19 April, 1776; see P. Fonçin, *Essai sur le ministère de Turgot*, Paris, 1877, p. 509.

72. *Œuvres complètes*, III, pp. 221–5; see Pierre Rosenberg and Udolpho van de Sandt, *Pierre Peyron, 1744–1814*, Paris, 1983, p. 290.

73. *Œuvres complètes*, III, p. 222.

74. *Correspondance des directeurs*, XIII, p. 478.

75. *Correspondance des directeurs*, XIII, p. 481.

76. *Correspondance des directeurs*, XIV, p. 14.

77. *Correspondance des directeurs*, XIV, p. 14. On the probable appearance of the *Socrates and Alcibiades*, see Rosenberg and van de Sandt, *Peyron*, pp. 102–4.

78. For data on the *St. Roch* and the *Count Potocki*, see Detroit Institute of Arts, *French Painting 1774–1830: The Age of Revolution*, 1975, pp. 361–4.

79. *Correspondance des directeurs*, XIV, p. 30.

80. See Rosenberg and van de Sandt, *Peyron*, p. 93.

81. See the discussion in Fried, *Absorption and Theatricality*, p. 156.

82. *Salons*, IV, p. 377.

83. *La Patte de velours*, p. 25.

84. See Boime, "Marmontel's Bélisaire," pp. 87–8.

85. *La Vérité critique des Tableaux exposés au Sallon du Louvre en 1781*, "à Florence," 1781, Deloynes no. 260, pp. 23; *Pique-nique*, p. 24.

86. *Mémoires secrets*, XIX, p. 290.

87. *Mémoires secrets*, XIX, p. 289.

88. See Rosenberg and van de Sandt, *Peyron*, p. 100.

89. Rosenberg and van de Sandt, *Peyron*, p. 95.

90. *Salons*, IV, p. 377.

91. *Mémoires secrets*, V, p. 196.

92. *Pique-nique*, pp. 26–8.

93. *Pique-nique*, p. 24.

CHAPTER VII

1. Jacques Cambry, *Essai sur la vie et les tableaux du Poussin*; Nicolas Guibal, *Eloge de Nicolas Poussin, peintre ordinaire du roi*; see Académie de France à Rome, *David et Rome*, Rome, 1981, p. 192

2. *Le Triumvirat des Arts ou Dialogue entre un peintre, un musicien et un poëte sur les tableaux*

exposés au Louvre, "Aux Antipodes," 1783, Deloynes no. 305, pp. 28–9.

3. This is David's own estimate; see D. and G. Wildenstein, *Documents complémentaries au catalogue de l'œuvre de Louis David*, Paris, 1973, item 1368.

4. See Alexandre Péron, *Examen du tableau du serment des Horaces peint par David*, Paris, 1839, pp. 27–8.

5. See Péron, *Examen des Horaces*, pp. 28–9.

6. Quoted in Jules David, *Le Peintre Louis David, 1748–1825, souvenirs et documents inédits*, Paris, 1880, p. 27.

7. *Le Frondeur ou Dialogues sur le Sallon par l'auteur du Coup-de-patte et du Triumvirat*, n.p., 1785, Deloynes no. 329, p. 67

8. "Exposition des Tableaux au Louvre," *Mercure de France*, September, 1785, Deloynes no. 348, pp. 758–9.

9. "Exposition des tableaux," pp. 758–9.

10. *Supplément du Peintre Anglais au Salon*, n.p., n.d., Deloynes no. 328, p. 4.

11. *Merlin au Salon en 1787*, "Rome," 1787, Deloynes no. 385, p. 19.

12. This is of course the general thesis of Locquin's fundamental *La Peinture d'histoire en France* of 1912. This view has been deployed more recently as a way of arguing against any dissident political meaning in the *Horatii* or *Brutus*: see L. D. Ettlinger, "Jacques-Louis David and Roman Virtue," *Journal of the Royal Society of Arts*, CXV, January, 1967, pp. 105–23; also Hugh Honour, *Neo-Classicism*, Harmondsworth, 1968, p. 82.

13. *Troisième Promenade de Critès au Sallon de l'année 1785*, London, 1785, Deloynes no. 333, pp. 37–8.

14. *Observations critiques sur les Tableaux du Sallon de l'année 1787*, Paris, 1787, Deloynes no. 373, p. 15.

15. *Troisième Promenade de Critès*, p. 36.

16. [Attributed to J. L. Soulavie], *Réflexions impartiales sur les progrès de l'art en France et sur les Tableaux exposés au Louvre, par ordre du Roi, en 1785*, London, 1785, p. 20.

17. *Le Frondeur*, p. 17.

18. *Le Frondeur*, pp. 19–20.

19. *Le Frondeur*, pp. 19–20.

20. *Supplément du Peintre Anglais*, p. 5.

21. *Supplément du Peintre Anglais*, pp. 2–3.

22. Carmontelle, *La Patte de velours*, 1781, p. 36.

23. *Le Cri public contre Pierre-Augustin Caron de Beaumarchais*, 3rd edition, n.p., n.d., p. 13.

24. *M. de Calonne tout entier, tel qu'il s'est comporté dans l'administration des finances, dans son commissariat en Bretagne, etc. etc., avec une analyse de sa requête au Roi, et de sa réponse à l'écrit de M. Necker; ouvrage critique, politique et*

moral. par M. C., Brussels, edition of April 1788, pp. vii–viii.

25. Carra. *Calonne tout entier*, pp. vii–viii.

26. *Examen critique des voyages dans l'Amérique septentrionale de M. le Marquis de Chatellux*, London, 1786, pp. 127–9.

27. *Calonne tout entier*, pp. 30–1.

28. S. P. Hardy, Journal, Bibliothèque nationale, fonds français 6685–7, 18 March, 1787. I am indebted to Darnton, "Trends in Radical Propaganda," for these citations from Hardy.

29. *Calonne tout entier*, pp. 30ff.

30. See the *Mémoires secrets*, 12, 14, 16, 20, 21, 28 August; 8, 22, September, 1787.

31. *Lettres de l'abbé Morellet de l'Académie Française à Lord Shelbourne, depuis Marquis de Landsdowne, 1772–1803*, Paris, 1898, p. 260.

32. See Honour, *Neo-Classicism*, p. 72.

33. Daudet de Jossan, in this strangely interconnected drama, had been, as we have seen, a popular art critic in the 1770s.

34. See Darnton, *Mesmerism and the End of the Enlightenment in France*, New York, 1970, passim; Darnton, "Trends in Radical Propaganda," provides an extensive discussion of the Kornmann affair and the radical literature which it generated. The present account is much dependent on his.

35. *Mémoire sur une question d'adultère, de séduction et de diffamation, pour le sieur Kornmann contre la Dame Kornmann, son épouse; le sieur Daudet de Jossan; le sieur Pierre-Augustin Caron de Beaumarchais; et M. Le Noir, conseiller d'état et ancien lieutenant-général de police*, n.p., 1787. Publishing political pamphlets as judicial *mémoires* was a way of escaping censorship; if signed by a lawyer and addressed to a particular court case, they could legally be published and sold without official censorship.

36. *Apologie de Messire Jean-Charles-Pierre Lenoir par son très humble et très obéissant serviteur Suard, l'un des quarante*, n.p., 1789, p. 79.

37. *Observations du sieur Kornmann en réponse au mémoire de M. Lenoir*, n.p., n.d., pp. 7–8.

38. Hardy, Journal, 12 November, 1788.

39. Note by Beaumarchais in Kehl edition of Voltaire, *Œuvres complètes*, Beaumarchais, Condorcet, and Decroix, eds., 1785–9, LXII, p. 293.

40. *Court mémoire en attendant l'autre. Par P. A. Caron de Beaumarchais, sur la plainte en diffamation qu'il vient de rendre d'un nouveau libelle qui paraît contre lui*, n.p., 1788, p. 5.

41. *Observations du sieur Bergasse, sur l'écrit du sieur de Beaumarchais, ayant pour titre: "Court mémoire, en attendant l'autre," dans la cause du sieur Kornmann*, n.p., 1788, p. 7.

42. [Gorsas], *Le public pour le second fois à Pierre-Augustin Caron de Beaumarchais*, n.p., n.d., 1787, p. 9.

43. Jean-François La Harpe, *Oeuvres*, Geneva, 1968, XII, p. 436.

44. See Grimm, *Correspondance littéraire*, XIII, pp. 517–25, 542–5; La Harpe, *Correspondance littéraire*, Paris, 1801, IV, pp. 122–4, 227–32; *Mémoires secrets*, 27 April, 1 May, 1 June, 1784.

45. See Brissot and Etienne Clavière, *De la France et des Etats Unis*, London, 1787, p. xxii.

46. *Promenades de Critès*, p. 35.

47. *Le Mannequin, dédié à Mm. du Caveau*, Paris, 1787, pp. 4–5.

48. *Supplément du Peintre Anglais*, pp. 2–3.

49. See Harold T. Parker, *The Cult of Antiquity and the French Revolutionaries*, Chicago, 1937. The radicals of the 1780s were quick to liken their enterprise to the heroism of the ancient Romans, even to claim that they had surpassed their example. This is Carra (*L'An 1787. Précis de l'administration de la bibliothèque du Roi, sous M. Le Noir, seconde édition, assurément plus correcte que la première; avec petit supplément*, 2nd edition, Liège, 1788, pp. 2–3: "Everywhere men eagerly exert themselves to enlighten the people by tearing aside the curtain that hides the secret iniquities of despotism from their eyes and unmasking the perpetrators of evil. Everywhere oppressed men call out to be avenged by natural law against the oppressor who violates all laws. Today such protests cannot be suppressed by any human power: the force has been unleashed and the force is universal; it is not, as it was in the times of the Greeks and Romans, the effect of a military plot or an individual conspiracy; it is born of a vast fire of enlightenment; it proceeds from an exceptional epoch in the great march of the natural order. Armed with public opinion and the smallest attributes of eloquence, the Truth today appears to be realizing the fabulous effects of the head of Medusa; it confounds the will of the evil-doers; their baneful activity turns torpid; the agents of depotism, even the Neros and Caligulas, are petrified."

50. This equation had of course been forcefully made in dissenting art criticism as early as La Font's writing: see *Sentiments*, 1754, pp. 92–3, 137–8.

51. "Exposition des tableaux," *Mercure de France*, September, 1785.

52. *Mémoires secrets*, XXXVI, p. 295.

53. *Mémoires secrets*, XXXVI, pp. 297–8; on the response to Vigée-Lebrun's portrait, see Joseph Baillio, "Le Dossier d'un œuvre d'actualité politique: Marie-Antoinette et ses enfants par Mme Vigée-Lebrun," part 2, *L'Oeil*, no. 310, May, 1981, pp. 52–60, 90–1.

54. *Mémoires secrets*, XXXVI, p. 297n.

55. *Mémoires secrets*, XXXVI, p. 318.

56. See *Dialogues*, 1773, p. 130.

57. Quoted in J. David, *Le Peintre Louis David*, p. 57.

58. The best biographies are Louis Hautecoeur, *Louis David*, Paris, 1954; Antoine Schnapper, *David, témoin de son temps*, Paris, 1980.

59. *Lettres Analitiques, critiques et philosophiques sur les tableaux du Sallon*, Paris, 1791, Deloynes no. 441, p. 56.

60. See Malcolm Easton, *Artists and Writers in Paris: The Bohemian Idea, 1803–1867*, London, 1964, p. 3.

61. Mme. de Genlis, *Mémoires*, IV, pp. 102–3. An effort to map David's network of social acquaintances during the 1780's has been made by Philippe Bordes (*Le Serment du Jeu de Paume de David: Le peintre, son milieu et son temps de 1789 à 1792*, Paris, 1983, pp. 17–26). Bordes is especially insistent that David's connection to Orléanist circles cannot be understood as revealing any involvement or sympathy with its political activities. David, he states, had no known contact with Choderlos de Laclos, who began directing the activities of the *parti orléaniste* at the beginning of 1789 and whose influence was established at the expense of Madame de Genlis'. David's continuing cultivation of the latter, Bordes states, means that his political position was "bien etrangère aux desseins politiques d'un Brissot ou d'un Choderlos de Laclos (p. 20)." In general, Bordes cautions his readers against a "naive equivalence" between Orléanist intrigues and pre-Revolutionary radicalism (note 22). One can only agree, but in fact the relationship between the Orléanist camp and the radical publicists around Clavière and Bergasse (which included Brissot, Gorsas, and Carra) was quite close in 1787. It is curious that Bordes omits any mention of the marquis Ducrest, Madame de Genlis' brother, who had served as chancellor (that is to say, chief economic and political operative) to the duc d'Orléans since 1785 and to whom she was close both intellectually and emotionally. In 1786, Ducrest had employed Brissot as a secretary-general of the Orléanist chancellery, with wide-ranging responsibilities over both financial and political affairs; earlier Brissot's wife had assisted Madame de Genlis in supervising the duc's children. (See Brissot, *Correspondance et papiers*, C. Perroud, ed., Paris, 1912, pp. lxi–lxv.) Surviving correspondence between Brissot and Ducrest discusses efforts to engage public opinion in favor of the Parlements' cause, and ultimately in favor of fundamental constitutional reform (*Correspondance*, pp. 145–60). In the latter part of 1787, Ducrest was accompanied by both Brissot and Clavière on an extended trip to the Low Countries. Actually no one, to my knowledge, has ever argued for a political reading of David's pre-Revolutionary pictures on the basis of his Orléanist connection, but the artist's frequenting of St. Leu certainly does not argue against sympathy for Brissot and other like-minded radicals (even if conclusive documentation one way or the other is lacking). A calculated alliance between the Orléanists and the Kornmann faction was active until 1788. (See Darnton, *Trends in Radical Propaganda*, p. 400.)

62. *Sur la peinture*, 1782, pp. 26–7.

63. See Péron, *Examen des Horaces*, p. 34.

64. Published in David, *Le Peintre Louis David*, pp. 28–9.

65. Wilhelm Tischbein, *Aus Meinem Leben*, Berlin, 1956, p. 254.

66. See Hautecoeur, *Louis David*, pp. 181–3.

67. *Vérités agréables ou le Salon vu en beau par l'auteur de Coup de patte*, Paris, 1789, Deloynes no. 415, p. 11.

68. It is possible, indeed, that David not only possessed but made a public display of Carra's *M. de Calonne tout entier* or some similar *libelle*. See the *Souvenirs de Madame Vigée-Lebrun*, Paris, 1867, II, p. 266, where she recalls that David "se procura je ne sais quel gros livre écrit contre M. de Calonne. . . . Ce livre restait constamment dans son atelier sur un tabouret. . . ."

69. *Correspondance des directeurs*, XV, p. 79.

70. See Deloynes no. 370, "Note du *Continuateur* de Bachaumont sur ce qu'il n'y a pas eu de prix en 1786."

71. See Régis Michel, "Jean-Germain Drouais et Rome," in *David et Rome*, pp. 200–4.

72. *L'Aristarque moderne au Salon*, Paris, 1785, Deloynes no. 340, p. 16.

73. *Le Frondeur*, pp. 19–20.

74. *Avis importante d'une femme sur le Salon de 1785 par Madame E.A.R.T.L.A.D.C.S. Dédié aux femmes*, n.p., 1785, Deloynes no. 344, pp. 29–30.

75. Hautecoeur, *Louis David*, pp. 83–4 and plate.

76. Herbert, *Brutus*, p. 38.

77. Rosenblum, *Transformations*, pp. 70, 72.

78. Honour, *Neo-Classicism*, pp. 34–6.

79. Published in David, *Le Peintre Louis David*, pp. 55–7.

80. *Lettre d'un amateur de Paris à un amateur de province sur le Salon de peinture de l'année 1787*, Paris, 1787, Deloynes no. 381, pp. 11–12.

81. I mean here hallucination in the clinical, psychoanalytic sense: the patient denies the

place of an object in his own history, refuses to make it part of the functioning symbolic order of his unconscious, and consequently faces the continual return of his memory of the object as a "real" presence; hallucination is nonsymbolic experience. See Sigmund Freud, "Negation," *Standard Edition of the Complete Psychological Works of Sigmund Freud*, London, 1953–73, XIX, p. 237; "The Case of the Wolf-Man," XVII, pp. 84–7; Jacques Lacan, "Réponse au commentaire de J. Hyppolite sur la *Verneinung* de Freud," *Le Psychoanalyse*, I, 1956, pp. 46–8.

82. Published in David, *Le Peintre Louis David*, p. 38.

83. Quoted in the Goncourts, *L'Art du XVIIIᵉ siècle*, II, pp. 366–8.

84. See Rosenberg and van de Sandt, *Peyron*, p. 125.

85. *Journal de Paris*, 3 October, 1787; *Mémoires secrets*, XXVI, p. 323; see Rosenberg and van de Sandt, *Peyron*, p. 126.

86. [Attributed to the abbé Robin], *Ami des artistes au Salon, par M. L'A.R.*, Paris, 1787, Deloynes no. 379, p. 37.

87. *Mémoires secrets*, XXXVI, p. 320.

88. In *David et Rome*, p. 148.

89. See J. L. Soulavie, *Mémoires historiques et politiques du regne du Louis XVI depuis son mariage jusqu'à sa mort*, Paris, 1801, VI, pp. 55–6; also Vincent W. Beach, *Charles X of France*, Boulder, Colorado, 1971, p. 9.

90. See Jacob-Nicolas Moreau, *Mes Souvenirs*, C. Hermelin, ed., Paris, 1901, II, p. 259.

91. See Beach, *Charles X*, p. 32.

92. See Louis Gottschalk, *Lafayette between the American and French Revolutions*, Chicago, 1950, pp. 311–19.

93. See Herbert, *Brutus*, p. 18.

94. See Livy, *History of Rome*, book I, section 40.

95. Livy, *History of Rome*, book I, section 49.

96. *Livret* for 1789, no. 88.

97. Herbert, *Brutus*, pp. 55ff, 124–5, reviews the relevant correspondence and press reaction.

98. Gorsas, *Apologie de Messire Jean-Charles-Pierre Lenoir*, p. 79.

99. *Observations du sieur Kornmann*, pp. 7–8.

100. *Mémoire sur une question d'adultère*, p. 50.

101. Journal, 8 July, 1788, quoted in Darnton, *Trends in Radical Propaganda*, p. 397.

102. See Christopher Sells, "Some Recent Research on J. L. David," *Burlington Magazine*, CXVII, December, 1975, pp. 811–14.

103. Brissot, *De la Vérité*, pp. 253–4.

104. Quoted in David, *Le Peintre Louis David*, p. 57.

105. See Root-Bernstein, *The Revolution on the Boulevard*, pp. 83ff for the best account of Nicolet; also Albert, *Les Théâtres de la foire*, pp. 220–32.

106. Quoted in Charles Clément, *Prud'hon, sa vie, ses oeuvres et sa correspondance*, 1872, pp. 154–5.

107. *Vérités agréables*, pp. 22–3.

108. *L'An 1787*, p. 1.

109. This kind of artistic strategy could indeed have found a legitimate foundation in classical rhetoric. In a passage that would not have been unknown to David, or certainly to his learned associates like Quatremère de Quincy, Longinus writes that an "arrangement of words or thoughts varied from the natural order" was one way an orator could convey the effect of a "mind disturbed by violent emotion." In such an instance, "art seems then best to accomplish its end when it most resembles nature. . . ." He then cites Demosthenes as one who "is pre-eminently addicted to this kind of figure, and while his transpositions produce strong effects together with the appearance of speaking on the spur of the moment, he lures his hearers into taking their own share in the risk of his long hyperbata. He often hangs up the thought which he set out to express, brings interpolated and discursive remark on remark rolling in by the way, thereby creates an apparently misfitting and incongruous arrangement, drives his hearers into fearing a complete collapse of the statement, then at length unexpectedly brings in at a telling moment the due conclusion for which his audience has long been looking, and so produces a much more striking effect through the very strangeness and riskiness of his transpositions." (*On Elevation of Style*, T. G. Tucker, trans., Melbourne, 1935, section XXII). In a scene which is anchored by Brutus's clenched immobility, the inner turbulence of the tragic hero is projected into his surroundings, conveyed by a calculatedly disruptive pictorial rhetoric.

110. *Lettres Analitiques*, 1791, pp. 57–8.

111. See Jocelyn C. Toynbee, *Death and Burial in the Roman World*, Ithaca, NY, 1971, pp. 40–8.

112. See Herbert, *Brutus*, p. 18, for discussion of this lost study.

POSTSCRIPT

1. The words of Dubois-Crancé proposing the commission to David, published in Bordes, *Le Serment du Jeu de Paume*, p. 149.

2. Quoted in Bordes, *Le Serment du Jeu de Paume*, p. 69.

3. See Herbert, *Brutus*, p. 101.

SELECT BIBLIOGRAPHY

Académie de France à Rome, *David et Rome*, Rome, 1981

Adhémar, Hélène, *Watteau, sa vie—son œuvre*, Paris, 1950

Albert, Maurice, *Les Théâtres de la Foire (1660–1789)*, Paris, 1900

Ami des artistes au Salon, par M. L'A.R., Paris, 1787

Angiviller, Charles-Claude de Flahaut, comte de la Billarderie d', *Mémoires de Charles-Claude Flahaut. Comte de la Billarderie d'Angiviller. Notes sur les Mémoires de Marmontel*, L. Bobé, ed., Copenhagen, 1933

L'Aristarque moderne au Salon, Paris, 1785

Avis importante d'une femme sur le Salon de 1785 par Madame E.A.R.T.L.A.D.C.S. Dédié aux femmes, n.p., 1785

Babeau, Albert, *Les Bourgeois d'autrefois*, Paris, 1886

Baillio, Joseph, "Le Dossier d'un œuvre d'actualité politique: Marie-Antoinette et ses enfants par Mme Vigée-Lebrun," part 2, *L'Œil*, no. 310, (May 1981), pp. 52–60, 90–1

Bakhtin, Mikhail, *Rabelais and his World*, Hélène Iswolsky, trans., Cambridge, Mass., 1968

Banks, Oliver, *Watteau and the North*, New York, 1977

Beaucamp, Fernand, *Le Peintre lillois Jean-Baptiste Wicar (1762–1834), son œuvre et son temps*, 2 vols., Paris, 1939

Beaumarchais, Pierre-Augustin Caron de, *Court mémoire en attendant l'autre. Par P. A. Caron de Beaumarchais, sur la plainte en diffamation qu'il vient de rendre d'un nouveau libelle qui paraît contre lui*, n.p., 1788

——, *Mémoires dans l'affair Goezman*, Paris, 1873

Becq, Annie, "Expositions, peintres, et critiques, vers l'image moderne de l'artiste," *Dix-huitième siècle*, no. 14, (1982), pp. 131–50

Bellier de la Chavignerie, E., "Notes pour servir à l'histoire de l'Exposition de la Jeunesse," *Revue Universelle des Arts*, XIX, (1864), pp. 38–72

Bergasse, Nicolas, *Mémoire sur une question d'adultère, de séduction et de diffamation, pour le sieur Kornmann contre la Dame Kornmann, son épouse; le sieur Daudet de Jossan; le sieur Pierre-Augustin Caron de Beaumarchais; et M. Le Noir, conseiller d'état et ancien lieutenant-général de police*, n.p., 1787

——, *Observations du sieur Kornmann en réponse au mémoire de M. Lenoir*, n.p., n.d.

——, *Observations du sieur Bergasse, sur l'écrit du sieur de Beaumarchais, ayant pour titre: "Court mémoire, en attendant l'autre", dans la cause du sieur Kornmann*, n.p., August 1788

Blunt, Anthony, *Nicolas Poussin*, 2 vols., New York, 1967

——, "The *Précieux* and French Art," in *Fritz Saxl: A Volume of Memorial Essays from his Friends in England*, D. J. Gordon, ed., London, 1957, pp. 326–38

Bordeaux, Jean-Luc, "François Le Moyne's Painted Ceiling in the 'Salon d'Hercule' at Versailles: A Long Overdue Study," *Gazette des Beaux-Arts*, 6th series, LXIII, (May–June 1974), pp. 301–18

Bordes, Philippe, *Le Serment du Jeu de Paume de David: Le peintre, son milieu et son temps de 1789 à 1792*, Paris, 1983

Borel, Pierre, *Les Antiquitez, raretez, plantes, minéraux et autres choses considérables de la ville et du comté de Castres d'Albigeois (contenant une liste des cabinets curieux de l'Europe)*, Castres, 1665

Boime, Albert, "Marmontel's *Bélisaire* and the Pre-Revolutionary Progressivism of David," *Art History*, III, (March 1980), pp. 81–101

[Brissot de Warville, Jacques-Pierre], *Un Mot à l'oreille des académiciens de Paris*, n.p., 1783

——, *De la vérité, ou méditations sur les moyens de parvenir à la vérité dans toutes les connaissances humaines*, Neuchâtel, 1782

Brockett, O. G., "The Fair Theatres of Paris in the Eighteenth Century: The Undermining of the Classical Ideal," in M. J. Anderson, ed., *Classical Drama and its Influence*, New York, 1965

Brookner, Anita, *Greuze: The Rise and Fall of an Eighteenth-Century Phenomenon*, Greenwich, Conn., 1972

Bryson, Norman, *Word and Image: French Painting of the Ancien Régime*, Cambridge, 1981

Bukdahl, Else Marie, *Diderot, Critique d'Art*, J. Pilosz, trans., 2 vols., Copenhagen, 1981–2

Burke, Peter, *Popular Culture in Early Modern Europe*, New York, 1978

Burnet, Mary Scott, *Marc-Antoine Legrand, acteur et auteur comique (1673–1728)*, Paris, 1938

Calvet, Arlette, "Unpublished Studies for the 'Oath of the Horatii' by Jacques-Louis David," *Master Drawings*, VI, (1968), pp. 27–42

[Carmontelle, Louis de], *Coup de patte sur le sallon de 1779. Dialogue précédé et suivi de réflexions sur la peinture*, "A Athènes et se trouve à Paris chez Caileau," 1779

——, *Le Frondeur ou Dialogues sur le Sallon par l'auteur du Coup-de-patte et du Triumvirat*, n.p. 1785

——, *La patte de velours pour servir de suite à la seconde édition du Coup de patte, ouvrage concernant le sallon de peinture. Année 1781*, London, 1781.

——, *Le Triumvirat des Arts ou Dialogue entre un peintre, un musicien et un poète sur les tableaux exposés au Louvre—Année 1783—pour servir de continuation au "Coup de Patte" et à la "Patte de velours"*, "Aux Antipodes," 1783

——, *Vérités agréables ou le Salon vu en beau par l'auteur de Coup de patte*, Paris, 1789

[Carra, Jean-Louis], *Le Cri public contre Pierre-Augustin Caron de Beaumarchais*, 3rd edition, n.p., n.d., p. 13

——, *M. de Calonne tout entier, tel qu'il s'est comporté dans l'administration des finances, dans son commissariat en Bretagne, etc., etc., avec une analyse de sa requête au Roi, et de sa réponse à l'écrit de M. Necker; ouvrage critique, politique et moral. par M. C.*, Brussels, April 1788

——, *L'An 1787. Précis de l'administration de la bibliothèque du Roi, sous M. Le Noir, seconde édition, assurément plus correcte que la première; avec petit supplément*, 2nd edition, Liège, 1788

Chamchine, B., *Le Château de Choisy*, Paris, 1910

Champion, P., *Notes critiques sur les vies anciennes d'Antoine Watteau*, Paris, 1921

Chassaigne, Marc, *Le Comte de Lally*, Paris, 1938

Chatelus, Jean, "Thèmes picturaux dans les appartéments de marchands et artisans parisiens au XVIIIᵉ siècle," *Dix-huitième siècle*, no. 6, (1974), pp. 302–24

Clément, Charles, *Prud'hon, sa vie, ses œuvres et sa correspondance*, Paris, 1872

Cochin, Charles-Nicolas, *Lettre à un jeune artiste peintre, pensionnaire à l'Académie royale de France à Rome, Par M.C.*, n.p., n.d.

——, *Mémoires inédits de Charles-Nicolas Cochin sur le comte de Caylus, Bouchardon, les Slodtz*, C. Henry, ed., Paris, 1880

——, *Les Misotechniques aux enfers*, Paris, 1763

——, "Réflexions sur la critique des ouvrages exposés au Sallon du Louvre," extract from the *Mercure de France*, (October 1757), Deloynes no. 86

——, *Voyage d'Italie ou Recueil de notes sur les ouvrages de peinture et de sculpture qu'on voit dans les principales villes d'Italie*, 3 vols., Paris, 1758

Collé, Charles, *Journal et mémoires*, H. Bonhomme, ed., Paris, 1868

Conisbee, Philip, *Joseph Vernet, 1714–1789*, Musée de la Marine, Paris, 1976

——, *Painting in Eighteenth-Century France*, Oxford, 1981

Coquereau, J. B. L., *Mémoires de l'abbé Terrai, controleur-général, nouvelle édition*, Paris, 1776

Coup d'œil sur le Sallon de 1775 par un aveugle, Paris, 1775

Courajod, L., *L'Ecole des élèves protégés*, Paris, 1874

Coypel, Charles, "Dialogue de M. Coypel, premier peintre du Roi sur l'exposition des Tableaux dans le Sallon du Louvre en 1747," extract from the *Mercure de France*, (November 1751)

Crow, Thomas, "Gross David with the Swoln Cheek," review of Anita Brookner, *Jacques-Louis David*, *Art History*, V, (March 1982), pp. 109–17

——, "The *Oath of the Horatii* in 1785: Painting and Pre-Revolutionary Radicalism in France," *Art History*, I, (December 1978), pp. 424–71

Dacier, E., A. Vuaflart and J. Hérold, *Jean de Jullienne et les graveurs de Watteau au XVIIIᵉ siècle Paris*, 4 vols., Paris, 1921–9

Darnton, Robert, *The Literary Underground of the Old Regime*, Cambridge, Mass., 1982

——, "The High Enlightenment and the Low-Life of Literature in Pre-Revolutionary France," *Past and Present*, no. 51, (1971), pp. 79–103

——, "Trends in Radical Propaganda on the Eve of the French Revolution (1782–1788)," unpublished D.Phil dissertation, Oxford University, 1964

David, Jules, *Le Peintre Louis David, 1748–1825, souvenirs et documents inédits*, Paris, 1880

Davis, Natalie Zemon, *Society and Culture in Early Modern France*, Stanford, 1975

Delécluze, E. J., *David, son école et son temps*, Paris, 1855

Démoris, René, "Les Fêtes galantes chez Watteau et dans le roman contemporain," *Dix-huitième siècle*, no. 3, (1971), pp. 337–57

Dethan, Georges, *Gaston d'Orléans: Conspirateur et prince charmant*, Paris, 1959

Detroit Institute of Arts, *French Painting 1774–1830: The Age of Revolution*, 1975

Dialogues sur la peinture, seconde édition, enrichie de notes, Paris, 1773

Dimier, Louis, *Les Peintres français du XVIIIᵉ siècle: Histoire des vies et catalogue des œuvres*, 2 vols., Paris, 1928

Dowd, David L., *J. L. David: Pageant-Master of the Republic*, Lincoln, Nebraska, 1948

Dowley, Francis, "D'Angiviller's *Grands Hommes* and the Significant Moment," *Art Bulletin*, XXXIX, (December 1957), pp. 259–78

Dresdner, Albert, *Die Entstehung der Kunstkritik*, Munich, 1915

Dubois de Saint Gelais, *Description des Tableaux du Palais Royal avec La Vie des Peintres à la tête de leurs Ouvrages, dédié à M. le Duc d'Orléans, Premier Prince du Sang*, Paris, 1727

——, *Histoire journalière de Paris*, Paris, 1717

Dumesnil, M. J., *Histoire des plus célèbres amateurs français et de leurs liaisons avec les artistes*, vol. 1, Pierre-Jean Mariette, 1694–1774, Paris, 1858

Duplessis, Georges, *Catalogue de la collection de pièces sur les beaux-arts imprimées et manuscrites recueillie par Pierre-Jean Mariette, Charles-Nicolas Cochin et M. Deloynes, auditeur des comptes, et acquise récemment par le départment des Estampes de la Bibliothèque nationale*, Paris, 1881

Du Pont de Nemours, "Lettres sur les Salons de 1773, 1777 et 1779 adressées par Du Pont de Nemours à la margravine Caroline-Louise de Bade," *Archives de l'art français*, new period, II, (1908), pp. 1–123

Egret, Jean, *Louis XV et l'opposition parlementaire*, Paris, 1970

——, *La Pré-Révolution Française (1787–1788)*, Paris, 1962

Eisenstadt, Mussia, *Watteaus Fêtes Galantes und ihre Ursprunge*, Berlin, 1930

Elias, Norbert, *The History of Manners: The Civilizing Process*, Edmund Jephcott, trans., New York, 1978

Encore un coup de patte pour le dernier ou Dialogue sur le Salon de 1787, n.p., 1787

Engerand, Fernand, *Inventaire des tableaux commandés et achetés par le direction des bâtiments du Roi (1709–1792)*, Paris, 1900

Entretiens sur les Tableaux exposés au Sallon en 1783 ou Jugement de M. Quil, Lay, procureur au Châtelet et son épouse, madame Fi, delle, et mademoiselle Descharmes, nièce de maître Lami, et de M. Dessence, apothicaire-ventilateur, n.p., 1783

Ettlinger, L. D., "Jacques-Louis David and Roman Virtue," *Journal of the Royal Society of Arts*, CXV, (January 1967), pp. 105–23

Faret, Nicolas, *L'Honneste homme ou l'art de plaire à la cour*, M. Magendie, ed., Paris, 1925

Fontaine, André, *Les Collections de l'Académie Royale de Peinture et de Sculpture*, Paris, 1910

Forster, Robert, *The Nobility of Toulouse in the Eighteenth Century*, Baltimore, 1960

Fox-Genovese, Elizabeth, *The Origins of Physiocracy: Economic Revolution and Social Order in Eighteenth-Century France*, Ithaca, NY, 1976

Fréart de Chambray, Roland, *Idée de la Perfection de la Peinture*, Paris, 1662

Fried, Michael, *Absorption and Theatricality: Painting and Beholder in the Age of Diderot*, Berkeley, 1980

Furcy-Raynaud, M., ed., *Correspondance du comte d'Angiviller avec Pierre, Nouvelles archives de l'art français*, 3rd series, XXI–XXII, 1905–6

Furcy-Raynaud, M., ed., *Correspondance de M. de Marigny, Nouvelles archives de l'art français*, 3rd series, XIX–XX, 1903–4

Gelbart, Nina R., "Frondeur Journalism in the 1770s: Theater Criticism and Radical Politics in the Prerevolutionary French Press," *Eighteenth-Century Studies*, XVII, (Summer 1984), pp. 493–514

Genlis, Stéphanie Félicité Ducrest de Saint Aubin, comtesse de, *Mémoires inédits de Madame la comtesse de Genlis, sur le dix-huitième siècle et la Révolution française, depuis 1756 à nos jours*, 8 vols., Paris, 1825

Gersaint, E. F., "Abrégé de la vie d'Antoine Watteau," *Catalogue raisonné des diverses curiosités du cabinet*

de feu M. Quentin de Lorangère, Paris, 1744

Goncourt, E. and J. de, *L'Art du dix-huitième siècle*, 2nd edition, 2 vols., Paris, 1873

Gordon, Alden Rand, *The Marquis de Marigny, Directeur-Général des Bâtiments du Roi to Louis XV, 1751–1773 : A Study in Royal Patronage*, unpublished Ph.D. dissertation, Harvard University, 1978

[Gorsas, Antoine-Joseph], *Apologie de Messire Jean-Charles-Pierre Lenoir par son très humble et très obéissant serviteur Suard, l'un des quarante*, n.p., 1789

——, *Le Mannequin, dédié à Mm. du Caveau*, Paris, 1787

——, *La plume de Coq de Micille ou aventures de Critès au Sallon pour servir de suite aux Promenades de 1785*, 2 vols., Paris, 1787

——, *Promenades de Critès au Sallon de l'année 1785*, London, 1785

——, *Le public pour le second fois à Pierre-Augustin Caron de Beaumarchais*, n.p., 1787

Gossman, Lionel, *Medievalism and the Ideologies of the Enlightenment: The World and Work of La Curne de Sainte-Palaye*, Baltimore, 1968

Grasselli, Margaret Morgan and Pierre Rosenberg, *Watteau, 1684–1721*, Washington, 1984

[Gresset, J. B. L.] *Vers sur les tableaux exposés à l'Académie Royale de Peinture, au mois de septembre 1737*, Paris, 1737

Gueullette, J. E., *Un Magistrat du XVIIIᵉ siècle, ami des lettres, du théâtre, et des plaisirs, Thomas-Simon Gueullette*, Paris, 1938

Guiffrey, J. J., *Collection des livrets des anciennes expositions depuis 1673 jusqu'en 1800*, 4 vols., Paris, 1869–71

——, "La Maîtrise des peintres à Saint-Germain-des-Prez (*sic*)," *Nouvelles archives de l'art français*, XXII, (1876), pp. 93–123

——, *Notes et documents inédits sur les expositions du XVIIIᵉ siecle*, Paris, 1886

Guiffrey, J. J. and Anatole de Montaiglon, eds., *Correspondance des directeurs de l'Académie de France à Rome avec les Surintendants des Bâtiments*, 17 vols., Paris, 1887–1912

Harvey, H. G., *The Theater of the Basoche*, Cambridge, Mass., 1941

Haskell, Francis, *Patrons and Painters*, New Haven and London, 1980

Hautecoeur, Louis, *Louis David*, Paris, 1954

Hazlehurst, F. Hamilton, "The Artistic Evolution of David's 'Oath'," *Art Bulletin*, (March 1960), pp. 59–63

Herbert, Robert, *David, Voltaire, Brutus, and the French Revolution: an essay in art and politics*, New York, 1972.

Honour, Hugh, *Neo-Classicism*, Harmondsworth, 1968

Hourticq, Louis, "Les Parisiens aux Salons de peinture," *La Vie parisienne au XVIIIᵉ siècle, Conférences du Musée Carnavalet*, Paris, 1928

Huppert, George, *Les Bourgeois Gentilshommes: An Essay on the Definition of Elites in Renaissance France*, Chicago, 1977

Ingrams, Rosalind, "Bachaumont: A Parisian Connoisseur of the Eighteenth Century," *Gazette des Beaux-Arts*, 6th series, LXXV, (January 1970), pp. 11–28

Isherwood, Robert M., "Entertainment in the Parisian Fairs in the Eighteenth Century," *Journal of Modern History*, LIII, (March 1981), pp. 24–47

Jolibois, Emile, *La Haute-Marne, ancienne et moderne, dictionnaire*, Paris, 1967

[Joly de St. Just], *Promenades d'un Observateur au Salon de l'année 1787*, London, 1787

*Jugement d'un amateur sur l'exposition des Tableaux. Lettre à M. le marquis de V****, n.p., 1753

Kaufmann, Thomas DaC., "Remarks on the Collection of Rudolf II: the *Kunstkammer* as a Form of *Representatio*," *Art Journal*, XXXVIII, (Fall 1978), pp. 22–8

Koch, Georg Friedrich, *Die Kunstausstellung*, Berlin, 1967

Kris, Ernst, and Otto Kurz, *Legend, Myth, and Magic in the Image of the Artist*, New Haven and London, 1979

Lacroix, Paul, "Correspondance de Pierre avec Bachaumont," *Revue Universelle des Arts*, V, (1857), p. 260–4

[La Curne de Sainte-Palaye, J.-B.], *Lettre de M. de S. P. à M. de B. sur le bon goût dans les arts et dans les lettres*, Paris, 1751, (reprint, Geneva, 1972)

[La Font de Saint-Yenne], *Lettre de l'auteur des Réflexions sur la peinture et de l'examen des ouvrages exposés au Louvre en 1746*, n.p., n.d., Deloynes no. 22

——, *L'Ombre du grand Colbert*, Paris, 1751

——, *Réflexions sur quelques causes de l'état présent de la peinture en France avec un examen des principaux ouvrages exposés au Louvre le mois d'aoust 1746*, The Hague, 1747

——, *Sentimens sur quelques ouvrages de peinture, sculpture et gravure écrits à un particulier en province*, n.p., 1754

[La Garde, l'abbé de], *Description des tableaux exposés au Salon du Louvre avec les remarques par une société d'amateurs*, special number of the *Mercure de France*, September 1763

——, *Observations d'une société d'amateurs sur les tableaux exposés au Salon cette année 1761 tirées de l'Observateur littéraire de M. l'abbé de la Porte*, Paris, 1761

Lanlaire au Salon académique de peinture par M. L. B. . . de B. . . de plusieurs académies, auteur de la Gazette infernale, Paris, 1787

Lapauze, Henry, *L'Histoire de l'Académie de France à Rome*, Paris, 1924

La Porte, J. de, *Sentimens sur plusieurs tableaux exposés cette année dans le grand Sallon du Louvre*, Paris, 1755

Laugier, Marc-Antoine, *Essai sur l'architecture*, The Hague, 1753

——, *Jugement d'un amateur sur l'exposition des Tableaux. Lettre à M. le Marquis de V[ence]*, n.p., 1753

——, *Observations sur l'architecture*, The Hague, 1765

[Leblanc, l'abbé], *Lettre sur l'exposition des ouvrages de peinture, sculpture, etc., de l'année 1747, et en général sur l'utilité de ces sortes d'expositions, à monsieur R. D. R. . .*, n.p., 1747

——, *Observations sur les ouvrages de MM. de l'Académie de peinture et de sculpture exposés au Sallon du Louvre en l'année 1753, et sur quelques écrits qui ont rapport à la peinture. A Monsieur le président de B***, n.p., 1753

Le Comte, Florent, *Cabinet des singularitez d'architecture, peinture, sculpture, et gravure*, 3 vols., Paris, 1700

Lenet, Pierre, "Mémoires," in *Nouvelle collection des mémoires sur l'histoire de France*, J. F. Michaud and J. J. Poujoulat, eds., 3rd series, II, Paris, 1850, pp. 185–632

Lettre à l'auteur (sur l'exposition de cette année), Paris, 1757

Lettre à Monsieur de Poiresson-Chamarande, Lieutenant-Général au baillage et siège présidial de Chaumont en Bassigny, au sujet des tableaux exposés au Salon du Louvre, Paris, 5 September 1741

Lettre d'un amateur à Paris à un amateur de province sur le Salon de peinture de l'année 1787, Paris, 1787

Lettre sur la cessation du Sallon de peinture, Cologne, 1749

Lettre sur les peintures, gravures et sculptures qui ont été exposés cette année au Louvre, par M. Raphael, peintre, de l'Académie de St. Luc, entrepreneur général des Enseignes de la ville, fauxbourgs et banlieue de Paris, à M. Jérosme, son ami, rapeur de tabac et riboteur, Paris, 1769

Lettres Analitiques, critiques et philosophiques sur les tableaux du Sallon, Paris, 1791

"Lettres écrites de Paris à Bruxelles sur le Salon de peinture de l'année 1748," *Revue Universelle des Arts*, X, (1859), pp. 431–62

Le littérateur au Sallon, l'examen du paresseux suivi de la critique des critiques. Au Sallon et se trouve à Paris chez Hardouin, Paris, 1779

Locquin, Jean, *La Peinture d'histoire en France de 1747 à 1785*, Paris, 1912

Lough, John, *An Introduction to Eighteenth-Century France*, London, 1961

——, *Paris Theatre Audiences in the 17th and 18th Centuries*, Oxford, 1957

——, *Writer and Public in France*, Oxford, 1977

Lucas, Colin, "Nobles, Bourgeois, and the Origins of the French Revolution," *Past and Present*, no. 60, (August 1973), pp. 84–126

Lundberg, G., "Le Séjour de P. G. Floding à Paris (1755–1764)," *Archives de l'art français*, new period, XVII, (1931–2), pp. 251–359

Magendie, Maurice, *La Politesse mondaine et les théories de l'honnêteté en France au XVIIᵉ siècle de 1600 à 1660*, 2 vols., Paris, 1925

Marat, Jean-Paul, *Les Charlatans modernes, ou lettres sur le charlatanisme académique, publiées par M. Marat, l'Ami du peuple*, Paris, 1791

Mariette, P. J., *Abécédario de P. J. Mariette*, P. de Chennevières and A. de Montaiglon, eds., 6 vols., Paris, 1851–60

Marlborough au Sallon du Louvre; première édition contenant discours préliminaire, chansons, anecdotes, querelles, avis, critiques, lettre à Mlle. Julie, changement de têtes, etc., etc., etc., ouvrage enrichi de figures en taille douce. A Paris, aux dépens de l'Académie royale de peinture et de sculpture et se trouve au Louvre, Paris, 1783

Marmontel, Jean-François, *Mémoires*, M. Tourneux, ed., 3 vols., Paris, 1891

——, *Œuvres complètes*, 7 vols., Geneva, 1968

Mathon de la Cour, *Lettre à Monsieur** sur les peintures, les sculptures et les gravures exposées au Sallon du Louvre en 1765*, 4 vols., Paris, 1765

Mauclair, Camille, *Greuze et son temps*, Paris, 1926

Mélèse, Pierre, *Le Théâtre et le public sous Louis XIV, 1659–1715*, Paris, 1934

Mémoires secrets pour servir à l'histoire de la république des lettres en France depuis 1762 jusqu'à nos jours, 36 vols., London, 1777–89

Mercier, Louis-Sébastien, *Le Tableau de Paris*, Amsterdam, 1782–8

Mercier de Lacombe, Bernard, *La Résistance janseniste et parlementaire au temps de Louis XV : l'abbé Nigon de Berty (1702–1772)*, Paris, 1948

Méré, Antoine Gombard, *Lettres*, 2 vols., Paris, 1689

——, *Œuvres posthumes*, C. Boudhors, ed., Paris, 1930

Merlin au Salon en 1787, "Rome," 1787

Mirimonde, A. P. de, "Le Sujets musicaux chez Antoine Watteau," *Gazette des Beaux-Arts*, 6th period, LVIII, (November 1961), pp. 249–88

Mitchell, Jerrine E., "The Decoration of the Gallery of the Royal Château at Choisy," unpublished M.A. thesis, University of California, Los Angeles, 1976

Monod, F., and L. Hautecoeur, *Les Dessins de Greuze conservés à l'Académie des Beaux-Arts de Saint-Petersbourg*, Paris, 1922

Montaiglon, Anatole de, "Confrérie de la nation flamande à Saint-Hyppolite et à Saint-Germain-des-Près de Paris (1626–1691)," *Nouvelles archives de l'art français*, XXIII, (1877), pp. 158–63

——, ed., *Le Livret de l'exposition faite en 1673, dans la cour du Palais-Royal . . . suivi d'un essai de bibliographie des livrets et des critiques de salons depuis 1673 jusqu'en 1851*, Paris, 1852

——, ed., *Mémoires pour servir à l'histoire de l'Académie royale de peinture et sculpture depuis 1648 jusqu'en 1664*, Paris, 1853

——, ed., *Procès-verbaux de l'Académie royale de peinture et de sculpture, 1648–1792*, 10 vols., Paris, 1875–92

Moore, A. P., *The Genre Poissard and the French Stage of the Eighteenth Century*, New York, 1935

Moote, A. Lloyd, *The Revolt of the Judges: The Parlement of Paris and the Fronde, 1643–1652*, Princeton, 1971

Moselius, Carl David, "The Carl Johan Cronstedt Collection of Drawings by Claude Audran," *Gazette des Beaux-Arts*, 6th series, XXVIII, (October 1945), pp. 237–56

Munhall, Edgar, *Jean-Baptiste Greuze, 1725–1802*, Hartford, 1976

Nemeitz, Joachim C., *Séjour à Paris, c'est à dire, Instructions Fidèles pour les Voyageurs de Condition*, Leiden, 1727

Nicolle, Jean, *Madame de Pompadour et la société de son temps*, Paris, 1980

Observations critiques sur les Tableaux du Sallon de l'année 1787, Paris, 1787

Olivier, Louis, "Bachaumont the Chronicler: A Doubtful Renown," *Studies on Voltaire and the Eighteenth Century*, CXLIII, (1975), pp. 161–79

——, *"Curieux", Amateurs, and Connoisseurs: Laymen and the Fine Arts in the Ancien Régime*, unpublished Ph.D. dissertation, Johns Hopkins University, 1976

Panofsky, Dora, "Gilles or Pierrot? Iconographic Notes on Watteau," *Gazette des Beaux-Arts*, 6th series, XXXIX, (1952), pp. 318–40

Parker, Harold T., *The Cult of Antiquity and the French Revolutionaries*, Chicago, 1937

Péron, Alexandre, *Examen du tableau du serment des Horaces peint par David*, Paris, 1839

Petit de Bachaumont, Louis, Mss, 3505, 4041, Bibliothèque de l'Arsenal, Paris

Pintard, René, *Le Libertinage érudit dans la première moitié du XVIIᵉ siècle*, 2 vols., Paris, 1943 de 1777," *Revue Universelle des Arts*, XIX, (1864), pp. 177–92

Pintard, René, *Le Libertinage érudit dans le première moitié du XVIIᵉ siècle*, 2 vols., Paris, 1943

Pique-nique convenable à ceux qui fréquentent le Sallon, préparé par un aveugle, n.p., 1781

Plax, Julie Ann, "Watteau's *Voulez-Vous*: An Interpretation and Inquiry into the Theme of Love," unpublished M.A. thesis, University of Missouri, 1979

Pomian, Krzysztof, "Marchands, connaisseurs, et curieux à Paris au XVIIIᵉ siècle," *Revue de l'Art*, no. 43, (1979), pp. 23–36

Populus, Bernard, *Œuvre gravé de Claude Gillot*, Paris, 1930

Posner, Donald, *Antoine Watteau*, London, 1984

——, "The Swinging Women of Watteau and Fragonard," *Art Bulletin*, LXIV, (March 1982), pp. 75–88

Rafle de Sept ou Réponse aux Critiques du Sallon, The Hague, 1781

Réflexions impartiales sur les progrès de l'art en France et sur les Tableaux exposés au Louvre, par ordre du Roi, en 1785, London, 1785

Renwick, John, *Marmontel, Voltaire, and the Bélisaire Affair, Studies in Voltaire and the Eighteenth Century*, CXXI, (1974)

Réponse à toutes les critiques sur les Tableaux du Sallon de 1783 par un frère de la Charité, "à Rome," 1783

Rocheblave, Samuel, *Les Cochin*, Paris, 1893

——, *Essai sur le comte de Caylus, l'homme, l'artiste, l'antiquaire*, Paris, 1889

——, *La Vie et l'œuvre de Jean-Baptiste Pigalle*, Paris, 1919

Rocheblave, S. and A. Fontaine, eds., "Les conférences inédits du comte de Caylus," *Bulletin de la société de l'histoire de l'art français*, (1907), pp. 100–104

Root-Bernstein, Michele-Marie, *Revolution on the Boulevard: Parisian Popular Theater in the Late-Eighteenth Century*, unpublished Ph.D. dissertation, Princeton University, 1981

Rosenberg, Pierre, *Chardin, 1699–1779*, Cleveland, 1979

——, "Le Concours de peinture de 1727," *Revue de l'Art*, no. 37 (1977), pp. 29–42.

Rosenberg, Pierre and Ettore Camesasca, *Tout l'œuvre peint de Watteau*, Paris, 1970

Rosenberg, Pierre and Udolpho van de Sandt, *Pierre Peyron, 1744–1814*, Paris, 1983

Rosenblum, Robert, *Transformations in Late Eighteenth-Century Art*, Princeton, 1967

Rou, Jean, *Mémoires inédits et opuscules de Jean Rou (1638–1711)*, Francis Washington, ed., Paris, 1857

Sacy, J. Silvestre de, *Le comte d'Angiviller, dernier directeur général des Bâtiments du Roi*, Paris, 1953

Sahut, Marie-Catherine and Nathalie Volle, *Diderot et l'art de Boucher à David*, Paris, 1984

Saisselin, R. G., "Neo-classicism: Images of Public Virtue and Realities of Private Luxury," *Art History*, IV, (March 1981), pp. 14–36.

Sandoz, Marc, *Gabriel-François Doyen (1748–1772)*, Paris, 1975

Scheicher, Elisabeth, *Die Kunst- und Wunderkammern der Habsburger*, Vienna, 1979

Schnapper, Antoine, *David, témoin de son temps*, Paris, 1980

Scott, Barbara, "The Comtesse de Verrue: A Lover of Dutch and Flemish Art," *Apollo*, XCVII, (January 1973), pp. 20–24

——, "Pierre Crozat: A Maecenas of the Régence," *Apollo*, XCVII, (January 1973), pp. 11–19

Seerveld, Calvin, "Telltale Statues in Watteau's Painting," *Eighteenth-Century Studies*, XIV, (Winter 1980–81), pp. 151–80

Sells, Christopher, "Some Recent Research on J. L. David," *Burlington Magazine*, CXVII, (December 1975), pp. 811–14

Seznec, Jean, "Diderot et l'affaire Greuze," *Gazette des Beaux-Arts*, 6th series, LXVII, (May–June 1966), pp. 339–56

——, *Essais sur Diderot et l'antiquité*, Oxford, 1957

Seznec J. and J. Adhémar, *Salons de Diderot*, 4 vols., Oxford, 1957–67

Snoep-Reitsma, E., "Chardin and the Bourgeois Ideals of his Time," *Nederlands Kunsthistorisch Jaarboek*, no. 24, (1973), pp. 147–243

Sorbière, Samuel de, "Lettre IX, à Monsieur Boucherat, conseiller du Roy en ses Conseils d'Estat et Privé, et Maistre des Requestes de son Hostel. De l'excessive curiosité en belles Peintures," in *Relations, lettres et discours de Mr. de Sorbière sur diverses matières curieuses*, Paris, 1660, pp. 235–69

Sorel, Charles, *Polyandre, histoire comique*, Paris, 1648

Stanton, Domna C., *The Aristocrat as Art*, New York, 1980

Stuffmann, M., "Charles de la Fosse et sa position dans la peinture française à la fin du XVIIᵉ siècle," *Gazette des Beaux-Arts*, 6th series, LXIV, (July 1964), pp. 1–121

——, "Les Tableaux de la collection de Pierre Crozat," *Gazette des Beaux-Arts*, 6th series, LXXII, (July–September 1968), pp. 11–144

Supplément du Peintre Anglais au Salon, n.p., n.d.

Sur la peinture. Ouvrage succinct qui peut éclairer les artistes sur la fin originelle de l'art et aider les citoyens dans l'idée qu'ils doivent se faire de son état actuel en France, avec une réplique à la Réfutation insérée dans la Journal de Paris no. 263, The Hague, 1782

Les Tableaux du Louvre ou il n'y a pas le sens commun. Histoire véritable, Paris, 1777

Tate, Robert S., *Petit de Bachaumont: his circle and the Mémoires secrets*, Geneva, 1968

Taylor, George V., "Non-Capitalist Wealth and the Origins of the French Revolution," *American Historical Review*, LXXII, (January 1967), pp. 469–96

Teyssèdre, Bernard, *Roger de Piles et les débats sur le coloris au siècle de Louis XIV*, Paris, 1964

Tourneux, M., ed., *Correspondance littéraire, philosophique et critique par Grimm, Diderot, Raynal, Meister, etc.*, 16 vols., Paris, 1878

——, "Un Projet de Journal de critique d'art en 1759," *Mélanges offerts à H. Lemonnier, Archives de l'art français*, new period, VII, (1913), p. 321–6

Trousson, Raymond, *Socrate devant Voltaire, Diderot, et Rousseau: la conscience en face du mythe*, Paris, 1967

Van Kley, Dale, *The Damiens Affair and the Unraveling of the Ancien Régime, 1750–1770*, Princeton, 1984

Verdi, Richard, "Poussin's *Eudamidas*: Eighteenth-Century Criticism and Copies," *Burlington Magazine*, CXIII, (1971), pp.513–17

La Vérité critique des Tableaux exposés au Sallon du Louvre en 1781, "à Florence," 1781

Vigée-Lebrun, Elisabeth-Louise, *Souvenirs de Madame Vigée-Lebrun*, 3 vols., Paris, 1867

Vision du Juif Ben-Esron, fils de Sepher, Amsterdam, 1773

Vitet, Ludovic, *L'Académie royale de peinture et sculpture, étude historique*, Paris, 1861

Voiture, Vincent, *Poésies, édition critique*, H. Lafay, ed., 2 vols., Paris, 1971

Von Holst, Niels, *Creators, Collectors, and Connoisseurs*, B. Battershaw, trans., London, 1967

Wiegert, Roger-Armand, *Jean I Bérain: Dessinateur de la chambre et du Cabinet du Roi (1649–1711)*, Paris, 1937

Wildenstein, Daniel and Guy, *Documents complémentaires au catalogue de l'œuvre de Louis David*, Paris, 1973

Wildenstein, Georges, "Le Goût pour la peinture dans le cercle de la bourgeoisie parisienne, autour de 1700," *Gazette des Beaux-Arts*, 6th series, XLVIII, (September 1956), pp. 113–194

Wind, Edgar, "The Sources of David's *Horaces*," *Journal of the Warburg and Courtauld Institutes*, IV, (1940–1), pp. 124–38

Wrigley, Richard, "Censorship and Anonymity in Eighteenth-century French Art Criticism," *Oxford Art Journal*, VI, (1983), pp. 17–28

Zmijewska, H., "La Critique des Salons en France avant Diderot," *Gazette des Beaux-Arts*, 6th series, LXXVI, (July–August 1970), pp. 1–144

PHOTOGRAPHIC CREDITS

INDEX